NX 506 DIX

DEBATES

Dixie Debates

Perspectives on Southern Cultures

Edited by
Richard H. King *and* Helen Taylor

Pluto Press

First published 1996 by Pluto Press
345 Archway Road, London N6 5AA

Copyright © Richard H. King and Helen Taylor 1996

The right of the individual contributors to be identified as
the authors of this work has been asserted by them in accordance
with the Copyright, Designs and Patents Act 1988.

British Library Cataloguing in Publication Data
A catalogue record for this book is available from the British Library

ISBN 0 7453 0958 5 hbk

Designed and produced for Pluto Press by
Chase Production Services, Chipping Norton, OX7 5QR
Typeset from disk by Stanford DTP Services, Milton Keynes
Printed in Malta by Interprint Ltd

Contents

Acknowledgements vii

Contributors ix

Richard H. King and Helen Taylor, *Introduction* 1

SOUTHERN CULTURES

1 Charles Joyner, *African and European Roots of Southern Culture:
 The 'Central Theme' Revisited* 12

2 Paul Binding, *Seasons of Nature, Seasons of History: A Reading
 of Southern Literature* 31

3 Maria Lauret, *'I've got a right to sing the blues': Alice Walker's
 Aesthetic* 51

4 Robert Lewis, *L'Acadie Retrouvée: The Re-making of Cajun
 Identity in Southwestern Louisiana, 1968–1994* 67

5 Diane Roberts, *Living Southern in* Southern Living 85

SOUTHERN MUSIC

6 Simon Frith, *The Academic Elvis* 99

7 Paul Wells, *The Last Rebel: Southern Rock and Nostalgic
 Continuities* 115

8 Brian Ward and Jenny Walker, *'Bringing the Races Closer'?:
 Black-Oriented Radio in the South and the Civil Rights Movement* 130

9 Connie Atkinson, *'Shakin' your Butt for the Tourist': Music's
 Role in the Identification and Selling of New Orleans* 150

SOUTHERN IMAGES

10 Richard Dyer, *Into the Light: The Whiteness of the South in The Birth of a Nation* 165

11 Jane Gaines, The Birth of a Nation *and* Within Our Gates: *Two Tales of the American South* 177

12 Judith McWillie, *Traditions and Transformations: Vernacular Art from the Afro-Atlantic South* 193

AFTERWORD

Richard Gray, *Negotiating Differences: Southern Culture(s) Now* 218

Acknowledgements

The editors would like to thank the University of Warwick for its generous financial support of the conference from which this collection arose, *Contemporary Perspectives on US Southern Culture*, 21–22 September 1994.

They also acknowledge gratefully the award of a British Conference Grant from The British Academy.

They would like to thank the support staff of the Department of English, Liz Cameron, Ann Kelly and Cheryl Cave, without whose efficient and imaginative help the conference and the collection would never have happened. The editors are also indebted to Dr Jacqueline Dempster, Computing Services, University of Warwick, for her computer compilation of the collection.

Finally, their greatest gratitude goes to everyone who participated, by speaking and attending, in the conference from which this collection arose. The enthusiastic commitment of everyone concerned, especially the contributors to this book, has made the editorial process both enjoyable and relatively painless.

Every effort has been made to locate the copyright owners of the material quoted in the text. Omissions brought to our attention will be credited in subsequent printings.

PHOTOGRAPHS

Cyrus Bowen's *Grave Monuments*, Sunbury, GA. (circa 1938), courtesy of Malcolm Bell and Muriel Bell, Hendersonville, NC.

The Reverend George Kornegay, *Yard*, Brent, AL., courtesy of Judith McWillie, Athens, GA.

James Hampton with the Throne of the Third Heaven, with permission of the National Museum of American Art, Smithsonian Institution, Washington, DC.

J. B. Murray, *Colour Drawing* (circa 1986), courtesy of Phyllis Kind Gallery, New York.

Dilmus Hall, *Crucifix* (1985), courtesy of Judith McWillie, Athens, GA.

Lonnie Holley, *Detail of Yard*, Birmingham, AL., courtesy of Judith McWillie, Athens, GA.

Contributors

Connie Atkinson had a distinguished career as a journalist in New Orleans, including founding and editing a music magazine, *Wavelength*. She is currently a research student at the University of Liverpool Institute of Popular Music, writing a PhD thesis on the music of New Orleans.

Paul Binding is a writer and journalist specialising in southern writers. He is the author of several books, including *Separate Country: A Literary Journey Through the American South* (Paddington Press, 1979 and University Press of Mississippi, 1988), *Lorca* (GMP, 1986), *St Martin's Ride* (Secker and Warburg, 1990, winner of the 1991 J. R. Ackerley Prize), and *The Still Moment: Eudora Welty, Portrait of a Writer* (Virago, 1994). He has also produced editions of works by southern novelists Ellen Glasgow, Eudora Welty, and Ellen Douglas. He reviews regularly for the *Guardian* and the *Independent*.

Richard Dyer is Professor of Film Studies at the University of Warwick. He is the author of many celebrated books and articles on film, television, cultural and gender studies, including *Stars* (British Film Institute, 1979), *Heavenly Bodies* (Macmillan, 1986), *Now You See It* (Routledge, 1987), and *Only Entertainment* (Routledge, 1992). He is currently preparing a book on 'The Representation of Whiteness'.

Simon Frith is Professor of English, and Research Director of the John Logie Baird Centre at the University of Strathclyde. A leading theorist of popular music, he has published many books and articles on the subject, including: *On Record, Pop, Rock and the Written Word* with Andrew Goodwin (Pantheon and Routledge, 1990), *Rock and Popular Music: Politics, Policies, Institutions* with Tony Bennett, Lawrence Grossberg and John Shepherd (Routledge, 1993), and *Music and Copyright* (Edinburgh University Press, 1993).

Jane Gaines is Associate Professor of Literature and English at Duke University. She has been awarded prizes for her books on film and

television studies, which include: *Fabrications: Costume and the Female Body*, ed. with Charlotte Herzog (Routledge and Chapman Hall/American Film Institute, 1990), *Contested Culture: The Image, the Voice, and the Law* (University of North Carolina Press, 1991), and *Classical Hollywood Narrative: The Paradigm Wars*, ed. (Duke University Press, 1992). She is currently preparing a book for Princeton University Press, *Other Race Desire: Early Cinema and Empire*.

Richard Gray is Professor of Literature at Essex University. His books include *The Literature of Memory: Modern Writers of the American South* (Johns Hopkins University Press, 1977), *Writing the South: Ideas of an American Region* (Cambridge University Press), which won the C. Hugh Holman Award for the most distinguished book on the American South published in 1986, *American Poetry of the Twentieth Century*, ed. (Longman, 1990) and *The Life of William Faulkner: A Critical Biography* (Blackwell, 1994). He is Associate Editor of the *Journal of American Studies* and the first specialist in American Literature to be elected a Fellow of the British Academy. He is currently working on a study of writing and social change in the South since 1960.

Charles Joyner is Burroughs Distinguished Professor of Southern History and Culture at Coastal Carolina University. He is a major historian of slave culture, best known for his book *Down by the Riverside: A South Carolina Slave Community* (University of Illinois Press, 1984) which won the National University Press Book Award in 1987. He has written two other books, *Remember Me: Slave Life in Coastal Georgia* (Georgia Humanities Council, 1989) and *Folk Song in South Carolina* (University of South Carolina Press, 1971), as well as co-authoring and introducing several others. He has published numerous articles on southern topics.

Richard H. King is Professor of American Intellectual History at Nottingham University, and past Chair of the British Association for American Studies. A Southerner, with a doctorate from Virginia, he is the author of *The Party of Eros* (University of North Carolina Press, 1972), *A Southern Renaissance* (Oxford University Press, 1980), and *Civil Rights and the Idea of Freedom* (Oxford University Press, 1992).

Maria Lauret is Lecturer in American Studies at Sussex University. She has published articles on feminist film theory, contemporary women's writing and sexuality and popular culture. Her first book, *Liberating Literature: Feminist Fiction in America* (Routledge), was published in 1994. She is currently writing a book on Alice Walker for Macmillan (1996).

Robert Lewis is Lecturer in American History at the University of Birmingham. He has published articles on recreation in nineteenth-century America (tableaux vivants, croquet, baseball and sport history) and teaches courses on US popular culture, cultural history and slavery. His most recent essay is 'Les médias francophones de Louisiane' in Claude-Jean Bertrand and Francis Bordat, eds, *Les Médias Français aux Etats-Unis* (Presses Universitaires de Nancy, 1994).

Judith McWillie is Professor of Drawing and Painting at the University of Georgia. She has had many years' experience as a writer, exhibition curator and video programme-maker, specialising in the area of folk/vernacular and African-American art. Nationally recognised as a leading scholar of African-American artists, she has published many articles and catalogue introductions, including 'Writing in an Unknown Tongue' in *Cultural Perspectives on the American South*, vol. 5, ed. by C. R. Wilson (Gordon and Breach, 1991), and 'Another Face of the Diamond: Afro-American Traditional Art in the Deep South', *The Clarion Magazine of the Museum of American Folk Art* (Fall 1987).

Diane Roberts received her DPhil from Oxford University in 1988 and now teaches American Literature at the University of Alabama. She is the author of *Faulkner and Southern Womanhood* (University of Georgia, 1993) and *The Myth of Aunt Jemima: Representations of Race and Region* (Routledge, 1994).

Helen Taylor is Senior Lecturer in American Literature at Warwick University. She has published two books on southern writing and culture, *Gender, Race, and Region in the Writings of Grace King, Ruth McEnery Stuart, and Kate Chopin* (Louisiana State University Press, 1989) and *Scarlett's Women: Gone With the Wind and its Female Fans* (Rutgers University Press and Virago, 1989). She has also published articles and edited collections on women writers, romantic fiction, and radical pedagogy. She is currently writing a book about British appropriations of southern popular culture.

Brian Ward is Lecturer in American History at the University of Newcastle upon Tyne. His publications include 'Dissecting The Dream: Civil Rights and Race Relations in the United States' in *Historical Journal*, 35, 4, (1992), and 'Racial Politics, Culture and the Cole Incident of 1956' in Melvyn Stokes and Rick Halpern, eds *Race and Class in the American South since 1890* (Berg, 1994). His book, *The Making of Martin Luther King and the Civil Rights Movement* (ed. with Tony Badger), will be published by Macmillan in 1995, and he is currently completing a book on the

politics of African-American popular music during the Civil Rights and
Black Power eras.

Jenny Walker is a postgraduate student at the University of Newcastle
upon Tyne, working on violence and nonviolence in the Civil Rights
and Black Power movements. Her review essay, 'Roots, Routes and
Resources: The Ideas and Language of Martin Luther King Jr and the
Civil Rights Movement', was published in *Over Here: Reviews in American
Studies* (Spring 1995).

Paul Wells is Senior Lecturer in Media Studies at De Montfort University,
Leicester. He has made a number of series on film for BBC Radio,
including *America – the Movie, Britannia – the Film,* and the Sony Award-
winning history of the Horror film, *Spinechillers*. He has chapters on
documentary and animation in Jill Nelmes, ed. *Introduction to Film
Studies* (Routledge). He has recently completed a six-part series on
comedy for BBC Radio called *Laughing Matters* and a book, *Understanding
Animation* (Routledge, forthcoming). He is currently researching for a
book on American situation comedy and preparing a television
programme on horror films and their audience.

Introduction

Richard H. King and Helen Taylor

Though renowned, or notorious, for everything from racial strife and country music to its Nobel Prize winners (William Faulkner and Martin Luther King), the most interesting thing about the contemporary South is its rich and variegated culture. Once described as the 'Sahara of the Bozart' by H. L. Mencken and represented as a place dominated by bourbon-swilling politicians for the (real) benefit of 'Bourbons' and 'Big Mules' and the (supposed) benefit of poor white dirt farmers, the contemporary South has become a region of economic expansion, national political power and cultural ferment.

To what do the terms 'South' and 'culture' and hence 'southern culture' refer? Of course everyone thinks they know what and where the South is. Yet when it gets down to it, the answer is far from clear. Is the South a geographical-political entity (the eleven states of the former Confederacy or those states where slavery existed after the 1820s); or is it a collective mentality obsessed historically with race, religion and violence (as Lillian Smith once summed it up, 'Sin, sex and segregation'); or has it become, as George Tindall and John Shelton Reed would have it, something like an ethnic entity, organised around a self-consciousness about a shared tradition and culture?

If such questions are not difficult enough to answer, the contemporary South is cross-cut by internal differences and divisions. A strong case can be made, for instance, that neither the northern Virginia suburbs of Washington, D.C., the Disney-generated enclave around Orlando nor the Miami area is 'southern' in any recognisable way. The skylines of southern cities not only all look alike but look like those of American cities elsewhere; not to mention the class and status uniformity of the upwardly mobile inhabitants of the cities and commuter suburbs: *Sleepless in Seattle* could as well have been *Sleepless in Charlotte*. Modernisation has proceeded apace and where the traditional South once was, there suburbs have sprung up.

There are other ways to register the problematic status of a distinctive South. The South might once have been identified as the place where

1

jukeboxes with country music selections could be found. Yet such has been the growth of country music that aficionados can be found in large numbers all over the United States, Japan and western Europe. The historic South has sometimes been considered the homeland of religious fundamentalism and Protestant evangelicalism, but such impulses, now embodied in political as well as religious movements, have spread throughout the United States, exerting their power among both white and black Americans, via cable television. Though still overwhelmingly Protestant, the South no longer seems plagued by the kind of anti-Catholic impulses that have so distorted the fate of Northern Ireland and once might have threatened to obsess southern Protestantism.

The question remains, however, as to whether and to what extent African-Americans living in the South are southern blacks or black Southerners. Which is another way of wondering to what extent the 'South' still implies a barely whispered but always understood 'white' preceding the regional designation. There is no denying that traditionally when most Southerners – or those outside the South who were interested in, or concerned with, the region – thought 'South', they thought 'white'. But it is too easy to conclude that this exemplifies some unconscious form of racial exclusiveness, since historically most black people in or from the South (which means pretty much all African-Americans) have also shared this identification of 'Southernness' and 'whiteness'. Still, the fact remains that over the last couple of decades, the in-migration of black Americans to the South has exceeded the exodus from the region of African-Americans. There are all sorts of interesting but obvious explanations for this demographic trend – improved race relations, a measure of economic growth and prosperity, the vicissitudes of life in northern and western urban ghettos. It all amounts to the fact that the old push–pull factor now works in the reverse direction.

Still, it remains a fascinating reminder that racial definitions of the South can no longer go uncontested – southern blacks may be in the process of becoming black Southerners and more startling, the white South may not be so 'white' after all, not at least in terms of those inflections of daily life such as speech, music, diet, humour and general demeanour. Though he failed to develop the theme in *The Mind of the South* (1941), W. J. Cash got it right when he spoke of the way: 'Negro entered into white man as profoundly as white man entered into Negro – subtly influencing every gesture, every word, every emotion and idea, every attitude'.[1]

Overall, then, the social profile of the South, however it is construed, cannot be so clearly delineated as it once was. Structures of class and status have proliferated and diversified in the economic modernisation of the region. This has meant, among other things, that the region is

no longer overwhelmingly agrarian; and sub-regional consciousness (Appalachia, the Cajun areas of Louisiana, the Piedmont) has grown apace. Patriarchal structures and attitudes underlying white male dominance have weakened and fragmented in the South as elsewhere. All this was described by John Egerton as 'the Americanization of Dixie' in the early 1970s and that remains perhaps as good a term as any for the process. But such a term fails to register with sufficient nuance that, with all the shifting 'externalities' and for all the transformations of the Southern landscape, literally and figuratively, people in the South still *feel* different – still feel, well, 'southern'.

MEMORY

But, it might be asked, in what does this difference consist? How can the South remain different if it is not clear that the South even exists any more? One sort of answer lies in a familiar area: memory. Memory is of course a major concern, even obsession, in classic modern southern writing, William Faulkner and his contemporaries being the creators of what Richard Gray has referred to as 'the literature of memory'. Writing in the 1950s and early 1960s, C. Vann Woodward in *The Burden of Southern History* identified memory as a central component of regional distinctiveness. This is not to say that Southerners have genetically programmed hyper-memories but rather to point to the fact that people, regions or nations to whom 'history has happened' are forced to remember – or to misremember – 'how it was' to the point that it often becomes 'how we wish it might have been'. Though the neat divisions between myth and history, fiction and fact are never that easy to draw, much contemporary southern culture still stands divided between a desire for a usable and for a truthful past.

Now, the South has manifestly been a place where history has happened and people have seen their lives yanked out from under them. The first obvious blow history meted out to the region was the Civil War and Reconstruction. The second, the period of the Civil Rights movement, roughly 1954–68, what Woodward and others named the 'second' Reconstruction, was also a period of heightened historical consciousness which made more explicit the political importance of collective memories. Visitors to the South know of the many Civil War battlefields and commemorative memorials all around the region and often come to the region for the purpose of visiting those sites. Since the early 1950s, the Confederate battle flag and anthem 'Dixie' have become symbolic expressions of southern recalcitrance. For instance, the University of Mississippi remains plagued by the inextricable links

between its self-image rooted in the flag, the song, the mascot 'Colonel Rebel' and the Lost Cause. As a recent report emphasised, Ole Miss may never return to regional or national athletic prominence since these historical associations do not comport well with the attempt to recruit black athletes to the university. Moreover, at various times in recent southern history, the Confederate flag has been brandished and waved and stuck onto automobiles and pickup trucks by descendants of white Southerners who had little or no use for the Confederacy or its cause. Memory, via symbols and song, unites part of the white South across class and geographical lines.[2]

And yet in recent years several impressive museums and monuments have been built to commemorate – and celebrate – the Civil Rights movement and the second Reconstruction. Thus where Shiloh, Chickamauga, Vicksburg and Atlanta once were names to conjure with, Montgomery, Birmingham, Selma and Memphis have assumed places alongside them in the consciousness especially, but not exclusively, of black Southerners. More generally, much of the South still lives in the memory of the Civil Rights revolution with race a constant presence in southern culture and southern politics. Thus the contemporary South is perforce united by a preoccupation with what has happened and its implications. White and black Southerners may differ significantly on how they evaluate the southern past, but it is a past which they share and with which they must deal, usually separately but sometimes together.

That said, the differences that mark the South are manifestly no longer differences that make a difference. That is, they are not fighting differences, uniting Southerners or significant parts of the South against the rest of the country – or even the world. Nor do they set Southerner against Southerner in violent confrontation. Indeed, our suspicion is that what unites the South may be a relatively new and refreshing sense that what the region has to show of itself derives from the cultural and not political realm, that contemporary southern culture refracts and transforms these political, social and economic changes and thus offers one way the South can open out to, rather than wall itself off from, the outside world.

SOUTHERN CULTURES

Which brings us to 'culture'. At the most general level, the process of paying attention to southern culture is both a constant reminder and a way of forgetting Walter Benjamin's mordant dictum: 'There is no document of civilization which is not at the same time a document of

barbarism.'[3] That is, history not only happened to the South, it hurt a lot of people, did violence to them and their existence. Much of southern culture, whether from white or black sources, is an attempt to deal with and to deny that fact of barbarism. There is no answer to the question that has been asked of students of the South and southern culture: 'Would William Faulkner and Richard Wright and B. B. King and Hank Williams and Eudora Welty and Alice Walker and Walker Percy and Jasper Johns have been possible without all the injustice and violation and poverty and abuse of power?' Yet the question does capture the intimate relation Benjamin suggested between the products of a culture and the injustices and suffering which feed it.

But an assertion of Ralph Ellison's, the substance of which he expressed at various times in his essays, must also be attended to. Responding in the early 1960s to Irving Howe's charge that he and James Baldwin had abandoned Richard Wright's 'protest' writing, Ellison countered with: 'I could escape the reduction imposed by unjust laws and customs, but not that imposed by ideas which defined me as no more than the *sum* of those laws and customs.'[4] Ellison's words are powerful reminders that, when we contemplate the cultural expression of black Southerners, we must resist the temptation to see it as only about their experience of racial oppression. The culture identified with white Southerners might also be granted this kind of 'moral holiday'. Not everything that white Southerners write or think or paint or sing has to make reference to, and amends for, the 'barbarism' of southern history. Some of it will – and properly should – engage with such issues, just as the protest element should never be expunged from the cultural life of black people in the South. But no individual or group should be consigned or condemned eternally to the category of victim or executioner.

The dangers in approaching southern culture, past or present, are legion. One is to aestheticise it and thus forget its grounding in historical realities of race and class and gender relationships; to admire the culture without remembering the conditions and context of its emergence. Another closely related tendency is to patronise southern culture, as though it were some sort of miracle that these untutored and benighted people could produce this music or that visual construct; or to patronise it as being 'so bad it's good', as a kind of backwoods 'camp', a not uncommon contemporary attitude toward much country music. To adopt this attitude is to take southern culture as essentially ironic performance rather than articulated expression. This is not to say that southern popular culture in particular has not included a healthy dose of self-parody, but the all too common response has been to mistake parody for playing it straight and vice versa. A final, dangerous tendency is to choose racial or class sides, to love the blues but to scorn country music,

to link aesthetics to politics too closely, and thus to judge cultural expression in the light of political or social position or racial identity. None of these problems in the reception and understanding of southern culture is unique to it; it's more that southern culture forces us to confront such issues in a particularly acute form.

All this is to say that a complicated attitude is required of someone interested in engaging with the various aspects of contemporary southern culture. But southern culture should be enjoyed as well, since it is often both about trying things out and trying things on. The image of that culture which emerges in this volume, the editors hope, will suggest variety and diversity above all else. Multiculturalism threatens to collapse under the weight of usage, while to characterise southern culture as sampled here as 'postmodern' is tempting but finally unsatisfactory, in part because the concept of the postmodern itself has been worn out, ironically enough, by overconsumption and promiscuous usage. More importantly, contemporary southern culture shows a healthy, latitudinarian attitude toward the attempt to mix high and popular culture and to link racial-ethnic traditions within one form of articulation, to combine the sacred and the secular in exciting new ways, and to deploy the present to interrogate the past and the past, the present. Indeed, these four axes of concern – high/popular culture; dominant/ minority traditions; sacred/secular visions; and contemporary/traditional orientation – might plausibly be seen as the crucial elements defining the relative uniqueness, the difference, that marks contemporary southern culture.

Yet, different as southern culture has undoubtedly been, some of the United States' most culturally resonant and universally popular texts have originated from, or focused on the South. Most famously, there is Mark Twain's *The Adventures of Huckleberry Finn* (1885). But hard on its heels are the most famous novels-made-films which have taken southern history as their theme: Harriet Beecher Stowe's *Uncle Tom's Cabin* (1852) and its many silent and sound film versions; Thomas Dixon's *The Clansman* (1905), on which D. W. Griffith based his film *The Birth of a Nation* (1915); Margaret Mitchell's *Gone With the Wind* (1936) made into David Selznick's classic 1939 film version; and Alex Haley's *Roots* (1976), with its TV mini-series that broke all viewing records. In recent years, this trend has continued with world bestsellers and box-office hits like *The Waltons* (1971–77), Alice Walker's *The Color Purple* (1982, filmed by Steven Spielberg in 1985), and Anne Rice's cult novel *Interview with the Vampire* (1976), also made into a commercial film in 1995. This is without even mentioning the steady rise in international acclaim for southern music of all kinds – blues, jazz, rhythm'n'blues, rockabilly, country, Cajun and more. So central to world music is this southern

tradition that several friends expressed surprise this book should feature a chapter on Elvis Presley: 'I never thought of Elvis as a Southerner.'

The book does not reflect a static and complacent, monolithic southern culture which is to be codified and buried in academic conferences and tomes. The dynamic nature of the multiple cultures – in terms of different and distinctive racial and ethnic groupings, local and regional specificities, social, cultural and linguistic formations – makes any attempt at comprehensive or even representative coverage a futile task. As John Shelton Reed reminds us, the rapidly changing South has given us Coca Cola, Holiday Inns and Kentucky Fried Chicken[5] and – one might add – Ted Turner and CNN; so to preserve a much-repeated image of parochial backward-looking quaintness is grossly to misrepresent the state of play. The tensions, since the Second World War, of New South socio-economic forward thrust co-existing with anguished or rebarbative clinging to traditional southern ways (with all the racially charged meanings of southern history), are reflected in a bewildering variety of discursive definitions and redefinitions of 'the South' and 'Southernness'.

One manifestation of this diversity has been that rich vein of modern southern humour which is to be found in self-parodying country songs, *The Dukes of Hazzard*, *Forrest Gump*, *Steel Magnolias*, and the contemporary voices of Florence King, Bobbie Ann Mason, John Kennedy Toole and Ishmael Reed, as well as books with titles like *New Times in the Old South* or *Why Scarlett's in Therapy and Tara's Going Condo*. Another is reflected in the new southern tourism: for instance, the jostling juxtaposition, within the city of Memphis, of Elvis Presley's Graceland (with its nine gift shops), the National Civil Rights Museum, located in the Lorraine Motel where Martin Luther King was assassinated in 1968, and the famed Beale Street, site of the W. C. Handy statue and B. B. King nightclub, as well as The Center for Southern Folklore.

SOUTHERN CULTURAL STUDIES

This Center is typical of a rising number of research institutes and departments devoted to southern culture. They exist, among other places, at the Universities of South Carolina, North Carolina at Chapel Hill, Duke and Texas. The most renowned is The Center for the Study of Southern Culture at The University of Mississippi, with its newly restored lavish building, vast blues archive, and range of home-grown journals, research and teaching programmes. From this Center originated the most important major publication in the field: in 1989 the Center's directors, historian Charles Reagan Wilson and folklorist William Ferris

produced their co-edited *Encyclopedia of Southern Culture* (The University
of North Carolina Press). This was not merely a book, it was an event
– involving ten years of exhaustive work, a cast of hundreds of researchers,
scholars and editors, funding by major foundations, trusts and individuals,
and a foreword by Alex Haley. This 'Encyclopedia Grittania', as it was
dubbed, ranged wide. 'What other volume', asked the *Texas Observer*,
'ranges from Faulkner to Foxy Brown, Dirt Eaters to Demagogues,
Cheerleading to Chickasaws?' Having already become a bestseller (over
100,000 copies sold), and soon to be available on multi-media CD-ROM,
this mammoth text provides a model of collaborative scholarship in the
field. The Center, dedicated as it is to interdisciplinary research, hosts
annual conferences on southern history, the literary marketplace,
William Faulkner and – from 1995 – Elvis Presley.

No such centre exists in Europe, and to our knowledge there is no
major interdisciplinary southern programme within a European
university. On the European side of the Atlantic, the enthusiasm for
southern culture is perhaps best found in small touring Cajun and New
Orleans jazz bands (often consisting of moonlighting civil servants and
teachers); the huge audiences that greet visiting blues, country and jazz
musicians (support which southern musicians acknowledge is vital for
their livelihood); the large readership of southern genre writers –
mystery, romance and especially gothic; and the following of southern
themes and fashions in film, advertisements, alcoholic drinks and cuisine.

But such enthusiasm is also to be found in pockets within European
institutes and universities. Scholars on both sides of the Atlantic are
increasingly focusing research on the South's literature (not just canonical
figures like Faulkner), music (not merely blues 'greats'), sport, film and
popular arts. There is a lively Southern Studies Forum of the European
Association of American Studies; this produces a regular newsletter, a
biannual Symposium, and sessions at EAAS conferences.[6] The conference
from which this book originated, 'Contemporary Perspectives on US
Southern Culture', The University of Warwick, September 1994, was the
first international, interdisciplinary southern culture conference to be
held in Europe, and a second meeting is being planned. American and
European speakers and delegates gathered to examine the current state
of southern cultural studies. It was found to be alive and kicking.
Exchanges and contacts were exuberant; scholars from the South were
delighted to meet European enthusiasts, while we Europeans welcomed
the opportunity to hear about the South from those who really know
it on the pulses. Papers ranged from a discussion of the Birmingham
Black Barons Baseball Team (Christopher D. Fullerton) and masculin-
ity and white narcissism in *Mississippi Burning* (Lola Young), to folklore
studies in nineteenth-century Louisiana (Rosan Augusta Jordan and Frank

de Caro), *Gone With the Wind* and race (Darden Asbury Pyron), and Texas Cyberpunk (John Moore). The conference testified to the rich multi-cultural and multifarious gumbo which has long characterised the culture of the South.

DIXIE DEBATES

This book contains a selection of expanded and edited conference papers. It is organised into three main sections representing central strains within southern studies which, for simplicity, we have labelled Cultures, Music and Images. While these areas are by no means exhaustive, they allow the writers to cover their chosen topics and also to explore key issues such as religion, oral culture and cuisine. Because of the book's emphasis on transatlantic southern studies, the chapters often draw attention to the mutual influences between European and southern cultures.

Appropriately, the first chapter in 'Southern Cultures', Charles Joyner's, 'African and European Roots of Southern Culture: The "Central Theme" Revisited', begins with an interdisciplinary focus on the African and European roots of southern culture, examining the problem of the 'central theme', using music, and specifically Dizzy Gillespie, to explore the international eclecticism within that culture. Paul Binding, in 'Seasons of Nature, Seasons of History: A Reading of Southern Literature', takes a mythic overview of southern literature from the perspective of historical and seasonal time. In '"I've got a right to sing the blues": Alice Walker's Aesthetic', Maria Lauret challenges the current orthodoxy about African-American writing being the equivalent of the blues; she reminds us of the specificity of each genre. Robert Lewis's 'L'Acadie Retrouvée: The Re-making of Cajun Identity in Southwestern Louisiana, 1968–1994' traces the changing identity of Louisiana Acadians from 'coon-ass' to CODOFIL and a new Cajun flag, identifying this change in historical, mythic and tourist terms. In 'Living Southern in *Southern Living*', Diane Roberts discusses the ideological and cultural work done by *Southern Living* magazine, one of the nation's most successful publications which proselytises in favour of, and educates readers in, a specifically upper-middle-class version of 'Southernness'.

'Southern Music' had to begin with Elvis, the South's most famed and lucrative export. In 'The Academic Elvis', Simon Frith deplores the dismissal of or indifference to Elvis by scholars of popular music and cultural studies, who manifest academic contempt for the middle-of-the-road and southern white working-class performing artists. Paul Wells, writing from the perspective of the culture of fandom in 'The

Last Rebel: Southern Rock and Nostalgic Continuities', highlights contemporary southern white rock's relationship with Confederate myths and images. Brian Ward and Jenny Walker, in '"Bringing the Races Closer"? Black-oriented Radio in the South and the Civil Rights Movement', focus on radio stations as an important but historically neglected medium of communication and information in terms of 1940s and 1950s race relations and civil rights. Connie Atkinson, writing with an insider's knowledge of the New Orleans music world in '"Shakin' your Butt for the Tourist": Music's Role in the Identification and Selling of New Orleans', discusses the role of musicians in that city's cultural and economic development, especially in the light of the tourist industry.

'Southern Images' begins with two complementary papers debating the continuing significance of D. W. Griffith's influential *The Birth of a Nation*, both in terms of classic Hollywood cinema and African-American film history and also in relation to theories of racial difference. Richard Dyer's 'Into the Light: The Whiteness of the South in *The Birth of a Nation*', explores the cinematic glorification of whiteness in Griffith's film, a whiteness paradoxically with strong northern connotations, while Jane Gaines ('*The Birth of a Nation* and *Within Our Gates*: Two Tales of the American South') discusses the long-neglected African-American film-maker Oscar Micheaux and his filmic response to *Birth*, the newly-discovered *Within Our Gates* (1919). The final chapter in the 'Images' section, Judith McWillie's 'Traditions and Transformations: Vernacular Art from the Afro-Atlantic South', returns to the cross-cultural 'creolisation' focus of Charles Joyner in order to discuss African cultural imagery in southern black vernacular art – a body of relatively marginalised work of considerable cultural and religious significance. Richard Gray's Afterword, 'Negotiating Differences: Southern Culture(s) Now', takes an overview of the issues raised within the book, focusing on the tensions between continuity and change, the past and the present, in terms of the ironies of southern history.

We make no apology for the eclectic nature of the chapters. There is still much suspicion in the academy about the possibility of interdisciplinary research and debate, and a fear that loosening boundaries between subject areas will lead to a collapse of intellectual rigour. But American Studies has long been an interdisciplinary area study, and Southern Studies requires of its enthusiasts a broad cultural span. One cannot read Faulkner or Eudora Welty sensitively without a knowledge of the South's storytelling and religious cultures; African-American visual art and writing demand a working acquaintance with African source materials and especially the blues; the ironic and didactic nuances

within *The Birth of a Nation* and *Forrest Gump* can only be understood against the South's traditions of political thought, song and popular myth. Southern cultures – it is impossible to talk of a single culture – have achieved world-wide recognition. It has become a cliché to say that the 'Americanization of Dixie' is paralleled by the 'Southernizing of America' – and indeed, we would say, the diffusion of southern culture on a multi-national scale. This is seen in the internationally celebrated fusion or hybridisation of musical forms, drawing on older European and African models combined with black and white southern musical experiment and innovation; in the universal enthusiasm for southern writing, film and music; and in the enormous global impact of *Gone With the Wind* (and its sequel, *Scarlett*), *Roots*, Robert Johnson, Elvis, Faulkner and Maya Angelou, to name but a few. This cultural outpouring has arisen from a region troubled and riven by its many divisions and conflicts – local, regional, racial, class- and gender-based. The South has been the United States' most recalcitrant and reactionary, but also its most culturally innovative and original region. It is, after all, the birthplace of America's only truly original art form, jazz. From the 'burden' of its history, an extraordinary cultural heritage has grown. Our intention in *Dixie Debates* is both to pay tribute to that heritage, and also – as the title suggests – to examine it critically with fresh eyes from both sides of the Atlantic.

NOTES

1. W. J. Cash, *The Mind of the South* (New York: Vintage, 1960) p. 51.
2. Reed Cawthon, 'That flag. That song. That Rebel', *The Atlanta Journal/ Constitution*, (9 April 1995), section C.
3. Walter Benjamin, 'Theses on the Philosophy of History' in Douglas Tallack, ed., *Critical Theory: A Reader* (New York: Harvester Wheatsheaf, 1995) p. 280.
4. Ralph Ellison, 'The World and the Jug', *Shadow and Act* (New York: Signet, 1966) p. 128.
5. John Shelton Reed, *Whistling Dixie: Dispatches from the South* (New York: Harcourt Brace Jovanovich, 1990) p. 3.
6. For details of the Southern Studies Forum, contact either Professor Tony Badger, Sidney Sussex College, Cambridge CB2 3HU, United Kingdom, or Professor François Pitavy, Faculté de Langues, Université de Bourgogne, B.P. 138, F 21004 Dijon, Cedex, France.

1

African and European Roots of Southern Culture: The 'Central Theme' Revisited

Charles Joyner

You're a spade. I'm an ofay. Let's blow.
Jack Teagarden to Louis Armstrong on their first meeting

In 1928 the Georgia-born, Yale historian Ulrich B. Phillips attempted to define the very essence of Southernness when he declared that the 'central theme of southern history' was neither climate, nor agrarianism, nor the plantation system, nor slavery, nor states' rights, nor one-crop agriculture, nor one-party politics, but what he called 'a common resolve, indomitably maintained – that it shall be and remain a white man's country'. White determination to maintain white supremacy, he noted, 'whether expressed with the frenzy of a demagogue or maintained with a patrician's quietude', constituted 'the cardinal test of a Southerner and the central theme of southern history'. To Phillips, of course, 'a Southerner' was white. His own genteel racism, expressed with the quietude of an academic patrician, did not blind him to a 'realistic recognition of the potency of racism as a factor in southern life'. Since then, most southern historians have been ambivalent about Phillips's choice of a central theme. Few doubted that white racism was *a* central theme; most doubted that it was *the* central theme. But all of them recognised that Phillips was on to a Good Thing with this 'central theme' business. Over the past two generations, the central theme of southern historians has been the search for a central theme.[1] It is difficult to find a pattern in their various representations of the region, expressed in such titles as 'The Solid South', *The Militant South, The Lazy South, The Fighting South, The Silent South, The Emerging South, The Lasting South, The Changing South, The Enduring South,* 'The Benighted South', and *The Other South.* Some have thrown up their hands in frustration.

'Some things can be known, experienced, practiced, but simply cannot be explained', declared Donald Davidson. William Faulkner had Quentin Compson tell his Harvard roommate, 'You can't understand it. You would have to be born there.' But the Americanisation of Dixie, in C. Vann Woodward's ironic understatement, has 'already leveled many of the old monuments of regional distinctiveness, and may end eventually by erasing the very consciousness of a distinctive tradition along with the will to maintain it'. Indeed, as Dan Carter notes, symposia on the Disappearing South are among the region's recent growth industries (at least among such depressed economic sectors as academia).

There is a wonderful southern proverb that says you can't tell the depth of a well by the length of the pumphandle. This bit of southern folk wisdom tells us that the tangible elements of southern culture, like the shadows cast upon the walls of Plato's cave, are only outward and visible representations of inward and invisible realities. That the folk culture of white Southerners is rooted in European – mainly British – sources has been so commonly assumed that its demonstration hardly seemed necessary. That the folk culture of white Southerners also has roots in *African* sources has seemed so patently absurd that few scholars have even bothered to explore the question. Recent scholarship has challenged the orthodoxy on white southern culture in two ways. One has been Grady McWhiney's emphasis on *Celtic* rather than *English* sources of southern culture, the other is David Hackett Fischer's emphasis on specific regional British roots for specific regional American cultures, North and South.[2]

Not only have the African sources of the white southern folk culture long gone unacknowledged, the African sources of *black* southern folk culture were denied by all but a few until the 1970s. In fact, the question of the nature and origin of the folk culture of black Southerners has remained one of the most controversial topics in the controversial literature of southern culture. One school of thought, derived from the black sociologist E. Franklin Frazier, emphasises the influence of European culture upon enslaved Africans. An opposite school of thought, emphasising the 'Africanity' of slave culture, derives from the white anthropologist Melville J. Herskovits. There is merit in both schools, but each has serious shortcomings as a representation of southern culture. To *under*estimate the Africanity of African-American culture is to rob the slaves of their heritage. But to *over*estimate the Africanity of African-American culture is to rob the slaves of their creativity. Africans were creative in Africa; they did not cease to be creative when they became involuntary settlers in America. What may be considered a third position was put forward in 1938 by the anthropologist Bronislaw Malinowski, who observed that 'the two races exist upon elements taken from Europe

as well as from Africa'. The process affected whites no less than blacks and drew 'from both stores of culture. In so doing both races transform the borrowed elements and incorporate them into a completely new and independent cultural reality.' Two decades later the southern thinker James McBride Dabbs, in a concurring opinion, cogently noted that 'not only has the Negro adopted *our* culture, he has helped to create it'.[3]

Not only did African and European cultures converge and modify each other, but in the new physical and social environment of such places as the South Carolina and Georgia lowcountry, where enslaved Africans and their descendants constituted eighty to ninety per cent of the population, a variety of African cultures converged in combinations that did not exist in Africa. There enslaved Africans created a creole language (composed of African grammatical elements and a mostly English lexicon) and a creolised culture, the roots of which were overwhelmingly African, but which was unlike any particular African culture.

And a variety of European cultures – English, Scottish, Scotch-Irish, Welsh, French, German, and Spanish, in particular – were converging and modifying one another in various ways throughout the South. In Louisiana, for instance, enslaved Africans created a creole language out of the convergence of French with their various native languages, and a creolised culture. As in South Carolina and Georgia, the creole language contained African grammatical elements and a mostly European lexicon. And, as in South Carolina and Georgia, the creole culture of black Louisianians proved to be influential upon the whites. An Acadian (or 'Cajun') culture developed in Southwest Louisiana upon a foundation of western French folkways, with major influences from English, Scottish, Irish, Native American, Caribbean, German, Spanish, and African folk tradition. One of the earliest Cajun recordings was 'Blues Nègres' (subtitled 'Nigger Blues'), with vocal by Cleoma Falcon, accompanied by accordian and guitar.

I have tried to explain this cultural transformation by drawing upon the linguistic and anthropological concept of creolisation. Creolisation was the subject of a recent exchange in the *New York Review of Books*. The distinguished historian C. Vann Woodward, characteristically generous but uncharacteristically obtuse, wrote that 'Charles Joyner is right in saying that Africans came to America without a common language or culture'; but he went on to complain with gentlemanly forbearance that I 'seem to be going a bit too far in holding that enslaved Africans were compelled to create a new language, a new religion, indeed a new culture'. Professor Woodward kindly offered to come to my aid. 'What I think he intended to say', he wrote, 'is that they Africanized the old culture they encountered in the South or adapted it to their needs'. But the enslaved Africans were among the very first

transatlantic settlers in the lowcountry of South Carolina and Georgia. European settlers far more often encountered old *African* cultures there than African settlers encountered old *European* cultures. Perhaps what Professor Woodward intended to say was that in the convergence of various African cultures and European cultures in the American South, Euro-Southerners had their old cultures Africanised by their black neighbours and Afro-Southerners had their old cultures Europeanised by their white neighbours.[4]

In William Faulkner's *Absalom, Absalom!*, the culture-haunted Southerner Quentin Compson sits in his Harvard dormitory room with his Canadian roommate Shreve McCannon attempting to deconstruct the tragic history of Yoknapatawpha County, his Mississippi home, attempting to listen to the long-suppressed voices of Miss Rosa Coldfield and others. To Shreve, the objective but obtuse Outsider, the South is simply an exotic place: 'The South. The South. Jesus. No wonder you folks all outlive yourselves by years and years and years.' But Quentin, the quintessential Insider, is obsessed by the burden of southern history, a burden he finds all too subjective. Neither can really understand Yoknapatawpha without the other. One point of significance is epis-temological: the study of southern culture in the midst of social transformation must be a collaboration between cultural Outsider and cultural Insider, between etic and emic, between native and newcomer. Cultural meaning is created by neither alone but by both together. This chapter is an attempt to restore the southern memory, to restore its meaningful narratives, its cultural texts – expressed in spirituals, blues, country ballads, funeral marches, and jazz improvisations – to their rightful place in the search for meaning.[5]

On the slave plantations of the Old South necessity was upon the slaves to make their own music, their own songs. They sang on the way to the fields in the morning, they sang while they ploughed and hoed under the broiling sun, they came in singing from the fields. Fanny Kemble believed the slaves had a natural gift of music. She found the melodies of their rowing songs on the Georgia coast 'wild and striking'. After the day's work was done, slaves entertained their children with play songs and at night sang them to sleep with lullabies.[6]

Slave religious services were especially marked by music. Whether they slipped away into the woods on Sunday evenings or had general prayer meetings on Wednesday nights at slave chapels, the slaves often 'turn de wash pot bottom upwards so de sound of our voices would go under de pot'. Then they 'would have a good time shouting, singing, and praying just like we pleased'. Deeply expressive of the life of the slaves, and at the same time deeply revealing of the Old South, the spirituals rank among the classic folk expressions. Ostensibly concerned with a

better life after death in a literal heaven with the troubles of this world left behind, the spirituals offered the slaves both escape from reality and meaning for life as they struggled for spiritual survival on the slave plantations. The spirituals expressed both a reaffirmation of their human dignity and a ringing condemnation of the wicked ways of the world. But the spirituals also expressed something much more specific. When the slaves sang:

Go Down, Moses,
way down in Egypt land,
tell old Pharaoh
to let my people go

the Pharaoh they envisioned often looked just like Ole Massa. The slaves knew that Moses had set his people free, but only after plagues had been visited upon the Egyptian power structure. And when the slaves sang.

Jordan's river is chilly and wide,
milk and honey on the other side

and

Jordan's river is chilly and cold,
chills the body but not the soul

the Jordan they were singing of may have flowed along the banks of the Potomac or the Ohio. And what could the slaves have meant by 'Steal away, steal away … I ain't got long to stay here'?

Singlehandedly the spirituals debunk whole schools of historical thought, that the slave plantations were schools for civilizing savages, that the only 'significant others' for the slaves were their masters. Singlehandedly the spirituals debunk the stereotype that enslaved Africans brought no culture with them to the New World, that the slaves were cultural beggars waiting for a few crumbs of culture to be given to them. The slaves were not merely *receivers* of European culture, they were also *donors* of African culture, and *creators* of southern culture. In many ways black and white spirituals of the Old South parallel one another in essence and in thought, with many exchanges of melody, rhythm, and lyric, although both white and black spirituals retained distinctive characteristics. In particular, the slave spirituals were distinguished by an explicit sorrow over the actual woes of the world, an indignation against oppression, and a ringing cry for freedom that had no counterpart in the white spirituals.

On Saturday nights, from Virginia and the Carolinas through Alabama and Mississippi to Louisiana and Texas, the slaves held dances and frolics. Slave musicians enjoyed advantages denied to most of their fellow bondsmen. 'De fiddler mos' impo'tant', a North Carolina slave recalled, 'When I'd rawsum up dat bow and draw it crost de strings, dey'd listen!' Slave musicians were typically self-taught, or more usually taught the rudiments of their instruments by older relatives or by other slaves. Occasionally, a master might provide formal instruction in the European system of music for a slave who already demonstrated musical ability. For example, a young South Carolina slave was found by his master fiddling 'upon a shingle[,] strung, with the hairs of the horse and with a bow made from a twig and horse hair'. The young slave received violin lessons and he, in turn, taught other slaves to play. The fiddle (which originated in Europe) was perhaps the most common instrument played by slave musicians, but the banjo (which originated in Africa) was widespread.[7]

The spirituals reflected the higher life of the slaves, but few of their secular songs were meant for the ears of the Lord – or of the white master. In the closing decades of the nineteenth century, itinerant musicians – singing on the street corners and in the saloons of the New South to the accompaniment of banjo or guitar – began to improvise a new musical and poetic form that came to be known as the blues. A black Mississippian recollected that on a Saturday afternoon in the Delta, 'everybody would go into town and those fellows like Charley Patton, Robert Johnson, and Howlin' Wolf would be playin' on the streets, standin' by the railroad tracks, people pitchin' 'em nickels and dimes, white and black people both'. The blues inevitably reflected the southern soil from which they sprang and to which they belonged. 'That's where the blues start from, back across them fields', explained the great Mississippi Delta blues singer 'Bukka' White. 'It started right behind one of them mules or one of them log houses, one of them log camps or the levee camp. That's where the blues sprung from. I know what I'm talking about.'[8]

Richard Wright described the blues as 'starkly brutal, haunting folk songs created by millions of nameless and illiterate American Negroes'. Out of the formless field hollers of southern cotton fields, they fashioned a cultural response to the disappointing experience of being 'free' in a New South in which the deck seemed forever stacked in favour of failure. Robert Johnson sang:

I got to keep moving, I got to keep moving
blues falling down like hail
blues falling down like hail

Uumh, blues falling down like hail
blues falling down like hail
And the days keeps on 'minding me
there's a hellhound on my trail,
hellhound on my trail,
hellhound on my trail.

The blues were 'secular spirituals', representing a post-emancipation extension of the sorrow songs of the slaves. The blues have been considered *secular*, the devil songs of the convict, the pimp, and the prostitute. But the blues may also be considered *spiritual* in the agonised poetry of their representation of ultimate concern in the African-American experience. 'To me, the blues are – well, almost religious', testified Memphis-born Alberta Hunter. 'The blues are like spirituals, almost sacred. When we sing blues, we're singin' out our hearts, we're singin' out our feelings. Maybe we're hurt and just can't answer back, then we sing or maybe even hum the blues. Yes, to us, the blues are sacred.' New Orleans banjoist and guitarist Danny Barker agreed. 'Bessie Smith was a fabulous deal to watch', he recalled. 'If you had any church background, like people who came from the South as I did, you would recognise a similarity between what she was doing and what those preachers and evangelists from there did, and how they moved people. The South had fabulous preachers and evangelists. Some would stand on corners and move the crowds from there. Bessie did the same thing on stage', Barker said. 'She just upset you.'[9]

The blues, according to Ralph Ellison, resulted from 'an impulse to keep the painful details and episodes of a brutal experience alive in one's aching consciousness, to finger its jagged grain, and to transcend it, not by the consolation of philosophy but by squeezing from it a near-tragic, near-comic lyricism'. It is difficult to imagine any more starkly brutal or haunting testimony to the loneliness and lack of hope in the early twentieth-century South, to the bleakness and bitter frustration of African-American life, than the 1926 recording of 'Two Nineteen Train' by South Carolina blues singer Bertha 'Chippie' Hill:

I'm gonna lay my head on some lonesome railroad line,
Let the two nineteen train ease my troubled mind.[10]

As a vocal music, the blues found their greatest interpreters in such 'classic' female blues singers as Ma Rainey, 'Chippie' Hill, Alberta Hunter and, above all, Bessie Smith. When Bessie sang 'Empty Bed Blues', everyone paid attention:

He boiled my first cabbage and he made it awful hot.
He boiled my first cabbage and he made it awful hot.
Then he put in the bacon and it overflowed the pot.

According to Alberta Hunter, 'Bessie Smith was the greatest of them all ... Even though she was raucous and loud, she had a sort of a tear – no, not a tear, but there was a *misery* in what she did.'[11]

As an instrumental music, the blues found their greatest interpreters in the early jazz musicians. Jazz was rooted in the blues. Despite learning to play their European instruments using European-style march music as a model, jazz musicians did not incorporate the so-called 'classical' timbre of their instruments into jazz, but adopted the blues timbre and the blues spirit. African-American horn players eschewed the tonal 'purity' pursued by European horn players in favour of a warmer, more expressive emulation of the human voice. Jazz was created on European instruments, but the sounds jazz musicians blew through them were not the ones that came with the horn. They were sounds African-Americans had been evolving in the South for more than two centuries, out of pain, poverty, and injustice, out of field hollers, work shouts, and spirituals. If the sources were old, however, the music those early jazz pioneers created out of them was something new, something indigenous to the cultural experience of black Southerners.

Not only were the blues at the heart of jazz, they influenced southern white music as well, lending chords and colour to the emerging new musical form known as country. Country music lyrics, mainly written and performed by working-class Southerners, explore the same themes that have preoccupied the region's greatest writers – the class struggle, the warm appeal of home and fireside and the lonesome trainwhistle call to forsake such an existence in search of new experiences, and the persistent spiritual travail of being torn between such conflicting values, the travail of what William Faulkner calls 'the problem of the human heart divided against itself'. Country music was ostensibly the purest expression of what might be called 'white soul', but it was heavily influenced by the music of black Southerners. The blues and country music were cousins. Country music is rooted in the music of the early settlers, deriving its forms and styles not only from the culture of the British Isles but also from that of Germany, Spain, France, Mexico, Africa, and the Caribbean. One can find in country music echoes of the old ballad styles of singing, of bagpipes and fiddle sounds, of minstrel show songs and sentimental songs of the nineteenth century, and – in large quantities – the blues. When guitars first became an integral part of southern folk music in the early 1920s, black and white musical inter-action accelerated. African-American melodic, textual, and instrumental

styles influenced white musicians, who enriched their music without losing their own identity. Social, economic, and racial barriers that separated Southerners were bypassed by music and converted into positive forces of mutual appreciation. The founders of the intense Delta Blues style were Mississippians, and the singer who brought the blues into country music was a Mississippian too. In the 1920s Jimmie Rodgers, a white Mississippian, fused the twelve-bar country blues of his black neighbours with the yodels of white music, to become the first great star of country music. As a youth Jimmie Rodgers learned to play the banjo from black gandy dancers in the Meridian railyards, and heard the songs and slang. Soon he picked up the guitar and the blues from black musicians on Meridian's Tenth Street.

Other important country musicians were also decisively influenced by the music of black Southerners. Some encountered that music at first hand from black musicians; others heard the music of black Southerners by way of recordings. The Carter Family of Virginia learned 'Coal Miner's Blues', 'Cannon Ball Blues' and many other songs from Leslie Riddles of Kingsport, Tennessee, a black guitarist and singer, who also taught Maybelle Carter a number of guitar techniques. At about the age of twelve, Bill Monroe, the 'father of bluegrass', received instrumental training from a black musician named Arnold Shultz, for whom Monroe then served as guitar accompanist. 'Arnold and myself', Monroe recollected, 'we played for a lot of square dances back in those days'. Monroe's early exposure to the blues from Shultz and other local black musicians instilled in him an enduring fondness for the blues. When he formed his 'Bluegrass Boys' band, he blended the blues with Anglo-American folk music to create an exciting new kind of country music containing elements of each.[12] Hank Williams grew up in Greenville, Alabama, his repertoire and singing style and song strongly affected by the black music he had heard. When he was about twelve years old, he began to follow a black street singer known locally as Tee-Tot (Rufus Payne), who played for nickels and pennies on the streets of Greenville. Tee-Tot liked the little white boy, taught him songs and guitar chords, and gave him tips on performing for an audience.

A few country performers included black musicians on their recording sessions. Jimmie Rodgers included jazz instrumental backing as early as 1928. Louis Armstrong and his then wife, Lillian Hardin Armstrong, joined him on a recording session in 1930, and on his celebrated recording of 'Blue Yodel No. 9' ('Waiting for a Train'), Armstrong played trumpet and Earl 'Fatha' Hines played piano. And another country performer, Jimmie Davis of Louisiana, was accompanied on his 1932 Victor recordings by two bluesmen from Shreveport. Davis was much influenced by black blues. Davis's early associations with black

Southerners, both personally and professionally, contrast strikingly with his later posture as an ultra-segregationist governor of Louisiana. The recorded blues of the 1920s became the urban, electrified, and aggressive 'rhythm 'n' blues' of the 1950s, mainly produced for blacks by blacks. But the fences between musical forms were not high enough to keep musical styles from 'crossing over'. Black and white Southerners had long engaged in a vigorous musical interchange, and it was probably inevitable that country and rhythm'n'blues would fuse their cultural traditions and musical chemistries. When they did, they set off a musical explosion called rock'n'roll that still reverberates in its latter-day forms.

The performer who most personifies the musical mixing of black and white Southerners, of rhythm'n'blues with country, was Elvis Aaron Presley of Tupelo, Mississippi, a poor, white, shy, country kid who fused the black sounds of urban blues and the white sounds of country music, along with large doses of both black and white gospel music, into something bold and charismatic, into the sound that made him a galvanising cultural force as the first great star of rock'n'roll. Presley is reported to have said, 'The colored folk been singin' it and playin' it just the way I'm doin' now, man, for more years than I know. Nobody paid it no mind 'til I goosed it up.' His first disc, recorded in 1954, featured 'That's All Right, Mama', an old rhythm'n'blues tune first recorded by bluesman Arthur 'Big Boy' Crudup on one side, and a supercharged version of Bill Monroe's 'Blue Moon of Kentucky' on the other. Elvis, and such kindred spirits at Memphis's Sun Records as Carl Perkins, Jerry Lee Lewis, Johnny Cash, and Roy Orbison, soon created the musical form known as 'rockabilly' music. Not only in his music, but in his accent, his diet, his manners, his hedonistic but pious religiosity Elvis Presley exemplified a characteristically southern blend of African and British cultures.

But black Southerners also left their mark on country music more directly, as country music performers. Some, like Louis Armstrong and Earl 'Fatha' Hines on the early Jimmie Rodgers recording sessions, or Ray Charles on his highly popular recordings of country music in the 1960s, made their contributions in their usual African-American style. Deford Bailey was another story. Bailey was a popular and frequently scheduled performer on the Grand Ole Opry from 1925 to 1941, playing harmonica and occasionally banjo. The first black superstar identified with country music, however, was Charley Pride. His first records were accompanied neither by photographs nor any mention in the promotional material that he was black. His singing was so country that white people hearing it on the radio or buying his records did not suspect his

racial identity. By the time they saw his photograph or saw him in concert, his singing had already won them over.

Country musicians expressed a working-class white understanding of continuity and change in an industrialising South in songs of love and loneliness, of the peaks and valleys of everyday life, in down-to-earth terms that captivated listeners over the generations with their apparent sincerity. Like the great blues singers, the most enduring legends of country music – such as Jimmie Rodgers, the Carter Family, Bill Monroe, George Jones, and Hank Williams – have been those who have put an autobiographical stamp on their songs, who have been able to convince their audiences that they have lived the songs they sing.

At the same time that the blues were developing in the Deep South, African-American musicians across the region were developing other new instrumental forms, drawing not only upon folk tradition but also upon European instruments and methods of playing them. Ragtime was most commonly played on a piano, which in itself marked a major innovation in African-American music. Whether played on piano or guitar, or played by a band, ragtime was marked by syncopation in the treble juxtaposed to a steady rhythm in the bass. The first published rag was composed in 1897 by a white musician, but the acknowledged 'King of Ragtime' was a black composer and pianist – Scott Joplin. Growing up in a musical family in Texarkana, Texas, he had not only absorbed African-American folk music, but he had also studied the European classics with a German piano teacher, after learning to play the piano by ear. Joplin based his musical compositions on the folk music of his youth, constructing them into what he called 'piano rags'. The interplay of African and European musical influences were crucial in Joplin's artistic development.

A third important element in the emergence of jazz at the turn of the century was the great New Orleans brass band tradition. Louis Armstrong declared, 'they had some funeral marches that would just touch your heart, they were so beautiful'. Brass band funeral marches had begun in antebellum white tradition; but they were well entrenched in African-American tradition by the end of the century, easily absorbing the musical traditions of slave funerals. Clarinetist George Lewis recalled, 'I always did know the spirituals … Even when I was a kid, I heard "The Saints Go Marchin' In" … I heard it in the churches; I heard it at wakes … When I first heard "Closer Walk with Thee", I heard it slow … I played it with the Eureka Band.' There was also a parallel New Orleans tradition in which white bands played for funerals as well.[13]

New Orleans at the turn of the century was the crossroads of an exciting mélange of musical traditions. Patterns of separating and mixing in New Orleans were always complex, even more complex than

in the rest of the South. But while new legal codes sought to keep the races apart, other activities conspired to bring creative and racially diverse people together. In New Orleans, spirituals and blues from the plantations rubbed shoulders with opera and concert music, ragtime and brass bands with French, Spanish, and Caribbean folksongs and dances. It was, in New Orleans terms, a rich gumbo.

The first musician to emerge from the misty bayous of jazz prehistory as an individual was Charles 'Buddy' Bolden. He played the cornet and led a band remembered with awe, but (despite rumours of a lost Buddy Bolden cylinder) he left no known recordings. All that remains of his legacy are the legends and memories of ageing musicians who heard him. Buddy Bolden has become a larger-than-life figure more nearly comparable to John Henry than to any known musician. 'On a still day', Louis Armstrong recalled, 'you could hear him a mile away'. 'Well, it could have happened', reflected Danny Barker, 'because the city of New Orleans has a different kind of acoustics from other cities'. Perhaps because of such legends, Buddy Bolden became the first 'King of Jazz'.[14]

The career of 'King' Buddy Bolden was cut short by mental illness, and his crown passed to Freddie Keppard, leader of the famous Olympia Band. 'Now, at one time, Freddie Keppard had New Orleans all sewed up', Papa Mutt Carey reminisced. 'He was the king – yes, he wore the crown.' Keppard was famed for his power and drive. 'He came to be the greatest hot trumpeter in existence', Jelly Roll Morton contended. 'He hit the highest and the lowest notes on a trumpet that anybody outside of Gabriel ever did. He had the best ear, the best tone, and the most marvelous execution I ever heard ... always was after women and spent every dime he ever made on whiskey'. Another New Orleans veteran, banjoist Johnny St. Cyr, said of Keppard's drinking, 'A quart a day? That was at the beginning. But Freddie Keppard graduated from that.'[15]

As Keppard's career disintegrated, he was succeeded by another cornet player in his Olympia Band, Joe Oliver, who was destined to become the next King and the most influential of the early jazz musicians. If Freddie Keppard was known for his power and drive, King Joe Oliver was famed for his subtlety and imagination. 'Whenever there was a dance or a lawn party', Armstrong recalled of his youth in New Orleans, 'the band ... would stand in front of the place on the side walk and play a half hour ... And us kids would stand ... on the other side of the street until they went inside. That was the only way that we young kids could get the chance to hear those great musicians such as Buddy Bolden – Joe CORNET Oliver MY IDOL – [and] Freddie CORNET Keppard.'[16]

The earliest of the New Orleans white bands to play the new music was that of Papa Jack Laine. Laine, born in 1873, organised Jack Laine's Ragtime Band in 1888. There were some mixed jazz bands in early New

Orleans, even after 1902, when, as Jelly Roll Morton put it, 'they began that segregation outfit'. In New Orleans, however, racial lines were somewhat more fluid than elsewhere, and race was often a matter of context. For example, Papa Jack Laine insisted he never had black players in his band, that his bands had always been white. When Laine was interviewed for the Jazz Archive at Tulane, however, his wife Blanche told Richard Allen that, despite what her husband claimed, around 1900 'they had some bands were pretty good mixed up'. Laine was defensive: 'When I found out he was a colored boy, I stopped hiring him ... One fine day I passed on Ursuline Street, where he lived, and I saw his Daddy and that was enough.'[17]

Laine veteran Tom Brown organised a band featuring his brother Steve and a group of other musicians who had worked with Laine. Strongly influenced by black musicians in New Orleans, they even hired a black bass player, according to Steve Brown, 'I'd say around 1913, 1912. He was a light complected Creole sort of a fella. He played a good bass. I used to admire him with the colored bands.' But there were no black faces in 'Tom Brown's Band from Dixieland' when it became the first to carry New Orleans jazz beyond the Crescent City. People whispered that Brown's Band was playing 'jazz' when it opened in Chicago in June of 1915, and the club's manager, recognising the titillating potential of the word (which had not theretofore been associated with music), billed the group as 'Brown's Dixieland Jass Band, Direct from New Orleans'. The band's success led to an eleven-week engagement in New York, and stimulated a northern search for more of this exciting music from the South.[18]

The year 1917 was a pivotal one in the history of jazz. In that year the general public began to hear about jazz with the release of the first recordings of the music; the Mayor of New Orleans closed down the legalised prostitution of Storyville at the instigation of Secretary of the Navy Josephus Daniels, sending many musicians to seek employment elsewhere; and a child was born in Cheraw, South Carolina, who was given the name John Birks Gillespie. The Jazz Age was underway. The historian Eric Hobsbawm marvelled at what he called the 'extraordinary expansion' of jazz, which, he wrote, 'has practically no cultural parallel for speed and scope except the early expansion of Mohammedanism'.[19]

It is not the least of the ironies of southern history that the first jazz recordings were made by a white band. They were fresh from the exciting New Orleans musical scene, they played without scores, they played 'hotter' than their audiences had ever heard white musicians play before, and they called themselves the Original Dixieland Jass Band. Led by cornetist Nick La Rocca, the ODJB consisted of five alumni of Papa

Jack Laine's bands. Both their songs and their styles were staples of the New Orleans jazz tradition as it had been developing for nearly two decades. They succeeded not only in playing jazz as something more than mere imitation, but also in reproducing something of the legitimate feeling of an Oliver performance, and in making separate and valid emotional statements within their adopted musical tradition. In both Chicago and New York, the ODJB stunned musicians, white and black, who had never heard anything like the new music from New Orleans.

By the 1920s the kind of jazz played by white musicians was known as Dixieland, and it was becoming a national fad. Inspired by the pioneer black jazz musicians of New Orleans, the New Orleans Rhythm Kings became perhaps the most prominent of the Dixieland bands. It was led by New Orleans trumpeter Paul Mares and featured such talented sidemen as clarinetist Leon Rappolo and trombonist George Brunies. 'We did our best to copy the colored music we'd heard at home', Mares acknowledged. 'We did the best we could, but naturally we couldn't play real colored style.' In the interracial jam sessions of the expatriate Southerners in Chicago, racial lines were loosened and cultural sharing began to occur. 'The cornet player, Armstrong', recalled white New Orleans bassist Steve Brown, 'I played alongside of Armstrong there, see. And Armstrong would come up there, we used to have more fun with Louis than enough, see.' An even more extraordinary example of the flouting of southern racial mores occurred in 1923, when Jelly Roll Morton served as musical director of the New Orleans Rhythm Kings to oversee their recording sessions. Morton even played piano on his famous composition 'Milenburg Joys' and several other pieces.[20]

There was a ready-made audience of black Southerners in the North thirsty for the kind of music they had left behind. According to Kid Ory, when his lead cornet player, King Joe Oliver, decided to move on to Chicago, 'Joe told me before he left that he could recommend someone to take his place', but 'I had already picked out his replacement'. Ory went to a teenaged cornet player named Louis Armstrong 'and told him that if he got himself a pair of long trousers I'd give him a job. Within two hours, Louis came to my house and said, "Here I am".'[21]

By 1922, Oliver sent for Louis Armstrong, then 22 years old, to come to Chicago and join his famous Creole Band at the Lincoln Gardens as second cornet. 'I jumped sky-high with joy', Armstrong recalled. 'I was playing a funeral in New Orleans [with the Tuxedo Brass Band] ... I told them the King had sent for me'. In the Oliver band, the young cornetist developed rapidly. His tone, his range, his speed and his creativity were like nothing jazz had known before. Once he hit his stride, jazz was never again quite the same.[22]

By 1924, Louis Armstrong felt sufficiently mature musically to venture out from under the shadow of his mentor into the bright lights of New York. There, from the brass section of Fletcher Henderson's Roseland band, he developed a unique voice in his improvisations, a distinctively African-American voice that embodied the central themes of black history and asserted an empowering creativity that contributed a musical component to the Harlem Renaissance. In his dramatic and lyrical improvisations, Louis Armstrong not only impelled the jazz world's first big band to prominence but also impelled the field of jazz into a new era – the era of the star soloist.

It was 1940, and the young musician was not quite twenty-three. They had named him John Birks Gillespie when he was born down in South Carolina, but somewhere along the way he had acquired the nickname 'Dizzy'. Dizzy was developing an individual trumpet style in keeping with the harmonies he heard in his head, when he began to meet at Minton's Playhouse on West 18th Street in Harlem to make informal music with a small group of musical dissidents. Many of these musical rebels were fellow expatriates from the South, such as North Carolinian Thelonious Monk and Texan Charlie Christian. Dizzy was stimulated by Christian's sudden eruption into a series of speedy eighth-note phrases and his substituting new chords into the progression, suggesting different keys. He was stimulated as well by the boldness of Monk's harmonies and his complex compositional probings, his surprising intervals, his unusual harmonic progressions, and his calculated use of dissonance. But the stimulation did not all flow one way. 'Dizzy was everywhere at the time', recalled bassist Milt Hinton. 'Charlie Parker was never there'. In fact it was some months later, in 1941, before Parker became part of the Minton scene. He was an original and fertile musician, and obviously a kindred spirit; but by then the Minton dissidents were already well on their way to creating a new form of jazz. But Dizzy Gillespie was the essential catalyst: he would blow a promissary note, then trampoline into the stratosphere with a series of lip-shattering choruses in the upper octaves, played at blistering speeds, built around exhilarating combinations of long asymmetrically phrased lines, punctuated by brief rhythmic ejaculations. He extended the trumpet's high range beyond gravity; and he not only hit climactic high notes, he played complex chromatic phrases up there. He played fast and flexibly, fast enough to keep up with Charlie 'Bird' Parker, but flexibly enough to create logical improvisations over the most bewildering of Monk's harmonic progressions. His solos were certainly playful enough to cast him as at least a proto-postmodernist. 'After a while', Dizzy said, 'as we began to explore more and more, the music evolved'. A synthesis

began to take place; a new kind of jazz began to crystallise. It came to be called 'bebop', after a characteristic Gillespie trumpet phrase.[23]

Dizzy Gillespie and his fellow southern expatriates knew they were creating a new jazz at Minton's. 'We're going to create something that they can't steal', Thelonious Monk said, 'because they can't play it'.[24] Nearly four years went by before the music created by the Minton dissidents was heard by very many people, in part because of the recording ban in effect at the time. But somehow the word got around. The success of bebop coincided with the end of the Second World War. In 1944, Gillespie, Monk, and Parker not only were able to make recordings of the new music, but also to find employment in 52nd Street clubs, where they could bring modernist ideas to a broader jazz audience. After 1944 the acceptance of bebop by the East Coast public enabled Diz and Bird to play in a quintet with each other or to lead their own along 52nd Street. 'The music of the forties, the music of Charlie Parker and me', Gillespie would later note without hyperbole, 'laid a foundation for all the music that is being played now'.[25]

As uprooted Africans and uprooted Europeans continued to mix their folk heritages in southern music, the Irish-Scottish type of vocal and instrumental ornamentation of tunes tended to be replaced by the glissandi, syncopation, and 'blue notes' of African-American music. With each passing year, the music became increasingly polyphonic and polyrhythmic. Black Southerners adopted the musical conventions of their white neighbours, but retained their own musical habits. They adopted the normal tune forms and song forms of white Southerners, but gave them an African performance treatment. Perhaps the importance of the African heritage to southern whites may best be highlighted by pondering, for a moment, what southern music might have sounded like without the influence of black Southerners. Consider, for example, the folksongs of Newfoundland, or of Australia. Many of the ballads and lyric songs widely collected in the South are well known in Newfoundland and Australia. But there they retain an Anglo-Irish flavour rather lacking in southern tradition, and they lack the propulsive rhythms and syn-copations of the same songs collected in the South.

The process of racial integration in the South did not begin with the Supreme Court's *Brown v. Board of Education* decision in 1954. On the folk level, black and white Southerners have been swapping accents and attitudes, songs, stories, and styles across the colour line for more than three centuries. Together – and only together – the black folk and the white folk of the South interwove the rich sturdy patterns of southern culture. In the rural South, black and white folk developed their folk culture, influenced and stimulated by each other. Various separate, but racially mixed, traditions developed. They were similar enough to

permit growth and continued cultural exchange, but different enough to keep those cultural exchanges exciting. Over the centuries those various hybrid traditions merged more completely.

Music is not, of course, the only element of southern culture. But the transformation of southern music may serve as a model for explaining other elements of culture change across the South. As E. P. Thompson notes, both 'resistance to change and assent to change arise from the whole culture'.[26] But it may serve as a paradigm for what has been happening. The mixing of cultural traditions in the South has been more responsible than any other single factor for the extraordinary richness of southern culture. The central theme of southern culture, as I have shown, is an unconscious resolve, subliminally maintained, that the South has been and will remain a multicultural mix of European and African elements. Whether expressed with the virtuosic frenzy of a Dizzy Gillespie or an Elvis Presley, or with the laid-back quietude of a Lester Young or a Willie Nelson, whether stubbornly denied or acknowledged with pride, every black Southerner has a European heritage as well as an African one, and every white Southerner has an African heritage as well as a European one. That shared heritage constitutes the cardinal test of southern identity and the central theme of southern culture. Recognition of that shared heritage is the necessary starting point for any understanding of southern culture.

NOTES

Portions of this paper were researched while I was an Associate of the W.E.B. DuBois Center for Afro-American Research at Harvard University during 1989–90. Earlier research reported in this paper was done during the tenure of a fellowship from the National Endowment for the Humanities. The support of Harvard and NEH are both gratefully acknowledged.

1. Ulrich B. Phillips, 'The Central Theme of Southern History', *American Historical Review* 34 (October 1928) pp. 30–43.
2. Grady McWhiney, *Cracker Culture: Celtic Ways in the Old South* (Tuscaloosa: University of Alabama Press, 1988); David Hackett Fischer, *Albion's Seed: Four British Folkways in America* (New York: Oxford University Press, 1989).
3. For a detailed exposition of these academic traditions and their modern exponents, see Charles Joyner, 'A Single Southern Culture: Cultural Interaction in the Old South' in Ted Ownby ed., *Black and White: Cultural Interaction in the Antebellum South*, (Jackson: University Press of Mississippi, 1993) pp. 6–12.

4. C. Vann Woodward, review of *Encyclopedia of Southern Culture*, in *New York Review of Books*, 26 October 1989; Charles Joyner, letter to the editor, *New York Review of Books*, 15 February 1990.
5. William Faulkner, *Absalom, Absalom!* (New York: Random House, 1936) p. 377.
6. Frances Anne Kemble, *Journal of a Residence on a Georgian Plantation in 1838–1839* (New York, 1863; Brown Thrasher ed., Athens: University of Georgia Press, 1984) pp. 141–2, 259–60.
7. Orlando Kay Armstrong, *Old Massa's People: The Old Slaves Tell Their Story* (Indianapolis: Bobbs-Merrill, 1931) p. 141; John Laurence Manning to the 'Institute Fair', 4 November 1856, Williams-Chesnut-Manning Papers, South Caroliniana Library, University of South Carolina.
8. Roebuck Staples, quoted in Robert Palmer, *Deep Blues* (New York: Viking, 1981) p. 44; Booker T. Johnson ('Bukka') White (b. 1909), quoted in David Evans, *Big Road Blues: Tradition and Creativity in the Folk Blues* (Berkeley: University of California Press, 1982) p. 43.
9. Richard Wright, foreword to Paul Oliver, *Blues Fell This Morning* (New York: Collier, 1963), p. xiii; Robert Johnson, 'Hellhound on My Trail' in Samuel Charters, *The Bluesmen: The Story and the Music of the Men Who Made the Blues* (New York: Oak Publications, 1967) p. 91; Alberta Hunter (b. 1897), quoted in Nat Shapiro and Nat Hentoff, *Hear Me Talkin' to Ya: The Story of Jazz as Told by the Men Who Made It* (New York: Rinehart, 1955) pp. 246–471; Danny Barker (b. 1909), ibid., p. 243.
10. Ralph Ellison, *Shadow and Act* (New York: Random House, 1964) pp. 78–9; Bertha 'Chippie' Hill (1905–50), 'Two Nineteen Train' (1926), quoted in Lawrence W. Levine, *Black Culture and Black Consciousness: Afro-American Folk Thought from Slavery to Freedom* (New York: Oxford University Press, 1977) p. 230.
11. Bessie Smith, 'Empty Bed Blues', Columbia 14312, rec. 20 March 1938, New York City; Alberta Hunter, in Shapiro and Hentoff, *Hear Me Talkin' to Ya*, p. 247.
12. Bill Monroe, quoted in Tony Russell, *Blacks, Whites, and Blues* (London: Studio Vista, 1970) p. 100.
13. Louis Armstrong, in Shapiro and Hentoff, *Hear Me Talkin' to Ya*, p. 14; Barney Bigard and Barry Martyn, *With Louis and the Duke: the Autobiography of a Jazz Clarinetist* (New York, Oxford University Press, 1986) p. 7; George Lewis, interviewed by Richard B. Allen, New Orleans, 14 November 1958, Hogan Jazz Archive, Tulane University, reel four.
14. Louis Armstrong, quoted in Hugues Panassie, *The Real Jazz*, rev. and enlarged edn (London: A.S. Barnes, 1967) p. 77; Danny Barker, in Shapiro and Hentoff, *Hear Me Talkin' to Ya*, p. 38.
15. Thomas 'Mutt' Carey (1891–1948), in Shapiro and Hentoff, *Hear Me Talkin' to Ya*, p. 45; Ferdinand Joseph ('Jelly Roll' Morton) La Menthe (1885–1941), in Alan Lomax, *Mister Jelly Roll*, 2nd edn (Berkeley: University of California Press, 1973), pp. 125–6, 154; John Alexander ('Johnny') St. Cyr (b. 1890), ibid., p. 154n.

16. Louis Armstrong, 'Scanning the History of Jazz', *The Jazz Review*, 3 (July 1960) pp. 7–8.
17. George Vitelle (Papa Jack) Laine, interviewed by Richard B. Allen, New Orleans, 24 April 1964, reel one, 25 January 1959, reel 2, Hogan Jazz Archive, Tulane University; Jelly Roll Morton, in Lomax, *Mister Jelly Roll*, p. 103.
18. Steve Brown, interviewed by Richard B. Allen, April 22, 1958, Hogan Jazz Archive, Tulane University, reel four.
19. Eric Hobsbawm (writing under the pen name Francis Newton), *The Jazz Scene* (Harmondsworth: Penguin Books, 1961) p. 41.
20. Paul Mares, in Shapiro and Hentoff, *Hear Me Talkin' to Ya*, pp. 123–4; Steve Brown Interview, 22 April 1958, Hogan Jazz Archive, Tulane University, reel four.
21. Kid Ory, in Shapiro and Hentoff, *Hear Me Talkin' to Ya*, p. 48.
22. Louis Armstrong, 'Scanning the History of Jazz', *The Jazz Review*, 3 (July 1960) p. 8.
23. Milt Hinton, quoted in Shapiro and Hentoff, *Hear Me Talkin' to Ya*, pp. 343, 337; Dizzy Gillespie, foreword to Leonard Feather, *The Book of Jazz* (New York: Horizon Press, 1957) p. 6; Dizzy Gillespie, in *Hear Me Talkin to Ya*, p. 337.
24. Thelonious Monk to Mary Lou Williams, quoted in Shapiro and Hentoff, *Hear Me Talkin' to Ya*, p. 341.
25. Dizzy Gillespie, quoted in W. Royal Stokes, *The Jazz Scene: An Informal History from New Orleans to 1990* (New York: Oxford University Press, 1991) p. 64.
26. E.P. Thompson, 'Time, Work-Discipline, and Industrial Capitalism', *Past and Present*, 38 (1967) p. 80.

2

Seasons of Nature, Seasons of History: A Reading of Southern Literature

Paul Binding

It seems appropriate to begin with a quotation from Eudora Welty, from her first novel, *The Robber Bridegroom*. This is set in the last years of the eighteenth century, in the declining days of Spanish rule in the Natchez country. Clement Musgrove, described by the author as an 'innocent planter', finds himself alone in the Mississippi forest, and placing stones around him in a small circle, tries to appraise his situation:

'What exactly is this now?' he said, for he too was concerned with the identity of a man, and had to speak, if only to the stones. 'What is the place and time? Here are all possible trees in a forest, and they grow as tall and as great and as close to one another as they could ever grow in the world. Upon each limb is a singing bird, and across this floor, slowly and softly and forever moving into profile, is always a beast ...' He stayed and looked at the place where he was until he knew it by heart, and could even see the changes of the seasons come over it like four clouds: Spring and the clear and separate leaves mounting to the top of the sky, the black flames of cedars, the young trees shining like the lanterns, the magnolias softly ignited; Summer and the vines falling down over the darkest caves, red and green, changing to the purple of grapes and the Autumn descending in a golden curtain; then in the nakedness of the Winter wood the buffalo on his sinking trail, pawing the ice till his forelock hangs in the spring, and the deer following behind to the salty places to transfix his tender head. And that was the way the years went by.

'But the time of cunning has come,' said Clement, 'and my time is over, for cunning is of a world I will have no part in. Two long ripples are following down the Mississippi behind the approaching somnolent eyes of the alligator ... Men are following men down the Mississippi, hoarse and arrogant by day, wakeful and dreamless by night at the unknown landings. A trail leads like a tunnel under the roof of this wilderness. Everywhere the traps are set. Why? And what kind of time is this, when all is first given, then stolen away?'[1]

31

Obviously on one level these lines are an anticipation of the changes imminent in the Mississippi Territory in 1798; the Spanish would withdraw, ambitious settlers would come from other states; the Mississippi would become the great American commercial artery; the plantations would grow and with them slavery. The lines are an elegy for loss of innocence, a melancholy fanfare for the age of business and industry. 'The time of cunning has come.' Though Eudora Welty's planter would not have known what our term 'Southerner' connotes, he *is* a Southerner nonetheless and his cry, 'Cunning is of a world I will have no part in', has been that of so many of his compatriots since, delivered with passion, belligerence, resentment, despair and sorrow. For the Southerner, industry, industrialisation, progress-as-imperative came from outside. Welty's description has great metaphorical accuracy. Two ripples, we read, advance towards the planter down the river preceded by an alligator. That alligator is the representative of the primeval, of life before arrogant humankind with its conviction that it is at the centre of things. And the two ripples – which will first flow parallel then converge – aren't these symbolic of the dual nature of the urban-originated culture from beyond, benign on the one hand with humanitarianism and material improvement, malign with destruction of the organic settlement on the other?

Before he speculates about the future, however, Clement Musgrove concentrates on his immediate surroundings. In this concentration he comes near to restoring the natural world – envisaged with the individual and indispensable beauties of the different seasons – to a prelapsarian condition. The singing birds on the limbs of the trees, the beasts moving into continuous profile, these suggest some forest before forests, a Platonic forest from which earthly forests derive. Even the movement of the seasons reminds us of some music of the spheres outside time, while assuaging us in our present state who have to endure time's cruel work. 'And that', thinks Clement Musgrove, 'was the way the years go by'.

It is not how they seem to go by for us now. The years, the decades are labelled by the media; even those decades which have not yet arrived. Repeatedly we are exhorted to live for the future – indeed this is the first precept given to industrialised man – and yet never has the future presented a more terrifying, a more hostile face.

Thus this passage from *The Robber Bridegroom* causes us to appreciate – by taking us into the mind of an 'innocent' southern planter – how we of the last two centuries live in two kinds of time: the 'seasonal' and the 'historical'. Seasonal time – though it enforces realisation of how we are all rolled on towards age and death – can also restore us to some atavistic state; we can, through following its rhythms, enter a kinship with the creature world, a *participation mystique* with all living things.

Historical time – though it prompts us to thoughts of the measured, measurable past, and enables us to see ourselves as part of some rationally analysable process – inevitably bears us on to the invisible future. And the future is apt to turn into a jealous and inexorable god. It seems to me that the southern tradition to which *The Robber Bridegroom* belongs is characterised by an extremely individual preoccupation with these two aspects of time. They form of course a palimpsest, for historical time is imposed in any construct over seasonal time. And the artist often sees it as his or her duty to remove the one to show the other.

How to account for the nature of this preoccupation? Southern literature, of any universal address, began, as its historians constantly remind us, not in the antebellum period, nor during the urgencies of Secession, the Civil War and defeat. It does not even date from the Reconstruction years. It begins when, emerging from a period of great suffering into a future with no certainties for themselves, Southerners could view what had happened as a fierce but unequal conflict – between an agrarian society, committed to preservation, to conservation, and a new industrial society firm in its conviction of the beneficial inevitability of progress. That thinking Southerners saw there was truth and morality on both sides created, of course, the tension, the inner warfare of values that seems so necessary for living works of literature. All this has been discussed many times. What I want to direct attention to here, however, has been insufficiently commented on.

From the mid-1860s to the mid-1890s the ideas of Darwin, first published in the 1850s, became firmly part of the western world's mental climate, and the first significant works of southern literature derive from a conscious and doctrinaire Darwinism, a *Weltanschauung* that seemed to render all previous ways of looking at existence invalid. These southern works are contemporaneous with the productions of the determinist school, and indeed the whole southern experience seemed – still seems – peculiarly susceptible to Darwinist determinist analysis. And the ideas of Darwin – the right or wrong of them – have continued peculiarly to exercise the southern mind. For it can surely be no accident that later the rallying point for the so-called Southern Renaissance was the famous Scopes, or Monkey Trial, in Dayton, Tennessee, in 1925, in which Clarence Darrow was the lawyer for the defence of J. T. Scopes, prosecuted for teaching evolution in a public school; Darrow lost the case. When the North, led by H. L. Mencken, derided the South for Tennessee's old-fashioned laws, a group of sophisticated intellectuals and internationally experienced writers avowed their solidarity with the popular ideas of their homeland. In doing so they were, in effect, protesting against a prevalent intellectual reading of their own southern history.

Our concern here is not, of course, with Darwinism as such but with its cultural impact and legacy. Briefly the determinist position which came out of it is this – and here I am to a large measure summarising the pervasive philosophy of its master, the English writer Thomas Hardy: the race in life, ordained by some unfeeling nescient will, is to the strongest, though the location of that strength may not be immediately apparent. For instance, in *The Mayor of Casterbridge*, Henchard superficially appears stronger than his rival, Farfrae, but his is a superseded and ill-equipped form of strength and cannot prevail. Awareness of what can and must befall us only compounds our pain, yet the intensity of our hopes and our sufferings must emphatically not be taken as evidence of any resolution of our problems, not in this world and certainly not elsewhere. For one thing – it is the crux of Darwinism – how do we differ from animals? Animals have needs and emotional responses analogous (to put it no more strongly) to our own. In the modern world – at least temporarily – those who master the most resources, those of science and technology, must win. There is no law against waste; waste on the most terrifying scale is an inextricable part of nature. More go under, so to speak, than go on. For many of the Darwinist determinists, the First World War came with all its immeasurable horrors to manifest the terrible blind plan behind our universe; to achieve a demographically new order, wholesale carnage broke out across the apparently civilised world.

A bleak vision, and yet not without its consolations. For one thing, to put disappointing hope into an inferior position and resignation to life's cruelty in a superior one can liberate us from servitude to false expectations. For another it makes us all, person to person, human beings to animals, bound more closely together. It encourages compassion and fellow-feeling of the most literal and practical kind.

Christianity might have seemed irreconcilable with scientific findings and with appreciation of the pain that existed all over the created world. This did not necessarily lessen regard for the altruism of Christianity's founder. A significant poem to remember here is Hardy's 'The Blinded Bird' – human cruelty, animal pain, and Christian charity, which can be present in creatures of the humblest kind, meet here in the subject; and its charity is evoked in language taken from St. Paul's letter to the Corinthians:

Who hath charity? This bird.
Who suffereth long and is kind,
Is not provoked, though blind
And alive ensepulchered?
Who hopeth, endureth all things?

Who thinketh no evil, but sings?
Who is divine? This bird.[2]

There was no greater admirer of this poem, indeed of all Hardy's oeuvre, than the first writer from the South of indisputable world stature, Ellen Glasgow (1874–1945). On a visit to England, she was received by Thomas Hardy in his Dorset home. Knowing her admiration for 'The Blinded Bird', Hardy read it aloud to her, telling her, to her delight, that it commemorated a real bird. A case could be made, I believe, for seeing Ellen Glasgow as the only committed admirer of Hardy who did not lapse into either regionalism or crude pessimistic melodrama; instead she harnessed his intelligence and nobility of spirit to her own, to make courageous investigations of human nature and history.

From the first, Ellen Glasgow took the destiny of the South for her subject, and she had a long writing life which contained, as we will see, a significant watershed. She herself was from Virginia, of Presbyterian upbringing, but, before she was twenty, she had embraced a Darwinist view of existence. Her family had suffered terribly during the Civil War and the Reconstruction, and her earlier novels deal with Virginia from antebellum days to the turn of the century, treating all sections of her society. And all from a determinist point of view.

The plantation South may have had many of the extraordinary excellencies and nobilities claimed for it and, in an early novel like *The Battleground* published in 1902, she does them full lyrical justice. But the law of the fittest ensured that it would go down. It did not have its hand on the tiller of the future and it contained – above all in the institution of slavery – the engines of implosion. Moreover, it was outnumbered: the North's resources were greater. Ellen Glasgow had interesting words to say about the forces that moved both Southerners and Northerners in their clash. Fearful of romanticism, Ellen Glasgow acknowledged its power in the very concept of the Confederacy, as well as in its upholding. Such romanticism was dangerous because it opposed the Federals' attachment to progress and their means to achieve it: emancipation and industrial expansion. But even more to the point is the fact that that romanticism was entertained in the face of obvious inequality. Similarly the harrowing of the South in the Reconstruction – which furnished Glasgow with some of her most poignant scenes – cannot be protested against. When Glasgow studies specific groups – from plantation squires to plain men, from freed blacks to carpetbaggers – she is interested in offsetting their psychological survival kits against their morality and their feeling lives. Above all is this true of her richly-worked portraits of women.

Her central women are all victims of one kind or another, some better equipped to deal with a world not of their making than others. The eponymous heroine of that fine early novel, *Virginia* (1913), has been brought up to be a graceful social ornament, no more: in a metaphor within the novel she is a lovely, carefully bred rose whose scent and colours are wasted upon the air. Her day is over and while she dimly realises this, she is helpless to do anything about it. Even more tragic a figure is the beautiful ex-singer, Eva Birdsong, the central character in the late novel, *The Sheltered Life* (1932). The small southern town, of whose society Eva should be a dazzling pivot, has been reduced and has become inward-turned, deprived of a real relation to anywhere else. Ellen Glasgow mirrors this in Eva Birdsong's neurasthenia, in her contraction of all emotional life to a continuous obsessional jealousy of her husband's relationships with others. He, too, is a moving embodiment of the failure demanded by Darwinist laws. He should have been a soldier, an adventurer, or vigorous in some forward-moving enterprise. Instead, he is a sorry small-town seducer who dies in the blaze of hysteria he has ignited.

Again, a very bleak vision, but its very intransigence leads to certain consolations and strengths of mind. In her portraits of the commerce-barons of the New South and their families, Ellen Glasgow shows their dislocation from natural life. Here is the key to their eventual decline. For, as we have already noted, Darwinist determinism demands for proofs of its truths an attention to the rhythms of nature and encourages a sense of community with all living things. Further, while it is true that Ellen Glasgow – with the most dreadful experiences of southern history green in the minds of her family and friends – insists upon the waste factor in mortal existence, she also uses her Darwinism to demonstrate that strong passions do not and cannot go dammed up forever. The oppressed – women, blacks, those who love their own sex, abused animals – may go to their individual deaths without personal emotional vindication. But, in the end, the desires and hopes of their kind will out. No man-made system can ultimately prevail against them and when we return to seasonal time we cannot but appreciate this.

I have spoken of a watershed in Ellen Glasgow's career, and this watershed takes us, I believe, to her wholly exemplary restoration of seasonal time, one made in a specifically southern context. Ellen Glasgow was a very sensitive woman, maybe morbidly so. The plight of a poor black child seen on the streets, a wanton fire in which horses were burnt – such things could keep her awake in torment night after night. Her family life was tragic, her relationships with men were unhappy and self-humiliating, and she suffered from a chronic ear disease. As with all thoughtful people of her time, the First World War

appalled her; her darkest perceptions of existence seemed to be being proved, even eclipsed by its massacres. At last there arrived the day, a year after America's entry into the war, when she could bear life no longer, and she took an overdose of sleeping tablets. She did *not* die, however; instead, she had a most remarkable experience. She felt herself transferred to some sphere outside space and time where she encountered all the beings whom she'd loved and lost in this world, people and animals alike. The aftermath of this visionary condition was extremely painful, but it made her appreciate – presumably because of the insights into existence it gave – that her best work was still ahead of her. She began work on the novel *Barren Ground*, published in 1925. It is, in my view, the first novel from the South to which the term 'masterpiece' can, with no exaggeration, be applied.

Barren Ground deals with, in Ellen Glasgow's phrase, 'good people' rather than 'people of good family', the Virginia country people of Scotch/Irish stock and Presbyterian conviction. Theirs is a hard lot; neither nature nor history deals with them kindly and, of course, they cannot escape the harsh laws of causality. The 'barren ground' of the title is both life and the soil of the particular region they inhabit. In order for it to yield desirable crops, the land has to be worked with really taxing energy. The indigenous growths of the area are economically non-productive: broomsedge, pine and life-everlasting. Each of these three plants gives its name to a section of the novel. Broomsedge stands for the sexual impulse which – often more foe than friend – drives people helplessly on to unsatisfactory connections and situations. The pine represents the brooding presence of sickness and death, the life-everlasting that unnameable force that enables us *somehow* to carry on through all adversities till death. You can call this the 'life-force', for Ellen Glasgow, like Faulkner after her, read her Bergson. You can call it, as Ellen Glasgow does, a 'Vein of Iron', later a title for a fine novel. You can also say that it includes that Christian sense of compassion and reverence for life which guided Hardy also. Life-everlasting, in its beauty and tenacity, prompts us to remember the seasons of nature behind those of history, and this is brought home beautifully to us in the closing pages of the novel, in the reflections of the heroine, Dorinda Oakley, who has endured such terrible things – some explicable in terms of southern economic history:

> Turning slowly, she moved down the walk to the gate, where far up the road, she could see the white fire of the life-everlasting. The storm and the hagridden dreams of the night were over, and the land which she had forgotten was waiting to take her back to its heart. Endurance. Fortitude. The spirit of the land was flowing into her, and her own spirit, strengthened and refreshed, was flowing out again toward life ... Again she felt the quickening of that

sympathy which was deeper than all other emotions of her heart, which love had overcome only for an hour and life had been powerless to conquer in the end, the living communion with the earth under her feet. While the soil endured, while the seasons bloomed and dropped, while the ancient, beneficent ritual of sowing and reaping moved in the fields, she knew that she could never despair of contentment.

Strange, how her courage had revived with the sun! She saw now, as she had seen in the night, that life is never what one dreamed, that it is seldom what one desired; yet for the vital spirit and the eager mind, the future will always hold the search for buried treasure and the possibilities of high adventure. Though in a measure destiny had defeated her, for it had given her none of the gifts she had asked of it, still her failure was one of those defeats, she realized, which are victories ... The best of life, she told herself with clear-eyed wisdom, was ahead of her. She saw other autumns like this one, hazy, bountiful in harvests, mellowing through the blue sheen of air into the red afterglow of winter; she saw the coral-tinted buds of the spring opening in the profusion of summer; and she saw the rim of the harvest moon shining orange-yellow through the boughs of the harp-shaped pine. Though she remembered the time when loveliness was like a sword in her heart, she knew now that where beauty exists the understanding soul can never remain desolate.[3]

The autumn harvest is the dominant image in perhaps the most famous poem of one of Ellen Glasgow's finest contemporaries, John Crowe Ransom. The poem in question is 'Antique Harvesters'. The scene is described in a prefatory note in the deliberately archaic language of heraldry. It is 'of the Mississippi the bank sinister, and of the Ohio the bank sinister', in other words we are being taken into the Old South, inclusive of Kentucky:

Tawny are the leaves turned but they still hold,
And it is harvest; what shall this land produce?
A meager hill of kernels, a runnel of juice;
Declension looks from our land, it is old.
Therefore let us assemble dry, grey, spare,
And mild as yellow air.[4]

Crowe Ransom's poem is an allegory cast in a pastoral mode: the harsh land being harvested is the post-Reconstruction South, venerable and ransacked and stubborn; the 'us' who must assemble are those like the poet himself and his friends who see themselves as heirs to the lofty, non-commercialist culture routed by the carpet baggers. The young men who want to live vigorously and are tempted to leave their dull work in the fields are the new generation who feel inclined to forsake the South or to embrace that way of life which comes from outside. But

'Resume, harvesters', Crowe Ransom tells these last, against all seductions. They must continue their thankless-seeming labour for the sake of someone he calls the Lady. Borrowing from Provençal troubadour poetry where Virgin Mary and chatelaine are fused, Crowe Ransom means her to be the mystic embodiment of southern civilization, a civilization not in its first youth:

And by an autumn tone
As by a grey, as by a green, you will have known
Your famous Lady's image.[5]

Behind his conscious allegorical intention in the poem, behind his learned employment of the Theocritus-like idyll, stands Ransom's veneration for a way of life dependent on an intimate and accepting relation to nature. This way of life cannot be separated from the South, both as Ransom in his country youth had experienced it, and as he wanted it to be perpetually. In his finest lines, his South *does* transcend the limited historical vision imposed upon it by him and his fellows, a vision that must derive, of course, from a deep fear of history. Often with Crowe Ransom, and with the other Fugitives, too, we are in danger of finding nature and its seasons being used as a place of escape from history and its seasons, history which these poets, for all their belief in an informed return to a preferable past, are too often reluctant to face squarely. We can only uncover that second layer of the palimpsest by proper treatment of the first. What stays vivid in 'Antique Harvesters' and in a handful of other poems by Crowe Ransom is not so much the somewhat irresponsible encouragement of devotion to the agrarian southern past, and its rather hazy poetic representatives such as the proud, famous and ageing Lady here, but the gentle emotional direction towards the atavistic, and away from the transient world of built-in obsolescence and conspicuous waste, which modern industrial (and post-industrial) society has to offer. And when Ransom moves backwards – in a *non*-political sense – we perceive him arriving at virtually the same point of spiritual acquiescence in the world and its dual load of happiness and pain that Ellen Glasgow arrived at in her novels from *Barren Ground* onwards: 'Antique Harvesters' concludes with these lines:

True, it is said of our Lady, she ageth.
But see, if you peep shrewdly, she hath not stooped;
Take no thought of her servitors that have drooped
For we are nothing; and if one talk of death –
Why, the ribs of the earth subsist familiar as a breath
If but God wearieth.[6]

The course run by the Nashville poets should perhaps here be briefly sketched. *How* the name Fugitives came to be thought of – to describe them in their regular gatherings in the early 1920s – and what it signified, these remain a mystery. It has been thought that – ironically in the light of their later development – the word denoted a flight away from the limitations of provincial society, from Tennessee. All members of the group were very sophisticated men with wide knowledge of ancient and European cultures. Allen Tate maintained, however, that 'Fugitive' was an old Romance name for 'poet', for one who, like the Flying Dutchman, eternally wanders. What is verifiably true is that only after the dispersal of the group by the later 1920s, only after their absence from their alma mater, Vanderbilt University, did the South begin to exert its hold over their individual imaginations, over their moral sensibilities, until, at the time of the Scopes Trial, they sprang to its defence. The South was more truly religious than elsewhere, its hierarchies concealed a deeper democracy, a more intense regard for the individual. Far from deserving censure for being retrograde, it deserved praise for having been steadfast against the modern commercial world. In the light of all this, indeed, even the most troubling aspects of southern life could be – if not actually defended – then explained and put into honourable context. The writers became not Fugitives but Agrarians, and the anthology *I'll Take My Stand* (1930) clarion-calls against the inhuman barbarism of mechanised culture (called 'American' in distinction to 'southern'). Fervour, it must be said, takes over too much in the book, directing too many of the contributors away from the facts of the case, and – more gravely still – from *human* realities. The conditions of flesh-and-blood men get lost behind the great abstractions hurled about in their (often one-sided) debates – history, America, culture. Here is John Crowe Ransom speaking about what he calls the 'squirearchy' of the Old South:

> It was a kindly society, yet a realistic one ... people were for the most part in their right places. Slavery was a feature monstrous enough in theory but, more often than not, humane in practice; and it is impossible to believe that its abolition alone could have effected any great revolution in society.[7]

We have to attack him here because he hasn't allowed himself to imagine properly the lives behind his thoughts. The injustices that lie behind that 'more often than not' do not merely vitiate his argument, they destroy it. We are encountering a running-away from history with its inevitable demands and a substitution of a romantic antiquarianism which does not admit of hard analysis. It is surely a strange paradox

that Crowe Ransom, Donald Davidson et al., who believed that the social problems of the South could be solved by some natural process in the slow rhythm of evolution, should at the same time be clamorously supporting the anti-evolution cause in Dayton, Tennessee.

Happily, in their creative work, the Fugitives/Agrarians exercised their imaginations more freely on the ambiguities and complications of life. And of no one is this truer than Allen Tate, poet, critic and novelist. Tate's was a difficult personality, a difficult art too. During his lifetime he made many enemies and they have not lacked voice since his death in 1979. I believe we should not heed them. His poetry records the battles of an honourable spirit that eventually found salvation in the Catholicism to which, from his young manhood onwards, he had been attracted. He once told me that a principal cause for this attraction was the fact that – in his view – the Catholic church did not tolerate racial segregation and that no Catholic society had practised it. The battles in Tate's poetry are highly germane to the theme of this paper.

In common with his fellow Agrarians, Allen Tate was obsessed by the cheapening and coarsening of man's imaginative heritage that modern society has brought about. In his incisive poem 'Retroduction to American History' (the 'Retroduction' betokening at once a leading back and a retraction) he complains:

Antiquity breached mortality with myths.
Narcissus is vocabulary. Hermes decorates
A cornice on the Third National Bank ...
Prospero serves humanity in steam-heated universities, three
Thousand dollars a year.[8]

Even sensual pleasure has become crudely indulgent, fatuous, as in the incident that inspired a fine bitter satirical poem, 'Causerie': a chorus-girl bathing nude on a New York stage in a bath-tub of wine. But when Tate looks back to former times, he lacks the confidence of his peers that they can be so easily resurrected. Or that they should be. The past is past, the dead are dead. This feeling surely dominates his most celebrated poem: 'Ode to the Confederate Dead'. Here the visitor to the cemetery with whose consciousness we are concerned cannot convince himself that the heroes of the Old South are anything more than thoughts in his head and decomposing bodies – 'the inexhaustible bodies', he says with grim twisted humour, 'that are not/ Dead, but feed the grass row after rich row'.[9] Like his fellow Fugitives, Tate admires the passion of his ancestors; urban man has evicted passion from his deeds, indeed from the whole fabric of his life:

Turn to the inscrutable infantry rising
Demons out of the earth – they will not last.
Stonewall, Stonewall, and the sunken field of hemp,
Shiloh, Antietam, Malvern Hill, Bull Run
Lost in that orient of the thick-and-fast
You will curse the setting sun.[10]

Like Crowe Ransom's 'Antique Harvesters', 'Ode to the Confederate Dead' is firmly anchored in a season, the season of autumn, but the autumn of November rather than September, with winter imminent, and the dead leaves flying, epitomising decay and death, the transitory nature of our existences. The heroes have had *their* season, they can have it no longer; they can only survive in translated form. That is the sad truth that attentive observation of the seasons leads to:

In a tangle of willows without light
The singular screech-owl's tight
Invisible lyric seeds the mind
With the furious murmur of their chivalry.
 We shall say only the leaves
 Flying, plunge and expire.[11]

As in Crowe Ransom's poems, Allen Tate's instinctual apprehension of the season is stronger than the symbolic weight he accords it. What his poem finally leaves us with is a sense that the man in the cemetery, for whom both past and present constitute problems of enormous philosophic and moral complexity, finds in the cyclic life of the seasons, here viewed at its most melancholy point – 'Autumn', says Tate, 'is desolation'[12] – a means of restoring himself to some form of equilibrium. In the abandoning of struggle against uncertainty, in his admission that this is inextricable from being alive, we are very near to the Ellen Glasgow of *Barren Ground* and *Vein of Iron*.

During the late 1920s and the 1930s – indeed in a perhaps less riven way during the 1940s too – Tate debated with himself whether or not to enter the Roman Catholic Church, a commitment he finally made in December 1950. One of his objections to surrendering to the Church was precisely that he might forfeit the relation to nature which he had built up over the years as solace against the pressure of external events and his own sense of impotence in the face of them. In meeting this inner objection he was greatly assisted by both the writing and the friendship of the Catholic philosopher, Jacques Maritain, and I must here acknowledge my own debt for what immediately follows to a remarkable book: *Three Catholic Writers of the Modern South* by Robert

H. Brinkmeyer, Jr. Maritain thought that modern intellectual man was guilty of what he called 'angelism' – in Brinkmeyer's words the 'attempt to reach a direct perception of God and the essences of life by circumventing the natural world'.[13] In Maritain's, and in Tate's view, the natural world must *never* be circumvented. In fact Tate's earlier poems abound in interesting and charged references to times of day and year, and a poem he wrote in his mid-twenties, 'Idyll', heralds thematically and imagistically his profoundest poetic achievement, and the nature of his own religious conversion:

> Summer, you are the eucharist of death;
> Partake of you and never again
> Will midnight foot it steeply into dawn,
> Dawn veer into day,
> Nor the promised schism be of year split off year.
> All time would be some tatters
> On a figure, and the arrested sun –
> Which are one.[14]

The major poetic achievement to which I've just alluded is the significantly titled 'Seasons of the Soul', completed in 1944. The intensity of work on this prevented Tate from getting on with a planned work of fiction sequent to his magnificent and still undervalued novel *The Fathers*. The poem-cycle was written at a time of great anguish, personal and exterior: references to the war in Europe abound, often made in deliberate antithesis to the beneficent planetary rolling of the earth:

> It was a gentle sun
> When, at the June solstice
> Green France was overrun
> With caterpillar feet.[15]

(The fall of France in the summer of 1940 would have had particular significance for Tate who had lived in and loved that country.) 'Seasons of the Soul' is prefixed by a quotation from Dante, which, translated, runs:

> Then I stretched my hand a little forward
> and plucked a branchlet from a green thorn;
> and the trunk of it cried: Why dost thou rend me?[16]

In Dante's *Inferno* the thorn trees are where the suicides are imprisoned, the suicides being, in Tate's vision, modern man whose inadequacies

were receiving such bloody proof in the second European war. The cycle moves through summer, the fullness of which promotes in Tate contrapuntal thoughts of the enormity of mankind's historical crimes, through autumn, suggestive of the alienation of modern man because its dying vegetation connotes the dying natural institutions of former communal life, and thence, to winter. This relates the coldness, the deadness of the external world to the coldness, the deadness of contemporary man's behaviour in love, particularly sexual love, with chivalry and courtesy so long gone.

Spring brings with it, however, the hope inherent in that season, though hope of a qualified, grave kind. It is only natural that the poet's mind turns in springtime, the season of youth, southwards again, to the region that had nurtured himself and his art:

Back in my native prime
I saw the orient corn
All space but no time,
Reaching for the sun
Of the land where I was born:
It was a pleasant land
Where even death could please
Us with an ancient pun
All dying for the hand
Of the mother of silences.[17]

The mother of silences is, of course, death, whom, thus personified, the poet approaches in the last stanza of this, his magnum opus, with fear and awe. Historical time, seasonal time – both must offer us, irrefutably, death, and how to choose between their presentations? Shall we see death as the end – as the summation of the individual career which can nevertheless be related to the forward movement of men? Or shall we see death as interwoven into some eternal-seeming pattern, like the falling of leaves from a tree? Our choice, our view will determine the nature of the culture we build. Allen Tate, while inclining to the seasonal concept of death, is too tormented by the confusions of the social world to be altogether content with it. What is needed, he feels, is some bridging edifice; for the first part of his life the civilisation of the Old South with its essentially Stoical Graeco-Roman traditions was this, and, later subsuming it, the time-defying structure of the Catholic Church.

Another linking edifice between historical and seasonal time is myth. Reinhold Niebuhr (1892–1971) considered myth, in his famous definition, to be a symbolical representation of a non-historical, or historically non-

verifiable, truth. I think we can extend this, and say that it can also be the symbolic presentation of a historical truth, one that concentrates, however, on essences and is comparatively unconcerned with immediate verifiability. The most important southern users of myth, as a means of reconciliation between the seasons of nature and the seasons of history, are the two Mississippians, William Faulkner and Eudora Welty, the South's greatest writers. While the Fugitives weren't much interested in Ellen Glasgow and Ellen Glasgow looked down on Faulkner's works as too raw and harsh for her taste, Faulkner and Welty admired each other; indeed Faulkner sent Welty a warm letter of congratulation on her novel *The Robber Bridegroom*.

It was, though, Allen Tate who provided in his essay on Faulkner the most concise, if not perhaps the most just, summary of the myth of southern destiny which pervades this complex novelist's work, a myth with the most obvious Biblical and Miltonic ancestry, and with significant symbolic resonances for other societies. While the South cannot be held solely responsible for the 'peculiar institution' of slavery, it is responsible for its reluctance to disentangle itself from it, and for the act of hubris that was Secession. However, if we say that the Civil War was the Faulknerian Fall – after which all men and women stand corrupt and incomplete – we must *not* say that the antebellum South represents a desirable prelapsarian state. Beyond doubt, Faulkner's black characters are drawn with an intensity of observation and of emotional identification that separates him entirely from any of his predecessors and any of his white contemporaries. Yet the blacks are, in his mythic view of things, bound to the whites in a spiritual collusion which – because they are the *more* innocent – only compounds the tragedy of their plight. In his sense of the inevitability of degeneracy, of man's cruelty to man, of internecine strife springing from lusts for vengeance, Faulkner, for all the mythopoeism of his imagination, comes near to the Darwinism of Ellen Glasgow – paradoxically, since it was precisely against the Genesis story that Darwinism was first addressed. But how else to explain the decline of the Compsons, the ascent of the Snopes, except through Social Darwinism? And his fiction – like his Nobel Prize speech – continually praises the quality of endurance.

Redemption comes through transcendence of history's hegemony, through release from the determining historical moment. That, not some wistful retreat into the antebellum past, is the significance behind that famous passage from *Intruder in the Dust*:

Yesterday won't be over until tomorrow and tomorrow began ten thousand years ago. For every Southern boy fourteen years old, not once but whenever he wants it, there is the instant when it's still not two o'clock on that July

afternoon in 1863, the brigades are in position behind the rail fence, the guns are laid and ready in the woods, and the furled flags are already loosened to break out ... and it's all in the balance, it hasn't happened yet, it hasn't even begun yet, it not only hasn't begun yet but there is still time for it not to begin ...[18]

'Yesterday won't be over until tomorrow and tomorrow began ten thousand years ago.' These words lead us back to Faulkner's most widely discussed novel, *The Sound and the Fury*, which takes its title from the same passage in Shakespeare that the sentence from *Intruder in the Dust* echoes. The first part of *The Sound and the Fury* is, you will need no reminding, literally a tale told by an idiot. However, it is *not* full of sound and fury. For it to be so would mean that Faulkner is one with Macbeth's vision, would mean that Faulkner is of Macbeth's party – which of course he is not, any more than Macbeth's creator was. Macbeth is our diabolical self, that side of us that tends towards damnation, and he/it cannot conceive of time in other than terrifyingly linear terms. How viewed thus can it signify *anything*? We are denying the fullness of our moral and psychic lives, just as surely as Macbeth did when he yielded to the temptation to murder Duncan. The idiot's brother, the sane Jason, with his devilish contrivances, even his agonised elder brother Quentin, imprisoned in his guilts and arrogances – *they* exhibit sound and fury: as did their parents, the father, the prisoner of his futile Latin-tag-ridden rhetoric, the mother wrapped up in self-dramatising pity. But Benjy, the idiot, is seen on the day we enter his mind – a day which is no simple twenty-four hours – as a miracle of love. And this principally because he does *not* see life as 'tomorrow and tomorrow and tomorrow'. We meet Benjy on his thirty-third birthday, but it is observed of him 'he been three years old thirty years'.[19] And while his guardian, a teenage boy, routs about in the grass for a lost quarter so that he can go to some humdrum show in the evening, Benjy inhabits laterally many days, all of them timeless with the emotion they contain: the day of Damuddy's funeral, the day his sister lost her virginity, the day she married, a childhood escapade down by the creek, the day of his name-change. And all this upon a golf-course where members of the middle classes go through their prescribed rituals while he himself listens for their magic call 'Caddy', the name of his loved, loving and lost sister, the call that breaks up linear time. Caddy, in perhaps the most persistent of Benjy's images of her, becomes a small girl again, caught with her muddy drawers showing. It was, Faulkner has told us, with a nagging image of a girl's muddy drawers that the enterprise of *The Sound and the Fury* came into his mind. The girl can be seen as the creature-need for love, later both despoiled and despoiling; the mud is at once the

faeces that are the proof of our body's corrupt nature, and the primordial slime from which we all originally emerged. Benjy's relation to Caddy and his images of her, when placed in conjunction with his relation to the other characters and his images of these people, constitute a paradigm for our psychological and ontological predicament, exactly as does Judaeo-Christian and Greek myth.

'Caddy smelled like trees.'[20] Over and over again Benjy repeats this phrase. The trees are those of Clement Musgrove's forest (in *The Robber Bridegroom*), trees which show the seasons and return us to nature's cycle; they are also those of Eden which contained the fruits of our nourishment and our doom. And they are the trees of fecundity and peace – which are our original birthright. An idiot's drivelling thus gives us a key to salvation.

The tree seems a fitting image by which to reintroduce the work of Eudora Welty, to whom we have now returned. No feature of her many-faceted art is stronger and more noteworthy than her use of nature in its complementary anodyne and awesome aspects and of her use of characters' myth-forming kinships to it. These kinships help them at once responsibly to come to terms with the demand of historical time, in both its public and its private manifestations, and to transcend it. And of no book is this more the case than *The Golden Apples*.

The sequence of seven related stories that make up *The Golden Apples* is on one level concerned with the interwoven fates of a representative group of inhabitants in a representative Mississippi town, Morgana. The work opens just after the year 1900; quiet though Morgana is, it is to be scarred by external happenings, pre-eminently the First World War. First, the lonely eccentric music-mistress and her old mother are hounded by other citizens for being putative supporters of the Kaiser; then the brother of surely the most sympathetic character, Virgie Rainey, is killed in France. The outside world impinges and imposes in subsequent years too, and by the time we reach the final story 'The Wanderers', which revolves round the funeral of perhaps the community's most bucolic member, Miss Kate Rainey – we realise that we have witnessed many transformations. A highway has been constructed, aeroplanes have arrived, the confusions of the modern world have propelled at least two women to suicide. We have also followed a long inexorable trail of birth, copulation and death, the book opening with the first, closing with the third and containing many sensitively delineated examples of the second within its course. Welty herself has commented on her choice of name for the community – Morgana is a likely enough place-name, made up of a family-name with an 'a' at the end such as one finds in rural Mississippi. But it is also an allusion to

the *Fata Morgana*, that will-o'-the-wisp of sea-and-marshland that leads people to take paths that are complete mirages, illusions. One can interpret the *Fata Morgana* as those dreams which mislead us while appearing to sustain us; we can also take it, I think, as our journey through linear time. For what is truest in all the life-journeys that we follow in *The Golden Apples*? In each case isn't it the immeasurable numinous moment (that calls the very concept behind the word 'moment' into question), the moment that connects every person with the atavistic, with the primordial, the prelapsarian itself? As I have already implied, these moments often partake of myth in themselves, myths being enacted through symbolic juxtaposition of person and place, or person and some other living being – bird, animal, plant. The golden apples of the title refer – in terms of written myth – first to the apples that her victorious suitor flung down in front of Atalanta's chariot to delay and alter her headlong course away from union with others – a diverted course that, it will be clear, parallels the *Fata Morgana*. Second, they are the apples of love and immortality in the Gardens of the Hesperides, at the far western end of the earth. The novel abounds in references to trees and fruit – so that Faulkner's idiot's phrase in *The Sound and the Fury*, '[She] smelled like trees', becomes for us a melodic snatch turned into a beautiful expanded tune in Welty's book. Fig-trees provide adolescent characters with wondrous promises of fulfilment, pears prompt the girl Nina in that haunting, Eros-charged story 'Moon Lake' to complex thoughts, ones that remind us of Allen Tate's eucharistic summer in his poem 'Idyll'.

> beautiful, symmetrical, clean pears with thin skins, with snow-white flesh so juicy and tender that to eat one baptized the whole face, and so delicate that while you urgently ate the first half, the second half was already beginning to turn brown. To all fruits, and especially to those fine pears, something happened – the process was so swift, you were never in time for them. It's not the flowers that are fleeting, Nina thought, it's the fruits – it's the time when things are ready that they don't stay. She even went through the rhyme, 'Pear tree by the garden gate, how much longer must I wait?' thinking it was the pears that asked it, not the picker.[21]

The girl Nina has entered unawares into a *participation mystique*. While it is true – as these brilliant lines so disturbingly remind us – that ripened fruit rots in the hand even while we enjoy it, yet there is in the split second of appreciation the time when the pear simply *is* and we enter into dialogue with it, hearing *it* and its tree ask *us* questions. Such a picture provides us with an earnest of the passing through historical

time to the mysteries themselves. So in the limitless first days of existence did we learn from the voices of animals, birds, insects, plants, fruits. Eudora Welty's affinities, like Faulkner's, are with the modernist masters. She admires the works of Yeats, three of whose poems stand behind *The Golden Apples* (one providing the title), and of Rilke. To show her kinship to these poets, here are lines from the thirteenth of the first *Sonnets to Orpheus* by Rilke, lines which remind us of the above passage and of others too from *The Golden Apples*:

What miracle is happening in your mouth?
Instead of words discoveries flow out
from the ripe flesh, astonished to be free.

Dare to say what 'apple' truly is.
This sweetness that feels thick, dark, dense at first;
then exquisitely lifted in your taste,

grows clarified, awake and luminous,
double meaning-ed, sunny, earthy, real –
oh knowledge, pleasure – inexhaustible.[22]

I'd like to end by emphasising the fact that in their employment of myth, Faulkner and Welty are following a major, forward-thrusting strand of twentieth-century thought. Not only myth itself but our reception of it enjoy a central position in the investigations of Freud and Jung. The truths myths embody are truths about our psychic natures and our ontological positions. Myths enable us to apprehend the forces *behind* history, those forces that impel us, often unconsciously, on our various courses.

Faulkner and Welty succeed in their use of myth not just because of the intensity of their individual imaginations but because of the intensity of their awareness and scrutiny of life. Indeed the two qualities are inextricable. The fierce demands of both southern past and southern present are responsible for this. Few writers have greater social franchise in their works than they, or greater emotional franchise either: murderers, old country women, hobos, rapists, musicians, the simple, the orphaned, the ambitious, the religious, the pagan – each a being of mysterious depths, and beyond all the diversity of the creature world. Few writers use their powers more penetratingly to explore on different levels different epochs, from Mississippi in its wild expectant territorial days, to the storms and stresses of the Civil Rights period and beyond. If their vision enables us to transcend historical time, it does so because they

have had the energy and courage to confront the bewildering complexities of the actual. For it seems that for us in our (as it were) fallen state, the seasons of nature and of the soul are only attained via rightful response to the seasons of history.

NOTES

1. Eudora Welty, *The Robber Bridegroom* (London: Virago, 1982) pp. 141–3.
2. Thomas Hardy, *The Complete Poems* (London: Macmillan, 1976) p. 146.
3. Ellen Glasgow, *Barren Ground* (London: Virago, 1986) pp. 408–9.
4. John Crowe Ransom, 'Antique Harvesters', in William Pratt, ed., *The Fugitive Poets: Modern Southern Poetry in Perspective* (New York: E.P. Dutton and Co., 1965) p. 69.
5. John Crowe Ransom, 'Antique Harvesters', p. 70.
6. Ibid.
7. John Crowe Ransom, 'Reconstructed But Unregenerate', in Twelve Southerners, *I'll Take My Stand: The South and the Agrarian Tradition* (Baton Rouge and London: Louisiana State University Press, 1980) p. 14.
8. Allen Tate, *Collected Poems 1919–1976* (New York: Farrar Straus Giroux, 1977) p. 11.
9. Ibid., p. 20.
10. Ibid., p. 21.
11. Ibid., p. 22.
12. Ibid., p. 20.
13. Robert H. Brinkmeyer, Jr, *Three Catholic Writers of the Modern South* (Jackson: University Press of Mississippi, 1985) p. 62.
14. Tate *Collected Poems*, p. 10.
15. Ibid., p. 115.
16. Ibid., p. 114.
17. Ibid., p. 126.
18. William Faulkner, *Intruder in the Dust* (London: Chatto and Windus, 1968) p. 194.
19. William Faulkner, *The Sound and the Fury* (London: Chatto and Windus, 1966) p. 15.
20. Faulkner, *The Sound and the Fury*, p. 17.
21. Eudora Welty, *Collected Stories* (London: Marion Boyars, 1981) p. 355.
22. Rainer Maria Rilke, *Sonnets to Orpheus*, translated by Stephen Mitchell (New York: Simon and Schuster, 1985) p. 43.

3

'I've Got A Right To Sing The Blues': Alice Walker's Aesthetic

Maria Lauret

When Billie Holiday sings 'I've Got a Right to Sing the Blues' in that slow, cracked way of hers, we hear not only a song of lost love (as the sleeve notes have it), but her own history of abuses of all kinds and indeed that of the history of African-Americans generally.[1] The lyrics 'I've got a right to sing the blues/ I've got a right to moan and sigh/ I've got a right to sit and cry/ Down around the riiiver ...' hark back to slavery times, but the river as trope of escape is now one of release of another kind: that of suicide.

'Negroes are the only descendants of people who were not happy to come here', writes LeRoi Jones in *Blues People*.[2] The foundation of the blues is 'working behind a mule way back in slavery time', adds Houston Baker in *Blues, Ideology and Afro-American Literature*, courtesy of bluesman 'Booker' White.[3] Both critics are clearly concerned to counter a popular impression that the blues is a twentieth-century phenomenon, arising from the big migrations North in the 1920s and 1930s, and as such a unique expression of African-American modernity. For Jones, the spirit of the blues originates in the experience of the Middle Passage: 'people who were not happy to come here'. For Baker, the lyrics and musical form of the blues evolved from worksongs which helped to lighten the load of field labour during slavery. These were the songs that Frederick Douglass wrote about in his *Narrative*, the songs that gave white people the impression of 'happy darkies' – people hear what they want to hear.

I have often been utterly astonished, since I came to the north, to find persons who could speak of the singing, among slaves, as evidence of their contentment and happiness. It is impossible to conceive of a greater mistake. Slaves sing most when they are most unhappy. The songs of the slave represent the sorrows of his heart; and he is relieved by them, only as an aching heart is relieved by its tears ... The song of a man cast upon a desolate island might be as appropriately considered as evidence of contentment and

51

happiness, as the singing of a slave; the songs of the one and of the other are prompted by the same emotion.[4]

I want to look at another, possibly related problem in white reception of African-American cultural expression, which is that of white women readers' responses to Alice Walker's work, notably *The Color Purple*, and white women listeners' appreciation of blues singers such as Billie Holiday. I want to look at the phenomenon of white readers' sense of identification with Celie's suffering, a kind of identification which I believe is intimately related to that of Billie Holiday's popularity among young white women. For me, as for many of my peers, listening to Billie Holiday prepared the ground for my reading of, and later my critical interest in, Alice Walker's work. Over the years, my musical involvement with the blues (as a listener, and as a singer) and my academic study of Walker and African-American culture have evolved to a higher plane, but not unproblematically so. Knowing more about the history of the blues (its roots in slavery and the Middle Passage, and its development in the rural South and then the urban North, as well as musicians' backgrounds and biographies), I felt I no longer had the right to sing the blues – whereas the question had never occurred to me before I started taking an interest in the blues as more than 'just music', just repertoire.

The phenomenon of 'blaxploitation' and appropriation of black culture by white artists has been copiously discussed in recent years.[5] Cora Kaplan's essay 'Keeping the Colour in *The Color Purple*' jolted my thoughts about reader-identification as one possible instance of such (mis)appropriation. In that seminal essay, Kaplan argued that her white British students' reading of Walker's best known novel was disturbingly decontextualised as, simply, 'women's writing'. She advocated a pedagogy in which students are confronted with the work of Walker's male peers and predecessors, to get a sense of the sexual politics of *The Color Purple* as not just feminist but engaged in a very specifically African-American debate around the black family, the history and legacy of slavery and also black sexism. For Kaplan, keeping the colour in *The Color Purple* meant work: a lot of historical and intertextual work to remedy crosscultural ignorance and to counter the 'indulgence' of a too-easy identification which elides the substantial class and racial differences between white women in Britain and the Celies and Billies of this world.[6]

Although I broadly agree with Kaplan's analysis in the context of teaching white students on a women's writing course, my own experience in teaching shows a slightly different set of problems. I have come across three sets of responses:

- a feeling of, at best, exoticism and, at worst, primitivism ('weird people doing weird things and talking funny', in the words of one student)
- empathy with Celie's plight and delight in the happy ending, and
- identification of a highly traumatic kind, with Celie as a victim of sexual abuse and violence.[7]

Whilst contextualisation might help, and is indeed intellectually essential in the first of these responses, it does not do much for the latter two except distance students from their deeply felt reading experience (which often works as a kind of catharsis).[8] Such distancing is obviously desirable as an educational process, but it should not obscure or de-valorise the intensity and importance of the initial empathic response.

I am reminded here of Lynne, the white woman in Walker's *Meridian*. Apart from her role as catalyst for Meridian's coming-to-consciousness of herself as a black woman, Lynne also functions as representative of a certain aesthetic attitude. Lynne sees the people of the South, more particularly southern blacks, as 'Art':

> This she begged forgiveness for and tried to hide, but it was no use ... to her, nestled in a big chair made of white oak strips, under a quilt called The Turkey Walk, from Attapulsa, Georgia, in a little wooden Mississippi sharecropper bungalow that had never known paint, the South – and the black people living there – was Art. The songs, the dances, the food, the speech.
> 'I will pay for this', she often warned herself. 'It is probably a sin to think of a people as Art.' And yet, she would stand perfectly still and the sight of a fat black woman singing to herself in a tattered yellow dress, her voice rich and full of yearning, was always – God forgive her, black folks forgive her – the same weepy miracle that Art always was for her.[9]

On the face of it, Lynne in this passage gives voice to an exoticising concept of art, which, as she realises, at the same time is racist towards black people. In seeing them as Art, Lynne objectifies black people: she looks at her environment as one would look at photographs of 'typical' southern scenes, which aestheticise the paraphernalia of poverty (the quilt, the rocking chair, the tattered dress and the artless, paintless, wooden house). Lynne is not *of* this world, but observes and admires it from a distance – the distance of class and racial superiority. But there is an underlying ambiguity in this passage. For what Lynne hears in the black woman's voice, the 'weepy miracle', is an echo and articulation of her own melancholy, her own debased status in southern society during the Civil Rights era. Lynne, as a white woman from the North, has stepped down from her pedestal only to find that southern blacks have no place for her, no use for her. Discarded by her black husband, mistrusted

by her black women peers and rejected by her northern Jewish family, she has become surplus to requirements. And realising that her position amongst southern blacks is inevitably, irrevocably compromised, she yearns for the authenticity that she hears in the black woman's voice. Unlike Douglass's northern whites, Lynne does not mistake the fullness of that voice for contentment or happiness. But like them she nevertheless makes a category-mistake in romanticising and aestheticising the culture of poverty, much as my white women students make a category-mistake when they identify with Celie's suffering.

'I could really identify with Celie' – anyone who has taught *The Color Purple* has heard this time and time again. But what exactly is meant by it? I have heard it said that such identification is a symptom of an unhealthy 'masochistic investment' in psychic suffering and powerlessness, akin to wallowing in Billie's blues. Billie singing 'My Man' ('two or three girls has he/ that he likes as well as me/ but I love him/ I don't know why I do/ he isn't true/ he beats me too') undoubtedly expresses a sentiment that many white women recognise.[10] It is a large part of the appeal of the blues that 'it speaks to, for, and about unmet needs and represents a catalysation of the desire for a kind of freedom as yet unfulfilled, and perhaps not even fully conceived, yet one that invites participation and experience of its particular *feeling*', writes Ray Pratt.[11]

Cross-race, cross-class identification and masochistic investment (if such it is) in women's suffering are problems for any kind of feminist analysis of Alice Walker's novel and Billie's blues. But to state such problems is not to resolve them. Who has a right to sing the blues? And who can really read them?

ALICE WALKER'S BLUES

The conjunction of Alice Walker and the blues is, of course, no co-incidence. Her short story, 'Nineteen Fifty-five' takes as its subject the misappropriation of a black woman's blues song by a white male singer, Traynor (who looks remarkably like Elvis).[12] When Traynor's manager tries to persuade Gracie Mae Still, the original composer and performer of the song, to sell it to him, he unselfconsciously sums up where Elvis/Traynor got his training: 'The boy learned to sing and dance livin' round you people out in the country. Practically cut his teeth on you.'[13]

The double-edged irony of a white man 'cutting his teeth' on a black woman's music is worthy of Zora Neale Hurston, and Gracie Mae Still is aware of both the exploitation *and* the irony of having her juke-joint songs packaged and commodified for white people's consumption. At

the heart of the story is Traynor's puzzlement at the meaning of the song which he goes on to make famous:

> I've sung it and sung it, and I'm making forty thousand dollars a day offa it, and you know what, I don't have the faintest notion what that song means. ... It's just a song, I said. Cagey. When you fool around with a lot of no count mens you sing a bunch of 'em. I shrugged.[14]

Like Lynne, Traynor, who is throughout portrayed as vacuous ('It was like some*thing* was sitting there talking to me but not necessarily with a person behind it' [15]), both admires and envies Gracie Mae's *living* ('fooling around with a lot of no count mens'), for it is the living she's done that has produced the songs – as he realises. Like 'Everyday Use', Walker's rather better-known short story about an old woman and her quilt, 'Nineteen Fifty-five' champions the authenticity and the use-value of African-American culture.[16] Just as 'Everyday Use' celebrates the black woman's artistry in needlework, so does 'Nineteen Fifty-five' revive black women's blues history – a history which has become somewhat obscured by the subsequent development of urban forms such as jazz and rock, both heavily masculinist in their connotations and accompanying lifestyles.

In *The Color Purple* these two strands of black women's artistic legacy (in the spirit of *In Search of Our Mothers' Gardens*) come together as Celie, the seamstress, and Shug, the blues singer, join forces in a mutually healing and nurturing relationship. Although both Shug and Celie have received their share of critical attention (Celie as slave, Shug as liberation theologian, both as echoes and revisions of Janey and Phoebe in Zora Neale Hurston's *Their Eyes Were Watching God*), Shug's significance *as* a blues singer has, perhaps, not been emphasised enough. For she is not just the one who enables Celie to discover her 'pleasure button' or the colour purple in the fields, signifying an immanent deity rather than the transcendent white-skinned, white-bearded God of Celie's earlier letters. Shug is, to all intents and purposes, a liberated woman, and it is her art which enables her to be so. As LeRoi Jones writes: '... the entertainment field [was] a glamorous one for Negro women, providing an independence and importance not available in other areas open to them – the church, domestic work, or prostitution'.[17]

And to this economic account of the blues as work, Hortense Spillers adds the dimension of blues singing as also a performance of sexual self-confidence:

> ... the singer who celebrates, chides, embraces, inquires into, controls her womanhood through the eloquence of form that she both makes use of and

brings into being. Black women have learned as much (probably more) that is positive about their sexuality through the practising activity of the singer as they have from the polemicist. Bessie Smith, for instance ...[18]

Bessie Smith is indeed a good example. Listen to her raucous rendering of 'I'm Wild at That Thing', accompanied by nothing more than a tinkling piano and acoustic guitar: 'Do it easy honey/ don't get rough/ give me ev'ry bit of it/ I can't get enough/ I'm wild about that thing/ just give my bell a ring/ you press my button/ I'm wild about that thing'. Or the blues discourse of 'You've Got To Give Me Some', which likewise leaves little to the imagination, and includes such phrases as 'I want a piece of your good ole meat', 'sweetest candy in the candyshop/ is your sweet sweet lollipop' and 'I'm going crazy about your hump'.[19] In these tracks and others, Smith represents the other side of women's blues: a sassy, demanding female sexuality far removed from the victimhood of Billie Holiday's best-known songs.

In *The Color Purple*, then, we can see against this background the cultural significance of Shug's occupation which goes beyond its mere narrative importance. As a blues singer Shug can teach Celie a lesson in sexual self-assertion and desire. Conversely though, and much more obliquely, Celie the archetypal victim also educates Shug in the ethics, if not the aesthetics, of everyday use. For everyday use is what Celie is to Albert, her husband, and also to Shug when they first meet: a doormat, nurse, nanny and cook combined. Shug has to learn to *see* Celie first, and then to value her dignity and integrity over and above her labour – a 'weepy miracle' indeed.

WILD GIRLS AND BLUESWOMEN

It has been suggested that feisty, funny, and outrageous Zora Neale Hurston herself was the model for Shug, but there are plenty of more accurate models available in the long line of hard-living, hard-loving women blues singers such as Ma Rainey, Ethel Waters, Bessie Smith, Mamie Smith, Trixie Smith – and others. Here for example is a quotation from the autobiography of Ethel Waters, who was a good friend of Zora's: 'Any God you worship is good if he brings you love. ... His is almost like an inner voice, soothing and calming.'[20] These lines could have been spoken by Shug. And if this sounds familiar, how about this echo from Zora Neale Hurston in 'How It Feels To Be Colored Me':

I have the soundest of reasons for being proud of my people. We Negroes have always had such a tough time that our very survival in this white world

with the dice always loaded against us is the greatest possible testimonial to our strength, our courage, and our immunity to adversity.

We are close to this earth and to God ... Our greatest eloquence ... comes when we lift up our faces and talk to God, person to person.[21]

Talking to God, person to person – this is a succinct description of Celie's early letters in *The Color Purple*. It is as if, in Waters's autobiography, we hear the voices of Shug, Celie and Zora mingled, singing in close harmony. When Waters writes: 'I was beginning to wonder if anyone could be so banged around and unloved during childhood days and still come out of it whole, a complete person',[22] she asks a question answered in *The Color Purple* – with a resounding 'yes'.

'Banged around and unloved during childhood days' is not just Celie's story, but that of many of Walker's characters (Brownfield Copeland, Meridian, Daughter in 'The Child Who Favored Daughter') and indeed, of Walker herself. The beginning of *His Eye Is On the Sparrow*, Ethel Waters's autobiography, could come out of a Walker novel, essay, or short story:

I never was a child.
I never was coddled, or liked, or understood by my family.
I never felt I belonged.
I was always an outsider.
I was born out of wedlock, but that had nothing to do with all this.
To people like mine a thing like that just didn't mean much.
Nobody brought me up.[23]

In Walker's *The Third Life of Grange Copeland*, nobody brings up Brownfield, who turns into a violent man and an abusive husband. Walker herself was shot in the eye by her own brother with a BB gun and scarred, as she thought, for life. This incident has been endlessly reiterated in interviews and critical articles as an originary trauma which brought her to writing and, although the shooting can be interpreted as an accident of children's play, Walker saw it, mindful of the discourse of 'accidents' in domestic violence, as a prefiguration of gender abuse in adult life. Such physical and psychological abuse of women by men is the stuff that women's blues are made on. But equally it is these women's critique of gender relations, their sassiness and their adept use of folk speech in their lyrics, as well as their enactment of female sexual desire in musical performance, which counteract the apparent bleakness and ostensible masochism of women's early blues songs. Michele Russell therefore calls women's blues, in an essay on

teaching black women, a 'coded language of resistance'.[24] In another essay, she adds:

> Blues, first and last, are a familiar, available idiom for Black women, even a staple of life ... We all know something about blues. Being about us, life is the only training we get to measure their truth. They talk to us, in our own language. They are the expression of a particular social process by which poor Black women have commented on all the major theoretical, practical, and political questions facing us and have created a mass audience who listens to what we say, in that form.[25]

I would call Alice Walker's *leitmotif* of childhood trauma and physical abuse (something which she extends cross-culturally to clitoridectomy in her latest novel, *Possessing the Secret of Joy*) characteristic of her blueswoman's aesthetic. The mourning of a childhood never known is a recurrent theme, and applies as much to slavery as the robbed childhood of the race as it does to Walker's own experiences. But elegy is always attenuated by an appreciation of the black community, the South's beauty and artistry and by a spiritual faith in social and political change. Most of all, it is attenuated by the creative act itself, for, as Ray Pratt reminds us, the blues (and Walker's writing) are not sad, but rather 'a way of laying sadness to rest'.[26]

Walker's womanist blues aesthetic is most famously and clearly expressed in the story 'Everyday Use': like the quilt which is made from scraps of the past to provide warmth and decoration on the bed, not the wall, art should be used, not framed. This use/blues aesthetic has its roots in Africa, as LeRoi Jones explains: 'It was, and is, inconceivable in the African culture to make a separation between music, dancing, song, the artifact, and a man's life or his worship of his gods. *Expression* issued from life, and *was* beauty.'[27] For Walker, then, an art which comes out of trauma *and articulates it* by that very function of expression becomes a healing art, an art for everyday use. In other words, art not as transcendence of, but immersion in, the mundane, which by virtue of that immersion, that intensity of feeling, produces transcendence of a different kind: by creating a community of listeners and readers which breaks the isolation that is (like Douglass's castaway's song), at the heart of the blues experience.[28]

A BLUES AESTHETIC?

In recent years the blues aesthetic has had a rather prodigious press, and I want to make it clear that I am not simply applying or adapting

it to fit Walker's work. In Houston Baker's *Blues, Ideology and Afro-American Literature*, the blues serves as hermeneutic and metaphor for a multiplicity of phenomena which he sweepingly terms: '... a phylo-genetic recapitulation – a nonlinear, freely associative, nonsequential meditation – of species experience'.[29] No less, I am not sure how useful this really is. In Baker's schema, the 'blues matrix' becomes, in his own words, 'a vernacular trope for American cultural explanation in general', which makes me wonder what place is left for the specificity and historicity of the blues as a *musical* form amidst the variety of literary, critical and theoretical discourses Baker discusses in his book.[30] The blues aesthetic has become problematic enough, even if we confine ourselves to literary studies. Gayl Jones's fiction has been described as blues writing; Toni Morrison's latest novel is said to be modelled on jazz; it seems that any self-identified black novelist's work is now in danger of being classified as a literary riff. A musical analogy, however, does not necessarily illuminate writing. Experiments with narrative voice, as in Morrison's *Jazz*, do not actually *need* jazz as a model.[31] Literature does not permit improvisation; if Morrison's style can be characterised as 'a performance', it is so only in a metaphorical sense: verbal acrobatics frozen in space and time. Literal performance and improvisation are unique, once-only events: they are evanescent. When we speak of a blues aesthetic, then, it is important to be aware of its reductiveness. A blues aesthetic in writing is a condensation, a solidifying of the 'spirit of the blues' abstracted from its everyday, improvised, performed and communally audited musical expression.

Nor is it good enough to speak of blues lyrics as some kind of vernacular poetry. Lyrics of any kind rarely survive as literature, and reading blues lyrics is like trying to catch a falling star – they fizzle to almost nothing on the page.[32] When I speak of Walker's blues aesthetic, I speak of stardust. The essence of the blues (its musical form, the repetition, the turns and twists of the voice, the blue-ing of the notes) cannot be reproduced in writing. What remains is part of the blues but not its multifarious whole. What remains is Houston Baker's vernacular, the vernacular of Celie's 'You better not never tell nobody but God', Ma Rainey's 'Don't Fish in My Sea', Zora Neale Hurston's 'Jumping at the Sun' and Bessie Smith's 'You Gotta Give Me Some'. Black speech in literature and lyrics, black women's life themes, and the non-linear, anecdotal, oblique narrative forms Walker employs are the literary residue of the slipping and sliding blue note. LeRoi Jones explains the connection between this mode of writing and the blues in their common African ancestry:

In language, the African tradition aims at circumlocution rather than at exact definition. The direct statement is considered crude and unimaginative; the veiling of all contents is considered the criterion of intelligence and personality. In music, the same tendency towards obliquity and ellipsis is noticeable: no note is attacked straight; the voice or instrument always approaches it from above or below, plays around the implied pitch without ever remaining any length of time, and departs from it without ever having committed itself to a single meaning.[33]

Think of *Meridian*'s multifaceted, oblique narrative, of the essay 'Looking for Zora' as a critical monument to a foremother, of *The Color Purple* as a comment on the origin of the novel, of *The Temple of My Familiar* as the spiritual history of a people. No note is attacked straight – whatever the overt 'content' of each text might be, there is never a straight narrative, no plot or subplots. Instead, we get a series of ostensibly disconnected vignettes, anecdotes, short scenes and dialogues which together, through circumlocution, amount to a story, an argument, a journey in space and time.

COMMODIFYING THE BLUES

Listen now to Ethel Waters, singing her vaudeville version of 'My Man'.[34] Using a classical style of singing, with a mock-French accent and an exaggerated emphasis on 'mon hoooomme', Waters improvises a whole new song of 'masochistic investment'. But with a difference: Waters's version of this classic, compared to that of Billie Holiday which I referred to earlier, illustrates vividly not just women blues singers' capacity for (self-)parody but also, in this recording late in her career, the commodification of the blues and its packaging for a white audience – as distinct from the black audiences for whom Bessie Smith's records were made in the 1920s, the so-called race records.[35]

In *Black Feminist Thought* Patricia Hill Collins explains how an Ethel Waters gave way to, and gave birth to, an Alice Walker:

Commodification of the blues and its transformation into marketable crossover music has virtually stripped it of its close ties to the African-American oral tradition. Thus the expression of a Black women's voice in the oral blues tradition is being supplemented and may be supplanted by a growing Black women's voice in a third location, the space created by Black women writers.[36]

It would be mistaken, however, to assume that, when Waters sings 'My Man' as 'crossover music', this is automatically a selling-out of the

authenticity of the blues. Waters satirises a notion of Frenchness (fore-shadowing the pathos of Edith Piaf) and of a European vocal tradition which she mimics in the way she uses her voice. Satire, inevitably, contains an element of critique, which is doubly ironic in face of the fact that 'My Man' was originally a French song, originally 'Mon Homme'.[37] Only when Waters says, at the end of the song, 'It's the same in any language' does she contain that element of critique by, in effect, universalising the spirit of the blues, extracting sentiment from song and thereby abstracting it from the southern blues experience: the blues becomes, precisely, sentiment, a 'song of lost love', the same in any language.

If we take this back to *The Color Purple* we can see a parallel in Walker's use of another European tradition, that of the epistolary novel.[38] Walker, like Waters, uses the conventions of the eighteenth- and nineteenth-century epistolary and realist novel *in a different voice* by way of critique. To draw out the parallels in a highly speculative way: like the eventually commodified form of women's blues, *The Color Purple* begins with southern 'raw material' (Celie/ southern country blues), which then has metropolitan influences (Shug/city blues) introduced into it as well as elements of high culture (Nettie's language, her 'written' discourse contrasting with Celie's down home orality/brass and strings). As the blues is 'Europeanised' and 'whitified' and recorded for a mass market, it becomes a commodity, a floating signifier unmoored from its berth in the southern black experience. But the same has long since happened to African-American literature. Unlike Patricia Hill Collins, I do not think that black women's writing now occupies the place of authenticity vacated by the blues, but rather that the rise of African-American women's writing is the product of the same crossover phenomenon that has transformed women's blues. Just as blues improvisation cannot be recorded *as* improvisation, so also is orality not simply transcribable. Instead, it mutates into a different form, as Zora Neale Hurston well knew.

The phenomenon of commodification is thus not one which lends itself to nostalgic regret, but is a necessary condition of modernity. In the same way, it is no accident that Celie inserts herself into modernity as a cottage industrialist, as part of the process of personal transformation and emancipation: instead of being a commodity herself, traded between men, she becomes a producer of consumer goods. Meanwhile, *The Color Purple* as a novel articulates, as a distinctly blue note, the passing of the African-American oral tradition into writing, print and commodification. Celie, in talking to God 'person to person', desperately creates an audience out of nothing; Walker parodies the European novel of letters to highlight her exclusion, whilst invoking a new, interracial and mass audience for African-American writing.

In both cases then the hybrid forms of mass market recorded blues and African-American novel of letters come to represent a kind of 'commodified authenticity' for a black and white market. But this 'commodified authenticity' of *The Color Purple* seems far removed from the aesthetic of everyday use that Walker espoused in the short story of that title, and in the blues story 'Nineteen Fifty-five'. What has happened?

AUTHENTICITY AND THE RIGHT TO SING THE BLUES

I think that both the passage about Lynne in *Meridian* and the ending of *The Color Purple* represent a shift in Walker's slightly naive defence of authentic folk art in 'Everyday Use'. In that story, the mother's poverty along with her artistry is in effect extolled over the daughter's educational and economic progress. But it is clear that when Lynne thinks of southern black people as Art, we are not supposed to concur with that view: she romanticises poverty in a way that only one who does not have to live it can. Poverty is not romantic; in *The Color Purple* Celie's progress is therefore marked as much materially as it is spiritually and sexually.[39]

Modernity and commodification complicate Walker's earlier championing of folk authenticity. And this is where the problem with white women's reception of the blues and of Celie's fate in *The Color Purple* lies. Like Lynne, and like Traynor, they respond to, and yearn for, an authenticity and experience that not only is not *of* them but which is also not *for* them (the only 'authentic' audience is that of the black community), and yet the commodity form makes that ersatz experience of the black woman's voice readily available to them. As Paul Gilroy demonstrates in *The Black Atlantic*, authenticity in music (and I would add in writing) is a complex thing:

> The discourse of authenticity has been a notable presence in the mass marketing of successive black folk-cultural forms to white audiences ... it is not enough to point out that representing authenticity always involves artifice. This may be true, but it is not helpful when trying to evaluate or compare cultural forms let alone in trying to make sense of their mutation. More important, this response also misses the opportunity to use music as a model that can break the deadlock between the two unsatisfactory positions that have dominated recent discussion of black cultural politics.[40]

These two unsatisfactory positions are Black (cultural) Nationalism, which absolutises difference, and a wholesale pluralism which deconstructs the notion of authenticity altogether. Yet the first of these,

cultural absolutism, is not unique to Black Nationalists. Whenever I speak to (white) blues buffs about the genius of Billie Holiday, for example, I am met with scorn: the 'real blues' is not that, the 'real blues' is always elsewhere, lesser known, farther away, longer ago, more 'authentic'. There is a danger, in teaching *The Color Purple*, to replicate that dismissive response with my students who 'identify with' Celie, by pointing to its inevitable artifice in representation, its self-conscious use of the history of the novel, et cetera. Contextualising *The Color Purple* in the history of African-American life and literature helps to identify Walker's discourse of authenticity *as* a discourse, distinguishes history from narrative play, and thus complicates a too-ready identification with Celie's suffering. Even so, my students' Lynne-like experience of having something of themselves articulated in the novel is also valid and need not be delegitimised by this intellectual work; as often as not I find that students emerge from their study of *The Color Purple* with both a better understanding of racial difference *and* a sense of solidarity or empathy with an experience not their own, but not entirely alien either.

Who has got a right to sing the blues, and who can really read them? In true Alice Walker fashion, I have no hard and fast answers. I still flinch at hearing a white person sing 'Strange Fruit', for example. But there are other songs and other texts, such as 'My Man' and *Meridian* and *The Color Purple*, which have always been part of the crossover repertoire: crossing over, and crossing back. Besides, as Paul Gilroy remarks, 'The relationship of the listener to the text is changed by the proliferation of different versions. Which one is the original? How does the memory of one version transform the way in which subsequent versions are heard and understood?'[41] For 'versions' we can also read 'readings', and so perhaps the whole question of authenticity, without quite disappearing, becomes much less tangible and much more interesting than it was when conceived as a simple black (experience)/white (appropriation) dichotomy.

And if Billie can also sing 'I've Got a Right to Sing the Blues' in a distinctly upbeat way, without a hint of the 'authentic' black suffering that we are used to hearing in her voice, then who is to say who has got a right to sing what to whom?[42]

NOTES

This essay was first presented at the conference 'Contemporary Perspectives on US Southern Culture', University of Warwick, September 1994. My thanks to Helen Taylor and Richard H. King for giving me the opportunity to try out this new work.

1. Billie Holiday, 'I've Got a Right to Sing the Blues' (Harold Arlen/Ted Koehler), recorded 25 August 1955 in Los Angeles, on *The Essential Billie Holiday* (Polygram, 1992).
2. Leroi Jones, *Blues People: Negro Music in White America* (New York: Morrow Quill, 1963) p. 12.
3. Houston A. Baker Jr, *Blues, Ideology and Afro-American Literature: A Vernacular Theory* (Chicago: Chicago University Press, 1984) p. 8.
4. Frederick Douglass, *Narrative of the Life of an American Slave* in Nina Baym et al., eds, *The Norton Anthology of American Literature*, 3rd edition (New York: W.W. Norton, vol. I, 1979) pp. 1887–8.
5. As Ray Pratt writes: 'Increasingly, some of the most dynamic blues interpreters are white women and men. Moreover, that the music comes through, as does most of our popular music ... largely through generations of white "mediators" (record company owners and executives, talent scouts, producers, writer-composers, agents, and critics) demonstrates an important exploitation factor at work here – the phenomenon known in some contexts as "white rip-off".' *Rhythm and Resistance: Explorations in the Political Uses of Popular Music* (New York: Praeger, 1990) p. 76.
6. Cora Kaplan, 'Keeping the Colour in *The Color Purple*' in *Sea Changes: Essays in Culture and Feminism* (London: Verso, 1986) pp. 177–87.
7. Maya Angelou's *I Know Why the Caged Bird Sings* has provoked the same, profoundly painful recollections, which I would like to think of as therapeutic in the long run. In the short run, however, they call for very careful and sensitive pedagogy. For a thoughtful account of problems in teaching *The Color Purple*, see also Alison Light's essay, 'Fear of the Happy Ending: *The Color Purple*, Reading, and Racism' in Linda Anderson, ed., *Plotting Change: Contemporary Women's Fiction* (London: Edward Arnold, 1990) pp. 85–98.
8. My students who are asked to read Kaplan's article often object to having their reading 'prescribed', as they see it, by the article and their identification proscribed or invalidated. This can lead to heated and productive arguments around the critic's role in cultural legitimation.
9. Alice Walker, *Meridian* (London: Women's Press, 1982) p. 128.
10. Billie Holiday, 'My Man' (Yvain/Charles/Willemetz/Pollock), recorded on Decca between 1944 and 1950, on *Billie Holiday: The Essential Recordings* (MCA Records, 1993).
11. Pratt, *Rhythm and Resistance*, p. 83.
12. Alice Walker, 'Nineteen Fifty-five' in *You Can't Keep a Good Woman Down* (London: Women's Press, 1982) pp. 3–20. The very title of this short story collection is taken from Mamie Smith's song, 'You Can't Keep a Good Man Down'. Walker dedicates the book to (amongst others) Mamie Smith, Bessie Smith and Ma Rainey 'for insisting on the value and beauty of the authentic'.
13. Ibid., p. 4.
14. Ibid., p. 8.
15. Ibid., p. 13.
16. Alice Walker, 'Everyday Use' in *In Love and Trouble* (London: Women's Press, 1984) pp. 47–59.

17. Jones, *Blues People*, p. 93.
18. Hortense J. Spillers, 'Interstices: a Small Drama of Words' in Carole S. Vance, ed., *Pleasure and Danger: Exploring Female Sexuality*, 2nd edition (London: Pandora, 1992) p. 87.
19. Bessie Smith, 'I'm Wild at That Thing' (Williams) and 'You've Got To Give Me Some' (Williams) probably recorded in the 1920s, on Bessie Smith, *Blue Spirit Blues* (Tring International, n.d.).
20. Ethel Waters with Charles Samuels, *His Eye Is On the Sparrow: An Autobiography* (1951; rpt. New York: Da Capo, 1992) p. 55.
21. Ibid., p. 93.
22. Ibid., p. 240.
23. Ibid., p. 1.
24. Michele Russell, 'Black-Eyed Blues Connections: Teaching Black Women' in Gloria T. Hull et al., eds., *All the Women Are White, All the Men Are Black, But Some of Us Are Brave: Black Women's Studies* (Old Westbury: The Feminist Press, 1982) p. 202.
25. Michele Russell, 'Slave Codes and Liner Notes' in Gloria Hull et al., eds, *But Some of Us Are Brave*, p. 131.
26. Pratt, *Rhythm and Resistance*, p. 85.
27. Jones, *Blues People*, p. 29.
28. Eileen Southern sees the blues as first and foremost an art of individual rather than collective expression. For her, call and response exist only in the interplay between the vocalist and the instrumentalists: the singer calls, whilst the players respond with echoes and improvisations. It will be clear that here I expand on this view and interpret the appreciation of the blues by a mass, interracial audience as a response to the 'call of the blues'. Eileen Southern, *The Music of Black Americans: A History* (New York: W.W. Norton, 1971) p. 333.
29. Baker, *Blues, Ideology and Afro-American Literature*, p. 5.
30. Ibid., p. 14.
31. In an interview with Paul Gilroy, Morrison is more careful than most of her critics in describing her work in terms of an analogy with music (rather than imitation of it) and an attempt at reconstruction 'of the texture of it' in writing; cited in Paul Gilroy, *The Black Atlantic: Modernity and Double Consciousness* (London: Verso, 1993) p. 78.
32. I am struggling with this difficulty here, myself, in trying to convert a conference paper – which is a performance, in part improvised, ad libbed and supported by the playing of Billie's and Bessie's blues – into a written article. The brief extracts from the lyrics cannot substitute for the music, for the cracked voice, the off-beat phrasing, for the soaring interludes, the rhythm and even the white noise of old studio recordings.
33. Jones, *Blues People*, p. 31.
34. Ethel Waters, 'My Man'. In her introduction, Waters says she sings it as she did in 1924, but the actual recording date is unknown. On *Who Said Blackbirds Are Blue?* (Sandy Hook Records, 1981).
35. Deanna Campbell Robinson et al., *Music at the Margins: Popular Music and Global Cultural Diversity* (London: Sage, 1991) p. 44.

36. Patricia Hill Collins, *Black Feminist Thought: Knowledge, Consciousness, and the Politics of Empowerment* (New York and London: Routledge, 1991) p. 102.
37. I thank John Moore for alerting me to the French origin of this song.
38. See, for orality and literacy, Valerie Babb, 'The Color Purple: Writing to Undo What Writing Has Done', *Phylon*, vol. XLVII, no. 2 (June 1986) pp. 107–16.
39. *The Third Life of Grange Copeland* (1970), Walker's first novel, is in my view similarly preoccupied with what modernity means for African-Americans in terms of psychological and educational as well as economic development.
40. Gilroy, *The Black Atlantic*, p. 99.
41. Ibid., p. 106.
42. Billie Holiday, 'I've Got a Right to Sing the Blues' (Arlen/Koehler), recorded sometime in the 1940s, on *History of Jazz: Billie Holiday* (Joker, n.d.).

4

L'Acadie Retrouvée: The Re-making of Cajun Identity in Southwestern Louisiana, 1968–1994

Robert Lewis

In May 1988, Raymond 'LaLa' Lalonde, Democratic representative for Sunset, introduced a bill in the Louisiana state legislature to grant Cajuns official minority status. According to Louisiana's affirmative action laws, any corporation engaged in construction or supplying a state public agency had to guarantee that at least 10 per cent of jobs were held by minority groups. Lalonde's bill would have qualified Cajuns, who comprised less than one-third of the state's population, for these state minority programmes. It defined a Cajun as 'a member or descendant of the community of French Acadians who colonized the Bayou Teche area of Louisiana after 1755'. Although the bill passed the House, it aroused bitter opposition from the black caucus, and belatedly from Governor Buddy Roemer. The public was apathetic. Seven weeks later, the 'Cajun bill' was withdrawn.[1]

Controversy surrounded affirmation action policy rather than the precise definition of Cajun identity in Lalonde's bill. Those who participated in the brief debate in the state legislature or commented in the opinion and correspondence columns of the local newspapers, agreed that merely living in the southwestern region of the state between New Orleans and the Texas border did not qualify all residents to be Cajuns.[2] Lalonde's criterion for distinguishing Cajuns from other Louisianians was traditional: Acadian ancestry. For several generations, the descendants of the refugees expelled by the British from Acadia, the modern Canadian provinces of New Brunswick and Nova Scotia, had recounted the saga of the Acadian Lost Cause: tragic exile and unhappy

wanderings in foreign lands, followed by proud resistance against Anglo-Saxon prejudice in Louisiana.

Lalonde represented both traditional views and a new wave of Acadian nationalists seeking to establish, or re-establish, intellectual and sentimental ties between Old and New Acadia. From the 1870s to the 1920s, southwestern Louisiana had been called 'the Acadian Land', 'Acadialand' or, after Longfellow's tragic heroine, 'Evangeline Country'. In 1971, the state legislature designated the region's twenty-two parishes, Acadiana, a conflation of 'Acadian' and 'Louisiana'. The Acadian revitalist movement offered Cajuns a myth-narrative, an 'invented tradition' of family and folklore ties, rediscovering an 'imagined community' of 'cousins' in 'Acadie du Nord' and 'Acadie du Sud'.[3]

Since the 1960s, there has also been a reawakening of the French heritage. Activists have sought links with the wider francophone world, particularly France and Quebec, beyond Acadia. Restoring the French language in Louisiana's 'French Triangle' is one of the movement's primary aims. Within Louisiana, the French renaissance appeals to a broader constituency than those with Acadian roots. It encompasses the descendants of the original settlers of the French and Spanish colony, of nineteenth-century immigrants from France, of English and Germans who became acculturated, and of blacks from the French Caribbean, as well as recent refugees from Vietnam. It also has a more mercenary motive in enticing tourists attracted by the French past to stray beyond New Orleans.

The Acadian and French wings of the revitalisation movement are complementary and interlinked. The accent on the broader French heritage, new to the past generation, promises a larger, more inclusive sense of identity, transcending race and genealogical descent from the Acadian Founding Fathers. But at a more popular level, ordinary Cajuns pay little attention to ideology or language revivalism. Instead, they celebrate 'French' food and fun. They do not regard the French language as an essential component of Cajun identity. In the next century, a vague French cultural background without a functioning French language may characterise the Cajun.

THE ACADIAN PAST

In the nineteenth century, all travellers to the swamps and prairies of southwestern Louisiana agreed that the descendants of the refugees from Acadia had a unique and distinctive identity. Northern visitors believed the 'Cajens', as they were also known by the 1870s, did not conform to Anglo-Saxon Protestant customs in religion, recreation or habits of

work.[4] Alcée Fortier, a New Orleans scholar of French descent, was also very conscious that the customs of the Acadians were quite different from those of the more cosmopolitan, educated, urban 'Creoles' who had settled in the early days of Spanish rule, or had come from the West Indies or directly from France.[5]

The term 'Cajun' was also applied far more loosely as an insult 'to all the humbler classes of French origin', reported the American traveller R. L. Daniels in 1880. 'Among themselves they are the *Créole Français*, and Acadian – or rather its corruption Cajun, as they pronounce it – is regarded as implying contempt.' The Cajuns referred to all those who were not 'French' as 'Americans' or 'Yankees'.[6]

The French language lost status rapidly in the late nineteenth century. By 1845, little more than a generation after the Louisiana Purchase, Anglo-Americans were the majority. In 1864 and 1868, the state legislature made it no longer obligatory to publish the state constitution and laws in both French and English. By the 1870s, the white Creoles, a group comprising the descendants of immigrants from France and refugees from the Caribbean, lost political power and social dominance even in New Orleans. By the 1890s, the Catholic Church held few services in French. The once-flourishing French literary culture in New Orleans atrophied. There were 33 French-language newspapers in 1860, but only seven in 1900, and the last major paper, the New Orleans *L'Abeille*, suspended publication in 1923. Cajuns were mostly illiterate in any language. After school attendance became compulsory in 1916, a law in 1921 made English the language of instruction. By 1900, only in three parishes, St. Martin, Lafayette and Vermilion, was more than a quarter of the population unable to speak English.[7]

There was less continuity of Acadian traditions than many observers believed. There were no songs or folklore commemorating exile, although some unaccompanied Acadian ballads and dance tunes were recorded in small Louisiana farming communities like Mamou and Kaplan in the 1930s and 1950s. But, by the twentieth century, Cajun music also had roots in other traditions – the Celtic fiddle, the German accordion, and African-American rural blues. French-language lyrics bridged traditional and new dance tunes.[8]

The Acadian influence was a little stronger in material culture. Like all folk house-building in the United States in the nineteenth century, Cajun architecture evolved, taking advantage of local influences, both Anglo-American and Caribbean. Traditional styles were altered to suit the semi-tropical climate, humidity and swamps of Louisiana. The ground floor was supported on cypress blocks for better ventilation and a front gallery added for covered storage and sitting outdoors. Local Spanish moss mixed with mud provided material for plaster infill

(*bousillage*) for interior walls. Cajuns retained the Acadian *garçonnière* or loft with outside staircase where the boys slept. The *pieux* fence around the house was constructed from cypress posts, but otherwise machine-sawn timber predominated. The overall look was hardly Acadian but distinctively Cajun.[9]

Cajun foodways had French roots, but the Acadian reliance on cod, herring, and wheat was replaced by the local produce of Louisiana – crawfish and shrimp, with rice and corn as the main cereals. French Creole planters who fled from the revolution in St Domingue imparted a taste for food highly seasoned with hot peppers. The local Houma Indians showed the uses in stews of filé, a thickening ingredient made from sassafras leaves. Slaves of African descent added okra and yams. Hence, the dishes regarded in the twentieth century as characteristically Cajun – gumbo and jambalaya – owed as much to Africa, North America and the Caribbean as to Acadia and France.[10]

By the Second World War, Acadian traits were disappearing. The most significant factor was the spread of large, mechanised farms which rendered obsolete and unproductive tenant-farming in small, isolated, self-sufficient Cajun communities. Traditional rural folkways – the *ramasserie* (communal harvest), the *boucherie* (cooperative neighbour-hood slaughtering) and *bals de maison* and *veillées* (local community dances and neighbourly visiting) – became far less common. Most rural communities suppressed the often rowdy Mardi Gras celebrations.

The oil and petrochemical industries led to rapid urbanisation, par-ticularly around Lafayette. In the generation from 1930 to 1960, Cajun society altered almost as much as it had in the previous hundred years. In the 1970 census, more than a half a million in Louisiana claimed French as their mother tongue, but everyday use had declined dra-matically. 'Coonass' became the new, more derogatory term for those of Acadian descent. To escape the 'French' stigma, children were generally given standard American first names. It seemed the process of Anglicisation was nearly complete.[11]

THE ACADIAN REVIVAL, 1925–1965

Organised protest against Anglicisation came mainly from well-placed Louisianians who traced genealogical descent from the eighteenth-century Acadian refugees. By forging ties between Old and New Acadia, they could both expunge the shame of exile and defend francophone culture against modernisation.

Since its publication in 1847, Longfellow's myth-narrative of Evangeline, separated from her lover Gabriel by the British and searching

Louisiana in the valiant but vain attempt to find him, had provided a model of virtue and fortitude against the enmity and prejudice of the English and English-speaking Louisianians. In 1907, a new version of the 'true story' appeared. Felix Voorhies's tale of the lovers Emmeline Labiche and Louis Arceneaux in *Acadian Reminiscences* excited great local interest. The myths now assumed tangible form. The semi-religious Evangeline 'shrines', statues and parks created in the 1920s in St Martinville and Grand Pré soothed the bitter memory of the unjust expulsion.[12] 'Never since the darkness of Calvary had apparently settled the fate of Him who had been proclaimed to be the Savior of the world had enmity and hatred triumphed in such a glorious fashion', wrote a local historian of the expulsion of 1755. Evangeline 'stands guard over the relics of her people' in 'a new Acadia'.[13] The Evangeline legend flourished in the area that the Southern Pacific Railroad promoted in 1929 as 'Evangeline Country' and 'Acadia-land'. The Evangeline label sold food-products and advertised businesses of all kinds.[14]

From the 1920s to the 1960s, Dudley J. LeBlanc, an ambitious politician from Abbeville, used his remarkable entrepreneurial talent in selling his patent medicine Hadacol and promoting the cause of Evangeline. In cooperation with Francois G. T. Comeau, he organised 'pilgrimages' of 'Evangelines' – 'girls' in Acadian dress – to Nova Scotia and hosted return visits by similarly-costumed delegations in 1930 and 1936. Other visits followed in 1946, 1963 and 1966.[15] In 1927, LeBlanc wrote the first popular and, he believed, authentic history of the Acadian exile. He always claimed that the language of the 'cousins from the North' was in common usage in south Louisiana, and that Acadians were 'difficult to distinguish one from the other'.[16] In his gubernatorial campaign of 1939, LeBlanc deployed women in Acadian costume, with Cajun music and speeches in Cajun French. His informal 'Couzan Dud' radio broadcasts on Sunday afternoons were highly popular. He became president of the elite Association of Louisiana Acadians, held barbecues to raise funds for an Acadian shrine, and distributed 'honorary Acadian' awards at banquets, and attracted great publicity for the cause.[17]

In 1955, the bicentennial of the Acadian deportation prompted celebrations – and another 'pilgrimage' to Moncton. The state appointed an Acadian Bicentennial Celebration Commission. Its chairman Thomas J. Arceneaux had been active in another elite association, the Société de France-Amérique de la Louisiane Acadienne. The celebratory parades and pageants organised throughout southern Louisiana by the Commission masked a deep unease about the future of Acadian culture. The modern mass media had left Cajuns, one of its publications noted, 'not very well acquainted with many of the deeply-rooted folk traditions of a simpler and gentler America, ... and perhaps within less than a

generation the songs and dances of the Acadians will have an interest purely historic and academic – unless interest in them is revived and unless they are taught to boys and girls today'.[18] The Commission published a cookbook and booklets (in English) detailing advice to schools on replicating traditional 'Acadian' dance, songs and costume.[19]

The Bicentennial also honoured the achievements of Louise Olivier's Louisiana French/Acadian Handicraft Project. In the 1930s, alarmed at the imminent demise of handicraft skills, Olivier used the resources of Louisiana State University's Extension Division to tour the state and organise groups of women to produce 'Acadian' textiles. Using hand-carding techniques, spinning wheels and looms, women produced and marketed quilts, blankets and other textiles, using the distinctive natural brown cotton *(coton jaune)* and vegetable dyes. Although the enterprise was only a modest commercial success, it was indicative of a growing ethnic pride.[20]

Thomas Arceneaux was also responsible for devising the Louisiana Acadian flag. In 1884, when nationalists wanted a symbol to unite the dispersed Acadian population in Nova Scotia, New Brunswick and Prince Edward Island, they modified the republican French tricolour, the traditional emblem of French Canada and Quebec, and added the Catholic gold star, the Stella Maris, representing the Virgin Mary. The flag was accepted by Acadian exiles in New England but was never popular in Louisiana. Arceneaux's Louisiana Acadian flag of 1955 incorporated the red, white and blue of France and the United States, three Bourbon white *fleurs de lis*, which also appeared on the new flag of Quebec, the gold Marian star, and a gold tower, representing the arms of Castille and Louisiana's Spanish heritage. In 1965, it was adopted as the official flag of Acadiana.[21]

However, there was an elegiac tone to the Bicentennial celebrations. Ruth Shaver Means's poem 'Exodus' lamented a disappearing culture:

They disappeared from L'Acadie when England's army came,
And now they face a new invader – Progress is the name.

It has become almost passé to speak the bayou French;
The pungent smell of fishing has become an oilfield stench.

The young ones – do they care about the weekly fais-do-do?
Mais non! They have a television – at least a radio!

The good French names – Alcée – Achille – so very few you meet.
The once abounding Jean Pierre's are now plain Jack or Pete.

Weep on, Evangeline, for him you sought across a nation,
And weep for us who love the past, but hardly find Cajun![22]

In 1968, the state legislature established and funded the Council for the
Development of French in Louisiana (CODOFIL). It permitted French-
language instruction in the public elementary and high schools, and
in 1975 made it mandatory (without additional funds) where a sufficient
number of parents petitioned for its introduction.[23] The key figure in
CODOFIL was James (Jimmie) Domengeaux, a wealthy Lafayette lawyer
and businessman, and a former United States Congressman and state
senator, who enlisted the support of ageing cultural nationalists like
LeBlanc. Domengeaux's principal aims were to restore Louisiana's place
in an international francophone community, to foster trade and tourism,
and ultimately to make Louisiana a truly bilingual state. Accordingly,
he looked to France, Belgium and Quebec (but scarcely to impoverished
Acadia) for support in introducing standard 'international' written
French to the state. Only non-Louisiana teachers who spoke 'good' French
should be employed.[24]

CODOFIL's aims differed from those of the Acadian revival. The
Bicentennial Commission had shown little interest in the French
language. Initially, CODOFIL ignored folk memory. Its mandate did not
include preservation or revitalisation of Cajun language and culture;
the most strongly French-speaking rural communities often resented
the slight to Cajun French and opposed the language programme in
their local schools. However, in contradictory ways, CODOFIL boosted
ethnic consciousness among Cajuns. Its placards and bumper stickers,
and the 'International Brigades' of foreign French teachers, gave the
French language high prominence, status and publicity, and drew
attention to Louisiana's unique ethnic group.

The 1960s and 1970s were a time of ethnic-minority consciousness
throughout the Western world. Celtic nationalism in Wales, Cornwall,
Scotland, Ireland and Britanny inspired pan-Celtic music festivals.
Within France, not only Bretons, but Basques, and Occitans in Languedoc,
protested for recognition of their regional cultures. In the United States
– 'divisible' America, as some called it – 'unmeltable ethnics' of European
stock searched for their roots, and blacks showed renewed interest in
their African heritage – and civil rights.[25] But nowhere were cultural
nationalism and ethnic revivalism more explosive than in franco-
phone Canada. Quebec's 'Quiet Revolution' of the 1960s gave way to
a far more assertive Parti Québecois, and in the Maritimes, encouraged
a more militant rebirth of Acadian identity.

THE ACADIAN REVIVAL SINCE THE 1960S

By the 1960s, only one-third of New Brunswick's and one-twentieth of Nova Scotia's population was francophone. Under Premiers Louis Robichaud in the 1960s and Richard Hatfield in the 1970s, New Brunswick gave greater rights to the French-speaking minority. Implementation of official bilingualism was slow, but by 1970 most school texts were also available in French.[26] Moncton became the focus of language revivalism. The Canadian Broadcasting Corporation opened a French-language radio station there in 1954 and added one for television in 1957. The Université de Moncton was created in 1963, and its Centre d'études acadiennes in 1968. The Moncton publishers Les Editions d'Acadie became the most active French-language press in the Maritimes. During the 1970s, Antonine Maillet's plays, novels and polemics about the Acadian past and present, especially *Pélagie la charette* (1979), gained her international recognition.[27]

In Louisiana, a small but influential group of young intellectuals were inspired by events in New Brunswick, as well as by the efforts of CODOFIL, to revive pan-Acadian identity. Unlike Domengeaux, however, they had few inhibitions about proclaiming Cajun-French nationalism. In 1980, the first anthology of poetry in Cajun French appeared.[28] At the Center for Louisiana Studies at the University of Southwestern Louisiana in Lafayette, the series of original creative writing was entitled 'Les Editions de la Nouvelle Acadie'. David Marcantel's play, *Mille Misères* (1980) of the Théâtre 'Cadien, was inspired by Antonine Maillet. In 1991, Louisiana signed an agreement, renewed in 1994, for cultural exchange and school instruction, with the Maritime Provinces.

Music was an essential part of the Acadian revival. Although Domengeaux had no interest in Cajun music, CODOFIL sponsored 'Acadian Festivals' which proved far more popular than school instruction. The first festival in Lafayette on 3–4 December 1968 announced its wish 'to Foster a Great Reunion of the Acadian People, together with the French-speaking Communities of North America'.[29] Zachary Richard, poet and songwriter, found inspiration in France and Canada. At the time of his most ardent ethnic consciousness in the mid-1970s, Richard would speak only French, even to monoglot Americans. His song, 'Réveille! Réveille!', about the deportation of Acadians in 1755, was a call to Cajuns to defend their traditions.[30] Michael Doucet of the group Beausoleil, named after an Acadian folk-hero, discovered his Acadian roots in France in 1974. Doucet articulated the role of the performer-nationalist:

A musician ... has also been a carrier of traditions and a cultural legacy. But now that legacy is in pieces. The original culture was blown apart with the nation in Acadia by the exile. It came back together in Louisiana in a new way. Then it was infiltrated and diluted by a lot of other people and influences and practically destroyed by Americanization. You have to put the pieces back together by looking at what's left and uncovering all the links to understand the whole.[31]

Acadian consciousness in Louisiana also had popular roots. Cultural activists had revived a sanitised Mardi Gras procession in Mamou in the 1950s, and the 'tradition' spread to other communities.[32] 'Neo-Acadian' houses, which simulate the appearance of the traditional design with a concrete base, a fake front gallery and side stairway, became a popular style. There has also been a flourishing of Acadian heritage sites. Inspired by the Village Historique Acadien at Caraquet, New Brunswick, the Acadian Village (1976) near Lafayette has reassembled and furnished nineteenth-century Louisiana houses, plus a few replica buildings. The Acadian Heritage and Culture Museum in Erath treats 400 years almost as a continuum. The Acadian Room illustrates settlement in Canada in the seventeenth and eighteenth centuries, with particular emphasis on the expulsion; the Cajun Room depicts life in Vermilion Parish in modern times. The Jean Lafitte National Park has planned three regional state-funded Acadian Cultural Centers. The 'Prairie' Center in Eunice opened in October 1991, to be followed by a 'Wetlands' outpost at Thibodeaux and an 'urban' one in Lafayette.[33]

Genealogy, tracing Cajun descent from Acadian ancestors, has flourished since the 1960s. Some 80 traditional Acadian surnames are seen as distinguishing Cajuns. Bona Arsenault's genealogical research paved the way for amateur enthusiasts.[34] A periodical L'Etoile d'Acadie (1981–85), later renamed Le Réveil Acadien/The Acadian Awakening (1985–), serves the Acadian diaspora. The theme at the Congrès Mondial Acadien in Moncton on 12–22 August 1994 was 'Return to Roots in Acadia'. The aim of the Retrouvailles, homecoming celebrations and reunions, for some 70 'families' sharing the same surname, was to 'renew' the 'ancestral ties' and 'reunite' the descendants of Acadians in Canada and Louisiana. However, since only one quarter of the population of Cajun Country has Acadian surnames, some see this genealogical definition of Cajun identity as too narrow – 'there is much more to the Cajun than Acadian roots'.[35]

Memories of past injustices to the Acadians still animate the present generation. In January 1990, Warren Perrin, a Lafayette lawyer, presented a petition (later adopted by a joint resolution of the state legislature in June 1993) to the Queen of Great Britain. On behalf of all Louisiana

Acadians, he asked for an official end to Acadian exile and recognition that it violated international law. And, reminiscent of the monument-building 1920s, he asked for the 'creation of a symbolic gesture of good will by the erection of a small, simple monument with appropriate inscriptions to historically memorialize the "end of the exile"'. The British government appointed lawyers to negotiate, and the issue is still unresolved.[36]

REDISCOVERING THE FRENCH HERITAGE

Since the 1960s, the state of Louisiana has established closer contact with the francophone world. But the centre of interest is not in New Orleans, the largest city, or in Baton Rouge, the state capital; the permanent trade and cultural delegations from Quebec, Belgium and the Maritime Provinces are in Lafayette, and there are close links between Lafayette and the long-established French consulate in New Orleans. CODOFIL's office in Lafayette has broadened its activities. It has encouraged the French-language media. It publishes the only bilingual periodical, *La Gazette de Louisiane*. In October 1991, it was also instrumental in bringing TV5, the European French-language television consortium, via Quebec; the 15 hours of programmes can, however, be seen only by cable subscribers. There are more French-language broadcasts than ever before: 150 hours of radio, and 50 hours of television weekly. However, few of the television programmes are made locally and much of the radio broadcasting consists of Cajun music, with bilingual or French-language commentary and advertising.[37]

Tourism publicises the unique 'French' heritage; the region has 'local color in language, food music, work and the land, ... a way different from that of mainstream America', the official state tourist guide claims.[38] Almost all the annual local 'Cajun' festivals were created in the 1960s and 1970s to publicise the distinctive attractions of local towns. As well as weekend festivals celebrating Cajun music and zydeco, there are food festivals honouring andouille, boucherie, boudin, Cajun hunters, catfish, cattle, crab, crawfish, duck, French food, frog, gumbo, jambalaya, oyster, rice, sauce piquante, shrimp, sugar and yams. In 1990, Louisiana doubled the budget for tourism. It funded a new campaign in France and francophone Canada to publicise the unique French heritage of 'Cajun Country'.[39]

Tourism's accent on 'French' Louisiana also attempts to incorporate the one major group of French descent which considers itself neither Acadian nor Cajun.[40] Most French-speaking African-Americans identify themselves as Creoles, or Creoles of colour. Although there are perhaps

only 10,000 French-speaking Creoles of colour today in a total black population of a million, many more can claim French cultural heritage as the descendants of free persons of colour or slaves brought from St Domingue after the revolution of 1791. Louisiana has had a troubled racial history, especially during Reconstruction when racial divisions deepened, and white and black Creoles became more separate than ever before.[41] More recently, Louisiana's record in civil rights has not been quite as bleak as that of its neighbours, Mississippi, Alabama and Arkansas. However, Creoles of colour have their own institutions, born of segregation and prejudice. There are still separate Catholic churches and different folklife traditions, including separate Mardi Gras festivals.[42] The monthly English-language *Creole Magazine* began in December 1990. The music has remained distinctive. Clifton Chenier, the renowned exponent of the accordion, always called his fast-paced, blues-style music, zydeco or 'French' music, not Cajun.[43]

And yet, as musicians, Creoles of colour have often been treated as 'guest' or 'honorary' Cajuns. Near the prairie towns of Basile, Mamou and Eunice, in tiny sharecropping communities like L'Anse de Rougeau or L'Anse aux Vaches, there was often close musical contact between white and black musicians in the 1920s and 1930s. Private house-parties and public dance-halls remained segregated, but, as in big-city jazz, the musicians were sometimes integrated. The black accordion-player Amédée Ardoin worked with the white fiddler Dennis McGee on the farm of Celestin Marcantel near Eunice. They played together at local dances and made some of the earliest, most influential, French-language recordings in 1929. Ardoin died in 1941 of mental and physical decline, reputedly following a racially-motivated attack. The account of Ardoin's crime by Joel Savoy, a local farmer, is an eloquent comment on racial etiquette among Cajuns in the 1930s:

> One night he was playing a dance and one of the daughters of the man on whose farm he lived lent him a handkerchief to wipe his face. There were some people, not from this area, at the dance who saw this and didn't like to see a black man use a white woman's handkerchief; so they followed him home and beat him badly … There wasn't anyone in this area who would have thought twice about Amédée using a white woman's handkerchief. Everyone knew and liked him.[44]

The practice of shared music-making tradition continued in the 1960s and 1970s with fiddle-players like the black Canray Fontenot and the white Dewey Balfa. Since, in generations past, almost all Cajuns and Creoles had been illiterate, the oral transmission of tradition had particular significance in rural areas. Jokes and tall stories told in French

by blacks and whites may differ in language and tone, but are often more similar in style and content than the folktales told by English-speaking members of the same racial groups.[45]

Since 1986, Lafayette has organised an annual Festival International de Louisiane. Its mission is to celebrate the arts of the francophone world – of Europe, Africa, Southeast Asia, Canada and the Caribbean, as well as Louisiana. The Festival International's promotion of 'the French cultural heritage of southern Louisiana' is not limited to whites of Acadian descent. The most recent theme has been 'Revelations of Diaspora', with 'The Acadian Legacy' in 1994, and 'The African Journey' in 1995, exploring Louisiana Creoles and the African diaspora in the Americas.

Lafayette's Vermilionville Living History Museum and Village, created in 1988, illustrates this recent, broader approach. A 'French' flavour gives thematic unity. In a Disneylandish setting of reconstructed buildings, authentic artefacts and costumed interpreters, Vermilionville offers tourist visitors re-creations of the nineteenth-century past, with both 'Acadian' and Creole attractions. In Le Quartier, an area of food stands serving both Cajun and Creole dishes, visitors may purchase Tony Cachière's Creole spices, or eat traditional Southern delicacies in the full-service restaurant, La Cuisine de Maman.

POPULAR TRADITIONS IN CAJUN COUNTRY

Paradoxically, given this new emphasis on the French heritage, there is a real prospect of a 'French' Louisiana without the French language. After 25 years, CODOFIL's programme appears to be successful. It has established instruction in the schools. Eighty thousand are enrolled in language classes, and Louisiana now produces more than three-quarters of the teachers it requires. The rapid acculturation of the 1950s has been checked. There is unprecedented access to French-language broadcasting. Yet decline in French language usage is slow but sure. Only the elderly born before the Second World War use French regularly in the home. Intergenerational continuity of the language is gravely threatened, and there is the serious risk of irrevocable loss. The decline of Creole French is equally marked.[46]

Most Cajuns are emotionally attached to the language as part of their cultural legacy, but few of the young esteem it highly as an everyday means of communication. Indeed, language is now seen as largely irrelevant to ethnic identity. 'A Cajun who speaks no French is not considered to be any less a Cajun than is a French-speaking one', reports an anthropologist who carried out extensive fieldwork in

Lafayette, Breaux Bridge and Baton Rouge in the late 1970s and early 1980s.[47] Multiculturalism also has its enemies. Alarmed at the prospect of 'hyphenated Americans' – 30 million have English as their second language, an increase of a third in the 1980s – Republican Pete King has introduced National Language Act 1995, one of four similar measures, which seeks to abolish the federal government department which oversees bilingual education. Although not under the same pressure as California or Texas for foreign-language instruction, Louisiana has had severe budget cuts in recent years, and continued funding for CODOFIL is in question.

As Louisiana's hopes of being part of the francophone world have faded, 'French' food and music have become the universal symbols of Cajun identity. As one high school student from Marksville explained to a sociologist from Quebec: 'The language is decreasing, the religion it is for the old, but everyone loves the food.'[48] Cajuns have assimilated and become acculturated, and, while there is nostalgia for the 'old' country of France and Acadia, they express their sense of individuality and group identity in gestures. 'Cajun food', an anthropologist states, 'is a flexible ethnic symbol, and is acceptable as such to a wide variety of Cajuns … and it distinguishes Cajuns from outsiders'.[49]

Most Cajuns remain oblivious to the nuances of the Acadian and French revitalisation movements. Few believe, like Raymond Lalonde, that Cajun is synonymous with Acadian. Reponding to a debate in *La Gazette de Louisiane* on the correct French spelling of 'Cajun', Dr Gerald J. Domingue of New Orleans conceded that both strict and loose definitions of Cajun identity were permissible:

> A Cadjin/Cajun is a Louisianian, but not all Louisianians are Cadjins/Cajuns! Any Louisianian of French Acadian ancestry can rightly call himself Cadjin/Cadjine/Cajun. Realizing that there are francophones who did not settle in Louisiana via the Nova Scotia route, I do not have strong feelings for or against these individuals calling themselves Cadjin/Cajun. Technically, they are not Cajuns. However, I believe that should be the Louisianian's (francophone's) choice.[50]

Domingue tolerated non-Acadian ancestry but left ambiguous the equally vexed question of francophone status: does past heritage qualify, or does it also require present competence in French?

The image of 'French' Louisiana promoted since the 1960s is unique in the United States. To tourists, Cajun Country is presented as 'south of the South'. There are few of the typical symbols of southern identity, especially those commemorating the Confederacy. The usual historical traits of Americanism – colonial English settlement, Protestantism and

the Revolution – have little significance in southwestern Louisiana.[51] Nowhere else, outside closed communities like the Amish, has a language other than English survived as a functioning means of mass communication for two centuries, until recent times. As French atrophied, it was replaced by a strident assertion of continuing ties with Old Acadia. Historically, Acadian nationalism has been the major force in creating ethnic consciousness, but narrow genealogy has weakened its influence. The French renaissance movement had limited success in reviving everyday language, but was sufficiently broad to incorporate both Acadians and other Louisiana French. It stimulated a new pride in the French cultural heritage and generated images for a tourist culture.

In 1976, Revon Reed, an activist from Mamou, defined a Cajun thus:

> If he has accepted the French language, has learned it, loves it, and speaks it the best that he can, that's a real Cajun! If he has accepted the culture, the traditions, and the music of the Cajuns, he is a Cajun; and if he keeps his Acadian heritage, ... he is a Cajun. A Cajun is the person who thinks he is a Cajun.[52]

Twenty years later, the great majority of young and middle-aged Cajuns lack these attributes – except the last. The Acadian revitalist movement of the twentieth century failed to establish enduring ties with Old Acadia, but ensured that Cajuns remained proud of their unique culture. Minority consciousness is based less on ancestral roots than a sense of belonging. For the ordinary Cajun, the ideological revivals are of little consequence. The crawfish and the accordion are the universal symbols of 'French' food and music, and are as characteristic of the region as 'Cajun' is as a registered trademark for the products of southwestern Louisiana.

NOTES

Research was made possible by a Faculty Enrichment Grant from the Canadian Government and a grant from the Foundation for Canadian Studies UK which allowed me to visit the Centre d'études acadiennes at the Université de Moncton in April 1991 and April 1994.

1. *New Orleans Times-Picayune*, 14 May 1988; 19 May 1988; 24 May 1988; 29 June 1988; 9 July 1988.
2. Lawrence E. Estaville, Jr, 'Mapping The Cajuns', *Southern Studies*, vol. 25 (Summer 1986) pp. 163–71; Estaville, Jr, 'The Louisiana-French Homeland', *Journal of Cultural Geography*, vol. 13 (Spring–Summer 1993) pp. 31–45.

3. See Eric Hobsbawm and Terence Ranger, eds, *The Invention of Tradition* (Cambridge: Cambridge University Press, 1983); Benedict Anderson, *Imagined Communities: Reflections on the Origin and Spread of Nationalism* (London: Verso, 1983), and the forum debate on 'The Invention of Ethnicity: The Perspective from the U.S.A.', *Journal of American Ethnic History*, vol. 12 (Fall 1992) pp. 3–63.

4. Carl A. Brasseaux, *Acadian To Cajun: Transformation of a People, 1803–1877* (Jackson, MS: University Press of Mississippi, 1992) pp. 99–105; Timothy F. Reilly, 'Early Acadiana Through Anglo-American Eyes', *Attakapas Gazette*, vol. 12 (Spring 1977) pp. 3–20; (Fall 1977) pp. 159–76; (Winter 1977) pp. 185–94; vol. 13 (Summer 1978) pp. 53–71.

5. Alcée Fortier, 'The Acadians of Louisiana and Their Dialect', *PMLA*, vol. 4 (1891) pp. 64–94.

6. L. Daniels, 'The Acadians of Louisiana', *Scribner's Monthly*, vol. 19 (1880) pp. 383, 384.

7. Patrick Griolet, *Cadjins et Créoles en Louisiane: histoire et survivance d'une francophonie*, (Paris: Payot, 1986) pp. 44–64; Carl A. Brasseaux, 'Acadian Education: From Cultural Isolation to Mainstream America', in Glenn R. Conrad, ed., *The Cajuns: Essays on their History and Culture*, 2nd edn (Lafayette, LA: Center for Louisiana Studies, University of Southwestern Louisiana, 1983) pp. 133–44; Lawrence J. Estaville, Jr, 'The Louisiana Cajuns in 1990', *Journal of Historical Geography*, vol. 14 (October 1988) p. 353.

8. Barry Ancelet, *Cajun Music: Its Origin and Development* (Lafayette, LA: Center for Louisiana Studies, 1989); Ancelet, Jay Edwards, and Glen Pitre, *Cajun Country* (Jackson, MS: University Press of Mississippi, 1991) pp. 32–65.

9. Peter Ennals, 'Acadians in Maritime Canada', and Malcolm L. Comeaux, 'Cajuns in Louisiana', in Allen G. Noble, ed., *To Build in a New Land: Ethnic Landscapes in North America* (Baltimore: Johns Hopkins University Press, 1992) pp. 29–43, 177–92; Jay D. Edwards, *Louisiana's Remarkable French Vernacular Architecture, 1700–1900*, (Baton Rouge: Department of Geography and Anthropology, Louisiana State University, 1988).

10. Marielle Cormier Boudreau and Melvin Gallant, *La cuisine traditionelle en Acadie*, (Moncton, NB: Les Editions d'Acadie, 1975); C. Paige Gutierrez, *Cajun Foodways* (Jackson, MS: University Press of Mississippi, 1992).

11. Carl A. Brasseaux, 'Four Hundred Years of Acadian Life in North America', *Journal of Popular Culture*, vol. 23 (Summer 1989) pp. 11–2; Clifford J. Clarke, 'Assimilationist Views of an Ethnic Region: The Cajun Experience in Southwest Louisiana', *Social Science Quarterly*, vol. 69 (1988) pp. 433–51.

12. Carl A. Brasseaux, *In Search of Evangeline: Birth and Evolution of the Evangeline Myth* (Thibodaux, LA: Blue Heron Press, 1988); Naomi Griffiths, 'Longfellow's Evangeline: The Birth and Acceptance of a Legend', *Acadiensis*, vol. 11 (1982) pp. 28–41; Barry J. Ancelet, 'Elements of Folklore, History and Literature in Longfellow's Evangeline', *Louisiana Review*, vol. 11 (1982) pp. 118–26; Felix Voorhies, *Acadian Reminiscences: With The True Story of Evangeline* (Opelousas, LA: Jacob News Depot Co., 1907).

13. James Thomas Vocelle, *The Triumph of the Acadians: A True Story of Evangeline's People* (Vero Beach, FL: n.p., 1930) pp. 38, 53.

14. *Evangeline Country* (New Orleans: Southern Pacific Lines, 1929) p. 3; Brasseaux, *Evangeline*, p. 31.

15. Floyd Martin Clay, *Coozan Dudley LeBlanc: From Huey Long to Hadacol* (Gretna, LA; Pelican Publishing Co., 1973) pp. 218–20, 239; Antoine Bernard, *La renaissance acadienne au XXe siècle* (Quebec: Le Comité de la Survivance Française, Université Laval, n.d.) pp. 69–78, 108; Maurice LeBlanc, 'Un grand patriot: Francois G. T. Comeau (1859–1945)', *Revue de l'Université Sainte-Anne* 1986, pp. 34–40; Clement Cormier, 'Tournée triomphale en Louisiane: octobre 1946', *Les Cahiers de la Société Historique Acadienne*, vol. 17 (octobre–décembre 1986) pp. 133–143. Correspondence between LeBlanc and Comeau 1930–39 is in the Centre d'études acadiennes, Université de Moncton.

16. Dudley J. LeBlanc, *The True Story of the Acadians* (Lafayette, LA: n.p., 1927) pp. 231, 225.

17. Clay, *Coozan Dudley*, pp. 94, 131.

18. *Our Acadian Heritage, Let's Keep It!* (Baton Rouge: Louisiana State Department of Commerce and Industry, 1955), n.p. Thomas Arceneaux's correspondence files relating to the Bicentennial are in the Louisiana Room, Dupré Library, University of Southwestern Louisiana, Lafayette.

19. *Acadian Bi-centennial Cook Book* (Jennings, LA: Acadian Handicraft Museum, 1955); *Costumes of Acadia* (Baton Rouge: Louisiana State Department of Commerce and Industry, 1955).

20. *L'Amour de Maman: La tradition acadienne de tissage en Louisiane* (La Rochelle: Musée de Noveau Monde, 1983); William Faulkner Rushton, *The Cajuns: from Acadia to Louisiana* (New York: Farrar Straus Giroux, 1979) pp. 193–204.

21. Perry Biddiscombe, '"Le Tricolore et l'étoile": The Origin of the Acadian National Flag, 1867–1912', *Acadiensis*, vol. 20 (Autumn 1990) pp. 136, 120–48; 'Le drapeau des acadiens de la Louisiane', *Les Cahiers de la Société Historique Acadienne*, vol. 4 (1973) p. 13; 'The Louisiana Acadian Flag', *Acadiana Profile*, vol. 13 (1988) p. 6.

22. *Lyric Louisiana: A Collection of Poems Honoring the Acadian Bicentennial Celebration of 1955*. By members of the Louisiana Poetry Society, (n.p.: 1955) p. 55.

23. Jacques Henry, 'Le mouvement louisianais de renouveau francophone: vers une nouvelle identité cajine?' (thèse de 3ième cycle, Université Paris V Réné Déscartes, 1981–82); James H. Dormon, 'Louisiana's Cajuns: A Case Study in Ethnic Group Revitalization', *Social Science Quarterly*, vol. 65 (1984) pp. 1043–57; John Smith-Thibodeaux, *Les francophones de Louisiane* (Paris: Editions Entente, 1977) pp. 68–117; Jean Charpantier, 'La Louisiane controversée: subsidence créole, efflorescence zydeco, mouvement francais, Cajun Power', *Etudes créoles*, vol. 9 (1986) pp. 121–40.

24. Philip F. Dur, 'James Domengeaux: Congressman, lawyer, and leader of a cultural revolution', *Acadiana Profile*, vol. 13 (1988) pp. 28–37.

25. Michael Novak, *The Rise of the Unmeltable Ethnics* (New York: Macmillan, 1971).

26. Léon Thériault, 'L'Acadie de 1763 à 1990, synthèse historique', in Jean Daigle, ed., *L'Acadie des Maritimes: études thématiques des débuts à nos jours* (Moncton: Chaire d'études acadiennes, Université de Moncton, 1993) pp. 45–91; Della

Stanley, 'The 1960s: Illusions and Realities of Progress', and John G. Reid, 'The 1970s: Sharpening the Sceptical Edge', in E. R. Forbes and D. A. Muise, eds, *The Atlantic Provinces in Confederation* (Toronto: University of Toronto Press, 1993) pp. 420–59.

27. Andrien Bérubé, 'De l'Acadie historique à la Nouvelle-Acadie: les grandes perceptions contemporaines de l'Acadie', in Jacques Lapointe and André Leclerc, eds, *Les Acadiens: état de la recherche* (Quebec: Conseil de la vie francaise en Amérique, 1987) pp. 198–228; Catriona Dinwoodie, 'Where Is Acadia?', *British Journal of Canadian Studies*, vol. 1 (June 1986) pp. 13–30; Marguerite Maillet, 'La littérature acadienne: en remontant le pays', *Zeitschrift der Gesellschaft für Kanada-Studien*, vol. 9 (1989) pp. 51–60; André Maindron, 'Appréhensions acadiennes', *Etudes Canadiennes/Canadian Studies*, no. 33 (1992) pp. 276–87.

28. Barry J. Ancelet, ed., *Cris sur le bayou: naissance d'une poésie acadienne en Louisiane* (Montreal: Editions Intermède, 1980); David Barry, 'A French Literary Renaissance in Louisiana: Cultural Reflections', *Journal of Popular Culture*, vol. 23 (Summer 1989) pp. 47–63.

29. Dormon, 'Louisiana's Cajuns', p. 1052.

30. Barry Jean Ancelet, *The Makers of Cajun Music/Musiciens cadiens et créoles* (Austin: University of Texas Press, 1984) pp. 98, 94–5.

31. Ancelet, *Makers of Cajun Music*, pp. 143, 149.

32. Barry Jean Ancelet, *'Capitaine, voyage ton flag': The Traditional Cajun Country Mardi Gras* (Lafayette: Center for Louisiana Studies, 1989); Ancelet, *Cajun Country*, pp. 84–94.

33. 'Eunice après le show', *La Gazette de Louisiane*, vol. 2 (novembre 1991) pp. 7, 10.

34. Bona Arsenault, *Histoire et généalogie des Acadiens*, 2nd edn (Quebec: Conseil de la vie francais en Amérique, 1978, 6 vols).

35. Glenn R. Conrad, 'How Acadian Is Acadiana?', *Attakapas Gazette*, vol. 21 (Winter 1986) pp. 148–67; Michael James Foret, 'Acadian Versus Cajun: What's In a Name?: An Essay Review', *Louisiana History*, vol. 33 (Fall 1992) pp. 417–21.

36. Warren A. Perrin versus Great Britain, et al., Caen, France, *International Defense of Human Rights*, (n.p., 1992) p. 8; Perrin, 'L'Exil des Acadiens', in *La defense des droits de l'homme: 4e Concours International de Plaidoiries*, 2 avril 1993, (Caen: Le Barreau et le Mémorial, 1993) pp. 119–40.

37. Robert Lewis, 'Les médias francophones de Louisiane', in Claude-Jean Bertrand and Francis Bordat, eds, *Les médias français aux états-unis* (Nancy: Presses Universitaires de Nancy, 1994) pp. 231–59.

38. *Louisiana Tour Guide*, (Baton Rouge: Louisiana Office of Tourism and Louisiana Travel Promotion Association, 1994) p. 110.

39. Marjorie R. Esman, 'Festivals, Change and Unity: The Celebration of Ethnic Identity among Louisiana Cajuns', *Anthropological Quarterly*, vol. 55 (1982) pp. 199–210; Esman, 'Tourism as Ethnic Preservation: The Cajuns of Louisiana', *Annals of Tourism Research*, vol. 11 (1984) pp. 451–67; 'La Louisiane se vend bien', *La Gazette de Louisiane*, vol. 1 (mai 1991) p. 5.

40. Cécyle Trépanier, 'The Cajunization of French Louisiana: Forging a Regional Identity', *The Geographical Journal*, vol. 157 (July 1991) pp. 167, 169–71. The outstanding book will be Carl A. Brasseaux, Keith P. Foutenot and Claude F. Ombre, *Creoles of Color of the Bayou Country* (Jackson, MS: University Press of Mississippi, 1995).

41. Virginia R. Dominguez, *White by Definition: Social Classification in Creole Louisiana* (New Brunswick, NJ: Rutgers University Press, 1986) pp. 133–48; Arnold R. Hirsch and Joseph Logsdon, eds, *Creole New Orleans*, (Baton Rouge: Louisiana State University Press, 1992).

42. Nicholas Spitzer, 'Cajuns and Creoles: The French Gulf Coast', *Southern Exposure*, vol.5 (1977) pp. 146–9; Alan Lomax (dir.), *Cajun Country: Lâche pas la patate (Don't Drop The Potato)* (Alexandra, VA: PBS, American Patchwork Series, 1991).

43. Robert Sacré, *Musique cajun et musiques noires en Louisiane francophone* (Liege: Editions Créatal, 1990); Ann Allen Savoy, ed., *Cajun Music: Reflection of a People*, vol. 1 (Eunice, LA: Bluebird Press, 1984) pp. 379, 381, 304–6.

44. Savoy, *Cajun Music*, pp. 66–7, and on separate and mixed musical traditions, pp. 327–31.

45. Barry Jean Ancelet, ed., *Cajun and Creole Folktales: The French Oral Tradition of South Louisiana* (New York: Garland, 1994).

46. Becky Brown, 'Une remise en cause de la situation linguistique de la Louisiane francaise', *Francophonies d'Amérique*, no. 3 (1993) pp. 171–9; Stephanie Thibodeaux, 'CODOFIL and a Culture at Risk', *La Gazette de Louisiane*, vol. 4 (aôut–septembre 1993) pp. 12–13; Robert E. Maguire, *Hustling To Survive Social and Economic Change in a South Louisiana Black Creole Community* (Montreal: Project Louisiane, no. 2, March/mars 1989) pp. 383–415.

47. Gutierrez, *Cajun Foodways*, pp. 19–20. See also Gerald L. Gold, 'Language and Ethnic Identity in South Louisiana: Implications of Data from Mamou Prairie', in Raymond Breton and Pierre Savard, eds, *The Quebec and Acadian Diaspora in North America* (Toronto: Multicultural History of Ontario, 1982) pp. 53–5; Eric Waddell, 'French America: American Outpost of L'Amérique Française or Another Country and Another Culture?', in Dean R. Louder and Eric Waddell, eds, *French America: Mobilization, Identity and Minority Experience across the Continent* (Baton Rouge: Louisiana State University Press, 1993) pp. 249–50.

48. Cécyle Trépanier, *French Louisiana at the Threshold of the 21st Century* (Montreal: Projet Louisiane monographie no. 3, mai 1989) p. 307. See also Marjorie R. Esman, *Henderson, Louisiana: Cultural Adaptation in a Cajun Community* (New York: Holt, Rinehart and Winston, 1985) pp. 9–10, 128.

49. Gutierrez, *Cajun Foodways*, pp. 133–4.

50. *La Gazette de Louisiane*, vol. 1 (février 1991) p. 2.

51. Gutierrez, *Cajun Foodways*, pp. 22–4.

52. Revon Reed, *Lache pas la patate: portrait des Acadiens de la Louisiane* (Montreal, 1976) p. 21.

5

Living Southern in
Southern Living
Diane Roberts

The cover photo for the first issue of *Southern Living Magazine*, published in February 1966, shows a red brick ranch house set in a green yard shady with pine trees. There are curvy flower beds full of pink and white azaleas, a spaniel playing on the grass, a big, new, pale Lincoln Continental in the double garage.

That picture looks like my life: our house was a brick one-storey my parents built in 1957, with gardens of azaleas, pines and dogwoods laid out by my mother. The Continental isn't right – we were Chevrolet people. But everything else, the air of affluence, modernity and ease, looks like home. My family were *Southern Living*'s original target audience: young, white, professional, the first generation off the farm translated to the suburbs, inheriting some silver but buying more, wanting to travel but not too far, university-educated but not intellectual, equally fascinated with new restaurants in Atlanta and new recipes for pickled peaches.

My mother read – still reads – *Southern Living* from cover to cover. When it said prune the roses, we pruned; when it gave a recipe for Lane cake, we made it; when it listed the top ten college football teams in the South, we believed it; when it suggested that a carport could be turned into a beautiful glass Florida room, we eyed that end of the house thought-fully. Every Christmas I puncture the skin on my fingers sticking lemons and kumquats onto a styrofoam cone with toothpicks, making a citrus centrepiece. An old family tradition. Or is it? No one in my house can swear that the idea didn't really come from a picture in *Southern Living* of some Low Country plantation decorated for Twelfth Night. *Southern Living* is in the business of transmitting traditions, teaching old-time gracious living; it is the lifestyle Bible of the genuine and the aspiring upper-middle classes. Throughout the 1960s and 1970s, it never mentioned the Civil Rights movement, or Martin Luther King, or share-

cropping, or even Elvis. It depicted a relentlessly prosperous world of Derby Day brunches, cakes requiring twelve eggs, golf courses, and made-over gardens, as if to insist that the Freedom Summer, the protests against the Vietnam war on (even southern) college campuses, the church bombings and police brutality orchestrated by Birmingham Police Commissioner 'Bull' Connor in the very city where *Southern Living* was born never happened. Like one of those exclusive streets with its own gates, walls and surveillance cameras guarding the big houses, the magazine acts as a refuge from the unlovely realities of the region it sets out to define and ameliorate.

INVENTING THE SOUTHERN MIDDLE CLASS

Southern Living grew like a lily out of the decidedly rural soil of *Progressive Farmer*, a venerable magazine founded in 1886 by an ex-Confederate officer and agrarian reformer called Leonidas Polk.[1] *Progressive Farmer* had long run a home column, aimed mainly at women, called first 'The Progressive Home', then 'Southern Living'. In February 1966, the column became a whole magazine, aimed at the new urbanising, suburbanising southern bourgeoisie which, like the American middle class as a whole, had been rapidly expanding since the Second World War.[2] By 1977, *Forbes*, the financial glossy, was calling *Southern Living* the most profitable magazine in the US. In 1985, Southern Progress Corporation, responsible for *Southern Living*, *Progressive Farmer*, *Creative Ideas for Living* and Oxmoor House, the division producing the annual recipe books, speciality recipe books and heritage collections, was bought by Time Inc. for $480 million. Southern Progress of Birmingham, Alabama had become a cash cow for the media leviathan of corporate Yankeedom.

The 1966 inaugural issue featured articles on the Azalea Trail, the carving of the Confederate Monument at Stone Mountain, Georgia, and the village of Rugby, Tennessee where Thomas Hughes (author of *Tom Brown's Schooldays*) founded a Utopian community in the nineteenth century. There were also pieces on air conditioning, hair-frosting, growing shade trees, a recipe for chicken 'a la vallée d'auge', pictured on a silver tray and surrounded with red roses, and a recipe for cornbread. One of the most prominent advertisements displayed books you could order through the magazine: the Bible, *The Garden Book for the South*, *True Tales of the South at War*, *The Wonder Book of Bible Stories*, *Pilgrim's Progress* and *The Southern Living Cake Book*. A subscription cost $2 a year unless you lived outside the South – then it cost $3 a year. The practice of charging more for extra-southern subscriptions was discontinued in 1994.[3]

By the second issue in March 1966, *Southern Living* was calling itself 'the Magazine of the Modern South' and was paying its readers $3 for 'prize recipes'. The magazine printed its first picture of an African-American, a 'menu boy' of ten or eleven, in a feature on a Smyrna, Georgia restaurant called Aunt Fanny's Cabin. The restaurant purported to be a much enlarged, 'genuine' slave cabin serving genuine old southern food. The menu boys wore chalk sandwich boards and recited the menu. The story says: 'As you eat happily, several Negro boys put on a singing, dancing show of century-old songs.' This issue also had pieces on turkey hunting, Teflon and Mrs John Connolly's 1-2-3-4 pound cake recipe.

By 1968, the masthead boasted over 500,000 subscribers. Now the number is something like 2.4 million subscribers, over 80 per cent of them in the South. *Southern Living* readers have higher educations and incomes than national or regional averages. Currently, 86 per cent are married couples with a median income of over $49,000 a year; 87 per cent own their own houses with a median value of $90,000; more than 80 per cent have gardens.[4]

Put another way, *Southern Living* is the magazine of the predominantly white, property-owning elite of what was once the New South, then the Modern South and now the Sunbelt. Its readers see themselves reflected in luscious photos of tasteful homes (never 'houses'), upbeat features on southern cities, helpful travel stories, even the section on 'Cooking Light', which shows how to make standards like fried chicken and sweet potato pie without the lard and salt and sugar southerners used to think they could not live without (reflecting the national war on fat and sodium). And if some readers are not precisely mirrored in *Southern Living*'s pages, they see what they aspire to be. The magazine teaches those who aren't from the region, or aren't quite as polished as their neighbours, how to be an upper-middle-class Southerner. Ever so subtly, *Southern Living* operates as a conduct manual.

The magazine is also good public relations for the region. In the words of one commentator, *Southern Living* shows 'a South without memory of pellagra or racial unrest, a South where none of the parents are divorced, where burglary and street crime are unknown, where few have Hatteras yachts but one and all play golf and tennis at the club – and in the right outfits'.[5]

In 1985, after the sale to Time Inc., Southern Progress president Emory Cunningham declared his company's mission 'is to give people in the South a sense of pride in being Southern'.[6] Cunningham affirms *Southern Living*'s twenty-year policy as laid out by its first president and editor-in-chief, Eugene Butler, in the inaugural issue: regional piety will be expressed in features on home improvement, food and travel. *Southern*

Living will lead the way in steering southern cities away from the noise, crime, pollution and overcrowding which 'blight' Northern cities.[7] The magazine will also 'promote better understanding between urban and rural people. Both have made an immense contribution to the building of this great nation but they are often at odds through lack of understanding.' Butler quotes Psalm 133, 'Behold how good and pleasant it is when brothers dwell in unity', going on to say: 'City and rural dwellers are indeed brothers. But there is an urgent need for these brothers to understand each other's problems.'

This is coded language. Take, for example, the 'blight' in Northern cities. What could that mean to a middle-class white Southerner (*Southern Living*'s core audience) in 1966? Or to a Dixie-cheerleading editor in Birmingham, Alabama, a coal and pig-iron producing town only founded in 1871? By most definitions, Birmingham in the mid-1960s could itself be called 'blighted'; blighted by coal-dust, blighted by the spectre of 'Bull' Connor and his cudgel and firehose-wielding thugs, blighted by such race hatred and such rigid segregation laws that it was often called 'the Johannesburg of America'. Just a few years before *Southern Living* was founded, Birmingham was commonly described as 'economically depressed and racially polarized'.[8] Perhaps the 'blight' Butler refers to really has more to do with what Northern cities were most famous for in the mid-1960s: race riots. Certainly, many industrial Northern (and some Midwestern and Western) cities *were* more congested, dirtier, more crime-ridden than Atlanta or Charleston or Memphis. But surely the 1964 riot in Harlem and the 1965 Watts riot in Los Angeles loomed large in Butler's idea of blight. As Joel Williamson says:

> [T]he racism and its physical results that white America had, heretofore, preferred to see and attack in the South was not merely Southern. Indeed, perhaps in its most awful modern manifestations it was Northern and Western as evidenced in the inner cities where black ghettoes were deteriorating materially, socially and morally, with devastating effects upon the lives of millions of individuals.[9]

It is significant that *Southern Living* comes not out of one of the old Confederate capitols – Montgomery or Richmond – but out of a New South construct, the relatively recent Birmingham. Northern money and northern companies like US Steel made post-war Birmingham affluent but did not divorce it from the social practice of segregation. The city fed the coffers of American industry with low-wage, non-union workers. Howell Raines has said that Birmingham was an economic colony of Pittsburgh; Virginia Foster Durr, brought up on Red Mountain within sight of the mines and their 'poor white trash' villages, concurs: 'when

I lived in Birmingham, it was a company town, just completely owned by Northern corporations'.[10] Birmingham 'was a blue-collar city with a history of violence'.[11]

Yet it is Birmingham which produced the Southern Progress Corporation and its greatest success, *Southern Living*. Unlike Montgomery or Richmond, Birmingham never had a Confederate myth, never had white-columned houses for Yankees to burn down. On the margins of a tradition, Birmingham needed to etch an identity for itself, defining itself as 'southern', despite (or because of) the way so much of it was owned by northern absentee landlords. So it is strangely appropriate that the magazine which endorses some and subverts others of the class, race and gender values of the 'ancien regime' should come from a place with only a tenuous hold on the white world of the Old South.

Given the recent history of Birmingham (as well as other southern cities), it might seem bizarre to imply that the late twentieth-century South is still Eden before the (Yankee) fall. Yet *Southern Living* thrives on denial. With the echo of the 16th Street Baptist Church bombing of September 1963, in which four young black girls died, still ringing in their ears, middle-class whites wanted their new cities and their new suburbs to be a haven from the world turning upside down around them. Enforced integration, changing gender roles, 'outside' agitators (popularly imagined to come from northern cities) were other manifestations of 'blight' the white middle-class sought to avoid in their pleasant, segregated subdivisions.

The other great theme in Butler's inaugural column is the healing of a rift he sees between the urban and the rural. Yet most southerners (especially the new residents of the suburbs) had either actual roots on the farm or a romantic-nostalgic connection to it. Maybe Butler really means the lack of understanding between the virtuous, agrarian, genteel South and the North represented by a white, defensive South as rude, rich, radical and unanchored to stabilising traditions. Butler's 'brother-hood' rhetoric recalls the Lost Cause literature that flourished in the South between 1880 and 1914. From Frances Butler Leigh's *Ten Years on a Georgia Plantation Since the War* (1883) to Thomas Nelson Page's *Meh Lady* (in which a young Virginia lady marries a Yankee captain and brings him around to the southern way of thinking), white southern writers embraced the image of estranged siblings brought together again. Leigh's memoir opens with a poem called *Brothers Again* which endorses union – on southern terms. In Thomas Dixon Jr's famous Ku Klux Klan trilogy, Abraham Lincoln reveals himself actually to be a Southerner – and a racist. The most rabid Reconstructionists convert to (segregationist) white southern politics and the nation is saved from chaos by the bravery of southern gentlemen.[12] Lost Cause southerners

preached largely to the choir, but insistence on a South revealed as the 'better' part of a strong Union (better on class, on race, on religion, on politics, on gender roles) lingers in the region today. As Eric Sundquist points out, the cadet South 'performs' its 'often disingenuous display of racial harmony and black progress, or its calculated explanations for the lack of either – before a northern "audience", whether in the press, in Congress, in business and industry or in literature'.[13] Early *Southern Living* is part of that performance; its pacific articles on dogwood trees, football, and plantation houses defied anyone to be ill-mannered enough to mention that the Freedom Riders were shot at as they rode buses through Mississippi and Alabama, or that water fountains still had signs reading 'white' and 'colored'.

BUILDING ARCADIA

Southern Living is still part of the South's 'performance', representing itself as special, chosen, a favoured region congratulating itself on not having the problems associated with the rest of the country. But then the South has always been an invented land, built out of scraps of Utopian longings and gothic anxieties. Sixteenth- and seventeenth-century European colonisers describe Virginia and the Carolinas as Edenic, a garden, a virgin land 'making sensible proffer of hidden treasure', as Robert Johnson wrote in the 'Nova Britannia' of 1609.[14] Putting a good spin on the South in early travel accounts was, among other things, a cunning strategy to lure the settlers needed to consolidate British power in the colonised lands Europeans insisted on calling the New World.

By the middle of the nineteenth century, the white elite of the South were still trying to show their 'country' in the best light, countering abolitionist attacks on slavery and insinuations of decadence and indolence. After *Uncle Tom's Cabin* (1852) charged slaveholders with moral cowardice and spiritual sloth, 'exposing' plantations as brothels and torture chambers, pro-slavery Southerners began to write in ever greater numbers, producing counter-fictions. The South was not hell but Eden; in J. Thornton Randolph's *The Cabin and the Parlor* (1852), Isabel Courtenay is forced by money-grubbing Yankees to leave her plantation: 'yet as the mansions disappeared behind them in the shadows of night, she felt like Eve when our first mother left Paradise forever'.[15] Southern hospitality was lavishly displayed to prove that the South was the best of all civilisations. As the heroine of Caroline Gilman's *Recollections of a Southern Matron* (1838) says, 'I was early taught to lay fresh roses on the pillows of strangers.'[16] The plantation masters' gracious living was a sign that the South's 'peculiar institution' was virtuous, indeed divinely

sanctioned. Nineteenth-century southern magazines also pushed a rosy vision of the South, from the defensive reviews and essays in *The Southern Literary Messenger* (edited for a while by Edgar Allan Poe) and *The Southern Review* to the genteel apologetics in ladies' periodicals like *The Magnolia* and *The Southern Rose*.[17] While they reflected much about the lives of the southern white elite, they were more prescriptive than descriptive.

While specifically southern periodicals became rare on the national scene after the Civil War, the white South was still engaged in presenting itself positively to the rest of the country. The 1895 Atlanta Cotton States Exhibition with its 'tableaux' of happy plantation life, and the monument-building projects of the United Daughters of the Confederacy in the first half of the twentieth century, form part of the white South's 'performance'. *Southern Living* operates out of this tradition. While it is a 'lifestyle' magazine, a form unknown in the nineteenth century, *Southern Living*'s mission is to present a view of the South as a (beautifully maintained) garden punctuated here and there by (beautifully maintained) houses, lovingly restored old ones or charming new ones (built from *Southern Living* designs), and lived in by people who entertain, travel and represent themselves as polite, cultured and urbane, never losing the sense of distinctiveness on which the southern soul thrives.

No doubt *Southern Living*'s editors would insist on the magazine's apolitical nature throughout its twenty-eight year history. Indeed, Clay Nordan, the current managing editor, says 'we leave to others' difficult, divisive or political issues. He describes *Southern Living* as 'service journalism', filling a particular 'carefully conceived' niche.[18] One commentator has written that *Southern Living* is 'relentlessly domestic and relentlessly optimistic … [tending] to exclude controversial issues and especially issues of public policy'.[19] Still, ignoring the cataclysmic events of the Civil Rights movement (among other things) is itself political. Of course, it's true that *Southern Living*'s central focus is the domestic sphere, not the wider world of social issues. *Better Homes and Gardens* and *Vogue* didn't exactly jump into the middle of the Civil Rights movement, either. But *Better Homes and Gardens* and *Vogue* do not identify themselves so completely and overtly with a region and that region's mythology. It seems a strange, even perverse strategy for a southern magazine in the 1960s and 1970s to turn a blind eye to the states of siege that existed in many southern communities. But perhaps the insistence on a bourgeois Eden is itself a southern characteristic. Bertram Wyatt-Brown says the culture allowed for 'the coexistence of southern hospitality and "unspeakable violence" in the same cultural matrix, without paradox, without any sense of contradiction'.[20]

The triumph of the 'New South', the 'Sunbelt', the 'Growth Belt', or whatever the current rejuvenative appellation, is that so many more people have a chance to participate in the middle-class world of *Southern Living*. As subscription sales go up, the educative process spreads: more readers are converted to southern boosterism. The South is presented simultaneously as actual and ideal in the sunny photos, sumptuous food spreads, and gracious homes in the photographs: very like the South that tried to present itself to the richer, more powerful, industrialised North both before and after the Civil War. Book-bannings in Texas, cross-burnings in Georgia, toxic waste-dumpings in Alabama, shootings of abortion doctors in Florida, all happen in the peripheral vision of the region, but fried chicken, pink dogwoods, Christmas menus, a new sun-porch remain, according to *Southern Living*, the cherished centre of southern domestic life.

SOUTHERNISING THE NATION

Southern Living is a class manual with a certain democratic subtlety. Its first principle is to mark the South as different – not difficult since the South colludes in its construction as alien, the Kingdom of the Weird, 'Uncle Sam's other province', Allen Tate said. As Florence King declared, not without pride, 'build a fence around the South and you'd have one big madhouse'.[21] The region's elite read southern peculiarity the way the English read eccentricity: that is, as something rather aristocratic. Not that most Southerners – or *Southern Living* – would use such a term. The play of class in the South is many-layered and disguised in the egalitarian rhetoric of 'coming up from nothing'. Nonetheless, *Southern Living*'s years of features on Derby Day parties hosted by Louisville society ladies in pearls, photos of Virginia hunt breakfasts, sideboards shuddering under the weight of Georgian silver, the yearly football stories showing a different set of white folks tailgating out of a new model station wagon (recipes included), the wedding cake directions (a recent feature was titled 'Tiers of Joy'), the how-to on freezing pink carnations in Dixie cups to make pretty ice cubes or confecting your own crystallised rose petals, speak to a world that insists on its graciousness and its privilege without reference to overwhelming wealth. When asked who the quintessential *Southern Living* reader is, an editor replied breezily 'a doctor's wife'.[22] In other words, an upper-middle-class woman who could afford a caterer but who likes to make things herself.

Really rich folks have their own periodicals: *Veranda* magazine and *Southern Accents* magazine (like *Southern Living*, published by Southern Progress) seem aimed more at the *Architectural Digest* audience who want

to see the most expensive, most 'designed', interiors in houses owned by, if not celebrities exactly, extremely well-off 'community leaders'.[23] *Southern Accents* and *Veranda*, out of Atlanta, do not focus on 'how-to' pieces: their readers hire somebody to put in the cedar closet or the new paving stones. These magazines prefer pieces on sensitive restorations of plantation houses, profiles of architects and interior decorators, lavish garden spreads. In the Summer 1994 issue *Veranda* ran a feature on top bracket fabric designers Brunschwig & Fils, the renovation of a house in Fort Worth owned by 'corporate executive and civic leader Carroll Collins', and a Fourth of July lunch in North Carolina with a menu including caviar mousse, poached salmon, stuffed tomatoes pesto and Grand Marnier strawberry shortcake. Nothing is made with canned soup (a common ingredient in *Southern Living* reader recipes). Advertising in the first twenty or so pages of *Veranda* reaches for the seriously affluent: there are advertisements for fabric designers (Rose Cumming), sound systems (Bose), Baccarat crystal chandeliers at Maurice Chandelier in Atlanta, Flora Danica porcelain, Lord and Lockwood handwrought iron furniture from Birmingham, and many advertisements for portrait artists all over the South.

I count eighteen advertisements, none smaller than a quarter page, for portraitists alone in *Veranda*'s Summer 1994 issue (not including people who will paint a picture of your house or your dog, or who call themselves 'American Impressionists' and do soft-focus *faux*-Renoirs of gardens). The portraits are all very similar, all of women or children or women *and* children (in my informal survey, I didn't see a single one of an adult man). They show off the women's jewellery (big diamond rings, opera-length pearls) or the children's large eyes. The women and children (especially girls) are often in semi-Victorian dress. One full-page advertisement, for portraitist William Carl Groh, III of Lafayette, Louisiana, features 'The Children of Mr and Mrs Vincent Joseph Saitta': two daughters in white sitting on a chintz sofa (in a cabbage rose patten) and the son standing behind the sofa. The portrait loudly recalls the work of John Singer Sargent, the Anglo-American painter who so flattered the upper classes (and the aspiring *nouveaux riches*) of the late Victorian and Edwardian periods. The elder Saitta daughter wears a huge white bow on the back of her head and all three children appear to be wearing gauzy silk – a Sargent trick reminiscent of 'Mrs Fiske Warren and Her Daughter Rachel' or 'The Wyndham Sisters'. Indeed, Sargent's portraits and the work of the artists who advertise in *Veranda* and *Southern Accents* perform the same sort of status work; for those who did not inherit Gainsboroughs, Lawrences or Sullys of their ancestors, flattering portraits in a throwback style (even in throwback costume) can furnish a sense of aristocracy. You can buy a plantation house: you

can buy the trappings of lineage to go with it. The silky wives and children are themselves trophies of affluent (invisible) husbands and fathers, just as the portraits are trophies of the family, transmitters of class.

Southern Living runs occasional advertisements for portrait painting but far fewer and more subdued than in the heavy-stock pages of *Veranda* and *Southern Accents*. Yet *Southern Living* broadcasts its own class codes and does ideological work reflecting and producing the southern upper-middle class through its advertisements. Home decor advertising (for an approximately 30 per cent lower income bracket than *Veranda* or *Southern Accents*) takes up a substantial portion of the magazine, selling wall to wall carpet, *Gone With the Wind* commemorative plates, Henredon and Thomasville furniture, Waterford crystal, and garden products. There is also a substantial amount of travel advertising, mainly for southern states but also for Mexico, Europe and the Caribbean. *Southern Living* has its own travel service with a toll-free number for readers to call. But perhaps the most interesting advertisements are those for china and silver. There are services that will trace your discontinued china pattern and warehouses full of old place settings that put out catalogues. There are agencies to track down your silver or outlet services that will sell you whole place settings of Francis I or Chantilly or Old Master – or just an oyster fork, in case you didn't get enough for wedding presents.

Silver occupies an obsessive place in the southern white, middle-class mind. Though most southern whites before the Civil War could not read, did not own plantations, did not own slaves, and did not own sets of Georgian teaspoons, stories about losing the silver to the Yankees or hiding the silver from them abound. In Faulkner's *The Unvanquished* (1938), the reader is asked first to be horrified over the slave Loosh's scheme to steal the Sartoris silver, then to feel glad that his plan is foiled, despite the fact that the silver was bought with the labour of slaves like himself. In a later *Unvanquished* story, the matriarch of the plantation family, Granny Millard, demonstrates her bravery by facing down an entire Union troop who dared raid her home, and shouting 'I want my silver!'[24]

Southern whites still want their silver: it is another class badge. Though there is some residual snobbery about 'bought silver' (as opposed to inherited), southern brides still faithfully register their patterns at local jewellery and department stores. Love of silver has become both a truism and a cliché of southern life; as Marlyn Schwartz says in *A Southern Belle Primer*: 'if you don't inherit your pattern at birth, you go down to the department store and pick it out, sometimes as early as age nine or ten. This is sort of like a First Communion for southern belles'.[25] *Southern Living* both feeds and illustrates this in its silver adver-

tisements *and* its features on entertaining with their lush photos of beau-tifully-set tables. Stories show not only what sort of menu is proper for a luncheon, a buffet supper, or a tea, but which fork goes where. It doesn't matter if you are self-made: you can order your silver out of *Southern Living*, then study the magazine to learn how to use it.

Southern Living creates a complete environment from the micro- to the macrocosm, from the silver and the flowers to the rooms in which they are displayed. There is now a toll-free number for house plans and a computer-visualisation service for landscaping. The house plans, like the houses shown in *Southern Living*, tend to be traditional, often based on patterns like Louisiana-raised cottages or Williamsburg brick in a style that has been described by a *Southern Living* editor as 'Junior League Georgian'.[26] The houses – 'homes' – in the magazine reinforce the image of a shared set of community values declaring themselves specifically southern.

Perhaps the most important aspect of *Southern Living* is also the most obvious: its insistence on its Southernness. The magazine defines and reinforces cultural identification with its version of the South by reminding readers of regional obsessions such as college football (there's an annual poll), gardening, family recipes, entertaining, sports such as hunting and fishing, weddings, home improvement and travel. However, while what is present in *Southern Living* is illuminating, what is not present is also instructive. Class is coded and subtly signalled in the magazine, but race is even more disguised. There are very few blacks (not counting football players) anywhere in the features on southern cities, barbecues and choosing good plants for shady ground. There are very few profiles of black community leaders. Managing editor Clay Nordan says that *Southern Living* employs 'some' black writers, editors and photographers but declines to define 'some'.

While it is true that blacks are no longer shown as predominantly waiters and maids, and it is also true that, as Sam Riley points out, *Southern Living* is more interested in places and things than people, blacks are still invisible men (and women), even in the New South they helped build. Every once in a while there are exceptions. For example, there was an article on Birmingham's new Civil Rights Institute and Museum. And in the March 1994 issue, a piece called 'All Hands in the Kitchen' details a gourmet cooking club of black urban professionals in Birmingham. The photo shows attractive young people in a huge designer kitchen.[27] One caption reads: 'Bill Gilchrist and Greer Geiger perfect the technique for "Souffle au chocolat Cointreau". While he was a student at the Massachusetts Institute of Technology, Bill became inspired to cook by none other than Julia Child.'[28] The whole story is

enormously reassuring to the white folks who make up the majority of *Southern Living*'s audience: black people behaving 'just like us'. *Southern Living* admits no sense that race has been the great sorrow and burden of the South. Rather, blacks are invited to enter the comfortable, decorated bourgeois world long denied them. After all, black Southerners and white Southerners are still 'southern', still more alike in their appreciation of boiled peanuts, Southeastern Conference football, and antique quilts than they are different. In this ideal middle-class community, it is region, not race, that is the central marker of difference.

By contrast, there are magazines which, while maintaining a strong sense of their Southernness, respond to *Southern Living* politically. *Southern Exposure*, out of the Institute of Southern Studies in North Carolina, is overtly and proudly leftist. It deals with everything *Southern Living* ignores: poverty (black and white), industry, violence, pollution, elections, sexism, popular culture, media.[29] And the now-extinct *Southern* magazine, begun in 1986 in Little Rock, declared in its first issue, 'Throughout the region folks have wanted a monthly magazine that explores the multidimensional South – the one beyond the well-adorned house and garden – and the South we carry in our head wherever we go.'[30] Like *Southern Living*, *Southern* carried articles on travel and food. It became known for its nostalgia pieces like Harry Crews's paean to the mule and its special White Trash issue which, again like *Southern Living*, reinforced its sense of audience as middle class. In common with *Southern Living* and *Southern Exposure*, *Southern* was much concerned with the question of whether there is such a thing as the South and what it consists of. Because of *Southern*'s upmarket intellectual appeal, it never made a dent in *Southern Living*'s market share or its mission to spread its brand of sweetness and Southernness.

With its book empire, its travelling cooking schools playing in civic centres all over the South, its house plans, its do-it-yourself furniture directions, its travel and gardening services, its circulation bonanzas, *Southern Living* is the most successful and comprehensive arbiter of taste and style for the region it perpetually defines and defends. The world of *Southern Living* is Arcadia for the middle classes, proof in and of itself that the South *is* distinct, *is* special, perhaps even chosen. *Southern Living* rebukes those who would insist that interstate highways, McDonalds, malls and CNN have destroyed any regionality in American life. In the orderly, well-behaved *Southern Living* world, there is a season for everything – parties, plants, sports – and everything is, or can be made, southern. America itself is not too big to be southernised.

NOTES

1. *Progressive Farmer* put out its first issue on 10 February1886 in Raleigh, North Carolina. In 1911 it moved to Birmingham, Alabama, where the Southern Progress Corporation, publishers of *Southern Living* and *Progressive Farmer*, remains.
2. I am not, of course, claiming to present a comprehensive history of *Southern Living* here, or of the rise of the middle class in the South. See Peirce Lewis, 'The Making of Vernacular Taste: The Case of *Sunset* and *Southern Living* in "The Vernacular Garden"', *Dumbarton Oaks Colloquium on the History of Landscape Architecture XIV*, ed. John Dixon Hunt and Joachim Wolschka-Bulmahn, Washington D.C., 1993, pp. 107–18.
3. The South was defined as the eleven states of the Old Confederacy plus West Virginia, Maryland, Missouri, Oklahoma, Kentucky and, weirdly, Delaware.
4. The most recent numbers come from Alan Vaughan of the *Southern Living* circulation department in an interview on 1 December 1994. See also 'Affluent Southern Living' by Judith Waldrop in *American Demographics*, October 1986, p. 60.
5. Sam G. Riley, *Magazines of the American South* (New York: Greenwood, 1986) p. 240.
6. Richard Zoglin, 'New Additions, Southern Style', *Time*, 4 March 1982, p. 72.
7. *Southern Living*, February 1966, p. 4.
8. William A. Nunnelley, *Bull Connor* (Tuscaloosa: University of Alabama Press, 1991) p. 5.
9. Joel Williamson, *The Crucible of Race* (Oxford University Press, 1984) p. 507.
10. Virginia Foster Durr, *Outside the Magic Circle*, ed. Hollinger Barnard (New York: Simon and Schuster, 1985) p. 33.
11. Nunnelley, *Bull Connor*, p. 3.
12. See Dixon's novels *The Leopard's Spots* (1902), *The Clansman* (1905) and *The Traitor* (1912). For discussions of Lost Cause rhetoric, see Williamson, *The Crucible of Race*.
13. Eric Sundquist, *To Wake the Nations: Race in the Making of American Literature* (Cambridge, MA: Harvard University Press, 1993) p. 273.
14. See Annette Kolodny, *The Lay of the Land* (Chapel Hill: University of North Carolina Press, 1975), especially ch. 2; and Louis Montrose, 'The Work of Gender in the Discourse of Discovery' in *Representations*, 33, Winter 1991, pp. 1–41.
15. J. Thornton Randolph, *The Cabin and the Parlor* (Philadelphia: Lippincott, 1852) p. 49.
16. Caroline Gilman, *Recollections of a Southern Matron* (New York: Harper, 1838) p. 23.
17. Novelist Caroline Gilman edited a number of antebellum Southern magazines and gift books for women and children. See Jan Bakker, 'Another Dilemma for the Intellectual in the Old South: Caroline Gilman the Peculiar Institution and Greater Rights for Women in the Rose Magazines' in *Southern Literary Journal*, 17, Fall, 1984, pp. 12–25. Other early Southern magazines include

the *North Carolina Magazine*, 1764–65, and the *South Carolina Weekly Museum*, 1797–98. See Riley, *Magazines of the American South* and Charles Reagan Wilson and William Ferris, *Encyclopedia of Southern Culture* (Chapel Hill: University of North Carolina Press, 1989), Media section.

18. Telephone interview with Clay Nordan, 1 December 1994.
19. Lewis, *Vernacular Taste*, p. 118.
20. Bertram Wyatt-Brown, *Southern Honor: Ethics and Behavior in the Old South* (New York: Oxford University Press, 1982) p. 34.
21. Florence King, *Southern Ladies and Gentlemen* (New York: Bantam, 1975) p. 1.
22. Lewis, *Vernacular Taste*, p. 119.
23. According to Riley in *Magazines of the American South*, the median income of the *Southern Accents* reader is $112,000 and their average house value is $213,000. According to Alan Vaughan of the *Southern Living* circulation department, the circulation of *Southern Accents* is about 275,000.
24. William Faulkner, *The Unvanquished* (London: Penguin, 1955) p. 75.
25. Marlyn Schwartz, *A Southern Belle Primer* (New York: Doubleday, 1991) p. 39.
26. Lewis, *Vernacular Taste*, p. 119.
27. A former garden editor of *Southern Living* (who wished to remain anonymous) told me a story about how when the May 1973 cover showed a bunch of people having a picnic – including, though not prominently displayed, some blacks, 5000 people subsequently called up to cancel their subscriptions. Clay Nordan now says that while *Southern Living*'s audience is 'predominantly white' it is 'becoming more black' as the South – and the magazine – evolve.
28. *Southern Living*, March 1994, p. 124.
29. See also the short-lived *Southern Voices* from the Southern Regional Council in Atlanta.
30. *Southern*, October, 1986, p. 1.

6

The Academic Elvis

Simon Frith

I don't think El will ever rate with the more serious students of popular song – his syrupy crooning with vibrato went out with Rudy Valee.[1]

John Ryan, attempting to do a Presley story after four or five other writers had failed, drafted a request to Colonel Parker, Presley's manager, saying in essence, 'Presley is loved by everyone except the intellectuals. Let me write a piece about him and make the intellectuals love him'. Colonel Parker, aware that there were at most three or four dozen intellectuals on earth, declined the honour.[2]

The academy has never had much interest in Elvis Presley. There are already many more theoretical articles about Madonna than about the King; indeed, there are, by now, more solemn studies of Elvis fans and impersonators than of the man himself.[3] Greil Marcus tells me that there is an Institute of Elvis Presley Studies, in Toronto, but my immediate professional response is that it can't be serious. Bob Dylan Studies, yes; Jimi Hendrix Studies, maybe; but an Elvis Presley Institute seems by definition loopy, the musicological equivalent of Edinburgh's Arthur Koestler Chair in Psychic Studies.

Or take this description (by Timothy D'Arch Smith) of Presley's 1955 recording of 'Mystery Train':

Elisions, grammatical lapses, in the first verse wholesale jettison of words, aggravate perplexity. In the dispensing with definite and indefinite articles, we are reminded of the opening of Henry Green's *Party-Going*, not altogether a pretentious analogy when one considers Green's novel is also about isolation – and trains for the matter of that.[4]

Not altogether a pretentious analogy, but certainly an unexpected one: we are used by now to Bob Dylan or John Lennon or even Jim Morrison being given high cultural credentials-by-association, but *not* Elvis Presley. To put this another way, we wouldn't really expect the academy to have any interest in Presley, anyway: it has, until recently, not been much

99

interested in any aspect of low culture; and, as we'll see, for the new scholars of popular music or cultural studies Elvis spent too much time in the middle-of-the-road. In academic cultural terms, then, Elvis (unlike either Dylan, Lennon and Morrison or Johnny Rotten, Madonna and Ice-T) has no redeeming features whatsoever. Everything he did was trashy and/or politically incorrect and I doubt if he'd even heard of Rimbaud or T. S. Eliot or Charles Ives. If one of the high academic's self-proclaimed tasks is to defend great art from the barbarians, Presley was clearly more barbaric than most.

Gil Rodman notes that in Don DeLillo's novel *White Noise* (1985), Hitler scholar Jack Gladney takes a calculated academic *risk* in associating his work with the Elvis studies of his young colleague, Murray Jay Suskind:

> Murray sat across the room. His eyes showed a deep gratitude. I had been generous with the power and madness at my disposal, allowing my subject to be associated with an infinitely lesser figure, a fellow who sat in La-Z-Boy chairs and shot out TVs. It was not a small matter. We all had an aura to maintain ...[5]

And Henry Pleasants writes that

> A phenomenon common to all the most original and the most influential of the great American popular singers has been the animosity they have aroused. It is not quite the right word. Loathing probably comes closer, or contempt.[6]

There is no doubt (just read Albert Goldman, a professor positively *obsessed* with Presley's barbarism) that in Elvis's case this loathing was heavily underwritten by a class contempt – and Presley was not just working class but, worse, *southern* working class; a class contempt which, among other things, assumed that someone like Elvis was *incapable* of artistry. As Karal Ann Marling has recently documented,

> Of all the ink spilled over Elvis Presley in the 1950s, only one article – by James and Annette Baxter [in *Harpers*] – credited Elvis with ... musical talent and a growing sense of how to manipulate his vocal pyrotechnics 'into an organic whole'.[7]

And Rodman suggests that such a lack of interest in Presley *as a musician* remains characteristic, even of people who now take popular music seriously: professional colleagues approached by *Musician* in 1992 for a story on Presley's studio craft told the magazine 'that no-one had ever asked them about *that* before', and popular music scholars

still tend to dismiss Presley's *musical* contribution to the history of pop, treating him as a naive, a thief, a freak or even, most baldly, as just 'the local thug'.[8]

It is this dismissal which concerns me in this paper. In the last fifteen years, since Presley's death, popular music studies have become respectable. There are now scholarly journals (*Popular Music, Popular Music and Society*), a scholarly organisation (the International Association for the Study of Popular Music), and scholarly centres (such as the Institute of Popular Music at Liverpool University); there is a growing scholarly literature, and pop and rock have a developing place on school, college and university curricula. Where amidst all this activity is Elvis Presley?

In constructing 'popular music' as an object of study, academics have created their own rock canon, their own account of musical history and value. Elvis has a voice in this but an oddly muted one. Paul Taylor's 1985 guide to popular music literature lists ninety books on Presley of which two might be described as academic (Jac L. Tharpe's collection, *Elvis: Images and Fancies*, and Neal and Janice Gregory's *When Elvis Died*); I know of only one subsequent academic study (besides Rodman's doctoral thesis), Patsy G. Hammontree's *Elvis Presley: A Bio-Biography*.[9] In its first thirteen years, *Popular Music* has not published a single Presley article; in their first five international conferences, IASPM members heard not a single Presley paper. At the sixth, in Stockton, California in 1993, Gil Rodman attracted less than twenty listeners (everyone else was jammed into the sessions on rap).

One reason for this apparent lack of interest is that the scholars feel they already know Elvis's place in the scheme of things. This becomes obvious when we turn to the basic academic books. John Shepherd's *Music as Social Text* has just two Presley references, one referring to his mix of 'parent culture' (country) and 'marginal' sounds (rhythm'n'blues), one suggesting that Presley's singing, like Buddy Holly's, 'reveals a marked innuendo of virile and individualistic masculine sexuality eminently successful in flouting the propriety of middle-class sensibilities'.[10]

These two sorts of argument – musical and sociological – are developed by other scholars. Peter Wicke's *Rock Music: Culture, Aesthetics and Sociology* thus characteristically confines Presley's significance to the brief moment of rock'n'roll's origins. Presley 'embodied the uncertain and consuming desire of American high school teenagers in the fifties, the desire somehow to escape the oppressive ordinariness which surrounded them without having to pay the bitter price of conformity'.[11] Iain Chambers's *Urban Rhythms: Pop Music and Popular Culture* situates Presley in the same moment, but focuses on what his 'American-ness' meant to Britons, with its 'suggestive combination of Latin good looks, country speech and manners, Negro sartorial taste and performance, and their

musical equivalent in ballads, country music and R&B'. The 'force of Presley's voice and performance' meshed all this together in 'a new musical and cultural code'. Like Shepherd (if with a rather better sense of detail), Chambers sees Presley's importance as putting the 'black' into white popular music: 'What emerges from Presley and rock'n'roll is the Atlantis of a previously largely unknown musical continent.'[12]

What we have here is popular music studies orthodoxy. On the one hand, Presley is heard as the boy who first and most powerfully put together black and white sounds to 'recode' mass music; on the other hand, he is recognised as the star who first and most powerfully caught the post-war mood of American (and then European) youth, who recoded the teenager. His phenomenal success was an effect of his integration of these musical and social forces but, from an academic point of view, what really matters is what Presley led to, and his own subsequent career is of no interest whatsoever. This argument is, perhaps, most obvious in the two most general academic texts, Charles Hamm's musicological *Yesterdays: Popular Song in America* and my own sociological *Sound Effects: Youth, Leisure and the Politics of Rock and Roll*. We both refer to Presley with respect; we both acknowledge his historical importance; but for both of us he is, for the most part, just a name to attach to an underlying logic of rock'n'roll and youth culture.[13]

Two things are striking about this position. The first is that it is almost certainly misleading, misunderstanding both Presley's musical and sociological place (to put it simply, he was neither a typical rock-'n'roll singer nor a typical American teenager), and misreading popular music history (in which continuities are as significant as breaks). I haven't got the space to go into this any further here, but I can make the point that these academic Presley references do not depend on scholarly research but are simply a reworking of pop convention. The second point, which I do want to explore, is that in these accounts Elvis himself – as an artist, as a star – is not really the issue. He is treated rather as a symptom, a randomly chosen medium through which musical and social currents passed. 'If it hadn't been him', we are constantly told, 'it would have been someone else'. But it was him, and the unanswered academic question is what difference that made – to the history of music, to the history of culture.

THE MUSICOLOGICAL ELVIS

In his wonderfully angry review of Goldman's Presley biography in the *Journal of the American Musicological Society*, Charles Hamm makes the point that Goldman's high cultural dismissal of Presley's musical abilities

reflected his own musical ignorance. Goldman, true to his debased form of academic orthodoxy, assumed first that Presley's success could have nothing to do with his sound (for Goldman, the Presley problem was precisely 'the incongruity between his limited talents and his limitless fame') and second that his sound was too crude, naive and sentimental to represent anything but a throwback to nineteenth-century ignorance and southern rural idiocy. Hamm concludes

> This may be Goldman's story but it is not the story of early rock'n'roll. The book is a disgrace. The publisher should withdraw it, and libraries should reclassify it as fiction. Neither of these is likely to happen, though, so we musicologists should take matters into our own hands by beginning to produce responsible, disciplined studies of the music of our own time, against which such a book as *Elvis* could be measured, and by subjecting the literature on popular and vernacular music to the same critical scrutiny we lavish on other books.[14]

For all Hamm's earnest plea, though, few musicologists have since turned their attention to Elvis Presley himself. There are a couple of reasons for this, I think. The first problem is generic. The best studies of American vernacular music focus on specific musical forms – country, gospel, blues; Elvis seems marginal (if not a threat) to their concerns. Thus in his exhaustive *Country Music USA*, Bill C. Malone devoted just two pages (out of 422) to Presley's career, and later admitted, 'I felt that Presley was a disrupter and that, as evidenced by the response given to him, the future of country music was dim.'[15]

Similarly, Tony Heilbut's *The Gospel Sound* refers only to Presley's attendance at East Trigg Baptist Church, even though, as Charles Wolfe points out, both the history of white gospel music itself and a proper account of Presley's own musical aesthetic need to take as much account of Presley the gospel singer as of Presley the country or blues singer: 'some day, when the full story of modern southern gospel music has been told and placed in perspective, we can make some serious judgements about the origins of a singing style that changed the face of American popular music'.[16]

For country and gospel musicologists, then, the problem is that Presley's approach was hybrid while their primary concern is the 'purity' of a tradition and a style. For academic writers about blues and rhythm'n'blues, meanwhile, Presley is plainly derivative (this is the argument on which Goldman drew so relentlessly), therefore either not worth consideration at all (as in most blues studies) or only as an example of what Chapple and Garofalo call 'black roots, white fruits' – sociologically but not musically significant.[17]

The question of Presley's 'originality' leads to a second analytic problem. Academic musicology is a discipline rooted in the study of the composer and the score (rather than of the performer and the performance). Popular musicology equally focuses on composers, whether singer/songwriters (such as the Beatles and Dylan) or innovative instrumentalists (such as Jimi Hendrix). Presley neither wrote his own songs nor (it is assumed) arranged (or even chose) his own material; he was not an innovative instrumentalist. There is nothing here for a musicologist to study. And the casual dismissal of Presley's creativity is only reinforced by the common assumption that his sound was anyway 'artificial', the result of studio trickery, amplification, the echo chamber. In its early days, teenage rock'n'roll was routinely regarded as an aural gimmick, the invention of clever engineers (the rock'n'roll recording studio was an easy comic butt for Stan Freberg), and, from this perspective, Elvis was no more musically inventive than any other teen idol.

This is, again, to accept the myth of Presley as primitive or puppet, and to ignore the obvious point that he was a profoundly creative musician – as a singer (and as a singer whose skill – like Frank Sinatra's – lay precisely in his use of technology, in his ability to exploit studio sound and to work with a microphone). Musicologists have always had problems with the voice, and by ignoring his singing Elvisologists can treat Presley simply as a dressed body, an object. Marjorie Garber's interesting analysis of Presley as female impersonator thus makes no mention of his vocals, but focuses on his image, on his hair, his clothes, his mobility. Presley is rendered entirely in the passive tense:

> From the beginning Elvis is produced and exhibited as parts of a body – detachable (and imitable) parts that have an uncanny life and movement of their own, seemingly independent of their 'owner': the curling lip, the pompadour, the hips, the pelvis.[18]

To turn one's attention from Elvis's look to Elvis's sound is, then, to turn from Elvis as object to Elvis as subject. As Henry Pleasants puts it succinctly in his admirable study of Presley in *The Great American Popular Singers*, 'He has a voice. He has an art. He has always had them. No singer survives for nearly twenty years without them.'[19]

The most interesting musicological work on Presley is focused on this voice and on how Presley, as an artist, used it. Pleasants himself gives a technical account of the unique 'confidence and inventiveness' (Charlie Gillett's terms) that rock fans and critics and historians have heard in Presley's early records, describing Elvis's 'extraordinary compass' and 'very wide range of vocal colour'.

The voice covers about two octaves and a third, from the baritone's low G to the tenor's high B, with an upward extension in falsetto to at least a D flat. His best octave is in the middle, from about D flat to D flat, granting an extra full step either up or down. In this area, when he bears down with his breath on the cords, the voice has a fine, big, dark baritone quality. When he eases off, as he often does in ballads, he achieves a light mellow, seductive sound reminiscent of Bing Crosby, if rather breathier, with a wide vibrato that he may have got from Billy Eckstine. Elvis' vibrato, however, is faster and less conspicuous. Call him a high baritone.

The voice has always been weak at the bottom, variable and unpredictable. At the top it is brilliant ...[20]

And Gregory Sandow adds that:

what's most important about any vocal range is not how high or low it extends, but where its centre of gravity is. And by that measure Elvis was very nearly all at once a tenor, baritone, *and* bass.

To hear him singing like a bass, listen to his 1961 hit 'Can't Help Falling in Love', a ballad from the *Blue Hawaii* sound track ... which lies mostly at the lowest end of the baritone range, from the D below middle C upwards to A, and downwards to the A below. Many baritones could produce these notes, but with a provisional tone suggesting they'd be more comfortable pitching the song a little higher; Elvis actually glows with warmth as the song goes lower (especially when it dwells on low A and B), sounding as if he'd relaxed into the comfortable centre of his voice.[21]

To take Presley seriously as a singer in these terms is to take him seriously as a musician. To begin with, he clearly did 'arrange' his own material – it is dominated by his vocal style – and, in the only musical way that matters, thus 'wrote' it too. The record producer, Bones Howe, a sound engineer on many of Presley's studio sessions in 1957–58, remembers that 'Elvis would keep working on a song – getting the vocal arrangements just right'.[22] And Henry Pleasants comments that:

It is not merely a matter of timbre, of the quality, colour or size of the voice as it is heard on any single pitch, or even as it might be heard in a vocal exercise. The sound becomes fully alive and distinctive only in the articulation of the musical phrase as shaped by the text and by the singer's identification with language. Elvis Presley's enunciation has not always been immaculate, although it can be as distinct as anybody's when he wants it to be. But he has never sung a phrase whose contours were not derived from his own native Southern American speech.[23]

Musically, then, Presley did know what he wanted: 'while deferring to Colonel Parker in promotional matters, he has been in charge of his

own music-making'. Pleasants's insight here has been followed up most illuminatingly by Richard Middleton, in his study of Presley's use of 'romantic lyricism' and 'boogification'. In giving Presley's singing a close musical analysis, Middleton makes three significant points. First, Presley was a self-conscious technician – the choice of vocal attack, the making of musical decisions, the playing of genre games, can be heard in the songs themselves; this is not a matter of 'instinct'. Second, Presley was well aware that pop songs are implicitly about their own performance – and their own performers; his 'narcissism' as a singer always had an ironic inflection, and the force and effect of that inflection – the rhetorical devices of embarrassment and seduction, sincerity and flippancy – were a key aspect of his appeal. Third, and perhaps most importantly, Presley's musical gifts were not momentary or accidental, something he 'had' in the Sun or early RCA days and then lost (or had stolen from him). He was always a vocal artist, a vocal technician, a vocal craftsman, even if he often had (at *all* times in his career) shoddy material on which to work (in this respect, Elvis Presley's art more resembled that of, say, Billie Holiday than that of a Chuck Berry or Hank Williams). As Middleton concludes (subtly varying the usual academic line), 'Elvis's originality, then, lay not so much in the cultural mix which he helped to bring into being – that was in the air and would have happened anyway – as in what he did with it.'[24]

THE SOCIOLOGICAL ELVIS

The sociological Elvis doesn't really exist. That is to say, sociologists have accepted the broad strokes of the comic book Elvis Story without ever investigating them. His relationship with Sam Phillips and Colonel Parker, the move from Sun to RCA, the years of bad movies, the return to public performance, the Las Vegas era – in as far as sociologists interested in 'the production of culture' refer to Elvis at all they refer to the facts gathered by Jerry Hopkins; they don't then measure them against more sophisticated accounts of how the music industry worked and changed between the 1950s and the 1970s. (This situation may be changed by the appearance of the first volume of Peter Guralnick's Presley biography, which offers a much more comprehensive account of the *context* of the Elvis story.) It is difficult on Hopkins's evidence, for example, to know whether Parker was a good or bad manager or, indeed, what these terms might mean, but it is noteworthy that Presley survived as a star more lucratively than any other white pop singer of his generation, and that in terms of, say, international marketing, the Hollywood strategy was far more effective than endless world touring.

Just as musicologists have too often accepted the picture of Presley as musically primitive, sociologists have too often treated Parker as economically primitive. This may or may not be the case; a proper analysis of Elvis Presley's career moves has yet to be made.

I find similar problems with the sociological tendency to treat Presley as uncomplicatedly a 'product' of his time or circumstances. Again this has become a sociological truism, but begs questions – questions, in fact, *about* his time and circumstances, questions not addressed by vague references to the South, to youth, to 'the 1950s'. It takes a non-academic, Dave Marsh, to place Presley more precisely in history, to relate Presley's experience of school and work and family to specific effects of the New Deal.[25] The problem, as Marsh suggests, is that to treat Presley as a social symptom is to fall into the same condescending trap as the musicologists who treat him as a musical symptom: this denies Presley any agency, any character, any moral force.[26]

There is no rigorous sociological study, then, either of Elvis as commodity (the details of his various deals remain hidden in RCA's archives) or of Elvis as working-class hero (no one has even gone through the mass of memorabilia to analyse what a boy like Elvis – at that time, in that place – could have known or thought or felt, though, again, Guralnick's new biography does address this issue). Rigorous sociological study has been concentrated, rather on a different issue: the media Elvis. And what both Stephen Tucker's study of Presley's 1956–65 magazine appearances and the Gregorys's exhaustive trawl through the coverage of Presley's death reveal is not just the gap between Elvis's image and reality but also, more importantly, the fact that the contours of Presley's life, the lineaments of his fame, were determined not by anything he said or did, but by the ideological needs and anxieties of the media themselves.[27]

This is to move into a different area of Presley scholarship, American Studies, an area dominated by Greil Marcus who is not technically an academic but whose extraordinary 'Presliad' in *Mystery Train* is undoubtedly the most cited piece of Presley literature (and whose *Dead Elvis* greatly extends our understanding of the USA, if not of Presley himself). And what most strikes me about the scholars who have followed in Marcus's footsteps is that, unlike his, their arguments seem less derived from what they hear, the records, than from what they've read about the records (which may be to define the academic approach). Thus, whether Elvis is dissected as an example of southern identity (as in Linda Ray Pratt's interesting account of his sentimentality) or placed in American literary tradition (as in Joan Kirkby's elegant account of his innocence and vulgarity), what seems to be at issue is less his music than his image.[28] The question that immediately arises is what, aesthetically, is being

asserted: is Elvis the author or a character in such readings? And if the latter, as seems to be the case, *who wrote him*?

THE CULTURAL STUDIES ELVIS

Contemporary cultural studies, the newest branch of academe to take a Presley interest, has a simple answer to this question: his fans. In the early days of cultural studies, this was merely a matter of reading Presley's meaning in terms of his fan appeal. So, as Paul Willis explained:

> The assertive masculinity of the motor-bike boys also found an answering structure in their preferred music. Elvis Presley's records were full of aggression ... his whole presence demanded that he should be given respect.[29]

But as subcultural theory has moved from a study of the 'homologies' between cultural forms and consumers' values to a more aggressive account of the culture created in the moment of consumption itself, so academics have begun to devote more time to the ethnography of fandom, more attention to the process of adoration. Thus Lynn Spigel describes the dead Elvis as 'a semiotic system of preservation'. The most besotted Elvis fans, she argues, are not just engaged in a form of story-telling, but also in a politics of memory:

> Impersonation thus becomes a kind of interpretation, a reading strategy through which the performer revives a memory for a community of fans – a memory which they consider more authentic than scandal, hype and rumour.[30]

The impersonated Elvis is thus more true-to-life than the historical Elvis, more true, that is, to the Elvis experience: Elvis fans 'know' Presley in a way that gets beneath the encrustation of fame and fable.

If one problem of this sort of analysis is that Elvis Presley himself exists in it only as a figment – or series of figments – of some very odd imaginations, another is that the academic also begins to float free from the material, to lose any sense of reason. One Elvis story becomes as good as any other. 'Elvis is alive', a prominent cultural studies academic tells Greil Marcus earnestly on a radio talk show. 'Not just in people's heads, but really, with a new face and a new life, courtesy of the FBI, the DEA.'

The effect of these analytic moves – from Elvis-as-star to his fans, from Elvis-as-performer to his impersonators, from Elvis-as-material to his tabloid sightings – is that cultural studies can evade the most challenging Presley question: how to explain *his sense of himself*. What I have in mind

here is simply that Elvis became a global icon without leaving home.[31] He may have spent much of his early years filming in Hollywood, much of his later ones performing in Las Vegas, but he lived – and was seen to live – in Memphis, hanging out with the same sort of people he grew up with. (Compare this with the mobile, self-reinventing life of an earlier global pop figure like Charlie Chaplin, or with the way later rock stars like the Beatles seized the opportunity to get away from their provincial roots.) Whatever else he achieved, in short, Presley remained first of all a Southerner.

This had obvious consequences for his cultural meaning, whether in terms of the snobbery of northern intellectuals like Albert Goldman or the possessiveness of southern fans who still see themselves in the reflected glory of Graceland, but it also tells us something about Presley's own sense of place. He was, one might say, a pre-rock star: his fame was dependent on the new mass media of television, Top 40 radio, the teen magazine, the LP, but his life (unlike, say, Madonna's) wasn't yet lived in the world the media made; 'making it' for him (as for country music stars still) simply meant being the snazziest spender in town. Eric Hobsbawm once noted that great wealth for the most successful African-American jazz and sports performers in the 1930s and 1940s didn't involve leaving the community, becoming someone nationally or internationally new, but showing the riches off, becoming someone locally glorious.[32]

In Presley's case, knowing his southern place meant knowing something specific about race and sex. One of the recurring Elvis biographical disputes is thus whether he was or was not a racist. This is a silly question, if only because it implies a definitive answer. In day-to-day terms Presley had, we can assume, the same cluster of contradictory and ambiguous, crude and gratuitous racial attitudes as any other white working-class Southerner of his generation. As a singer, though, he did not black up – he used blues and rhythm'n'blues styles and devices (among many others) for his own ends and not (like, say, Jerry Lee Lewis) to signify 'blackness'.[33] It was as if he took for granted that whatever sounds he heard on southern streets and airwaves, in southern bars and churches, were his for the taking (his idols, performers known only at a distance, were thus figures mediated by television and film: he really wanted to sound like Dean Martin; to look like Marlon Brando or James Dean).

If Presley seemed musically at ease with the complications of southern race relations, he also sounded surprisingly comfortable with his sexuality – he expressed tenderness without embarrassment, was always as much a soft, voluptuous singer as a hard, demanding one; he had obviously 'feminine' as well as 'masculine' appeal (which is why a

feminist fan like Sue Wise can look back on Elvis 'as a very dear friend' even as contemporary boy critics were hearing 'an angry young bull').[34]

The challenge for cultural studies is to reconcile what we hear in the music with what we know of the life. Psychologically Presley seems to have been self-abusive, sexually childish, racially vulgar, socially crude (the terms on which Albert Goldman seized so gleefully); musically, *as a performer*, his ease with himself – with his class, his race, his sex – was precisely the basis of his appeal. As arguments about performance and identity begin to inform cultural studies, so perhaps Presley will at last be taken more seriously than his fans. If so, two methodological points will need to be remembered: first, that his meaning still lies in his music (not his myth); second, that socio-cultural identity, Elvis as white male Southerner, is just as much a matter of performing convention as musical identity, Elvis as rock'n'roll star.

CONCLUSION

In February 1992 the *London Review of Books*, a quasi-academic journal, published a review of Greil Marcus's *Dead Elvis* which succinctly expressed the familiar academic attitude. Presley's career was reduced to cliché: 'His first year of stardom may have been subversive, but thereafter he settled in to become one of the most conservative, least adventurous of all pop singers.' The reviewer, Graham Coster, expressed the British snob's contempt for the craftsman:

> Elvis never said no to anything ... He could be a rock'n'roll singer, a gospel singer, a Christmas carol singer (frequently), a balladeer, a crooner – but he wasn't any of them. He was brilliant at turning his hand ...

And the high cultural disdain for popularity: 'what looks like democracy is really only meretriciousness ... People liked Elvis because he gave them nothing to fear'.

> Presley's great skill, and great shallowness, was that he could make you forget what he was singing about. Death – as in 'Long Black Limousine'; poverty – as in 'In the Ghetto': he sang them into mawkish sentiment, song by song.[35]

The argument slips easily down. No, of course, Elvis wasn't worth much in the great cultural scheme of things. No, of course, he wasn't a real artist – 'there is no consistent, cumulative, considered body of work bequeathed to us'. How can we take this man seriously? But then I listen

to the music again, and wonder at the layers of assumption through which Coster must hear things. I go back to those academics who are prepared to let Presley reach them directly. Pleasants:

> Elvis's is, in a word, an extraordinary voice – or many voices. In classical singers a multiplicity of voices is commonly the result of a singer's failure to achieve a uniform sound as the voice moves up and down the scale and through the register breaks. It is counted a fault unless the variety of colour is related to characterization.
>
> In Elvis's early records, the multiplicity of voices is often clearly faulty, especially in ballads ... in later years the vocal multiplicity has been rather a matter of idiom, with Elvis producing a sound for country, a sound for gospel, a sound for ballads, and a sound for rhythm'n'blues. He would seem always to have been a naturally assimilative musician, with an acute sense of style.[36]

The same basic description as Coster's but in a different tone, a tone blessedly free of the mannerisms of high-culture-looks-at-low-culture and sniffs.

Or Middleton. Elvis, he agrees, 'is all things to all men *throughout* his career', and he documents Presley's mastery of various song-types:

> The unifying factor is Elvis himself – or more precisely, Elvis constructed as a particular category: 'Elvis as romantic hero'. He turns all his songs into celebrations of his own power, exercises in self-presentation.[37]

Again, the same point as Coster's but spun to take account of what is in the songs (and not what Coster supposes to be in the heads of their listeners).

My conclusion is that the only academic studies of Presley that make any sense at all are those that begin with love and affection, and bring all their scholarly skills to bear on its sources: the right academic question is, why does Elvis do this *to me*? The wrong question – leading to a mindless contempt for Elvis himself and/or fascination with his fans – is, why does he do it to other people? Coster quotes *Dead Elvis*'s last sentence. Marcus writes,

> The story shrinks then, down to the size of your favourite song, whatever it is – down to the size of whatever mystery *it* contains, whatever it was that made you like it then, and like it now.

And Coster dismisses this as the banal comfort of a late-night deejay. The point, though, is that anyone who doesn't *hear* the mystery in Presley's music (or in any other art) should not be writing about it.[38]

NOTES

1. Arthur Jackson, 'Light Side', *Audio and Record* (August 1962).
2. Stanley Booth, *Rhythm Oil* (London: Vintage, 1993) p. 50.
3. For a comprehensive survey of the Elvis (and Madonna) literature see Gilbert Brinkley Rodman, *Elvis After Elvis: The Strange Posthumous Career of a Living Legend* (PhD in progress, Dept of Communications, University of Illinois at Urbana-Champaign) ch. 3, pp. 54–8.
4. Timothy d'Arch Smith, *Peepin' in a Seafood Store* (Wilby, Norwich: Michael Russell, 1992) p. 139.
5. Quoted in Rodman, *Elvis After Elvis*, p. 53.
6. Henry Pleasants, *The Great American Popular Singers* (London: Victor Gollancz, 1974) p. 269. For the earliest and still most entertaining account of such contempt (which, in the end, the author shares) see Alan Levy, *Operation Elvis* (London: Andre Deutsch, 1960).
7. Karal Ann Marling, *As Seen on TV: The Visual Culture of Everyday Life in the 1950s* (Cambridge, MA: Harvard University Press, 1994) p. 182. We now take this balance of interest (in Elvis as phenomenon rather than as musician) so much for granted that it is a jolt to realise that the original sleeve of *Elvis Presley* (his first RCA LP, released in 1956) sold Presley as a kind of folk performer: front and back photos feature Elvis as a working singer/guitarist. The sleeve note explains:

 > Born in Tupelo, Mississippi, Elvis began singing for friends and folk gatherings when he was barely five years old. All his training has been self-instruction and hard work. At an early age, with not enough money to buy a guitar, he practised for his future stardom by strumming on a broomstick. He soon graduated to a $2.98 instrument and began picking out tunes and singing on street corners ... Elvis is the most original protagonist of popular songs on the scene today. His style stands out vividly on records and in personal appearances and accounts for the universal popularity he has gained.

 This was probably the last time his success was explained, even by his record company, only in terms of his musical style.
8. See Rodman, *Elvis After Elvis*, pp. 58, 95 – thug quote from the British anthropologist and popular music scholar, Stephen Nugent.
9. Paul Taylor, *Popular Music Since 1955: A Critical Guide to the Literature* (London: Mansell, 1985). And see, for confirmation, Mark W. Booth, *American Popular Music: A Reference Guide* (Westport, CT: Greenwood Press, 1983). Patsy G. Hammontree's *Elvis Presley: A Bio-Biography* (London: Aldwych Press, 1985) is essentially a reference book, complete with bibliography, filmography and discography, as well as a guide to Elvis interviews. It tells Presley's story by reference to the best primary sources, but makes no attempt to theorise or analyse.
10. John Shepherd, *Music as Social Text* (Cambridge: Polity Press, 1991) p. 146.

11. Peter Wicke, *Rock Music: Culture, Aesthetics and Sociology* (Cambridge: Cambridge University Press, 1990) p. 42.
12. Iain Chambers, *Urban Rhythms: Pop Music and Popular Culture* (London: Macmillan, 1985) pp. 36–7.
13. See Charles Hamm, *Yesterdays: Popular Song in America* (New York: Norton, 1979) pp. 403–8, and Simon Frith, *Sound Effects: Youth, Leisure and the Politics of Rock and Roll* (New York: Pantheon, 1981).
14. Charles Hamm, review of Albert Goldman's *Elvis* in *Journal of American Musicological Society* (1982) p. 340.
15. Bill C. Malone, 'Elvis, Country Music and the South' in Jac L. Tharpe, ed., *Elvis: Images and Fancies* (London: Star Books, 1983; originally published in 1979 as a special issue of *The Southern Quarterly*) p. 124. And see Bill C. Malone, *Country Music USA* (Austin and London: University of Texas Press, 1968).
16. Charles Wolfe, 'Presley and the Gospel Tradition' in Tharpe, *Elvis*, pp. 153–4. And see Tony Heilbut, *The Gospel Sound* (New York: Simon and Schuster, 1971).
17. Steve Chapple and Reebee Garofalo, *Rock'n'Roll Is Here To Pay* (Chicago: Nelson-Hall, 1977) pp. 242–6.
18. Marjorie Garber, *Vested Interests: Cross-Dressing and Cultural Anxiety* (New York: Routledge, 1992) p. 372.
19. Pleasants, *The Great American Popular Singers*, p. 274.
20. Ibid., pp. 274–5. One of the values of Pleasants's approach is that he places Presley in the history of American popular singers, and not just in terms of country/blues influences or as a teen rebellion against the mainstream. As Chris Spedding has more recently pointed out in *Musician*, Presley's early ambition to sound like Dean Martin should be taken seriously – in a comparison of Martin's 'Memories Are Made of This' and Presley's 'Don't Be Cruel', for example. See Michael Jarrett, 'Concerning the Progress of Rock & Roll', *South Atlantic Quarterly*, 90:4 (1991) pp. 813–4.
21. Gregory Sandow, 'Rhythm and Ooze', *Village Voice* (18 August 1967) p. 75. Sandow provides equally detailed descriptions of Presley's baritone and tenor songs.
22. Bones Howe, quoted in the sleeve notes to *Essential Elvis Volume 2* (RCA, 1983).
23. Pleasants, *The Great American Popular Singers*, p. 264.
24. Richard Middleton, 'All Shook Up? Innovation and Continuity in Elvis Presley's Vocal Style' in Tharpe, *Elvis*, p. 163. For Middleton's further thoughts on Presley see his excellent *Studying Popular Music* (Milton Keynes: Open University Press, 1990).
25. See Dave Marsh, 'Elvis: the New Deal Origins of Rock'n'Roll', *Musician* (December 1982).
26. One of the few scholarly studies which manages a grand reading of Presley (as 'a radical romantic') without losing sight of the specificities of his experience is Van K. Brock: 'Images of Elvis, the South and America' in Tharpe, *Elvis*.

27. See Stephen R. Tucker, 'Visions of Elvis: Changing Perceptions in National Magazines, 1956–1965' in Tharpe, *Elvis*; Neal and Janice Gregory, *When Elvis Died* (Washington DC: Communications Press, 1980); and Marling's *As Seen on TV*, ch. 5, which provides an illuminating account of how the social meaning of the young Elvis was shaped by the needs and anxieties of the equally young medium of television.

28. See Linda Ray Pratt, 'Elvis, or the Ironies of a Southern Identity', and Joan Kirkby, 'Memphis Faun: a View from Australia', both in Tharpe, *Elvis*. I assume there is a considerable body of such work in American Studies journals by now, but this is not a field I know much about.

29. Paul Willis, *Profane Culture* (London: Routledge, 1978) p. 71. The best analysis of Presley from this perspective can be found in Dick Bradley, *Understanding Rock'n'Roll: Popular Music in Britain 1955–1964* (Buckingham: Open University Press, 1992) pp. 64–70, 136–143. For a feminist critique of this approach to Elvis through male fan response see Sue Wise, 'Sexing Elvis' in Simon Frith and Andrew Goodwin, *On Record* (New York: Pantheon, 1990).

30. Lynn Spigel: 'Communicating With the Dead: Elvis as Medium', *Camera Obscura*, 23 (1990) p. 184.

31. Perhaps the reason why, by the end of the 1950s, countries as far apart as Argentina and Iceland, India and Spain, had their own Elvis Presleys was not just because the real thing wasn't ever going to visit, but also because Presley was the sort of star who was essentially local.

32. See Francis Newton [Eric Hobsbawm], *The Jazz Scene* (Harmondsworth: Penguin, 1961).

33. For Jerry Lewis see Bernard Gendron, 'Rock and Roll Mythology: Race and Sex in "Whole Lotta Shakin' Going On"' (Working Paper 7, Milwaukee: Center for Twentieth Century Studies, 1985). For a more general historical discussion of minstrelsy (drawing usefully on cultural studies), see Eric Lott, *Love & Theft: Blackface Minstrelsy and the American Working Class* (New York and Oxford: Oxford University Press, 1993).

34. Wise, 'Sexing Elvis', pp. 393, 395. (The angry young bull image is from George Melly.)

35. Graham Coster: 'Uncle Vester's Nephew', *London Review of Books*, 14:4 (1992) p. 22.

36. Pleasants, *The Great American Popular Singers*, pp. 275–6.

37. Middleton, 'All Shook Up?', in Tharpe, *Elvis*, pp. 164–5.

38. An earlier version of this essay appears, as 'Wise Men Say', in Alan Clayson and Spencer Leigh, eds, *Aspects of Elvis – Tryin' To Get To You* (London: Sidgwick and Jackson, 1994).

7

The Last Rebel: Southern Rock and Nostalgic Continuities

Paul Wells

'What song is it you wanna hear?'
'FREEBIRD!!!!!'

Hammersmith Odeon, London 1975. Two young lads from the South (of England). One, stetsoned and cowboy-booted, perched precariously on the shoulders of the other, waving an outsized Confederate flag. Three guitarists, hair tumbling wildly, united at the front of the stage, each producing the satisfying wail and screech of the extended solo at the end of Lynyrd Skynyrd's rock anthem, 'Freebird'. Somehow, some way, the music of the American South had come to mean so much to an insecure English teenager hundreds of miles away.

On 10 February 1992, I once again saw the band that had so engaged my youth. This time, though, I resisted taking my Confederate flag. The intervening years had seen a rise in my understanding of American history, the development of a political consciousness, and an inability to fit into my concert outfit. I should stress, however, that there remained an ongoing commitment to 'Southern Boogie' and the bottle of Jack Daniel's that often accompanied the raucous nights spent listening to it.

A number of questions arise out of this brief personal history, not least the ongoing tension between being a 'fan' and the supposed consciousness of being an 'academic' addressing some of the fundamental ideas which inform the culture of fandom and the politics of personal engagement. First, it is necessary to interrogate the idea of 'southern rock' as a genre, to formally investigate its constituent musical form; the bands engaged in this type of music; the key themes of the genre, and the cultural history from which these themes emerge. Second, it is important to view southern rock as an enduring form and to evaluate its appeal, both for American audiences and for audiences (like those

115

in Britain) who do not share the geographic or cultural context from which the music comes. Third, it is crucial to recognise how the music represents 'the South' as it is mediated in the contemporary socio-political and musical arenas.

It is interesting to note, then, that both Lynyrd Skynyrd and the Allman Brothers Band, the two key bands that essentially defined southern rock, reformed in the late 1980s, reclaiming the audience that first saw them, gaining new audiences, by sustaining a network of 'nostalgic continuities'. Both bands essentially look forward by permitting their audiences to look back. The identity of southern rock is therefore sustained by a fresh participation in old codes and conventions.

THE SOUTHERN LANDSCAPE

One might usefully map the terrain of southern rock by addressing the lyric of Charlie Daniels's rebel-rousing, and perhaps prophetic polemic, 'The South's Gonna Do it Again' (1974):

The train to Grinderswitch is running right on time,
The Tucker Boys are cookin' down in Carolina.
The people down in Florida can't be still,
Cos Lynyrd Skynyrd's pickin' down in Jacksonville.
The people down in Georgia come from near and far,
To hear Richard Betts pickin' on that red guitar.

Gather round, Gather round children, get down,
Get down children, Get loud,
You can get loud and be proud,
Be proud to be a rebel, cos the South's gonna do it again.

Though operating essentially as a tribute to the most popular bands in the South, the song signifies particular attitudes, most notably the pride felt in being from 'the South' and representing a specific point of view derived from and defined by the ethos of the 'Rebel' and the politics of the South during the Civil War. The song assumes each band's direct affiliation with the place which it is from and, consequently, the community intrinsically bound up in a relationship with the music. This sense of historicised community is then further placed within the context of celebrating and, most importantly, delineating 'the South' as a unique geographical and cultural region. The crucial underlying imperative of the song, though, is the recognition of 'loss' and the resistance of history in the creation of revisionist myths. 'The South',

as it were, is still 'of itself', representing what it has always insisted on representing, unbowed by social and political change.[1]

The chief thematic modes which inform southern rock are drawn from this basic stock of ideas. They are namely:

1. the contemporisation of a Civil War ethos as a mode of identity
2. the defence of a pre-Civil War ethos in the determination of gender roles
3. the symbolic potency of 'guitar' music in the definition of masculinity and the address of 'race' issues
4. the rationalisation of 'continuum' through the resolution of personal tragedy
5. the tension between secularisation, faith and social de-stabilisation.

These themes are located in southern rock music in a fundamentally self-conscious way, enabling audiences to readily recognise and relate to a specific identity in the image and sound of the music. This distinguishes it from other modes of 'rock', whilst sustaining its own traditional familiarity. It is this very familiarity which engages audiences at the level of identification and empathy, which, in turn, enables them to endorse, collaborate with and perpetuate the ethos southern bands represent.

ATLANTA'S BURNING DOWN

People still remember, in another day,
The Battle of the Union and the Rebel Grey,
How they burned Atlanta,
Drove her down to the sea
And you can never drive that memory from me.
 'Lonesome Guitar' (1988) (Doc Holliday)

Bruce Brookshire, vocalist, guitarist, and creative force behind Doc Holliday, the South's major 'biker' band, localises his notion of the South in the contemporisation of a Civil War ethos. Like most southern bands, Doc Holliday bedeck the stage with the Confederate flag, champion the southern cause, and still advocate 'fighting' for it.[2] Brookshire introduces the live version of 'Lonesome Guitar' with these words:

During the Civil War we lost a lot of good men. We
lost 'em at Gettysburg. We lost 'em at Shiloh, but
we whooped their ass at Cold Harbour !

This direct appeal to the audience attempts to locate the South within the context of conflict.[3] These words recall events which took place over a century ago, but which remain at the core of a southern sensibility which southern rock bands believe is part of a unique and essential 'otherness' from that time down to now.

This historic cross-referentiality enables Brookshire to create an 'imaginary' contemporary conflict. These *received* memories create *perceived* myths which constitute nostalgic continuities. Further, these continuities are given authenticity because they are localised in a historic 'need' that southern bands recall. This may be understood as the belief in, and resurrection of, 'the South' as an ideal and an identity in its own right. Southern bands express pleasure and celebration in this representation through the endurance of the music and its symbolic import.

Brookshire's lament for the burning of Atlanta is not an isolated case. Dickey Betts, estranged from the Allman Brothers Band, and fronting his own group, Great Southern, wrote 'Atlanta's Burning Down' (1978). Implicit in the citings of Atlanta is the use of nostalgia as a system of refusal and resistance. The 'finality' implied by the burning of the city is unacceptable and is challenged by the notion in the songs that by 'not forgetting' nor forgiving the enemy (now, not explicitly 'the North' but anything non-southern), means that the issues symbolised by that defeat have not been resolved.[4] This view is confirmed in Lynyrd Skynyrd's 1993 album, *The Last Rebel*, when Johnny Van Zant sings, 'Atlanta burns forever' in the defiant lyric of 'Can't Take That Away'. It is clear that whatever was achieved politically by 'the North' in winning the Civil War, little has changed psychologically and emotionally in 'the South'. Southern rock has thus taken on the mantle of resistance group, still metaphorically fighting the war by refusing closure and signifying an enduring alternative culture, perhaps most significantly embodied in the figure of 'the Rebel'.

The Last Rebel (1993), Skynyrd's second 'comeback' album, is a reiteration of southern values in a changing world. 'Can't Take That Away', mentioned above, even contemplates the psychological strength required to endure the possible removal of the cross on the hill and the rejection of the Pledge of Allegiance; a strength, however, gained by being assured of the 'truth' inherent in southern traditions. The same strength is required in 'Kiss your Freedom Good-bye' to sustain small-town country values in the face of young graffiti artists and urban crime. It is within this context that the title track locates 'the last rebel', where once more the contemporary singer constructs an emblematic moment of social history, as this estranged figure from the Civil War confronts his physical statelessness, comforted only by his dream, which in itself is bound up

with the defence and perpetuation of a pre-Civil War South. This view of the South is overtly romanticised and subject to no real definition or political scrutiny. However, to the people of the South it is self-evident, beyond specific justification and exclusive to those who understand and accept it. 'Home', it seems, is the reconciliation of 'tragedy' and 'defeat' in the name of a greater good which operates over and beyond contemporary social mechanisms and resides in a southern essentialism. Here nostalgic continuity literally combines the nostalgic yearning for a God-given southern ethos with the continuity of merely travelling on.[5]

LIQUOR IN THE FRONT AND POKER IN THE REAR

These tendencies are closely related to gender issues within the southern context. It is clear that for men the codes of the road, which include hard drinking, gambling and womanising (neatly summarised in the slogan emblazoned on Blackfoot's battered white tour-bus – 'liquor in the front and poker in the rear'), sit uneasily with the conservative notions of family and community championed within a southern ethos. Ironically, these codes of the road *do* fit in with a tradition of behaviour among southern males at large in the South as early as the 1850s. For that period, Christie Anne Farnham suggests, 'The biggest problems at male schools were swearing, lying, feasting on stolen chicken, drunkenness, fighting, gambling, and visiting houses of prostitution.'[6]

Clearly, this recognisably sexist and aggressive agenda, championed by men in this period, bears strong resemblance to the 'good ole boy' sensibility of the contemporary era. However, I would argue that southern rock not merely embodies the 'good ole boy' model but also legitimises the more romanticised and socialised aspects of masculine behaviour by recalling the hierarchical and patriarchal codes of the plantation era.

Obviously, the 'good ole boy' is intrinsically southern. .38 Special's 'Wild-eyed Southern Boys' (1981), informed by a blue-collar mentality and a strong aversion to men with 'wealth and power', suggests that women prefer more aggressive men:

The ladies hate the violence,
But they never seem to look away,
Cos they love those Wild-eyed Southern boys

The small-scale bar-brawls mentioned here, for which Lynyrd Skynyrd became notorious, echo the larger-scale, if mythic, Civil War-mongering

of Doc Holliday, and both offer role models to social groups of young males (particularly 'bikers' and teenagers uncertain about the complexities of their [hetero]sexuality), who readily identify with the apparently unchecked expression of male appetites. This is not unusual within rock culture in general, of course, but is endorsed not merely as part of youth culture, but as acceptable within the observable parameters of 'southern' culture, a culture which makes constant reference to family, community, and tradition to legitimise a broader spectrum of behavioural codes and the overt romanticisation of southern males who did not participate in *actual* conflict in the grand scale of the Civil War. The tension between the desire for a certain gentility, derived from the plantation model, and the aggressive bravura that informs the 'good ole boy' is central to the southern rock outlook.

In the antebellum southern context, the institution of the plantation and its particular modes of organisation, and the specificity of the role and function of men and women, enable contemporary women to be encoded within the parameters of a neo-aristocratic ideology of chivalry and honour which *refines* masculine identity and *defines* feminine behaviour. The 'refinement' of masculine appetites is to legitimise them as necessary, inevitable, and irrefutable, i.e. they are invested with acceptability, while femininity is defined through the conception of the 'Southern Belle', ultimately a set of codes perpetually subject to patriarchal recontextualisation:

> Men were her protectors, her knights in shining armour, who rode into the world fighting her battles for her. She deferred to their superior knowledge, which came from their experiences in this world and did not feel much necessity for enlarging her understanding of his sphere.[7]

Southern rock takes up this patriarchal chivalry to authenticate its romantic agenda. Here men respect women, invest them with status, and dignify their own sexual feelings. Further, wherever the errant rocker has roamed, it is clear that 'Dixie Women', 'Georgia Peaches', and 'Magic Midnight Ladies' are the best, elevated once more, not merely by their intrinsic beauty, but by a yearning for the nostalgic continuity of what feminists would regard as the outmoded conception of 'the belle'.[8]

Implicit here is the idea that the role of southern women is fixed by traditional codes, and that to mystify women as magically 'other' is recognition and reward. This clearly fits into the chivalric pattern cited earlier, and serves to reinforce modes of white male behaviour as unalienable 'rights', and perhaps more importantly, sustains this kind

of masculinity as an important cultural and aesthetic myth in spite of the challenge of political correctness and possible revisionism.

Using the plantation model simultaneously to reinforce traditional codes of masculinity and to elevate the status of certain codes of femininity naturalises hierarchies and the idea of the 'extended family' as a benevolent, self-evidently moral social construct. This enables southern rock bands to represent the South without reference to the key issue of 'race'. These are particularly complex issues because the form of southern rock music borrows extensively from black music, while the content rarely addresses the racism that is an inherent part of championing 'the southern way' as it was originally defined.

WHITE BOY SINGS THE BLUES

The southern tradition of music embraces blues, gospel, jazz and country music. From this melting pot of styles emerged rock'n'roll through Elvis Presley, Chuck Berry, Jerry Lee Lewis and one Richard Penniman – 'Little Richard' out of Macon, Georgia. James Brown and Otis Redding also hailed from Macon, the latter a close friend and associate of Phil Walden, the man who essentially put southern rock on the map through Capricorn records and their first signing, the Allman Brothers Band.

Virtuoso slide guitarist Duane Allman, and his brother Greg, had played in black groups in their youth because, as Duane pointed out, 'White kids surf; Black kids play music.'[9] Simply, the black tradition of music was a white tradition too. As Jim Curtis has noted:

> This music tends to employ the pentatonic scale of folk musics the world over, and consequently, has ambiguous keys and usually lacks a definite climax. As a result, it has an emotional resonance rather than a narrative structure.[10]

This description certainly fits the ambitious peaks and swoops in the music of the Allman Brothers, particularly in their extended instrumental pieces like 'Whippin' Post'(1971), 'From the Madness of the West' (1980) and 'Kinda Bird' (1991). All exhibit the fluidity of improvisational style which belies narrative and points up shifts in emotional state. Dickey Betts describes the process of constructing these pieces:

> They usually begin with a feeling I want to express, but it's something that's very difficult to explain. Writing a good instrumental is very fulfilling, because you've transcended language and spoken to someone with a melody. My instrumentals try to create some of the basic feelings of human interaction, like anger and joy and love.[11]

The 'black' context of this music is enmeshed with a country tradition:

> I listened to a lot of country and string music – what's now called Bluegrass – growing up. In fact, I played mandolin and ukulele and fiddle before I ever touched the guitar, which may be where a lot of the major keys I play in come from. But I also always loved jazz, and once the Allman Brothers were formed, Jaimoe really fired us up on jazz, which is all he listens to. He had us listening to a lot of Miles Davis and John Coltrane, and a lot of our guitar arrangement ideas come from the way that their horns played together.[12]

J. Johnny 'Jaimoe' Johanson, along with Butch Trucks (and now Marc Quinones), form the percussive backbone to the Allman Brothers' music displaying quasi-African and jazz influences in the development of complex harmonic sequences. Curtis stresses the emotive sensibility in early southern rock culture and the apparent resistance to a definitive climax. I would suggest that it was this sense of climax which contemporary southern rock achieved, as an evolution of Allmanesque guitar harmonies and as a denial of a black jazz sensibility, in the extended guitar 'tag' at the end of a band's most emblematic song. Most representative and influential here, of course, is Lynyrd Skynyrd's 'Freebird'.[13]

Contemporary southern rock thus distances itself from its black roots, establishing a white rock, ritualistic, anthemic climax to both songs and concerts, asserting perhaps a mode of white difference. It may be argued that someone like Phil Walden at Capricorn records was clearly race sensitive, having championed black music, resisted segregation laws and developed into the largest concert promoter of black talent in the country,[14] but the issue of race has never really been dealt with by bands locating themselves within the southern ethos discussed earlier. This became a *cause célèbre* when Neil Young wrote 'Southern Man' (1970), a scathing critique of the racist continuities in southern culture.

This provoked a response from Lynyrd Skynyrd in 'Sweet Home Alabama' (1974) which was curt and personalised:

> I heard Mr Young sing about us,
> I heard old Neil put her down,
> But I hope Neil Young will remember,
> A Southern Man don't need him around anyhow.

Such defensiveness with, later in the song, an endorsement of Governor George Wallace into the bargain, only serves to support the view that southern rock expresses a mode of unquestioning traditionalism which

signals separateness and resists ideological revisionism or political guilt. Southern rock may be viewed as an idiom which refuses to engage with the notion that there is a 'political correctness' elsewhere, preferable to the social codes and conventions already in place. Whilst not being overtly racist – few songs ever engage with the issue[15] – choices are made which reinforce the traditional attitudes on race. Perhaps most significant here, though, is the overt distancing from any mode of a 'White Negro' ideology, so often felt to be the appropriation and signature of Elvis Presley.[16] To appropriate aspects of black music is not to appropriate aspects of black physicality or identity.

If southern rock distances itself from the politics of race by essentially ignoring it (a political position in itself, of course), this is not to suggest that this is depoliticised music. Indeed, many of the more contemplative songs, particularly those by Lynyrd Skynyrd, may be constituted as songs of protest. 'Wino' (1978), contemplating the fate of a homeless drunkard; 'Lend a Helping Hand' (1978), citing the poor and diseased; 'Ain't No Good Life' (1977), considering poverty; 'All I Can Do is Write About It' (1976), complaining of encroaching urban ugliness; and 'Things Going On' (1973), encouraging people to challenge the conspiratorial and unjust aspects of government, particularly in regard to Vietnam and the 'Space Race'; are all poignant statements.

What is important about these songs is their essential defence of the 'simplicity' and 'honesty' of rural southern ways in the face of misrepresentation and corruption by those in power. What becomes clear is that protest like this, targeting the self-evident failures of national government, serves to endorse the apparently preferable outlook and attitude embodied in southern culture. The notion that southern culture is 'Pure and Simple' (1991) (Lynyrd Skynyrd), however, is purely simplistic. This view of the South does not examine the contradictions inherent in that culture, nor does it recognise contemporary modes of gender and race politics in the construction of ideology. In other words, this apparently democratic outlook is selective, and operates in accordance with a nostalgic longing for a mythic South defined by traditional codes which, ironically, do not reflect democratic processes.

The desire for nostalgic continuity is a desire to live in this mythic South, which addresses and overcomes its problems through a commitment to God, and a view of faith which only believes in the word of God and not the operations of social democracy. The word of God and unquestioning faith has helped both Lynyrd Skynyrd and the Allman Brothers reconcile personal tragedy and authenticate their historic identity as southern bands.

The Flight Of The Freebird Continues

With undisguised joy and an immediate propensity to create and perpetuate the 'mythic' identity of Lynyrd Skynyrd, Dale Krantz, wife of Skynyrd guitarist, Gary Rossington, delivers the lyric of 'Prime Time', the opening cut of *Anytime, Anyplace, Anywhere*. This was the comeback album by those members of the Skynyrd band that survived a tragic air-crash in October 1977. Whatever imitators had come along to try and fill the gap left by Skynyrd, chiefly Doc Holliday, .38 Special, Molly Hatchet and Blackfoot, here was the reassurance of the 'Real McCoy', the 'Big, Big Boys', 'Alive and Well' in the face of adversity, offering the musical and cultural authenticity of the very band who had helped define southern rock, but here represented in a new form.

If the emergence of the Rossington Collins Band tried to echo the spirit of the original Lynyrd Skynyrd group, it succeeded not only in a musical sense but at the level of reconciling tragedy with the mythos of survival. The chief aspect of this reconciliation is the quasi-deification of Ronnie Van Zant as the emblematic persona of a southern ethos and the principal embodiment of an increased commitment to a faith in God.

The death of Van Zant was to prompt intense grief within the band itself and other bands who acknowledged his influence and importance. Doc Holliday's 'Song for the Outlaw' (1989) summarises this:

He held the crowd in the palm of his hand,
With a rebel flag and a guitar band.
He lived the life, the whisky and the fights,
But he died too young,
When the big time had just begun.
Sing a song for the outlaw,
For the way he makes you feel,
Young and proud and strong,
And Southern to the core.
There is no score to settle now,
Since the Good Lord called him home.[17]

Only in recent tours have Skynyrd seen fit to let Johnny Van Zant sing the song but not without an extended introduction formally recognising the absence of all those who have gone to 'Rock'n'Roll Heaven', principally Ronnie Van Zant and the air-crash victims, but also guitarist Allen Collins, who died of respiratory problems in 1990, shortly after the deaths of his wife and child. Tragedy seems to have dogged Lynyrd

Skynyrd but the band constantly refer to their faith as the mechanism by which they can endure their fate.[18]

Within southern culture, this intensity of faith was most explicitly expressed by black people through 'sacred' songs, most obviously hymns and gospel songs, and it is this tradition of the sacred song which Lynyrd Skynyrd has borrowed and contemporised in a personal anthem like 'Freebird' and the other tribute songs for Van Zant. In mythologising Van Zant and coming to terms with tragedy, the underpinning ethos of white southern culture is reinforced. That is to say, white Southerners, as they are represented in southern rock, feel that their only ultimate judge is God, and that their personal and social identity is reconciled by God and no other determinate historical or cultural force. This conveniently distances white Southerners from any response to political criticism and safely locates them within the 'sacred', while sometimes exercising the 'profane'.[19]

KEEPING THE FAITH

The 'God' of a white southern culture is both lore and law – the 'folk' aspect of this faith simultaneously frames a utopianism in simple southern traditions whilst mobilising a fundamentalism to resist political intervention. The 'sacred' song of 1970s southern rock is a hymn to southern essentialism, a symbol of southern identity and a resistance to particular kinds of interrogation and possible revisionism. Further reinforcement of this position emerges through the 'extended community' represented by the groups themselves.

This model is consistently reinforced by the Allman Brothers and Lynyrd Skynyrd (and, indeed other southern rock groups) through the snapshots, sleevenotes, and songs illustrating the enclosed yet broad 'church' the communities surrounding the bands themselves serve to represent.[20] Group, family and friends become the epitome of a self-governing, self-perpetuating model of idealised southern culture, politicised only by a resistance to centralised government, valorised by a 'faith' in God's law and no other, and identified by a reworking of the musical traditions at large in the melting pot of southern musical culture.

It can be argued that if the 1950s offered a coherence in the evolution of 'rock'n'roll' itself and the 1960s offered 'rock'n'roll' a particularly conducive social and cultural position, it was the 1970s that saw the increased fragmentation of rock audiences across numerous musical styles and genres, from disco to punk. Ironically, southern rock cemented its

identity in this period by remaining essentially reactionary. Southern rock determinedly clung to its rural roots, ignored its apparent unfashionableness within rock circles and placed its trust in an audience to support and identify with the music beyond the fickle trends of radio airplay. In keeping the faith in themselves and their loyal fans, southern rock bands sustained a particular ideology around faith itself. 'Faith' here carries a multiplicity of meanings which cohere with the nostalgic continuities I have defined in this article. Ironically, in southern rock culture, looking back equates with looking forward, and creating an identity which resists the contradictions of contemporary life. This construction is its own 'happy ending', validating the notion that, even if only at the level of consolidating a place in popular culture, the South has risen again.

NOTES

I would like to thank Tim O'Sullivan and Simon Geal for their help in the preparation of this article. I would also like to thank Richard H. King for his helpful advice concerning an earlier draft.

1. As an overview of the key players in the southern field, Daniels's song makes few omissions. Noted are Lynyrd Skynyrd and their homebase of Jacksonville, Florida; the Allman Brothers Band, referenced through the outstanding guitarwork of Richard 'Dickey' Betts; Grinderswitch, formed by two ex-Allman Brothers roadies, Dru Lombar and Joe Dan Petty; and the Marshall Tucker Band, with its leanings towards bluegrass and country music. Later in the song there are name checks for ZZ Top, Wet Willie, Elvin Bishop and the Charlie Daniels Band itself.

 There are a number of self-referential songs written by southern rock groups. Two that reference other bands include Lynyrd Skynyrd's 'When You Got Good Friends', released on *Legend* (1980), though recorded in the early 1970s, that extends the southern canon by including country and western artists like Merle Haggard, Willie Nelson, as well as endorsing Charlie Daniels and the Marshall Tucker Band. Molly Hatchet also include a litany of southern bands in *Gator Country* (1978) in order to validate their own southern context in preference to that of Skynyrd, Betts, Bishop, Tucker, Daniels and the Outlaws.

2. The iconography of the Confederate flag has experienced a particular bricolage in that the flag itself is now intrinsic to the recognition of southern rock and not necessarily 'the South' as a geographically and historically located concept. Roger Daltrey, lead singer of The Who notes:

 Went down South in America, we had the Rebel flag. They loved it. That was the only way we stayed alive in the South in America in those days.

And in those days you'd have to go some to find a southern flag. Not like it is now.

Mojo (September 1994) p. 34.

Daltrey's point is significant in the sense that at the very moment when the Confederate flag was both physically unavailable and culturally anachronistic, the flag became re-signified as the symbol of rebellion within the rock idiom. The flag is essentially depoliticised in the historic sense and commodified in relation to southern music. Consequently, in many contexts (particularly in Japan) the flag represents 'Lynyrd Skynyrd' or southern rock, and not the emblem of the southern states.

3. Brookshire's introduction to this song did not vary when in England yet still gained similar responses of support and endorsement. It is likely that the ethos of implied, if not actually fulfilled, confrontation, appeals to the predominant audience of young adolescent males. As James Lull suggests:

Ideas contained in music are often perceived and interpreted privately or with friends in locations that are not supervised by adults. Of course there is no homogeneous, alternative ideology expressed in music. But much popular and subcultural music does contain themes that conflict with the common ideological orientations of mainstream culture as a whole ...

James Lull, 'Listeners' Communicative Uses of Popular Music' in James Lull, ed., *Popular Music and Communication* (New York: Sage, 1987) p. 156.

It is likely that the appeal of southern rock outside the southern context is its defiant masculine code, its expression of physical indulgence and its ideological 'difference'. If only for the period of the concert, it legitimises certain fantasies and participatory modes of collective behaviour.

4. A corollary to this idea occurs in the real resistance shown by the people of Vicksburg. Confederate general, John C. Pemberton, finally surrendered the city to Union general, Ulysses S. Grant, after 48 days of siege on 4 July 1863. The Fourth of July, therefore, was not celebrated by the population of Vicksburg until 1944.

5. Whether 'Born in the back of a Greyhound bus on Highway 41' (*Rambling Man*, 1973) like Dickey Betts of the Allman Brothers, or wearing *Travellin' Shoes* (1974) like Elvin Bishop, or citing the loneliness of the road in *Highway Song* (1979) like Rickey Medlocke of Blackfoot, the southern rocker is perpetually drawn to the escape of the road in pursuit of 'freedom' whilst perhaps contradictorily, desiring the ultimate security of the southern mythic 'home'.

6. Christie Anne Farnham, *The Education of the Southern Belle*, 1st edn (New York: New York University Press, 1994) p. 136.

7. Ibid., p. 128.

8. Inevitably, there is often a less charitable view of women demonstrated in songs like Molly Hatchet's 'Cheatin' Woman' (1978) or, more mischievously,

in Duane Allman's 'Happily Married Man' (1974) in which he sings, 'I haven't seen my wife for two or three years, I'm a happily married man!'

9. Michael Bane, *White Boy Sings the Blues*, (Harmondsworth: Penguin Books, 1982) p. 26.

10. Jim Curtis, *Rock Eras* (Bowling Green, Ohio: Bowling Green State University Popular Press, 1987) p. 26.

11. 'Live and Well': An interview with Dickey Betts and Warren Haynes in *Guitar World* (July 1994) pp. 150–1.

12. Ibid., p. 150.

13. A cursory look at the repertoire of other southern bands reveals that nearly all have an equivalent song based on a slow-building, mournful ballad that moves into a fast double or triple guitar break when guitarists swap lead and rhythm and occasionally harmonise, modelled on 'Freebird'. These include 'Green Grass and High Tides' (1975) by The Outlaws; 'Highway Song' (1979) by Blackfoot; 'Fall of the Peacemakers' (1983) by Molly Hatchet; 'Edge of Sundown' (1981) by The Danny Joe Brown Band; 'I Reserve the Right' (1979) by Stillwater; 'Standing in the Darkness' (1980) by the Johnny Van Zant Band; and 'Lonesome Guitar' (1989) by Doc Holliday.

14. Phil Walden's contribution in the development and exposure of both ostensibly 'black' music and southern rock cannot be undervalued. Instrumental in bringing the Allman Brothers Band together, and showcasing their music through the Capricorn label, Walden brought southern rock into the mainstream and highlighted the central tension of the region in its black and white/blues and country fusion of styles. Walden's view is that 'The southern white man and the southern black man have always enjoyed a more personal relationship than anyone outside the South thought.' Quoted in Michael Bane, *White Boy Sings the Blues* (Harmondsworth: Penguin Books, 1982) p. 226.

15. Narratives in southern rock songs rarely mention race issues, though one interesting scenario emerges in 'Rebel Girl' (1993) from Doc Holliday's *Son of the Morning Star* album, in which a mute 'colored boy' is lynched because he has an affair with a white girl. The girl resents her father's instigation of the lynching and does not mourn his eventual death. This 'Rebel Girl' the song refers to ultimately leaves, distancing herself from the Confederate notion of 'the Rebel', redefining rebellion, ironically, by leaving her southern roots.

16. For a reading of the 'White Negro' ideology, see Eric Lott, 'White like Me' in Amy Kaplan and Donald Pease, eds, *Cultures of US Imperialism* (Durham & London: Duke University Press, 1993) p. 483.

17. Other tribute songs to the memory of Van Zant include 'Standing in the Darkness' (1980) by the JVZ Band; 'Teshawna' (1981) by the Rossington Collins Band; 'Rebel to Rebel' by .38 Special; 'Brickyard Road' (1990) by Johnny Van Zant; 'End of the Road' (1991) and 'The Last Rebel' (1991) by the reformed Lynyrd Skynyrd. Molly Hatchet played 'Freebird' on their *Double Trouble Live* set (1985) with the introduction 'You're gone Ronnie, but your song lives on', while the Lynyrd Skynyrd tribute tour of 1987, incor-

porating the original band plus guests, featured an instrumental version of 'Freebird' with a movingly loud and word-perfect rendition by the crowd.

18. The Allman Brothers' career is also characterised by tragedy. Lead guitarist, Duane Allman, and bassist, Berry Oakley, died in separate motorcycle accidents. Both are now buried in Rose Hill cemetery in Macon, Georgia, where Dickey Betts penned 'In Memory of Elizabeth Reed', the 'sacred' instrumental that has become synonymous with their memory.

19. Significantly, the two Rossington Collins Band albums are far more influenced by a 'religious' code than any Lynyrd Skynyrd album that preceded them. Songs like 'One Good Man' (1980) refer to Sodom and Gomorrah, and 'Pine Box' (1981) is an unaccompanied spiritual song.

20. This mode of touring group as extended family is echoed in contemporary groups like the Spin Doctors and the Levellers.

8

'Bringing the Races Closer'?: Black-Oriented Radio in the South and the Civil Rights Movement

Brian Ward and Jenny Walker

In August 1967, Martin Luther King Jr addressed the annual convention of the National Association of Television and Radio Announcers (NATRA) – an increasingly radical organisation of black deejays which in the late 1960s was at the forefront of a campaign for more 'responsible' and politically engaged black-oriented broadcasting in the United States. In his home town of Atlanta, Georgia, King commented on the crucial role radio played in the lives of African-Americans:

> I have come to appreciate the role which the radio announcer plays in the life of our people; for better or for worse, you are opinion makers in the community. And it is important that you remain aware of the power which is potential in your vocation. The masses of Americans who have been deprived of educational and economic opportunity are almost totally dependent on radio as their means of relating to the society at large. They do not read newspapers, though they may occasionally thumb through *Jet*. Television speaks not to their needs but to upper-middle-class America. ... Tonight I want to say thank you ... to all of you who have given leadership to our people in thousands of unknown and unsung ways.[1]

King was certainly right to note the importance of radio in the black community. In 1957, it was estimated that 90 per cent of blacks listened to some radio each week, with 75 per cent listening on four or more days; in 1964, 71 per cent of blacks, but only 57 per cent of whites, responded to questions about their leisure activities with the fact that they listened to the radio; a report in the early 1970s concluded that

'black-oriented radio may well be the single most powerful mass medium for reaching the black population of this country'.[2]

Focusing principally on the years between 1945 and 1970, this article considers the development of southern black-oriented radio in terms of its racial, economic, political and cultural coordinates. While seeking to demonstrate the positive role radio could play in promoting and reporting black activism after the Second World War, it is also concerned to examine the combination of structural and contingent factors which prevented the airing of more explicitly 'engaged' news and public affairs programming for blacks during the Civil Rights and Black Power eras, and which circumscribed the contribution of the medium to the black struggle.

Two major factors shaped the dramatic expansion of black-oriented radio in the South – and beyond – after the Second World War. The first was the 'discovery' of a growing, concentrated and increasingly affluent black consumer market. The increased urbanisation of southern blacks meant that even small wattage stations in key locations could reach vast numbers of black listeners – listeners whose average income, although still sorely depressed relative to whites, was nonetheless increasing more rapidly. Local and, increasingly, corporate advertisers extended their support of black-oriented programming in line with this burgeoning purchasing power. By 1961, nine million dollars were spent advertising on black-oriented radio; by the end of the decade the figure was $35 million.[3]

Potential advertisers were also encouraged by the frequency of black radio usage. By 1957, even the rural South could claim black radio ownership levels of between 75 and 85 per cent, with much higher percentages in the cities.[4] Moreover, various analyses revealed that recall of advertisements and all other types of information among blacks tuned to black-oriented stations was much higher than for blacks tuned to general radio; much higher also than for whites tuned to general radio.[5] Some estimates claimed that the number of purchases attributable to commercials on black-oriented radio was nearly twice that of mainstream radio.[6] In sum, the southern black audience listened often and attentively to the radio, but it listened longer and more attentively to black-oriented programmes.

The second major factor in the growth of post-war black-oriented radio was the partial collapse of the old triumvirate of Tin Pan Alley publishing houses, major record companies and radio networks which had largely controlled American entertainment broadcasting since the 1920s. This decline was precipitated by the phenomenal rise of television and the emergence of a whole range of independent recording companies, like Atlantic, King, Imperial, Specialty and Chess, which specialised in

cutting rhythm'n'blues music, initially for an almost exclusively black record-buying public. From the late 1940s, radio programmers began to explore the minority markets which television, with its overwhelming emphasis on middle-class white audiences, did not serve at all and mainstream radio served badly. Just as the independent recording companies exploited the gaps in the services provided by the major recording companies, so a new breed of radio stations emerged in concert with them, often heavily dependent on their products, to cater to neglected sections of the radio audience, most notably blacks.

By 1956, just nine years after WDIA-Memphis switched to an all-black format – the first station in the US to do so – there were 28 radio stations in America with all-black programming, 22 of them situated in the deep and rim South, and 24 stations in the region which broadcast over 30 hours a week of black-oriented programming. Many more southern stations offered at least some regular black programming.[7]

Reflecting the economic underdevelopment of the black South, ownership and management of these stations and the bulk of sponsorship for individual shows remained predominantly white. However, there were small signs of a growing black presence in the financing, management and administration of black-oriented radio, with appointments like that of Rev. L. H. Newsome as head of religious broadcasting and advertising at WOKJ-Jackson, Mississippi.[8] In 1949, Jesse Blayton, a wealthy Atlanta accountant and financier, became the first African-American to own a station in the United States when he purchased WERD from some white business associates for $50,000. Whereas in 1948 no blacks had held stock in any southern radio outlet, by 1954 not only WERD and WDIA, but also WEDR-Birmingham, WBCO-Birmingham/ Bessemer, WNOE-New Orleans and WSOK-Nashville had some black stockholders. Nevertheless, by 1960 there were still only four black-owned radio stations in the whole country and a decade later at most fourteen.[9]

While the overwhelmingly white ownership and senior management of 'black' radio and the need of all broadcasters to attract white, as well as black, advertisers inevitably had a profound effect on the content and tenor of the programming, it is important to stress that the meaning and significance of those broadcasts for the black community frequently transcended the simple economics and racial politics of their production. The 'meaning' of black-oriented broadcasts was also dependent on the specific nature of the material aired, coupled with the manner in which that material was interpreted and consumed by black listeners.

This is well illustrated by the case of 'King Biscuit Time' on KFFA-Helena, Arkansas, featuring bluesman Sonny Boy Williamson. In purely economic terms, the show emerged in the early 1940s as a result of white station-owner Sam Anderson's need for sponsors, Interstate Grocer Co. proprietor

Max Moore's desire to advertise a new brand of flour in Phillips County, whose population was two-thirds black, and Williamson's need for a job and a means to promote his forthcoming appearances. Yet the 15 minutes of 'King Biscuit Time' at 12.15 p.m. every weekday soon acquired a currency and significance within the black community far beyond the initial commercial purposes of Moore, Anderson or Williamson. Millworker J. C. Danley admitted to Mark Newman that he was no great fan of the blues, but that he and his community had responded enthusiastically to a black voice on the radio. 'We never heard blacks on the radio 'cause Sonny Boy was the first ... something we had never been able to witness ... When Sonny Boy Williamson came on, we would turn that on because he were black.'[10]

The history of WDIA-Memphis similarly reveals how essentially economic motivations on the part of white businessmen could provide a showcase for black culture, limited employment for blacks as announcers and staff, and a social institution which resonated, albeit imperfectly at times, to the changing moods of the black community. WDIA opened on 7 June 1947, and, after a disastrous year trying to penetrate the Memphis pop radio market, white co-owners John Pepper and Bert Ferguson moved gradually to an all-black format.[11]

Blacks bought an estimated 40 per cent of the merchandise sold in Memphis, and the success of WDIA depended on its ability to attract a large and prosperous enough proportion of that 150,000-strong black population to convince Memphis businessmen to advertise on the station. As *Variety* pointed out, the use of black deejays and the programming of rhythm'n'blues immediately helped to rally this segregated southern black audience:

> The Negro disk jockey has a much stronger standing in the colored community, particularly in the South, than the ofay platter pilots have generally due to the social situation. This influence over their listeners is proportionately stronger and that explains why their shows are solid commercial stanzas ... Their accent on R and B platters stems from that music's widespread and almost unique acceptance by Negro audiences.[12]

Ferguson and Pepper recognised and shrewdly exploited this racial loyalty by hiring almost exclusively black on-air staff at WDIA, although there were still no blacks in key managerial or executive positions at the station. Deejays like Nat D. Williams, Maurice 'Hot Rod' Hulbert, Theo Wade and Rufus Thomas became 'personality deejays'. Ferguson, meanwhile, orchestrated a 40,000-flyer mailshot to black Memphis, encouraging racial pride in this black-oriented, largely black-staffed

operation and in the process ensuring the loyalty of a large audience for prospective advertisers. By 1956, in Memphis it was heard regularly in 70 per cent of black homes.[13]

Black deejays and announcers like those on WDIA, Ernie 'The Whip' Brigier in New Orleans, Bruce 'Sugar Throat' Miller in Winston-Salem, Bill Spence in Indianola and Professor Bop in Shreveport assumed a function in the southern black community beyond that of simple entertainers. Simply by playing black music, speaking in the distinctive argot of the black streets and fields, promoting black concerts and dances, reporting on the achievements of local and national black leaders and celebrities, and announcing the latest community news, they helped to define what was distinctive about black culture and to legitimise it as something unique and valuable. Thus they contributed to a growing sense of black identity and encouraged the new mood of pride and assertiveness which the southern civil rights movement sought to harness politically.

Vernon Winslow, the highly influential black broadcaster who created the 'Poppa Stoppa' show for WMJR-New Orleans in the late 1940s, but who was not allowed to appear on air because of the station's lily-white announcer policy – Winslow was required to teach white announcers to 'talk black' – recognised that the essentially segregated nature of southern black broadcasting in the 1940s and early 1950s had actually made it more responsive to and reflective of a uniquely black experience and culture. 'The language was for insiders, most white folks couldn't understand it so it became a unique identity and people were proud of it as a way to show solidarity and brotherhood.'[14]

During this period, religious broadcasts for southern blacks were similarly important in stimulating a new sense of dignity and pride. There was a whole range of radio preachers, black and white, who were extremely popular with southern black listeners and therefore sponsors. From Keith Miller's scholarship we know that southern blacks, not least Martin Luther King Jr, heard the radio sermons of eminent white liberal preachers like Harry Fosdick and Ralph Sockman and responded enthusiastically to their emphasis on the social gospel and condemnations of prejudice and discrimination.[15]

Perhaps even more compelling and influential for the southern black masses were the broadcasts of black preachers, like the Catholic Primate, Archbishop Ernest L. Peterson, who broadcast for about twenty years on WMBM-Miami and the Rev. John W. Goodgame, who preached regularly on air from the Sixth Avenue Baptist Church in Birmingham.[16] William Holmes Borders, the pastor of Atlanta's Wheat Street Baptist Church, was perhaps the most important of these radio clergymen, openly protesting discrimination and promoting a doctrine of universal brother-

hood and racial equality in his Sunday evening sermons on WAGA and WGST-Atlanta. In one sermon, Borders assured his listeners that, 'the rugged fact that "All Blood Is Red" blows asunder the position of racial or national superiority', and proceeded to chronicle the remarkable achievements of 'Negroes' in every sphere of human endeavour.[17]

The religious broadcasts of preachers like Fosdick and Borders, with their emphasis on human dignity, brotherhood and equality, their espousal of variants on the social gospel, pacifism and even occasional positive invocations of Gandhi, fused with African-American Christianity to help lay the ideological and tactical foundations for the mass southern movement of the 1950s and 1960s. The southern black pulpit, occupied with such vigour by the likes of 'Daddy' King, Vernon Johns and Benjamin Mays, was, of course, vital in that educative process, but it is also likely that religious broadcasting played a greater role in preparing and predisposing ordinary black southerners to participate in a massive campaign of civil disobedience and protest than has been fully appreciated by movement historians.

Because of their high standing in, and special access to, the black masses, there was always a certain latent potential for black broadcasters, sacred and secular, to provide some kind of political and economic leadership in their communities. Certainly, there were efforts to realise that potential and deploy radio in the social, political and economic struggles of southern blacks. It is striking how many black teachers and educators found their way onto the air in the South, often hosting 'educational' programmes dedicated to black history, achievements and current affairs which helped to raise collective black consciousness and pride. Nat Williams chaired an important discussion forum, 'Brown America Speaks', on WDIA, while the same station's 'Call For Action' slot provided practical advice to Memphis blacks on dealing with landlords and government agencies. Black educator, Jerome Stampley, presented a showcase for black accomplishments on WQBC-Jackson, Mississippi, while Atlanta University professor William Boyd offered a daily round-up of 'black' news gleaned from W. A. Scott's black Atlanta newspaper, the *Daily World*, on WERD.[18]

Dr J. S. Nathaniel Tross's 'Community Crusaders' show – 'the best programme we had', according to WBT-Charlotte's white programme director, Charles Crutchfield – began in the late 1930s and claimed partial credit for various concrete improvements in the conditions of the black community in that city during the following decades. Illustrating the sort of tentative racial progress within segregation which was typical of much of the urban South during the decade or so before *Brown v The Board of Education* (the historic decision outlawing segregation in public schools), 'Community Crusaders' orchestrated a successful black

campaign for the appointment of black policemen and truant officers, the creation of a black park and other recreational facilities and the formation of black scout troops.[19]

Tross, publisher of the *Charlotte Post* and pastor of China Grove AME Zion Church, primarily used his show to promote positive images of blacks and encourage greater interracial understanding and cooperation. This was the area in which southern black broadcasters were often deemed to offer the most effective contribution to improved race relations. In 1950, the black magazine, *Our World*, paid due deference to the South's sensitivity to outside interference in its racial affairs when reporting that 'many southern civic leaders are of the opinion that Negroes on the air have done more to better racial understanding in one year than hundreds of orators from "up north" in the last decade'.[20]

There was, however, a certain caution and conservatism in Tross's broadcasting which was typical of southern black-oriented news and public service radio. While it highlighted problems in the black community, 'Community Crusaders' rarely referred directly to white racism and discrimination in explanation of those problems. Instead, Tross gently appealed to the desire of southern white liberals and business leaders to improve the region's entwined reputations for racial and economic backwardness. This acceptance of a gradualist, conciliatory, approach to racial change later won Tross a reputation as something of an 'Uncle Tom' – not least because white Charlotte was so obviously appreciative of his efforts, dubbing him the 'Ambassador of Goodwill' in May 1950 when gratefully presenting him with a new automobile.[21] 'He talked about the rights and wrongs that were being perpetrated,' recalled Charles Crutchfield. 'And he was later ... given credit for actually lifting Charlotte, this whole area, above the rest of the South. We had practically no problem at all. We had one incident that was bad, but our school integration went very smoothly and Tross was one of the people given credit for that.'[22]

Very occasionally, black-oriented broadcasters or their guests went beyond reportage and the much-needed celebration of black culture and achievements, and actually attempted to mobilise and direct black southerners politically. In 1945 Charlotte's Bishop Dale mounted a campaign to be the first black elected to the city council via appearances on WBT, prompting the city managers to reintroduce a simple 'at-large' electoral system and thus effectively thwart Dale's candidacy, which had depended on his command of a single overwhelmingly black ward.[23]

A few bold black-oriented broadcasts even condemned southern racial mores and practices outright. In 1949, for example, WJXN-Jackson

carried a speech by Washington attorney Belford W. Lawson to a Jackson State University fraternity, in which he unequivocally demanded 'the total abolition of segregation and discrimination everywhere'.[24] By the 1950s all the major Civil Rights organisations were employing radio to dramatise the gap between American egalitarian ideals and actual racial practices in the South. The Urban League, for example, regularly used the syndicated 'Wings over Jordan' and 'Southernaires' gospel shows, as well as hiring time on black-oriented stations like WERD and KOKY-Little Rock.[25] National Association for the Advancement of Colored People (NAACP) national president Arthur Spingarn used his guest spot on the 'Southernaires' show to denounce the evils of racism, while the Association sought to eradicate stereotypes and promote positive images of blacks on the radio by compiling a list of 'the words which are objectionable to Negroes,' and of 'concepts of the Negro as being any more lazy, amoral or immoral than other persons or any more addicted perpetually to the use of dialect and the eating exclusively of watermelon and chicken'.[26]

In the summer of 1953, less than a year before *Brown*, Anna Kelley, executive secretary of the black YWCA in Charleston, South Carolina, told a workshop on school desegregation at the Highlander Folk School in Monteagle, Tennessee, that the 'Y' planned a series of radio broadcasts to 'prepare a favorable climate in our community for the Supreme Court decision'. Thirteen of these broadcasts were eventually carried on WCSC-Columbia, South Carolina.[27] Clearly for Kelley, radio was destined to play a major role in the impending desegregation of the South. Given the tradition of tentatively 'engaged' southern black broadcasting in the heart of the Jim Crow era, she might be forgiven for expecting that, as the southern Civil Rights movement flourished in the aftermath of *Brown* and the Montgomery bus boycott and swept across the region in the early 1960s in an irresistible wave of sit-ins, freedom rides, voter registration drives and local direct action campaigns, the political content of black broadcasts would increase to reflect, perhaps even help direct, this growing militancy.

It is certainly true that southern radio – black- and white-oriented – did play a significant, ambiguous and still relatively unexplored, part in reporting and sometimes shaping the southern movement. For example, in August 1960, NAACP Youth Council adviser, Clara Luper, partially orchestrated the boycott of segregated stores in downtown Oklahoma City, via a local black-oriented radio station.[28] When state officials and a white mob sought to prevent James Meredith becoming the first black to register at the University of Mississippi, white preacher Robert Walkup of the First Presbyterian Church in Starkville – who claimed a sizeable black listenership for his regular Sunday morning

broadcasts – bravely went on air to denounce the white intolerance, hatred and arrogance which masqueraded as a noble commitment to states' rights in his home state.[29]

Individual black deejays played their part in particular campaigns. For example, in Birmingham, Martin Luther King credited deejay 'Tall' Paul White of WENN with a major role in mobilising the city's young blacks and encouraging the maintenance of nonviolent discipline among the majority of participants in the struggle against 'Bull' Connor and the forces of segregation.[30] Individual stations and their owners also played a role. There are apocryphal stories about Martin Luther King's relationship with WERD, the black-owned radio station which shared premises with the Southern Christian Leadership Conference (SCLC) in Atlanta. Legend has it that when King wanted to make public announcements in the city, he simply rang upstairs to the on-duty WERD deejays, who would then lower a microphone out the window, down the three floors to King's office window, from where he would speak. Certainly, WERD frequently waived, or substantially reduced, charges to the SCLC, Urban League, NAACP and Negro Voters League for their announcements.[31]

This secret history of explicit, direct, connection between southern protest and the radio clearly merits more thorough investigation than is possible here. Nevertheless, the fact is that such overt political engagement by black-oriented radio in the South remained excep-tional, even at the height of the Civil Rights and Black Power eras. Indeed, it appears as if the quantity and quality of news and public affairs broadcasting on black-oriented radio in the South actually declined during the decade or so after *Brown*, as southern black radio became increas-ingly characterised by an almost relentless diet of rhythm'n'blues and soul, alleviated only by traditional gospel and religious slots on Sundays and parsimonious weekday helpings of jazz, talk shows, and current affairs programming.

As the 1960s progressed, black activists and their white allies became increasingly critical of this preoccupation with soul music and the relentless invocations of soul brotherhood, especially in the absence of quality news and public service broadcasting on black-oriented stations. There was a fear that the sort of cultural pride and solidarity promoted by soul radio might atrophy and become a dead end in itself; that the black community's new capacity to feel good about itself might transmute into a sort of souled-out complacency, rather than acting as the catalyst for effective challenges to the continuing black predicament. 'Do we need 24 hours of James Brown?' asked William Wright of the Unity Housing Project in Washington and founder of Best Efforts For Soul in Television (BEST). 'We need to talk about drug addiction, about slum

landlords, about jobs, about education. But the white man gives us 24 hours of "soul" because it pads his already stuffed pockets and keeps black people ignorant.'[32] Arthur Chapital, director of the NAACP chapter in New Orleans similarly complained, 'I hear news analysis from Huntley, Brinkley, from Wall St, but no analysis for blacks ... We can't get a total picture of the black community in the country without such analysis.'[33]

It was this conspicuous lack of attention to black community affairs and the absence of accurate news coverage of black protest which, in the late 1960s and early 1970s, motivated a diverse range of organisations like NATRA, BEST, the National Black Media Coalition, the Citizens Communications Center, the United Church of Christ, SCLC and NAACP to campaign for greater attention to black social, political and economic matters on the air. These campaigners sought to encourage black broadcasters and the handful of black station-owners to assume a more conspicuous and dynamic role in community affairs. They also worked to increase the numbers of such black owners and senior management in the industry, believing that this was the key to realising black-oriented radio's latent political potential. 'For blacks to gain control of a significant portion of the electronic media,' insisted Charles Hamilton, '... would be the most important single breakthrough in the black struggle, and would justify every bit of time, talent and resources expended towards its achievement'.[34]

Despite these diverse and earnest initiatives, soul and other forms of music retained their clear ascendancy on southern black-oriented radio. By the early 1970s, typical stations like WYLD-New Orleans still devoted more than 90 per cent of their airtime to music and most others programmed over 70 per cent. Nationally, less than five per cent of black-oriented airtime was allocated to news and public affairs – considerably less than stations like WDIA and WERD had provided in the early 1950s.[35]

The failure of black activists to secure more attention and commitment to the economic, social and political travails of the black community on southern black-oriented airwaves during the Civil Rights and Black Power eras was the consequence of a complex pattern of structural, economic, racial and historical forces. The most obvious way in which the political potential of black radio was circumscribed had to do with the economic structure and ownership patterns in the industry. In the 1940s and 1950s, individual black broadcasters were often required to buy airtime from stations and then broker it to their own advertisers. Consequently, they were not always employees of the stations in a regular, salaried sense. Nevertheless, they certainly didn't own those stations – indeed, Vernon Winslow did not even own his microphone name and persona, Dr Daddy-O, which was the property of the Jackson Brewing

Company.[36] The fact is that most black announcers and deejays were in thrall to white owners, managers and sponsors.

The predominance of white executives in black-oriented broadcasting meant that there were seldom any plans to utilise the medium to promote or support black activism among those people in power in the industry. It is important to recognise that the initial expansion of black-oriented radio in the South had occurred during a particular phase of that region's history when the most overt racial tensions were partially eased into the background: a period of relative racial quiet before the reactionary storms unleashed by *Brown*, the Montgomery bus boycott and the Little Rock school crisis. During this period of deceptive calm, southern businessmen, whose main concern was to participate in the economic boom being enjoyed elsewhere in America, shuffled their racial and economic priorities. Yet, even if for a while they were able to downplay the race question, they did not suddenly abandon their racial prejudices. Rarely did they endorse or join, let alone spearhead, the campaign for black equality. J. Edward Reynolds, owner of WEDR-Birmingham, was typical in announcing the station's intention to 'stay completely out of politics,' while paternalistically maintaining that, '... We've established WEDR to help the Negro ... Birmingham Negroes need WEDR. They need it for their own advancement as well as for their entertainment.'[37]

In his *Memphis World* newspaper column, Nat Williams explained that Bert Ferguson and John Pepper were not driven by feelings of racial enlightenment or philanthropy in switching WDIA to the service of the black community in Memphis. 'They are businessmen. They don't necessarily love Negroes. They make that clear. But they do love progress and they are willing to pay the price to make progress.'[38] Even when southern white owners like Ferguson did permit the airing of news programmes, discussion forums and public service announcements which touched upon the racial situation, or supported various community projects like black Little League baseball teams and a local hospital, the commercial wisdom of doing so was never far from their minds. Thus, Ferguson warned those who might neglect the 'social' aspect of running a black-oriented station that it 'will cause the weakness or failure of many an operator who thinks that the key to the mint in the negro market is a few blues and gospel records, and a negro face at the mike'.[39]

The crux of the matter was that white sponsors, station-owners and programmers consistently eschewed 'controversial' broadcasts to blacks because of the hostility they might arouse from their southern white brethren. The condemnatory messages WDIA received upon its switch to a black format – although less vicious or widespread than some had feared – suggested that any programming of and for blacks carried

some risk of white disapproval, while southern network affiliates had a long tradition of withdrawing support for shows which offered too much in the way of commentary on racial matters or presented blacks in particularly positive or assertive roles – as had happened to black singer Ethel Waters in the 1930s.[40] When, in 1935, WMC-Memphis had scheduled a programme on 'The Catholic Church and the Negro Question', threatening white phone calls ensured that the show was never broadcast. In 1939 the same fate befell an NAACP-sponsored show on WCAO-Baltimore, when the management discovered that segregation at the University of Maryland was among the topics for discussion.[41] After the War, Arthur Spingarn's anti-discrimination plea on the 'Southernaires' show created such an outcry in the South that the guest spot on the show was cancelled. The destruction of WEDR's antenna by Klansmen and the constant threat of white boycotts of stations or sponsors associated with black militancy on the airways served as reminders of the consequences for those who overstepped the mark and ensured that public interest broadcasting for blacks was invariably very conservative.[42]

After *Brown* and Montgomery, as both black activism and white resistance grew, this traditional reluctance to court controversy by discussing or reporting the race issue became even more pronounced. Bert Ferguson was certainly worried about becoming more conspicuously involved in the Civil Rights struggle, commenting after *Brown* that, 'I think that we're doing enough, and we'd rather move ahead as we've been moving in race relations than get involved in that, where we couldn't do anything anyway.'[43] At KOKY-Little Rock, manager Eddie Phelan felt that, 'by serving the black community as an entertainment and news medium and not committing ourselves in the controversial problems, we can serve best. When you choose one side you alienate people.' More specifically, he noted, you alienate advertisers.[44]

Both directly and indirectly, the campaign of Massive Resistance by which the white South sought to preserve segregation, created further restraints on the political content of black-oriented radio. In an era which witnessed intense scrutiny of, and often action against, any organisation or institution which might effectively help the black struggle and which demanded strict conformity to white supremacy, advertisers, station-owners, managers and programmers became increasingly sensitive to any suggestions that their broadcasts might be reporting, let alone facilitating or encouraging, the revolt against Jim Crow. Ironically, this paranoia about the content of southern black-oriented radio was intensified by the controversy over rock'n'roll music, a cultural development which had initially seemed to augur well for the future of southern race relations.

As rhythm'n'blues emerged from the segregated black community in the early-to-mid-1950s to realign the popular music tastes of white American youth, black-oriented radio played a crucial role. The broadcasts of southern black rhythm 'n' blues deejays, together with those of their hip white colleagues, like Dewey Phillips on WHBQ-Memphis, John Richbourg on WLAC-Nashville and Zenas Sears on WOAK-Atlanta, helped to make possible the chaotic black–white exchanges, thefts, fusions and homages which characterised the new musical hybrid: rock'n'roll. Moreover, there was initially a mass black enthusiasm for the biracial rock'n'roll phenomenon which has largely been erased from the historical record. As has been noted already, any black presence on southern radio was viewed as a potential catalyst for greater racial understanding, and such beliefs only intensified in the decade after *Brown* as black rhythm'n'blues, rock'n'roll, pop and soul gained exposure, first on black-oriented shows and later on mainstream pop programmes.

In the summer of 1955, Howard Lewis, a southwestern dance promoter, reported that rhythm'n'blues 'has become a potent force in breaking down racial barriers', while that winter, the black magazine, *Our World*, commented unequivocally, 'It's bringing the races closer.'[45] Herbie Cox, lead singer of the New York vocal group, the Cleftones, who toured the South in the late 1950s, really believed that 'disk-jockeys and record distributors were doing more for integration than *Brown versus the Topeka Board of Education*'.[46] A decade later, Martin Luther King was equally convinced that the desegregation of popular music and dance had helped to create a favourable environment for racial progress. In 1967, he assured the black deejays gathered in Atlanta, 'School integration is much easier now that [blacks and whites] share a common music, a common language, and enjoy the same dances. You introduced youth to that music and created a language of soul and promoted the dances which now sweep across race, class and nation.'[47]

White segregationists viewed the breakthrough of rock'n'roll in much the same way, if from a rather different perspective, and organised a vigorous campaign against rock'n'roll and the southern radio stations which carried it. Asa Carter, the leader of the North Alabama Citizens' Council, spearheaded this campaign, denouncing rock'n'roll for its 'coarse negro phrases', which eroded 'the entire moral structure of man ...'. Declaring war on 'b-bop and Negro music', Alabama's Citizens' Councils openly announced their intention to visit those responsible for broadcasting the sort of music which 'promotes the integration of races and demoralizes children'.[48]

Again, this pressure resulted in a much closer examination of what exactly was being broadcast on black-oriented shows than when it was believed that blacks alone listened. As Ralph Bass of King Records noted,

'It was alright so long as blacks were listening, but as soon as the whites were listening, it was no good.'[49] After the mid-1950s, 'Censorship ... was very tough. All the people who were on the radio stations were tough because they valued their licenses. If you had a black station you figured you gotta be twice as cool as the other cats, so they were screening everything.'[50] Jim Rundles, a black announcer on WOKJ-Jackson, agreed, 'We knew we were being monitored by the FCC and the "white" stations.'[51]

This trend toward greater management scrutiny and control over the content of black-oriented radio was accelerated by the 'payola' investigations of 1960, themselves a coda to the campaign against rock'n'roll. In the wake of revelations about illegal payments from record companies and distributors to deejays, the FCC compelled station managers to assume greater responsibility for accurate accounting procedures and for monitoring the nature of the material their stations broadcast, which they often did by adopting the tightly-controlled 'Top Forty' formats. Both requirements reduced further the limited independence of black broadcasters, who had enjoyed at least some latitude in programming choices under the old brokerage system. In these increasingly embattled circumstances, the possibilities for southern black-oriented radio to offer accurate news coverage of the Civil Rights and Black Power movements, let alone assert the sort of radical community leadership role which NATRA and the other militants urged, were sorely limited.

By the late 1960s, the militants were still convinced that this situation could be changed and the latent political and social potential of black-oriented radio realised, if only blacks could acquire ownership of more stations and secure greater representation in key management and pro-gramming positions. Yet, while they were correct to identify black-oriented radio as a classic example of black economic underde-velopment and restricted opportunity, their belief that a simple increase of black ownership and senior management would inevitably herald a new era of community responsibility and political leadership was deeply flawed.

The main error the militants made concerned the dominant impulses of entrepreneurial capitalism and, in particular, the motivations and priorities of those few blacks who occupied positions of executive responsibility or proprietorship within the broadcasting industry. Radio stations were expensive to build, buy and operate. Given the cost of entry into the radio industry, those few blacks who did acquire broadcasting facilities, either as individuals or as members of cartels like Sheridan Broadcasting, InterUrban Broadcasting and Inner City Broadcasting, had invariably made fortunes elsewhere. By the early 1970s, this tiny group of wealthy black entrepreneurs had been joined by a corps of black college

graduates, many of whom were alumni of Washington D.C.'s Howard University, where there was a prestigious communications course.[52]

This broadcasting elite constituted an unlikely stratum of black society from which to expect support for radical black programming and politics. This was particularly true in the South, where any conspicuous Civil Rights activism risked incurring the white wrath and the destruction of hard-won, relatively comfortable, if invariably segregated, social and economic positions. It is not necessary to condemn all successful black professionals and entrepreneurs as cynical exploiters and race traitors, to recognise that their willingness to engage in conspicuous support for black protest was often tempered by such personal economic and status considerations, or that specifically racial agendas were often subordinated to, if rarely eradicated by, the eager pursuit of maximum economic rewards.

In 1969, for example, Jesse Blayton, the owner of WERD-Atlanta, having decided that his station was no longer profitable enough, saw no problem in selling it to the highest bidder, the white-owned Radiad Inc., despite the pleas of Chuck Stone, president of the National Conference on Black Power, that he wait until a way could be found to retain it under the control of the black community. This was entirely in keeping with Blayton's hardnosed, commercial agenda. Blayton had always been calculating and conservative when it came to supporting, or even reporting, black activism on air. WERD, for example, was one of the many black-oriented stations in the South, including KCOH-Houston and WILA-Danville, Virginia, which routinely censored news of black urban unrest.[53] While he was not unaware of the social and, possibly, political potential of his station, nor immune to the pull of racial solidarity, this was not his principal purpose in running a radio station. Rather, Blayton saw WERD 'as a medium for bringing together black people ... economically, as well as socially. It didn't.'[54] Regardless of its cultural or political value to the black community, Blayton sold WERD when it no longer served his own economic interests.

Jesse Blayton was by no means unique in putting profits ahead of racial politics. Throughout the history of black-oriented broadcasting, most other black owners, announcers and executives have shared his sense of priorities. In 1953, Leonard Evans established Negro Network News to provide a coordinated news service for black-oriented stations. 'This is not a crusade for the intermingling of the races', Evans assured prospective southern advertisers and affiliates. 'We're out to move tonnage, to sell merchandise. If we do help race relations it's incidental.'[55]

In large measure the story of the relationship between black-oriented radio – white- and black-owned – and the southern Civil Rights movement was one of just such 'incidental' help. It is the story of how

essentially commercial interests coincided with and encouraged the promotion of a racially-specific, but inherently conservative, form of broadcasting. In the decade after the Second World War, black-oriented programming in the South secured the special loyalty of black consumers, and therefore attracted investment and sponsorship, because it alone regularly featured black performers and addressed particular black interests and concerns. Similarly, in the 1960s, a mild form of 'black is beautiful' nationalism and the relentless programming of soul music secured a unique identity for soul radio by distinguishing it from the all-pervasive Top Forty pop stations. Again, this allowed advertisers to target effectively a market niche which had some $27 billion of spending power by 1966.[56] The periodic creation of distinctively black broadcasting environments was thus the consequence of broad economic impera-tives, not of some ideological commitment to the use of southern black radio as a vehicle for racial politics and protest.

Moreover, regardless of the economic, legal and terrorist constraints imposed upon 'engaged' black broadcasting in the South, it has always proved extremely difficult for the handful of black activists in positions of influence within the radio industry to impose their ideas of 'relevant' broadcasting on black audiences who listen primarily for 'entertainment' – although the special place 'entertainment' has occupied in black life as a focus for communal identity and a vehicle for resistance to white cultural domination must be fully acknowledged. Problems relating to black audience expectations and uses of radio continue to plague those who would use black-oriented radio for overtly political or educative ends in the South. In 1982, for example, the black, Chicago-based, Inter Urban group of broadcasters bought WYLD-New Orleans and tried to introduce community news, public affairs and discussion programmes into the station's all-music format. By 1987, Inter Urban president James Hutchinson partially blamed this commitment for the fact that WYLD was losing the war for black listeners against WQUE, a white-owned New Orleans station with a non-stop music format.[57] Despite the efforts of organisations like the Young Black Programmers Coalition and the Minority Division of the National Association of Broadcasters, most of the 91 black-owned stations on air in the South in 1992 remained overwhelmingly committed to music-based formats. Consequently, the best news and information services for the southern black community are now usually to be found on the 40 or so local, often under-resourced, under-powered, non-profit-making, black public radio stations, or on the region's 50 or so black college stations.[58]

Ultimately, black-oriented radio's strength – and its relationship to the southern Civil Rights movement – was its ability to dramatise and celebrate shared aspects of the black experience, primarily through its

airing of black cultural productions, most notably music and preaching. Thanks largely to the manner of its consumption by the black community, black-oriented radio helped to promote the sense of solidarity and common consciousness which was a necessary pre-requisite for the effective political mobilisation of black southerners in the 1950s and 1960s. It was, however, probably beyond the medium's functional capacity, let alone agenda, to transform such feelings of cultural cohesion and pride into effective political action. That respon-sibility lay elsewhere and, for about a decade after Montgomery, it appeared as if nonviolent direct action and voter registration offered a means to convert such feelings of collective worth and personal empow-erment into a viable campaign for genuine black equality. By the late 1960s, however, despite substantial legislative achievements and the emergence of a powerful black political presence in the South, such hopes and optimism had faded. Since then there have appeared no groups or individuals capable of offering the southern blacks a compelling strategy for effecting meaningful changes in the circumstances of their lives. Whatever its faults, black-oriented radio should not be blamed for that.

NOTES

The authors wish to thank Tom Hanchett, Keith Miller and Steve 'Hot Burrito' Walsh for their help in preparing this essay.

1. Martin Luther King, 'Transforming a Neighborhood into a Brotherhood' (Address to the NATRA Convention, Atlanta, 11 August 1967), *Jack The Rapper*, vol. 13, no. 666, (January, 1989) p. 1.
2. *Radio and the Negro Market* (New York: Radio Advertising Bureau, 1957) p. 5; 'Air Media and the U.S. Negro Market', *Sponsor*, (17 August 1964) p. 36; Anthony Meyer, *Black Voices and Format Regulations: A Study in Black-Oriented Radio* (Stanford: ERIC Clearinghouse, 1971) p. 3. Despite this centrality to the lives of African-Americans, the role of radio remains largely 'unknown and unsung' by historians of postwar southern race relations and the Civil Rights movement. When they have considered the role of the media, historians have tended to focus on television, with its dramatic images of southern white brutality against nonviolent Civil Rights demonstrators, or on the print media, seeking to assess their respective impact on white opinion. There remains, however, very little scholarship on the role of radio, the medium which, as Martin Luther King appreciated, was actually most important to the mass of black Americans.
3. 'The Negro Market; $15 Billion Annually', *Sponsor*, 7 (24 August 1953) p. 66; Richard Kahlenberg, 'Negro Radio', *Negro History Bulletin* (March 1966) p. 128; Mark Newman, *Entrepreneurs of Profit and Pride: From Black Appeal to Soul Radio* (New York: Praeger, 1988) p. 80; 'How to Use Negro Radio

Successfully,' *Sponsor*, (20 September 1954) pp. 54–5; Fred Ferretti, 'The White Captivity of Black Radio', *Columbia Journalism Review*, (Summer 1970) p. 35.

4. Newman, *Entrepreneurs of Profit and Pride*, p. 80.
5. 'Air Media', pp. 31–43; Raymond Oladipupu, 'Black-oriented radio: the problems and possibilities', *Broadcasting* (22 June 1970) p. 18.
6. *A Study of the Dynamics of Purchase Behavior in the Negro Market: Negro Radio Stations*, vol. 2, (New York: The Center for Research in Marketing, Inc, May 1962) pp. 14–23.
7. *Broadcasting Yearbook* (February 1957) pp. 342–4.
8. Julius E. Thompson, *The Black Press in Mississippi, 1865–1985* (Gainesville: University of Florida Press, 1993) p. 56.
9. Gloria Blackwell, 'Black-controlled Media in Atlanta, 1960–1970: The Burden of the Message and the Struggle for Survival' (PhD dissertation, 1973, Emory University) pp. 121–62; Cloyte Murdoch, 'Negro Radio Broadcasting in the U.S.' (Master's thesis, University of Wisconsin, 1960) pp. 97, 325; Stuart Surlin, 'Ascertainment of Community Needs by Black-oriented Radio Stations', *Journal of Broadcasting*, vol. 16, no. 4 (Fall 1972) p. 421; J. Fred MacDonald, *Don't Touch That Dial!* (Chicago: Nelson-Hall, 1979) p. 366.
10. J. C. Danley, quoted in, Newman, *Entrepreneurs of Profit and Pride*, p. 98; also, Ibid., pp. 93–104.
11. For an overview of WDIA's development, see, Louis Cantor, *Wheelin' on Beale: How WDIA-Memphis Became The Nation's First All-Black Radio Station and Created the Sound that Changed America* (New York: Pharos Books, 1992); Newman, *Entrepreneurs of Profit and Pride*, pp. 105–22.
12. *Variety*, 25 February 1953, p. 39.
13. A. Abarbanel and Alex Haley, 'New Audience for Radio', *Harper's Magazine* (February 1956) p. 57; Cantor, *Wheelin' on Beale*, p. 13.
14. Vernon Winslow, quoted in Janette L. Davis and William Barlow, *Split Image: African Americans in the Mass Media* (Washington D.C.: Howard University Press, 1990) p. 218.
15. Keith Miller, *Voice of Deliverance: The Language of Martin Luther King and its Sources* (New York: The Free Press, 1992) p. 44.
16. See Marcus Hanna Boulware, *The Oratory of Negro Leaders: 1900–1968* (Westport: Negro Universities Press, 1969) pp. 279–82.
17. 'All Blood Is Red', in William Holmes Borders, *Seven Minutes At The 'Mike' in the Deep South* (1943; rpt Atlanta: Logan Press, 1980) pp. 16–18. See James W. English, *The Prophet of Wheat Street: The Story of William Holmes Borders: A Man Who Refused to Fail* (Elgin, Ill.: David Cook, 1967) pp. 62–71; also Boulware, *The Oratory of Negro Leaders*, pp. 280–1.
18. See Davis and Barlow, *Split Image*, pp. 211–12; Newman, *Entrepreneurs of Profit and Pride*, pp. 114–19; 'Tan Town Disk Jester', *Tan*, vol. V, no. 5, (March 1955) p. 71; Thompson, *Black Press in Mississippi*, p. 36.
19. Charles Crutchfield, (interview with Lynn Haessly, 1986), Charles Crutchfield Papers, Southern Oral History Collection, University of North Carolina, Chapel Hill (hereafter, Crutchfield Interview); John S. Lash, 'The Negro and Radio', *Opportunity* (October 1943).

20. 'Radio Revolt in the South', *Our World* (February 1950) p. 33; see also, ibid., (May 1951) p. 10.
21. Boulware, *The Oratory of Negro Leaders*, pp. 278–9.
22. Crutchfield Interview; *Charlotte Observer*, 31 March 1971, pp. 1B–2B.
23. See Thomas W. Hanchett, 'Sorting out the New South City: Charlotte and its Neighborhoods' (PhD thesis, University of North Carolina, Chapel Hill, 1993) pp. 458–9; *Charlotte Observer*, 8 April 1957, p. 1B.
24. Belford Lawson, quoted in *Jackson Advocate*, 5 March 1949 (cited in Thompson, *The Black Press in Mississippi*, p. 36).
25. Blackwell, 'Black-controlled Media in Atlanta', pp. 121–62; *Arkansas Gazette*, 14 June 1964. The authors wish to thank John Kirk for this reference.
26. Davis and Barlow, *Split Image*, p. 187; Walter White, memorandum, 16 June 1948, NAACP Papers, II–A-507 (Radio: General, 1943–51 and undated), Library of Congress.
27. Anna Kelley, quoted in Highlander Folk School Papers, State Historical Society of Wisconsin at Madison, Social Action Collection, Reel 33, p. 568, The authors are very grateful to Peter Ling for this reference.
28. Carl Graves, 'The Right To Be Served: Oklahoma's Lunch Counter Sit-ins, 1958–1964', in D. Garrow, ed., *We Shall Overcome: The Civil Rights Movement in the United States in the 1950's and 1960's*, vol. 1 (New York: Carlson Publishing Inc, 1989) pp. 283–98.
29. Robert H. Walkup, 'Not Race But Grace', (a series of three sermons broadcast between 30 September and 7 October 1962 and collected in Donald W. Shriver, Jr, ed., *The Unsilent South: Prophetic Preaching in Racial Crisis* (Richmond: John Knox Press, 1965) pp. 58–71.
30. King, 'Speech to NATRA', p. 1.
31. Nelson George, *The Death of Rhythm and Blues* (London: Omnibus Press, 1988) p. 46; Blackwell, 'Black-controlled Media in Atlanta', p. 130.
32. William Wright, quoted in Bernard Garnett, *How Soulful Is 'Soul' Radio?* (Nashville: Race Relations Information Center, 1970) p. 14.
33. Arthur Chapital, quoted in Meyer, *Black Voices*, p. 12.
34. Charles Hamilton, 'Blacks and Mass Media', *Columbia Forum* (Winter 1971) p. 53.
35. Meyer, *Black Voices*, p. 5; Davis and Barlow, *Split Image*, p. 221.
36. 'Dr. Daddy-O!', *Tan*, vol. V, no. 7, (May 1955) p. 76.
37. J. Edward Reynolds, quoted in 'Dream Radio Station', *Black World*, vol. VIII, no. 3 (January 1950) pp. 23–4.
38. Nat Williams, quoted in Margaret McKee and Fred Chisenall, *Beale Black and Blue* (Baton Rouge: Louisiana State University Press, 1981) p. 93.
39. Bert Ferguson, quoted in 'Negro Radio: 200-plus Special Stations', *Sponsor* (24 August 1953) p. 79.
40. Cantor, *Wheelin' on Beale*, p. 48; Davis and Barlow, *Split Image*, p. 212; ibid., p. 183.
41. Ibid., pp. 186–7.
42. Ibid., 'Dream Radio Station', pp. 23–4.
43. Bert Ferguson, quoted in Cantor, *Wheelin' on Beale*, p. 3.
44. Eddie Phelan, quoted in *Arkansas Gazette*, 14 June 1964.

45. *Variety*, 6 July 1955, p. 43; *Our World* (November 1955) pp. 40–3.
46. Herbie Cox, quoted in Philip Groia, *They All Sang On The Corner*, 2nd edn (New York: Phillie Dee Enterprises Inc., 1983) p. 128.
47. King, 'Address to NATRA', p.1. There was a certain naivety here and little evidence to suggest that widespread admiration for black musicians *necessarily* bespoke radically new racial attitudes among the mass of young white Southerners. This, however, does not detract from the fact that blacks initially invested the breakthrough of black and black-derived music into the mainstream of American popular culture and broadcasting with much the same sort of symbolic and political significance which had attended Jackie Robinson's breakthrough into major league baseball.
48. *The Southerner*, March 1956, p. 5; *Birmingham News*, 9 April 1956, p. 9. For a fuller discussion of the links between Massive Resistance and southern opposition to rock'n'roll, see Brian Ward, 'Racial Politics, Culture and the Cole Incident of 1956', in Melvyn Stokes and Rick Halpern, eds, *Race and Class in the American South since 1890* (Oxford and Providence: Berg Publishing, 1994) pp. 181–208.
49. Ralph Bass, quoted in Arnold Shaw, *Honkers and Shouters* (New York: MacMillan/Collier, 1978) p. 243.
50. Ralph Bass, quoted in Michael Lydon and Ellen Mandel, *Boogie Lightning* (1974; rpt New York: DaCapo, 1980) p. 84.
51. Jim Rundles, 'Black Radio Pioneers Were a Breed Apart', pt. 1, *Jackson Advocate*, 18 April 1991, p. 1B.
52. Somewhere near the bottom of the price scale in the South was WORV-Hattiesburg, the first black-owned radio station in Mississippi, which cost Reuben C. Hughes and brothers Vernon C. and Robert L. Floyd $60,000 in 1969. James Brown paid about $500,000 for a prime urban facility, WBBW-Augusta, in 1968. See *Jet* (31 July 1969) p. 47; ibid., (14 March 1968) p. 55.
53. Robert Meeker, quoted in *New York Times*, 11 November 1968, p. 17; *Billboard*, 29 June 1968, pp. 18, 30.
54. Jesse Blayton, quoted in Blackwell, 'Black-controlled Media in Atlanta', p. 157.
55. Leonard Evans, quoted in *Newsweek*, 18 January 1954, p. 51.
56. Richard Kahlenberg, 'Negro Radio', p. 128; 'Advertiser Interest in Negroes Zoom', *Broadcasting*, 7 November 1966, pp. 76–82.
57. Bob Davis, 'Tuning Out', *Wall Street Journal*, 23 September 1987, pp. 1, 16.
58. Compilation by State of Minority-Owned Commercial Broadcast Stations (Washington, DC: The Minority Telecommunications Development Program, United States Department of Commerce, 1992); Davis and Barlow, *Split Image*, pp. 232–44.

9

'Shakin' Your Butt for the Tourist': Music's Role in the Identification and Selling of New Orleans

Connie Zeanah Atkinson

Academics often say that it is only while you are doing a piece of research that you find the kind of research that you would ideally like to do. In my case, I did research in New Orleans for over a decade before deciding that what I was doing was, in fact, research. From 1980 until 1992, I was editor and co-publisher of *Wavelength*, a music magazine in New Orleans. 'Dedicated to New Orleans music', *Wavelength* specialised in extended interviews with members of the New Orleans musical community, along with historical anecdotes, in-depth coverage of the city's many music festivals and cultural activities, as well as listings of musical events in the city. Its readership included subscribers across the United States and in several foreign countries.

In the young discipline of popular music studies, material on music-making in local communities is scarce. As Sara Cohen has said, 'What is particularly lacking in the literature is ethnographic data and micro-sociological detail'.[1] My work in New Orleans pointed out the possibility for a broader definition of research that could include the contribution of people other than professional academics, especially the often overlooked resource of the specialist press. Researchers are often limited, by funding or pressures to submit a thesis, to a short period of research. Since my work was not done through a traditional academic route, and not constrained by the usual institutional structure associated with research projects, I had the opportunity to observe, intimately and at leisure, one of music's most influential communities through time. I was also in a position to examine at first hand the interplay between the international music industry and a local music scene, as well as to

150

observe the global network of music fans, journalists, and musical legends who were attracted to the city by its cultural practices.

This chapter, which focuses on the part music plays in the image and packaging of New Orleans as a tourist site, and the consequences of tourism initiatives on the city's musical traditions and musicians, is a result of my observations and research conducted from 1980 to 1992, a crucial period for the city's cultural industries. A case study of one New Orleans musician is presented to demonstrate how conflicts between local musicians and the tourist industry may be negotiated or resolved.

TOURISM AND THE SOUTH

Music is an often overlooked but powerful conjurer of place. Cohen has called music a 'unique and important resource in the constitution of place and local subjectivity'.[2] People invest intensely in personal, cultural, and national identities through music. Frequently people say music captures the essence of a place. Music is frequently thought of as culture-specific and sounds are often identified in place terms: Texas Swing, the Hawaiian guitar, the Liverpool Sound, and so forth.[3] The American South has been the place of origin for several musical styles that have become international in influence – jazz, blues, country, Cajun, bluegrass, gospel, zydeco. In many parts of the South, regional musical styles have been used as attractions, as towns and cities which may have lost their traditional economic bases open their cultural activities to tourism, with its potential for economic development and urban regeneration.

For many of these places, music provides a context for personal and collective identity, and plays an important role in the development of a distinct culture. What are the consequences of the commodification of these regional styles on traditional music practices and local identity? And to what degree are the musicians passive or engaged players in these activities?

MUSIC AND PLACE IMAGING

New Orleans holds a unique place in the southern landscape. Probably the most Africanised city in the United States,[4] along with its Mediterranean culture and Catholicism, its history of racial ambiguity and Native American integration, it is part of, yet distinct from, the South. The city has long served southern writers as a location of moral counterpoint to the rest of the region. Literary critical writing has explored the

way the city's distinctive culture has been appropriated by fiction writers to render their own themes – for instance, the familiar 'New Orleans as courtesan', the city as a metaphor for the new, decadent South (Tennessee Williams, William Faulkner, Walker Percy) or as a landscape upon which to comment on the irrationality of racial divisions (George Washington Cable, Alice Dunbar-Nelson, William Faulkner).[5]

From these literary texts have emerged images of the city that mark it as an exotic site in popular imagination – a tantalising dichotomy of beauty and ruin, openness and danger, opulence and poverty, vibrant urban core and urban decay. Thus, the impact of *literature* on the way cities and places are recognised and accepted and the influence of *literary* images on the portrayal and development of culture have been studied extensively.[6] However, the relation between *musical* images and place recognition has rarely been studied.

MUSIC IN THE IMAGING OF NEW ORLEANS

No city's image has been constituted and evoked through its music more often than that of New Orleans. The city has one of the longest histories of musical activity in North America, both vernacular and art music, much of it carried out in public settings. Early visitors were often entertained, sometimes shocked, by the measure of musical activity, and the city's reputation grew. In 1802, a visitor to the city remarked, 'New Orleanians manage during a single winter to execute about as much dancing, music, laughing and dissipation as would serve any reasonably disposed, staid, and sober citizen for three or four years.'[7]

As Henry Kmen has written, military and more informal parades, accompanied by brass bands, were an almost daily occurrence from the city's earliest days, and African dances, along with other regional styles, were performed in conjunction with slave markets until the 1850s. When the city's population was only 10,000, it had two full-time opera companies, and dances and balls were held almost nightly. Dance, music, and entertainment from classical to folk were available to people of all classes, slave and free.

Around the turn of the century, different musical sounds converging in the city – Mexican, Cuban, Paris Conservatory, country blues and others – fed the creation of many new musical styles, including what would become jazz. Jazz historians notwithstanding, not all of the city's talented musicians emigrated to Chicago, and though no longer in the national spotlight, music continued to be an integral part of the family and community life of many New Orleanians. The late 1940s and 1950s were periods of intense musical activity, centred in the pre-

dominantly black neighbourhood music clubs, with artists such as Wynonie Harris, Smiley Lewis, Little Richard, and Fats Domino, among many others, inspiring a rollicking new style of music that was influential in the development of contemporary rhythm'n'blues and rock'n'roll.

These musical styles associated with New Orleans – hot jazz, funky rhythm'n'blues – came to evoke images of a certain ribald way of life in the minds of producers of text. Jazz music, denounced in its infancy by some cultural critics as a symptom of moral decay in America, became the city's musical calling card and the film industry's music of choice for accompanying salacious scenes. The raucous activities linked with Mardi Gras and the myth of jazz's 'birth' in the notorious red light district of Storyville fed an idea of the city as a site of continual celebration. Tin Pan Alley tunes and travel writers reinforced this notion of New Orleans and formed an enduring myth of the city. Journalists dubbed it 'The City That Care Forgot'.

For rock'n'roll lyricists, New Orleans has served as a location for stories of intrigue, mystery, sin, often portrayed in the past. Examples are legion: 'New Orleans Ladies', 'Stagolee', 'Bojangles'. From the Rolling Stones' 'Brown Sugar' and the Animals' 'House of the Rising Sun', to Sting's 'Moon Over Bourbon Street' and Dire Straits' 'Planet New Orleans', the city is used as a setting for experiences that often seem out of time, out of reach, out of tune with the mores of middle America. This image, represented through musical text and certain musical styles, persists in scholarly as well as popular imagination. Films such as *Easy Rider, Cat People, Angel Heart, Walk on the Wild Side, Streetcar Named Desire* and countless others reinforced this notion in the public mind.[8]

In this century, this image, derived from a distinct social history, bound up with myth and reinforced from the outside, has been in its turn embraced by the city, rejected and, more recently, embraced again as a means of economic development through tourism.

MUSIC AND CITY TOURISM POLICIES

In the 1940s, city policymakers, after decades of attempting to disengage New Orleans from its association with jazz's antecedents, reversed this strategy and adopted the romanticised image of the city as the 'birthplace of jazz' to attract tourists. As Bruce Raeburn has pointed out, 'jazz pilgrims joined with locals to institutionalize a policy of "enlightened" conservation and preservation of the city's jazz heritage, resulting in museums, archives ... performance halls, and festivals'.[9] But in the 1950s, as streams of hits came out of New Orleans from such rhythm

'n'blues stars as Fats Domino, Little Richard, Lloyd Price and others, the local music industry remained small and fragmented, with little support or interest from the city's business leaders or politicians. As legendary studio owner Cosimo Matassa said, 'Record companies were running from all over the world to record in New Orleans, but no one made any money because we didn't wind up with a homegrown industry.'[10]

In the midst of the 1970s offshore oil boom, the city's tourism initiatives were confined primarily to convention trade, and the city's ribald reputation was considered detrimental to attracting business and developing into a top convention destination. The city concentrated on building facilities (hotels, a convention centre, and the 80,000-seat Superdome) and attracting national political and sports events. Yet, in the mid-1980s, with the oil industry in a downward spiral, the convention centre only partially booked and new hotels standing half empty, the hotels passed a self-imposed $1 room tax to finance the New Orleans Tourism Marketing Corporation. Its brief was to market the city to the *discretionary tourist* – the non-convention visitor.

This commitment to tourism for urban regeneration placed New Orleans in competition with other cities in attracting people for entertainment and leisure activities. The marketing group commissioned research to discover what distinctive quality of the city would be the most competitive. This research indicated that discretionary city travellers list 'excitement' most often as the goal of their travels, and the images of New Orleans as a city of spontaneous celebration, sin and frivolity fed into this. The tourism marketing board decided once again to exploit the city's music image, this time to attract tourism.

Use of Music in Place Marketing

As the tourist board's director put it, 'Music is integral to our marketing plan. Our theme is "come join the parade" and all our television and radio spots use New Orleans music. The whole spirit of the city is summed up in its music.'[11] Instead of encouraging tourists to come and be entertained, therefore, the tourist is invited to participate, join in. This promise of participation creates a different kind of expectation for the tourist, and travel and convention booking agents responded. Faked jazz funerals, Mardi Gras balls, 'spontaneous' brass band parades have become regular features of convention and hotel entertainment, recreating the city's cultural activities for the visitor's enjoyment.

What are the implications of these initiatives for local musicians, and how do they affect the musicians' images of themselves and their city? In an interview on BBC radio before his 1993 Proms performance, jazz

superstar Wynton Marsalis (who is from New Orleans) told a reporter, 'I wasn't into jazz as a kid. I thought it was just shakin' your butt for the white tourists in the French Quarter.'[12] Marsalis's comments reflect the sometimes contentious relationship between the tourism industry and local musicians, and the conflicts that can arise when tourism strategies include packaging complex local cultural activities and rituals for sale.

As cities enter the competitive tourism market, music has been identified as important in what Kevin Robins has termed 'the race between places' to create distinct place identity.[13] But many cultural critics have declared tourism detrimental to creativity in areas of distinctive musical activity. In their influential work on the music industry in small countries, Wallis and Malm wrote:

> All along the line, tourism appears to provide short-term employment advantages but leaves cultural disadvantages. The tourist hotels attract talented musicians who have to play a repertoire suitable for the majority of tourists who come to relax, not to learn the intricacies of [local musical traditions] ...
>
> Few government[s] seem to be concerned about the cultural dangers of tourism. Even those individual officials who expose [sic] concern find it hard to affect the situation. The need for foreign currency gets first priority – the tourists must be given the entertainment it is assumed they want.[14]

These and other commentaries on the impact of tourism on regional musics are often lacking in ethnographic research that could show the degree of involvement of local musicians in the decisions that affect repertoire and musical performance. Are musicians passive pawns in the tourism game? Or are they actively involved in how their music is represented? What patterns emerge in the presentation of local music for tourism in specific places and how does this reflect greater patterns of acculturation, power, and consumption?

There has been little research specifically on the implications of New Orleans marketing policies for musicians and locals. However, in *Wavelength* interviews collected over the last decade, New Orleans musicians often talked about tourism and its implications for the future of the city's music and how they have interacted – and many have refused to interact – with the tourist marketing strategies of the city. The way that New Orleans musicians negotiate with the industry points up ways that through music, issues of political, social, and economic identity, as well as creativity and ownership, can be addressed. Even Wynton Marsalis, despite his early hesitancy to 'shake his butt for the tourists', eventually did get into jazz, but on his own terms, and anyone

familiar with the man and his music would agree that those are very uncompromising terms indeed.

MUSIC-MAKING IN NEW ORLEANS

Although New Orleans has its share of rock bands with dreams of recording success in Los Angeles or New York, the vast majority of musicians in New Orleans develop their music for consumption locally, for a community that uses music in most of its innumerable social occasions, and the majority of musicians, even some celebrated musicians, rely on employment outside music for their main support.[15] Band membership in New Orleans is informal and shifting, and one player may play with several different groups (and a variety of styles) even within one week.

The popularity of New Orleans music in Europe does create occasional opportunities for playing international festivals, and many New Orleans musicians who have never travelled within the United States have travelled to Europe. Musicians often mention 'Europe' as a place of musical discernment where New Orleans music is appreciated, and this reaffirms feelings of local difference and worth. An invitation to play overseas can be seen as a reapprobation and endorsement of their talent and creativity.

When Jim Crow laws swept the South at the turn of the century and racial policies in New Orleans hardened, music became a sphere or domain within which people could achieve a measure of control and expression outside the closed political hierarchy.[16] Music provided and still provides a place for accomplishment and belonging. The late Danny Barker, guitarist with the Cab Calloway Band and mentor to many young New Orleans musicians, often repeated that, 'There was something about playing music that gave you something special.'[17] Musicians often refer to a bond that exists between the city's musicians. Ed Blackwell, drummer for John Coltrane and Ornette Coleman:

> I think growing up in the culture that is New Orleans has a very big part in the way I approach the drums.
>
> For one thing, in New Orleans I was around a lot of music every day, all the time. Music from the parade bands, music from gospel groups on Sunday that would set up on the corner with a tambourine, a guitar and a set of drums, music from all different aspects. Dixieland, rhythm and blues, or whatever.
>
> When I lived in New Orleans, drummers used to practice together quite a bit. I think it was the great respect that musicians had for one another. There was no such thing as any kind of animosity of one musician for another.

Everyone had respect for what the other one's ability was and in that way it was very easy to communicate.[18]

In interviews with New Orleans musicians of all ages, the city is often described as a place of creativity that is undervalued by its municipal authorities. 'An untapped gold mine', one singer called it, and the term became a slogan for the city's music association and other local music initiatives in the 1980s. New Orleans often is referred to in ways that characterise it as blameless, fragile, warm, trusting, misused, and so forth. Mark Bingham, record producer:

> This is not a slow time for New Orleans music, just New Orleans music business ... The music is fine, it's these subhuman business creeps who have destroyed the musicians' ability to get the music out of New Orleans and into the world. So many players in this town have been ripped off that many simply do nothing rather than get robbed again.[19]

Talk of the dangers of being 'ripped off' when venturing outside the city helps mark distinctions between New Orleans and other localities, most often music industry centres. Dr John:

> That's how Detroit got their big start. They imported Wardell (Quezergue) and Smokey (Johnson) and all these cats from New Orleans and held all their ideas and for ten years there was a good twenty or thirty percent of Motown Records' music that was New Orleans influenced ...
> Their contribution was made little by them just using a piece of something, it became distorted; and that was what the American public heard as what funk was. Later when they heard the real shit from New Orleans, it didn't have the impact on them that it should. This is to me a crime.[20]

Musicians often refer to New Orleans as a type of music, though they may be referring to many different styles: 'He's been away for 20 years, but he still plays New Orleans.' Often the city is mentioned in terms of endowing talent or style. Singer Nolan Washington says, 'New Orleans brands local gospel just as surely as it does the music of the Neville Brothers or Dr John.'[21]

Michael P. Smith has named the second line parades, jazz funerals, neighbourhood clubs, vernacular churches, and Mardi Gras Indian gangs as the five basic elements of New Orleans music.[22] Andrew Kaslow has documented how the New Orleans musical community is linked through family ties and membership in social aid and pleasure clubs, carnival organisations, churches, and clusterings of other organisations and institutions.[23] The extensive kinship networks within the musical community of New Orleans are celebrated in Jason Berry's book *Up from*

the Cradle of Jazz.[24] In New Orleans, journalists and musicians commonly describe their music in terms of family relations. Through individuals holding multiple memberships in widely different associations, these connections proliferate, revolving around charismatic leaders, who maintain the continuity of the groups over time.

In sum, as Kaslow has written:

> Through conditions of economic deprivation and social injustice, sociocultural adaptations, including the traditions of benevolent societies, carnival organizations, the ecstatic religions, and music have enriched the lives of Orleanians in ways that have served to give a different focus to the meaning of 'community' than in other settings.

Kaslow described the musical community of New Orleans as composed of 'overlapping thick social and kinship networks that generate a cohesiveness and integration which makes New Orleans atypical of other major American cities'.[25] Especially distinctive is the linking of sacred and secular domains.

GOSPEL

Although primarily known for jazz and rhythm'n'blues, New Orleans also has a large gospel community. The city contains the largest African-American Catholic parish in the United States, and was one of the first places where gospel was performed within Catholic churches.[26] With a few exceptions, such as New Orleans's Mahalia Jackson, whose career blossomed in Chicago, New Orleans gospel groups get little exposure outside the city. Gospel deejay Wilson Howard says, 'These are regular people with jobs who are close to their communities and their families. Most of them don't do it to make money and they don't have the same freedom of movement as other entertainers so they can't uproot.'[27]

Despite its immobility, gospel continues its popularity in New Orleans. Recently, the local newspaper *Gambit* has commented: 'All signs point to gospel music in New Orleans continuing to gain a firmer foothold among its musical cousins in the city and becoming more important to the economic growth of the city.'[28] This is because gospel choirs have become part of the tourist industry's strategy to 'recreate the New Orleans experience for the visitor'. One of the city's premier gospel groups, the Zion Harmonizers, had 15 convention appearances in a two and a half week period last year. Beverly Gianna of the New Orleans Convention and Tourism Commission says, 'New Orleans welcomes approximately 600,000 international tourists a year, and gospel music, as one of the

major original American artforms, is a compelling draw for many of those visitors.'[29] Thus, gospel music has been targeted as an attraction to use in the city's competition with other US cities for the lucrative international visitors market.

Gospel in New Orleans has a long history of performance in a secular environment,[30] perhaps due to the permeability of the New Orleans musical community, as well as the influence of the city's less restrictive Catholicism on this fundamentally Protestant musical practice. Dan Ackroyd's House of Blues, Tipitina's, and other music clubs have gospel nights or gospel Sunday brunches, as do several of the hotels. The sight of thousands of festival-goers in full festival gear, drinking beer and crowding into the gospel tent, is a common, if incongruous event at the annual New Orleans Jazz and Heritage Festival.

'WE'RE NOT SOME BACKDROP'

One of my long-time informants is Lois, a gospel singer, and leader of a gospel youth choir in New Orleans. Lois is an African-American widow, mother of four and grandparent of 13 children, who all sing. Born to a large Protestant family, Lois describes herself as 'Baptist, but all denominations, really'.[31] Her parents were from a small community outside New Orleans. She describes her mother as having some French, Spanish and Native American heritage. 'My grandfather was blue-eyed, very fair and real nice hair. My grandmother was darker, had some Indian in her. My mom had these high cheekbones, pretty hair, and she married my father who was just an ordinary man.' Her father, a carpenter, became a preacher. He was a gospel quartet singer, and taught her brothers to sing 'quartet'. He also taught Lois, and allowed her to sing her first solo in his church when she was five years old. Lois performed for many years with her sisters and nieces. Today, she and her daughters and son are a successful family gospel group. Another group consists of Lois, her children, grandchildren, nieces, nephews, and siblings. One of her daughters tours with rock musician Boz Scaggs.

She says: 'The goal of (our group) was to keep the family together. When you sing together with your family, I don't care how bad your kids are, it keeps this pull in them.'

Although a Protestant, she was choir director at the prestigious Greater St Stephens Catholic Church. She now leads a choir in a very poor neighbourhood miles from her home, 'because they have a greater need, and the talent there would be lost'. She is also a member of several neighbourhood social groups and church organisations, works as a civil servant for the city, and is a member of the city's music commission.

At the age of 54, she entered college with her grandson. She is now working on her Master's degree.

From a small amount of money left to her when her husband died, she formed her first choir, composed of children from the poorest neighbourhoods in the city. She believed it was important for them to perform in the city and to travel, so in her words she 'bullied' local and state officials and politicians for money for concerts and tours. Through these efforts, the choir has travelled to Central America and Europe.

She takes great pride in the success of her choirs, and in the belief that gospel music and singing keep young people out of trouble. She often lobbies city councillors, mayors, and members of Congress to support her projects. On a visit to New Orleans, United Nations ambassador Andrew Young was approached by Lois. 'I saw him resting under a tree. Before I was finished with him, our choir was picked to go to the UN mission in Central America.' She is proud of her political connections and her success in gaining their acknowledgement of her efforts on behalf of her choir and gospel. Scattered through her conversation are references to 'the heritage', music as a resource belonging to the community, an integral part of the community identity. 'Gospel is a part of New Orleans's heritage', she says, 'a part of the culture of the people. We have a responsibility to take care of it.' In this way Lois, and many New Orleans musicians, refer to ownership of the music, and take responsibility for the way music is used.

So, for Lois, her music provides a way of expression of herself and her faith. At the same time she uses music as a way to reinforce family unity, contribute to her community, participate in the political process, and construct various social networks that shape her notions of locality – community, region, nation.

Lois works to get her music (gospel) included in the initiatives of the wider music community. In the 1980s, when several city music initiatives were formed, she took part. 'I will not let gospel be left behind', she said. As a member of the city's music commission, she demands that the wording of city's ordinances and various initiatives substitute the word 'group' for 'band', so that gospel groups will be included. When applying to the National Endowment for the Arts, she was advised to omit the word 'Jesus'. 'I said I will not. We have to learn to respect each other's beliefs. The First Amendment gives me the right.' Like most New Orleans musicians, she is willing to commodify her music, but on her own terms. Her activities are distinguished by continuing negotiation and demands for her rights for herself, her music, and the young people with whom she works. This extends to her work with the tourist industry. Various tourist and convention planners regularly hire Lois and her group to sing. She is anxious to do this, but within certain

parameters. She demands high rates from the tourist industry, though when performing elsewhere her group plays free 80 per cent of the time ('it's not right to charge churches'): 'A lady called me the other day. She said she wanted gospel for her convention, what could she get for $250. I said "a solo". They got enough money to give a convention, they've got enough money to pay us right.'

She is concerned that her music be presented with respect, and is careful about how the event planners use her groups. Lois has been asked to perform in what she refers to as some 'strange' situations, for instance, riding down an escalator in a hotel, or singing on the levee as a riverboat is loaded for a corporate function. How does she feel about performing gospel in all these different contexts? 'Wonderful, because it shows the music's versatile.'

But there are limits. For instance, her groups do not wear robes. 'They're bogged down in their head that a good singing gospel group's got to have robes on. It doesn't make sense. They don't want it to be in church, and yet they want you to put a robe that represents it. Robes don't sing, people do!' She will not hesitate to reject a job if she feels the group is being used for anything but its music. 'We're not some backdrop. Nobody asks Patti LaBelle what she's going to wear when she sings.'

Like many New Orleans musicians, she isn't supported financially by her music, but she would like to be. For example, she would like to become a booking agent, specialising in booking gospel for conventions. Although most of the tourist industry in New Orleans is locally owned, she talks of the industry in terms of 'outsiders', and complains that the tourist industry doesn't connect with the musicians. 'Their network doesn't hook up with ours', she says. 'They have their people, we have our people. They book some kind of old gospel group, then, when they don't work out, they say "gospel doesn't work". I want to be their point person. I'll hook up their networks with our network. If they want a duet, I'll get them the best. If they want a 200-voice choir, I can get them the best. They need to be on that point-person system.' Thus she, like many New Orleans musicians, sees herself in conflict with the decision-makers in the tourist industry. Her efforts to integrate her *music* into the city's mainstream economy and its politics, reflect her efforts to integrate *herself* into these – on her own terms, however.

As a member of a complicated social, kinship, and political network, Lois is typical of many of the hundreds of New Orleans musicians with whom I have talked. She uses music networks to provide coherence, status and stability to her life. She demands her rights as a member of a group (gospel) within the New Orleans music community, and the larger community's political, economic and social worlds.

Her assertiveness as a representative of her music, again not atypical in the New Orleans music community, reflects her belief that her music is the heritage of her people and community, and as such she feels a responsibility to ensure that it is respected. New Orleans and music are interrelated concepts in her world, a context for expression of a collective and personal identity, and she lives in these worlds.

In music-related scholarship, the emphasis on chart performance, record sales, and genre overlooks people such as Lois and in doing so misses what Ruth Finnegan, in her study of music-making in Milton Keynes, refers to as the 'hidden musicians'.[32] Also, the emphasis by scholars on jazz and rhythm'n'blues in New Orleans denies the participation of women, who, for example, are active in gospel in all phases, including organisation and administration.

CONCLUSION

New Orleans is a city facing a period of extreme transition. Deriving its vitality from the black neighbourhoods – the street parades, the Indian gangs, the corner joints and the ecstatic churches – the city's unique musical activities have garnered New Orleans international attention as a travel destination. Yet, ironically, these activities are undergoing increased regulation by the city, and, with the loss of natural neighbourhood environments and the flight of native performers from the city to make a living, the musical community is under extreme pressure.[33]

Equally ironic is that, in a time when New Orleans cultural activities are enjoying their widest international recognition, and the city has mobilised itself for tourism to merchandise these activities, the music community and the tourism industry have as little understanding of each other as ever. The possibilities of these two groups uniting to demand support by the authorities for cultural activities, and in turn building a lasting infrastructure for local cultural industries that will help rebuild the economy of the city, while allowing people to maintain control over their cultural activities, looks like a dream. But New Orleans is, after all, the Land of Dreams.

NOTES

1. Sara Cohen, *Rock Culture in Liverpool: Popular Music in the Making* (Oxford: Clarendon Press, 1991) p. 6.
2. Ibid.

3. John Shepherd, 'Value and Power in Music' in Valda Blundell, John Shepherd and Ian Taylor, eds, *Relocating Cultural Studies: Developments in Theory and Research* (London: Routledge, 1993) pp. 171–206.
4. Gwendolyn Midlo Hall, *Africans in Colonial Louisiana: the Development of Afro-Creole Culture in the Eighteenth Century* (Baton Rouge: LSU Press, 1994).
5. Violet Harrington Bryan, *The Myth of New Orleans in Literature: Dialogues of Race and Gender* (Knoxville: University of Tennessee Press, 1993).
6. Jan Nordby Gretlund, *Eudora Welty's Aesthetics of Place* (Denmark: Odense University Press, 1994); Leonard Lutwack, *The Role of Place in Literature* (Syracuse, NY: Syracuse University Press, 1984); David Kranes, 'Space and Literature: Notes toward a Theory of Mapping' in Karl-Heinz Westarp, ed., *Where? Place in Recent North American Fictions* (Aarhus University Press, 1991); Bryan, *The Myth of New Orleans*.
7. Henry Kmen, *Music in New Orleans* (Baton Rouge: LSU Press, 1966) p. 4.
8. Don Lee Keith, 'New Orleans Music In Film' (series), *Wavelength*, 1984–1987.
9. Bruce Raeburn, 'New Orleans Style: The Awakening of American Jazz Scholarship and Its Cultural Implications' (PhD thesis, Tulane University, 1991) p. 5.
10. John Broven, *Rhythm and Blues in New Orleans* (Gretna, LA: Pelican Publishing, 1974) p. 85.
11. Gary Esolen, interview by author 24 February 1994.
12. Wynton Marsalis, BBC 3 interview, 11 September 1993.
13. Kevin Robins, 'Tradition and Translation: National Culture in its Global Context' in J. Corner and S. Harvey, eds, *Enterprise and Heritage* (London: Routledge, 1991) p. 38.
14. Roger Wallis and Krister Malm, *Big Sounds From Small Peoples: The Music Industry in Small Countries* (London: Constable, 1984) pp. 293–4.
15. Jeff Hannusch, *I Hear You Knockin': the Sounds of New Orleans Rhythm and Blues* (Ville Platte, Louisiana: Swallow Publications, 1990), p. 347.
16. Thomas Fiehrer, 'From Quadrille to Stomp: the Creole Origins of Jazz', *Popular Music*, vol. 10, no. 1 (January 1991) p. 23.
17. Jason Berry, Jon Foose and Tad Jones, *Up From the Cradle of Jazz* (Athens and London: University of Georgia Press, 1990) p. 12.
18. Kalamu ya Salaam, 'Give the Drummer Some: Interview of Ed Blackwell' *Wavelength* (April 1988) p. 35.
19. Mark Bingham, 'It's All Music', *Wavelength* (July 1985) p. 8.
20. Hammond Scott, 'Dr. John on Mac Rebennack', *Wavelength* (November 1981) p. 13.
21. Teresa Askew, 'The Gospel Truth', *Gambit* (29 March 1994) p. 15.
22. Michael P. Smith, *A Joyful Noise* (Dallas: Taylor Publishing, 1990) p. 206.
23. Andrew Jonathan Kaslow, 'Oppression and Adaptation: The Social Organisation and Expressive Culture of an Afro-American Community in New Orleans, Louisiana', (PhD thesis, Columbia University, 1981).
24. Berry, et al., *Up From the Cradle*.
25. Kaslow, 'Oppression', p. 2.

26. Joyce Marie Jackson, 'Singing His Praises in the Crescent City: The Dynamics of African American Gospel Music in New Orleans', *Louisiana Folklife*, vol. XVII (1993) pp. 38–44.
27. Askew, *Gambit* (29 March 1994) p. 15.
28. Ibid., p.16.
29. Ibid., p.16.
30. Jackson, 'Singing His Praises' p. 41.
31. This and all further quotations are from several interviews with informant held in 1992–94.
32. Ruth Finnegan, *The Hidden Musicians: Music-making in an English Town* (Cambridge: Cambridge University Press, 1989).
33. Michael P. Smith. 'Behind the Lines', in *Black Music Research Journal*, vol. 14, no.1 (Spring 1994) p. 66.

10

Into the Light: The Whiteness of the South in *The Birth of a Nation*

Richard Dyer

The Birth of a Nation (USA, 1915) shows the forging of a national identity, in which geographical division (North versus South) is transcended through a realisation of a common white racial identity, but one defined in southern terms. The film's grand spectacle (never before applied to a US subject), the vivid but nuanced central performances and the terrific momentum of the editing leave the audience little time or space to reflect on how the film presents this history. These cinematic elements are, however, in many ways having to make up for a rather faltering presentation of the film's central explanatory concept, race. This is evident in the characterisation of black and, especially, mixed race people, where the instability of racial categories is implied, an instability itself a product of southern history. It is still more evident in aspects of the way white people are cinematically glorified. Situated as it is within developments in the film industry, developments at once formal, technical and commercial, *Birth* has recourse to certain embryonic cinematic elements (notably of star presence and lighting) to represent the whiteness of white people. Paradoxically, however, these elements have strongly northern connotations.

In this chapter I shall follow the stages of the argument just outlined. I look first at the film's overall trajectory, then at the enactment of blackness within it. Following this, I look at the representation of whiteness in the film, and especially at the use of light in a film that can be seen as being on the cusp of 'early' and 'classical' cinema. Griffith, as a Southerner, set out to make a pro-southern film, as is evident in the film's trajectory, but he had recourse to traditions of the performance of race and to emergent aesthetic technologies that are, despite him, at odds with this trajectory.

The Birth of a Nation tells its version of history through the story of the relations between a southern family, the Camerons, and a northern one, the Stonemans. Both are of equivalent social standing, both lose sons in the war, and both have children who fall in love with each other, the film ending in twin betrothals that will constitute two mixed (that is, North and South) white families, who will literally bear the race nation forward. Yet the film has very different emotional investments in these families.

In the first half of the film, dealing with the war and the assassination of Lincoln, the southern Camerons are privileged over the northern Stonemans. Parallel sequences (for example, bidding farewell to the sons going off to war, receiving news of the death in conflict of the younger son) give the Camerons not only more screen time, but also more spectacle, psychological elaboration and melodramatic intensity. Throughout this part, we see a great deal of the Camerons and the world of mansions, busy streets, plantations and meadows to which they belong, whereas the Stonemans are restricted to two interiors and a front yard and to much less screen time. The Stoneman family is also, in the film's terms, a deformed one: the father is lame and bewigged, the mother is dead and not only has her place, as housekeeper and sexual partner, been taken, without marriage, by another woman, but, worst of all, the latter is a mulatto (to use the film's own terminology). The Cameron family, by contrast, is intact, as a group and individually, mother, father and children. As Scott Simmon points out,[1] this is intensified by always showing the Camerons grouped together within the frame, whereas the Stonemans are 'intercut across distant spaces'.

The first half alternates geographically (albeit unequally) between North and South; the second, dealing with Reconstruction, moves all the action to the South by the simple expedient of having Mr Stoneman and Elsie move South, in fact to Piedmont, where the Camerons live. It also now ups the emotional investment in the northern family, the Stonemans, by pivoting the climax of the film on the rescue of Elsie from an enforced marriage to Silas Lynch, her father's mulatto protégé. A large and much discussed section of the second part focuses on Flora Cameron pursued by a black 'renegade', Gus, until she throws herself off a cliff in terror; but with her death the emotional centre for the rest of the film is the northern woman, Elsie Stoneman. However, by this point in the film, racial unity has asserted itself over regional conflict: the fleeing Cameron family is sheltered by a pair of Union veterans (all now 'united in common defence of their Aryan birthright'), while the Ku Klux Klan avenges the death of one white woman (the Southerner Flora) in coming to the rescue of another (the Northerner Elsie). The sense of a transcendent racial identity is conveyed by the shrinking of

geographical and temporal coordinates: the Camerons come upon the Northerners' log cabin home somewhere in the immediate vicinity of their own southern home, while the Klan know of Elsie's plight without benefit of being told of it (the film cuts straight from her shrinking in terror from Silas's advances to shots of Klansmen gathering and riding to the rescue). It is of course a tribute to the extraordinary narrative drive of the film that such ellipses contribute to a sense of surpassing momentum rather than being perceived as implausibilities.

By the end of the film, then, on the face of it, white identity as national US identity has been asserted in southern terms. The North is now in the South (the two Union veterans as well as the Stonemans), the northern white woman has suffered the same plight as her southern compatriot, and she rides with the Klan, the epitome of southern white supremacy, in the final victory celebration. The nation is born – in a sense, will literally be so in the two Cameron–Stoneman marriages to come at the end of the film – through the actions of the Klan, and the fact that their actions focus on the plight of a northern white woman justifies the southern perspective, proving that the South was right (about race) all along.

Yet it is just when we turn to consider the representation of race – which includes the whites just as much as blacks, something *Birth* itself is clearer on than most current white discourse about race – that the confidence of this triumphant ending becomes less certain. The stability of a racial view of the world – by which I understand one based on a belief in fundamental and hierarchically disposed racial differences, rather than necessarily on racist hatred – is founded on the assumption that there are indeed clear and distinct racial categories. In fact, such categories are inherently unstable at the levels of ordinary perception, scientific investigation and genealogy (which, used by enlightenment race theorists to demonstrate the pedigree of the white race, also indicates a constant process of human migration and 'inter'-breeding). *Birth* does not say this, of course, yet its very basic means of representation, at variance to what its director must consciously have intended, imply that racial categories have already become confused beyond recall, especially in the South.

This might be thought to be evident in the extraordinary inconsistency in the casting of black (as opposed to mixed race) characters. The film uses three means of performer representation for African-Americans: actual black performers for crowd scenes and bit parts,[2] white performers with darkened faces (notably Gus), and whites with not only blacked-up faces but also the white lips, ringed eyes and fuzzy wigs of the minstrel show. There are many gradations between the last two possibilities and there seems to be no pattern to this in relation to roles.

The Cameron's mammy, a good black in the film's terms, is very darkly made-up but without minstrel elements (though her figure may well be padded in an 'Aunt Jemima' style); she contrasts to the very minstrelly, comic, 'uppity' Stoneman servant (who even does a bit of grotesque comic business with his hairline) and is in fact closer, at the level of the means of representation, to Gus, the quintessential 'bad nigger' in the film. In a scene, recounted by Ben to his cronies, in which a black man is 'tried before a Negro magistrate and the verdict rendered against the whites by the Negro jury', the plaintiff has very broad, white lips and wears minstrel show plantation dungarees, the jury are clearly African-American performers, while the magistrate is either the latter or unusually naturalistically made-up. All the blacks in this scene are bad by the film's lights, yet the polarities of naturalism and artifice are deployed in the means of representation. The whole thing is made more confusing still, as Simmon points out, when later Elsie 'somehow recognises two "white spies" who have blacked themselves to hide among the black mob; the pair of actors appear to us indistinguishable from the other white actors in blackface'.[3]

One might interpret this in terms of race as performance and mask, not as a given of the body.[4] However, as Doane and also Michaels point out,[5] in at any rate the legal and scientific discourses of the period, race was deemed a matter of blood not skin colour. Doane argues that this means that the appearance of blackness (or whiteness) is thus no guarantee of racial identity, that the film denies the body as a source of knowledge about race in order to deny 'the power of blackness as it was conceived within a white epistemological framework (as *the* mark of the biological)'.[6] This however is to treat the legal and scientific discourses as if they themselves are not also biological and rooted in the body (albeit in invisible properties of it) and also to treat *Birth* as a more fully 'classical' film than is warranted (as if it operates wholly within an aesthetic of visual consistency or what Doane calls the 'reality effect'). It seems as likely that the haphazard quality of the represen-tation of African-Americans in the film is a sign of the confidence with which they could be known – it was enough to nominate them as black for them to be black, regardless of how that blackness was figured. At the same time, working in a predominantly visual medium, the film always signifies blackness by some visual means or other, but in order to indicate that the character is black, not to give a naturalistically coherent representation of black people.

It is not in the black but in the mulatto characters that the problem of the instability of racial categories is more evidently courted by the film. All the troubles in the film's world are engendered by the historical failure to keep racial categories distinct. The second inter-title after the

credits states the case: 'The bringing of the African to America planted the first seed of disunion', a phrasing that, consciously or otherwise, suggests at once a means of production, the spectre of miscegenation and the inadvertent tragedy of national discord. The narrative pivots on the notion of blurring categories through miscegenation, which, within a racial perspective, is entirely the proper focus, for race is nothing if not a notion of sexual reproduction. The explanation for both the war and, as the film shows it, the chaos of Reconstruction is returned to the results of the act of miscegenation, the mulattos. It is they, in the characters of Lydia Brown and Silas Lynch, respectively Stoneman's housekeeper/mistress and political protégé, who manipulate liberal white characters and stir up the ignorant black masses. The tensest narrative set pieces – Gus's pursuit of Flora, Silas's proposal to Elsie – concern acts whose violence expresses the horror of the interracial mingling of blood as much as of male domination of women. In the racialist imagination, miscegenation is rape.

In these ways, *Birth* knows that it is about racial purity or, to use a contemporary phrase, ethnic cleansing. By foregrounding the matter so strongly, it may seem to have dealt with the matter. However, the use of the mulatto as the key to understanding the racial history of the South always courts two distinct problems. First, miscegenation always implies – even while it seldom acknowledges – a history of white as well as black sexuality. It takes two to miscegenate, and you have to have one of each colour. As has been pointed out many times, the main practice of interracial heterosexuality in the South was white men on black women (in routinised *droit de seigneur* relationships). However vivid the representation of black men on white women, of miscegenation as rape, in *Birth* and other white supremacist fictions, it is hard not to assume that the history of southern white male sexual practice was at the back of most people's minds, not least because of the vivid portrayal of it in the most successful of all representations of the South up to this time, *Uncle Tom's Cabin* (phenomenally successful as a novel in its own right, ever since its first publication in 1852, and also in numerous subsequent theatrical and cinematic versions). Secondly, there is also something potentially damaging (to white identity) in the suggestion that mulattos are more dangerous than pure black people. While there are many possible explanations for this – the monstrosity of mingled blood, an idea that mulattos obtained vigour without morals from their white blood, the frustration of people who have one foot in the white camp – there must surely always be the suspicion that what makes them dangerous, compared to the supposedly happy-go-lucky, pure black slave, is their whiteness. This gives them intelligence and energy but also perhaps rapacity and greed. As much is implicit in *Uncle Tom's Cabin*. Here

Stowe credits all African-Americans with moral superiority, while endowing the light-skinned (and thus presumably mulatto) characters with courage and enterprise, and the ability to get away. Alongside this, she portrays white men (with exceptions) as materialistic, insensitive and violent. Given the widespread knowledge of Stowe's book, one may again speculate that the danger of the mulatto characters in *Birth* derives from their having too many white characteristics. Either way, the use of the figure of the mulatto, a product of the 'planting of the seed of disunion', cannot but indicate the problem of white conduct and character in southern history.

The mulatto characters – so central to the film's narrative and version of history – already raise a question mark concerning southern whiteness and this is compounded by a number of aspects of the representation of whiteness in the film, which together suggest (though certainly do not consciously insist) that what the South needs is northern whiteness. To understand how this came about, we need now to take a schematic detour into film history. Part of my argument is that Griffith was making this consciously pro-South film under formal/commercial pressures significantly northern in character. I am thus not arguing that Griffith had doubts about southern whiteness but that the inherent problems (of white complicity) always thrown up by any reference to miscegenation are met within the text of *Birth* by an alternative, North-inflected view of whiteness, which has the effect, intended or otherwise, of 'rescuing' the 'contaminated' whiteness disclosed by the mulatto narrative.

Birth is widely seen as being on the cusp of developments in film, developments in which it played a key role.[7] These developments are both formal and commercial and include the quest for respectability, the consolidation of the star system and the establishment of a film style that has come to be called 'classical Hollywood cinema'.[8] The first, 'respectabilisation' (or, perhaps, embourgeoisement), showed itself in strategies aimed at bringing more middle-class audiences into the cinemas, using, among other things, notions of the feminine (in address and subject matter) as the bearers of gentility, elevated subject matter (including history), literary inter-titles and elements of the legitimate theatre (styles of architecture, length of films and timed screenings as well as the scale and distance of the spectacle). The star system (which deCordova sees as emerging around 1915 as a phenomenon distinct from that of 'the picture personality', whose importance went beyond his or her 'professional existence' to include their 'existence outside [their] work in films')[9] not only provided a primary means of selling films but also affected the shape of a character's role and the prominence of a performer in the frame, as well as the interest that a spectator might take to

viewing a film. 'Classical Hollywood cinema' has been adopted as a term to describe a way of making films, not yet securely in place in 1915, that has become so standard that for most audiences it is simply the way movies are; it is a cinema that gives primacy to narrative, using editing, mise-en-scène and framing to guide the spectator's attention and creating a space that, by means of editing and camera movement, the spectator can seem to enter (even to the point of entering characters' heads to see from their point of view).

I want to focus here on one formal, technical element: lighting, central to all three factors just outlined. One of the ways in which film announced its respectability lay in the development of lighting styles (themselves made possible by a movement away from outdoor to studio shooting) that drew upon both the realism of the well-made play (marked by a shift away from the footlights and frontal light of vaudeville and popular melodrama to the sculpted, directional light developed by theatre producers such as David Belasco) and also the forms of lighting used in middle-class portrait photography (well established by the 1880s, but only just being adopted by film in the 1910s).[10] The latter provided some of the visual vocabulary for the presentation of the star, notably the aura or halo of light round head and shoulders, and techniques for singling the star out from the rest of the company. The elements of respectability and stardom come together explicitly in *Birth* in the portrait of Elsie that her brother Phil shows to Ben and which Ben then keeps with him. When he first sees it, there is a cut from him looking to what he sees, Elsie's photographed face, multiply-framed by film camera, the iris,[11] the photo frame (itself double) and the veil round her face. The formality of such framing is paradigmatic of the codes of respectable culture. Lighting is also a basic element of the classical Hollywood style: it singles out the key characters, provides (especially in the use of backlighting) a sense of depth to the flat screen image and directs the attention of the viewer to what is important in a shot and the nature of its importance. The codes of portrait photography and Belasco-style theatre lighting that contributed to this development were augmented by the study of lighting in European painting, notably Rembrandt and Vermeer.

All the above have strong but not inescapable northern connotations. The concern for respectability derived from a desire both to bring in the middle-class audience and to appease the moral reformists in the expanding cities of the US Northeast and Midwest. Women were central to this. As Miriam Hansen suggests, the proper definition of womanhood was very much at stake in the respectabilisation of the cinema – at issue was not so much getting urban women into the cinema, for they were there in their millions, but the fact that they might not be getting the

proper instruction in femininity.[12] Stars provided role models, some disapproved of, but some embodying the ideals of reform. Of these, many (including Lillian Gish) had real or fabricated biographies stressing their northern upbringing or character. Finally, it is significant that it is northern European painters who were taken as the model; indeed the lighting style favoured in Hollywood became known as 'North lighting'.

All of this can be seen at points in *Birth*, though again it must be stressed, following Gunning's account of Griffith's development, that *Birth* is not a 'classical' film but rather one caught between conventions of early and classical cinema. The casting of.Lillian Gish, already a major star by this time, emphasises the importance of the character of Elsie. She provides a telling contrast to the two southern/Cameron women in the film, Margaret (Miriam Cooper) and Flora (Mae Marsh). Cooper plays Margaret as reticent and, after the war, twitchily withdrawn; Marsh, on the other hand, plays Flora as a child-woman, emotionally nuanced, but fluttery and excitable. The contrast between her and Gish's Elsie is especially emphasised at their first meeting, where Flora's jumping all over Elsie in greeting astonishes her, so that she points and mimes in amusement as if to ask who this demented creature is. Margaret and Flora represent the rather debilitated nature of southern womanhood, repressed or over-excited and in any event helpless. Gish's Elsie – though in the end requiring white male rescue from mulatto male lust – is upright, tough, morally certain, a useful helpmeet to her father. Out of loyalty to the latter, she breaks off relations with her sweetheart Ben because of his involvement with the Klan, and she stands up to Silas with moral hauteur until his physical menaces provoke her into panic. She represents – both in the character but also in the fact that she is a North-associated star – the vigour as well as the purity of northern womanhood.

White women are the central focus of *Birth*. What is at stake in the film is the survival of the white race. Women are both implicitly the means for its survival as the bearers of children (a strong theme in white supremacist rhetoric)[13] and explicitly the carriers of the values of whiteness. It is their purity that literally embodies the transcendent superiority of the white race. This is why the second half of *Birth* focuses so insistently on the threat to white women by proposals from black or mulatto men, marriage proposals represented as rape. Yet it is striking that it is not the southern women who most confidently embody this whiteness, but the northern character and star, Elsie/Lillian Gish. Almost the last shot in the film has the Klan marching triumphantly down the street; both Margaret and Elsie ride with them, but the latter (partly just because this befits a star) is centre frame and better lit. She,

the northern woman, is both the biggest prize and the best hope for the white race.

Most of *Birth* is shot either out of doors or with the even, frontal lighting of early cinema. It is only at key moments that something like classical lighting comes into play. Apart from some romantic sequences (encounters which will lead to proper white breeding), these are generally moments involving the assertion of the whiteness of the characters.

Though as much an effect of costume as lighting apparatus, one repeated instance of this is the gathering and riding of the Klan. One shot especially has the Klan riding into town, entering at rear left and coming right up to the camera, then turning about in front of it, so that the screen is filled with whirling whiteness.[14] It is perhaps the moment evoked by Ned McIntosh in his review for the *Atlanta Constitution* (7 December 1915): 'At least as far as the camera's scope can gather is assembled a vast, grim host in white.'[15] All film takes place on a white background (the screen); to fill the screen with white costume is to increase the radiation of the light reflected off the screen. To have it swirl, as the Klan costumes do, especially when riding and rearing up on horseback, heightens the primary spectacle of film as light. This is the moment at which white men are whitest – but of course we cannot see their flesh. As Walter Benn Michaels puts it, 'Klan wear sheets because their bodies aren't as white as their souls, because *no* body can be as white as the soul embodied in the white sheet'.[16]

But if white men could never be bodily white enough (partly because they also had to have the physical drives of masculinity that were coded as dark), white women could. The make-up of the period still aimed at a pure white and unblemished surface. The whiteness of the white woman could be brought out by editing. In the sequence in which Gus chases Flora, cross-cutting between them has him less strongly lit, often lurking behind foliage or bleeding into the iris within the frame of the image, whereas she is always fully in the light, often with a halo created by her being kept away from the iris so that she is rimmed with light.[17] This light, being outdoor light, is not 'northern' light, but at another later point in the film, where Margaret is briefly the focus of attention, something much closer to the classical norm is apparent. The Cameron family (father, mother and Margaret) are besieged by the marauding blacks in the log cabin with the Union veterans; Margaret comforts her mother. In a medium shot, there is even, frontal light, but in an inserted close-up, Margaret is lit from both behind and overhead, sculpted in something like glamour fashion, even her dark hair made to glow. At this point of maximum threat to white womanhood, the film reaches for northern lighting codes to affirm her worth.

Still clearer is the use of lighting in the sequence in which Silas tries to force Elsie into marriage. Lighting, in concert with costume and actor movement and positioning, gradually heightens Elsie's whiteness. There is frontal light over the scene as a whole, but Silas is positioned three-quarters side on to it, so that he is in semi-darkness, whereas she is positioned full on to it, catching all its glow. As with Gus and Flora, in irised cross-cuts between them, Silas bleeds into darkness, Elsie is contained within a circle of light (even when she puts her arms up to her head). She wears a white dress which, with her dashing movements and flailing arms, creates a whirl of white in the image. She also wears a black shawl over her head and in irised close-ups this creates a strong contrast with her very white face. In the medium-frontal shots that make up the bulk of the sequence, all taken from the same camera position (but intercut with the Klan riding to the rescue), this shawl gradually slips back off her head until at one point Lillian Gish surreptitiously unhooks it so that it falls off her shoulders. The overhead lighting thus increasingly catches her fair hair, heightening the whiteness of her image. Finally, at the climax of the scene, she moves from the back of the set (where her face and hair contrast to the dark backdrop of the locked door) down towards the camera and into a spotlight fixed overhead; in other words, as the tension mounts, she is positioned to glow even more vividly white in the image. This kind of overhead light, very white, from a clear source, is the epitome of the northern light so prized by Hollywood. Just when the pearl of white womanhood is most under threat, its northernness is most strongly asserted, in character, star and lighting.

The racial implications of this northernness lie not only in the way it comes to the rescue of southern miscegenation and debilitation within the text of the film, but more generally in the role of the North in white supremacist rhetoric. As Martin Bernal argues,[18] the development of ideas of Aryanism was distinctly linked to ideas of people from northern climes. The very term Caucasus was used to refer to a people bred in a cold, mountainous region who had invaded ancient Greece from the North and thus founded white European civilisation (contrary to the understanding, in place up until the end of the eighteenth century, that Greece had been invaded from the South, giving its civilisation an African origin). The cold, high North was repeatedly held to have created the strong, vigorous and pure character of the white race.

Rather startlingly (at any rate, to me), *The Birth of a Nation* seems to allude at one point to this notion of the North as the true home of whiteness. When the Klan is formed, Ben declares: 'Here I raise the ancient symbol of an unconquered race of men, the fiery cross of old Scotland's hills …'. The notion of a Scottish connection is expounded more fully

in *The Clansman* itself (the main literary source for *Birth*), where Thomas Dixon writes:

> In the darkest hour of the life of the South ... suddenly from the mists of the mountains appeared a white cloud the size of a man's hand. ... An 'Invisible Empire' had risen ... How the young South, led by the reincarnated souls of the Clansmen of Old Scotland, went forth under this cover ... forms one of the most dramatic chapters in the history of the Aryan race.[19]

More generally, the idea of Scotland had been important in southern US culture, notably in the influence of Walter Scott.[20] One can see certain affinities between Scotland and the US South: both small nations contained, perhaps against their will, within larger, conglomerate nation states; both investing much of their national identity in aristocratic imagery. These, though, are surely outweighed by the discrepancies between the cold, misty, mountainous and ancient world of the Scottish North and the hot, steamy, pastoral and 'new' world of the southern US states. However much the reference to Scotland may assert the continuity between the heart of whiteness in the North and its contemporary southern embodiment, it appears in a context where southern whiteness is enfeebled in its feminine embodiments, implicitly eroded by miscegenation, hysterically over-expressed in the sheets of the KKK, and requiring the reinvigoration that only a northern character/star and northern lighting can supply. In short, at times it does seem as if *The Birth of a Nation*, dedicated though it is to a southern white supremacist definition of US identity, betrays a feeling that the South is, after all, not quite white enough to give birth to the new white nation.

NOTES

1. Scott Simmon, *The Films of D. W. Griffith* (Cambridge: Cambridge University Press, 1993) p. 130.
2. I am grateful to my 1992–93 MA group, and especially Corin Willis, for drawing my attention to the interest of these.
3. Simmon, *Griffith*, p. 107fn.
4. Cf. Mary Ann Doane, *Femmes Fatales: Feminism, Film Theory, Psychoanalysis* (New York: Routledge, 1991) and Michael Rogin, '"The Sword Became a Flashing Vision": D. W. Griffith's *The Birth of a Nation*' in Robert Lang, ed., *The Birth of a Nation* (New Brunswick, Rutgers University Press, 1994) pp. 250–93.
5. Walter Benn Michaels, 'The Souls of White Folk' in Elaine Scarry, ed., *Literature and the Body* (Baltimore: Johns Hopkins University Press, 1989) pp. 185–209.

6. Doane, *Femmes*, p. 229.
7. Cf. Larry May, *Screening Out the Past: The Birth of Mass Culture and the Motion Picture Industry* (Chicago: University of Chicago Press, 1983); Tom Gunning, *D. W. Griffith and the Origins of American Narrative Film* (Urbana/Chicago: University of Illinois Press, 1991); and Miriam Hansen, *Babel and Babylon: Spectatorship in American Silent Film* (Cambridge, MA: Harvard University Press, 1991).
8. See David Bordwell, Janet Staiger and Kristin Thompson, *The Classical Hollywood Cinema: Film Style and Mode of Production to 1960* (New York: Columbia University Press, 1985). I should stress that in offering this description I do not endorse some of the monolithic and deterministic accounts of 'classical cinema'. What is described is a kind of cinema remarkable for its flexibility and openness to interpretation.
9. Richard deCordova, 'The Emergence of the Star System in America' in Christine Gledhill, ed., *Stardom: Industry of Desire* (London: British Film Institute, 1991) pp. 17–29.
10. Barry Salt, *Film Style and Technology: History and Analysis* (London: Starword, 1983) pp. 134–6.
11. The darkened area within the frame of the camera which creates an oval shape round the subject.
12. Miriam Hansen, *Babel and Babylon: Spectatorship in American Silent film* (Cambridge, MA: Harvard University Press, 1991).
13. Cf. Marilyn Frye, 'On Being White: Towards a Feminist Understanding of Race and Race Supremacy' in *The Politics of Reality: Essays in Feminist Theory* (Trumansburg, NY: The Crossing Press, 1983) pp. 110–27.
14. In Lang's shot break-down in his *Birth*.
15. Reprinted in Lang, *Birth*, pp. 183–5.
16. Michaels, 'Souls', p. 190. Here, Michaels is referring to the Thomas Dixon novels and play that were Griffith's sources.
17. The halo effect is classically achieved by the use of backlighting, but I don't think this is the case here.
18. Martin Bernal, *Black Athena*, vol. 1 (London: Free Association Books, 1987).
19. Thomas Dixon Jr, *The Clansman: An Historical Romance of the Ku Klux Klan* (New York: Doubleday, Page & Co., 1905), from unpaginated foreword 'To the reader'. (Taken from facsimile edition, Ridgewood, NJ: Gregg Press, 1967.)
20. James Chandler, 'The Historical Novel Goes to Hollywood: Scott, Griffith and Film Epic Today' in Lang, *Birth*, pp. 225–49.

11

The Birth of a Nation and Within Our Gates: Two Tales of the American South

Jane Gaines

Two films, released within four years of one other. The one about the US as white, stirring up periodic trouble for nearly eighty years, but trumpeted as a classic; the other about the US as black, stirring up more fear of trouble than actual trouble, and disappearing into oblivion soon after its release. While D. W. Griffith would encounter public resistance to *The Birth of a Nation* (1915) but not to his later features, Oscar Micheaux, the African-American producer-director of *Within Our Gates* (1919), was plagued with censorship threats throughout a career that spanned 1918 to 1948. In spite of these setbacks, Micheaux was resilient and continued to consider his films as harmless when compared with the proven power of *The Birth of a Nation* to cause social unrest. In 1925, answering the concerns of the Virginia Motion Picture Censors, who wanted changes in his film *The House Behind The Cedars*, Micheaux answered: 'There has not been but one picture that incited the colored people to riot, and that still does, that picture is *The Birth of a Nation*.'[1]

Although he has long been remembered by the African-American community, it has only been recently that film historians have begun to look closely at Oscar Micheaux. This re-examination has been somewhat hampered because, of the nearly fifty films he produced and directed between 1918 and 1948, only twelve are extant. Also, for decades Micheaux was known mostly for his work produced in the sound film era, much of which was marred by technical sound problems. However, with the recent discovery in European archives of two films from the silent period, the serious revaluation of Micheaux began. Immediately scholars began to say that the first of these discoveries, *Within Our Gates*, was the 'long lost answer' to *The Birth of a Nation*.

While I will certainly want to assert the significant political differences between these two post-Reconstruction vantages on US history, they can also be seen as preoccupied with the same question: 'Who is an American?' From a contemporary point of view, this question is somewhat embarrassing, especially for US citizens aware not only of the way the name 'America' has been historically appropriated from the peoples of South America, but also of the continuing plight of immigrants pleading for state protection.[2] Equally discomfiting, in the early decades of the century this question of nation was always in danger of succumbing to a dangerous biologisation.[3] The idea of the 'natural nation' was attractive because it would be inviolate as well as divinely ordained. From here it is not surprising that, by the same logic, 'the nation' could be understood as a 'family'. The emerging popularity of 'family' as a 'race' extended the biology metaphor further. But that was not the end of this series of venal substitutions. The intermingling of the concept of 'racial identity' with 'cultural identity' would extend the reach of the biology metaphor into new territory – would apply it to closely knit groups of all kinds, to community, to shared experience, indeed to forms of everyday life.

Walter Benn Michaels has recently characterised the period following *The Birth of a Nation* and *Within Our Gates* as the time when cultural identity was emerging from racial identity as a concept, giving us our current notion of culture as directly descending from that selfsame scoundrel, 'racial identity'.[4] This conceptual legacy explains why one still finds the tiniest drop of blood in the contemporary notion of 'cultural identity'. If I understand Michaels correctly, *The Birth of a Nation* and *Within Our Gates* come directly out of that period when racial identity was effectively functioning as cultural identity and enjoying a heyday as a concept – in African-American as well as European-American usage.

There is no better example of this race–culture conflation in African-American history than the phenomenon of what were popularly called 'race' movies, films produced for all-black audiences in segregated theatres in the first several decades of the century.[5] In the post-Civil Rights era, the term 'race movie' can't help but sound retrogressive in its harking back to exclusion and classification on the basis of 'racial characteristics', what W. E. B. DuBois called the 'grosser physical differences of skin color, hair, and bone'.[6] But these films, produced specifically for a self-defined audience living as a community, sharing religion, folk wisdom, rituals, and speech patterns, constituted a culture at the same time that they spoke to one. With their all-black casts and often black directors and producers, these films came out of the middle class and went back into the wider black urban community. Like DuBois,

whose ambiguous position on the subject has been noted by Anthony Appiah, Micheaux would probably have explained 'race' as having to do with birth.[7] But in this period for this group of middle-class leaders, 'race' would have been coming to serve double duty – as indicating something both biological and cultural. So it also seems clear that, increasingly, Micheaux and the other 'race film' pioneers would have said 'race' and meant what we now refer to as African-American 'culture'.

It is already well established that one of the most offensive aspects of *The Birth of a Nation*, as well as *The Clansman* and *The Leopard's Spots*, the Thomas Dixon novels from which the film was drawn, is its imagination of 'race' as the basis for a new nation.[8] It has even been argued that the white-sheeted night-riders represent this vision of the pure white nation that Dixon imagined.[9] The Dixon–Griffith collaboration, thrusting together two proud Southerners, seems to have produced a design in which everything is organised in terms of a black/white division where North and South and male and female are charted along a 'raced' axis. Furthermore, race and culture are constantly confused in this film with the deification of 'family' and the veneration of 'nation'. There is nostalgia for the time when the South was a family, that is, a nation including both white and black, as well as a longing for the nation that would be born when North and South white brothers were united. There is even a touch of concern about familial estrangement and betrayal in the attitude toward black family members who deserted their white families. Above all, the film expresses a terror of such strangers, especially those who might marry your daughters. As we all know, *The Birth of a Nation* ends with proper double marriages uniting Cameron and Stoneman families and, in an alternative ending, the strangers are shipped back to Africa where they 'belong' – that is, they are returned to their 'own' culture, nation, and family.[10]

In contrast, Micheaux's race/culture scheme is less fantastic and more pragmatic, consistent as it is with the programme of black advancement that included education and voting rights. In this film, his second of around fifty features, he uses at least two strategies for advancing his 'One Negro Race' ideal. In one strategy, which I call the 'mechanism of hypocrisy', Micheaux criticises blacks who hinder the progress of the race/culture, often using comedy to comment on the two-faced character who exhibits two sides, one for blacks and the other for whites. In the other strategy, worked out in melodramatic terms, the need for 'One Race' is expressed through the yearning for betterment, the nearly missed opportunity, and the long separation between and eventual estrangement of family members. One might call this the 'separation and reunion' or 'loss and return' strategy.

At heart, *Within Our Gates* is an 'elevation of the race' narrative in which 'race' appears to be synonymous with 'culture', especially as it is the story of Sylvia Landry, a young schoolteacher who travels back and forth between the North and the South in an attempt to raise money for the Negro school where she teaches. Sylvia first travels to Boston to find the money that can help to keep the school from closing. In the city she is rescued by two people who change the course of her life. First, Dr Vivian, to whom she later becomes engaged, rescues her when her purse is snatched by a street thief. Second, she is hit by a car after saving a young boy in its path, but is rescued and befriended by the wealthy Boston matron who is a passenger. Although the Boston suffragette is nearly dissuaded from helping Sylvia's cause by a Southerner who thinks that blacks should not be educated, the society matron finally decides to give the school $50,000. Sylvia's return to the South with money for the school doesn't bring the film to an end because another obstacle stands in her way of happiness. To save her reputation she is forced to leave the school and return to Boston where she again meets Dr Vivian. The early years of Sylvia's life appear at the end of the film (in the flashback I will later discuss as the 'lynching sequence'), and the film concludes with an epilogue that suggests that Sylvia and Dr Vivian are to be married.

Not the most compelling of narratives, *Within Our Gates* hangs together by a principle that has little to do with classical causality. It appears to be organised around the principle of interruption – Sylvia is constantly thwarted in her attempts to better the race. In the Micheaux scheme, the 'One Race' aspiration is taught by the example of the characters who come between Sylvia and her goal. These conflicted characters enable the forces that, as he might have put it, keep the 'Negro race' from realising the opportunity that was 'theirs for the taking'. Although Micheaux was by no means an avowed assimilationist, his work is premised on the conviction that blacks had a place in American society and that with the advantage of education and the application of hard work they could be equal to whites in anything that they attempted.

THE MECHANISM OF HYPOCRISY

What is often noted about Micheaux is the unrelenting blame he appears to heap upon some of his black characters, especially relative to the white characters, exemplified in the treatment of the black butler Efrem in contrast to the vengeful 'white trash' farmer in *Within Our Gates*. In the flashback sequence that I will discuss shortly, the farmer kills

landowner Phillip Gridlestone with his shotgun at close range, a murder for which black sharecropper Jasper Landry and his wife are unjustly lynched. While the sniper is accidentally shot by the lynch mob, the scheming Efrem is not only mocked for his deference to whites but 'strung up' for his treachery and misguided allegiance. The white characters are as shadowy and flat as black characters in all of those films by white folks and clearly Micheaux cares relatively little about them. And why should he? The more interesting problem to him is the behaviour of those Negroes who, when faced with the opportunity to influence others, to change the course of events, to contribute to the greater good, resort instead to socially irredeemable villainy. He is drawn to this pattern of duplicity, this mechanism of hypocrisy, that governs these social types. These are the showgirls, madams, thieves, card sharks and especially the preachers who are caught in a double bind because of the duplicity of the white culture that offers opportunity and belonging on the one hand and withdraws all offers with the other.

The comedic mechanics of hypocrisy as well as the melodramatic scenario of loss and return are Micheaux's modes of dealing with the same underlying contradiction. To quote Toni Morrison, this contradiction has to do with the intolerable 'presence of the unfree within the heart of the democratic experiment', and the way black people both adjust to and resist this inconsistency provides Micheaux with his richest material.[11] Comedy, which relishes the incongruous and the discrepant, produces the fool from the character who wears two different faces, one for whites and the other for blacks. Melodrama, which needs to produce pathos, reaches for the longer-term narrative consequences, using the family structure to criticise the brutality of the contradiction. To further suggest the proximity of comedy and melodrama, consider how the double-sidedness of things, often expressed in parallelism (punctuated by melodrama's 'all the while' or 'meanwhile'), is personified in the two-sided character, no better example of which can be found in Micheaux than Paul Robeson's preacher in *Body And Soul*, a character who is not only two-faced but two-bodied.[12]

Melodrama sees the difference between the ideology of familial love and the actuality of broken bonds and draws a lesson, using the victimised and the excluded to drive the lesson home, to accentuate the difference between what is espoused and what is enacted. Penalties are paid in lives relinquished and opportunity lost for ever. What needs to be acknowledged here is how much Micheaux and Griffith both depend upon the ideology of the family and the structure of melodrama in these two films in particular. Whereas Griffith uses the family to justify Gus's lynching, Micheaux uses the family to argue the inhumanity of the practice, essentially showing the ideal family suffering the conse-

quences of vigilante justice. Not the punishment for rapists we were told it was, lynch mob justice ruptures families and harms children. But so effective is Griffith's melodramatic technique at mounting its emotional case that viewers of *The Birth of a Nation* often lose sight of the cause espoused beneath the surge of feeling. Viewers often say that they *feel* they want the Night Riders to rescue the white community against the black threat, whether they would rationally want this outcome in the abstract or not. Positioned with the white families and offered no black family outside the plantation system with which to identify, viewers are doomed to hope that whatever family is offered will be protected and defended.

I will later return to the question of the rhetoric of family melodrama, significant because it is really in his conception of 'family' that Micheaux goes beyond Griffith, breaking out of the highly ideological pattern of seeing equivalences between race, culture, family, and nation. But also, 'race' booster that he was, Micheaux never went so far as to imagine 'race' as the basis for a separate nation as the Pan-Africanists had earlier envisoned it and as Black American Nationalists would later conceive of nationhood.[13] Micheaux was also deeply concerned with keeping the black community together physically and much of his work is concerned with its spatialisation. He envisioned black communities as protected enclaves within the white community, as overlapping circles starting from the middle-class family home (with its central stairwell), the jazz club, and the Southside Chicago neighbourhood. Micheaux's middle-class, Midwestern world, in his autobiographical novels, runs on a horizontal East/West line, along the railroad connecting Chicago with South Dakota. Attracted as he is to the metropolis in these novels, he rejects the allure and returns to the lonely prairie, but won't give up his attempts to get black people out of the city and onto the plains that meant opportunity to him in his early homesteading years. Try as he might, he can't get his wife to return to him or her preacher father to let her go. Each hinderer who conspires against him is eventually taught a bitter lesson for his or her refusal to envision a better life for their people, their 'race'.

Micheaux's East–West traverse in the novels is intersected by Sylvia's North–South trips between Boston and Vicksburg, Mississippi, in *Within Our Gates*. So frantic are these trips to rescue, to cajole, to intervene in time, to stop its clock, that one wonders if Micheaux is trying, with his superhuman Negro characters, to knit the black community together, to constitute some idea of nation through editing. Although the novels occasionally include scenes on the train, Micheaux's surviving films are more often marked by the instantaneous appearance, the miraculous arrival in a new city after travelling a long distance. This miraculous

arrival, almost a jump cut, is an obvious attempt to use film form itself to bind up the disparate black community and give it continuity.

The Birth of a Nation is so deeply rooted in the southern point of view that virtually all of Griffith's shots work to re-edit a history from that point of view, but we may not notice that this point of view is produced by radically shrinking the North to a few scenes in the hospital, Stoneman's Washington D.C. home, President Lincoln's office, and the assassination of Lincoln in Ford's theatre. All that is or was grand and glorious is located below the Mason-Dixon line, an irony considering Richard Dyer's argument in this collection that the South, not being 'white' enough, had to borrow 'light' from the North. The union of the nation is not of spaces, North and South, but of peoples who look the same (and therefore should be brothers). Whereas the visualisation of the nation space in Griffith's film is bottom heavy in its emphasis on the South (the model nation), Micheaux's film is fairly symmetrical in its placement of the action in both North and South. I would therefore argue that, in comparison with the Dixon–Griffith imagination of a better nation *in the South*, it is Micheaux's spatial dynamics that render the unity of North and South. In both films, the South is poverty and the North is capital, but, whereas in the Dixon–Griffith imagination, southern white poverty equals integrity, in Micheaux's epic, southern black poverty equals struggle and opportunity.

Linked together, these two 'race' epics give us a long span of American history, from the early pre-Civil War scenes in *The Birth of a Nation*, through its disputed version of Reconstruction through the post-Reconstruction, early twentieth-century setting of *Within Our Gates*, which picks up where Griffith and Dixon left off and ends just after the First World War. While, in the one, the Reconstruction nightmare is a dream backward, in the other, the nightmare is found within a dream forward toward the future. In the scenes preceding the Civil War in *The Birth of a Nation*, the 'family' includes the black household members who are spatially close to the Camerons, whereas, after the war and ostensibly by means of the Republicans' Reconstruction scheme, these same members become estranged from their former families.

FAMILIAL ESTRANGEMENT

With all of the sexual readings of *The Birth of a Nation*, in terms of father–daughter incest, daughter–son incest, the white woman's 'affiliation with blackness', and the infamous fear of rape and miscegenation in the mulatto Gus's encounter with Little Sister at the edge of the cliff, it would seem that no new way to read this film in terms of sexuality

is imaginable.[14] Unless we read the film in tandem with *Within Our Gates*. I want to argue that Micheaux's film, itself concerned about immigrants and strangers, further brings out that concern in *The Birth of a Nation*. Lillian Smith in her important *Killers of the Dream* describes the relationship between the sex education of white southern children and their initiation into the racial stratification of the society. She describes how the body was used as the operative metaphor of segregation – the touchable separated from the untouchable 'down there' parts of the body. The message was 'you cannot associate freely with them any more than you can associate freely with colored children'.[15] One might argue from this that for white Southerners, the estrangement from blacks is always an estrangement from themselves. To adapt this observation to southern history, consider how whites and blacks, who had formerly lived closely together on farms and plantations, were suddenly distanced after the Civil War in the reconstruction period.[16] And if *The Birth of a Nation* is a chronicle of that very move (especially with its trauma of discovery that the very plantation blacks who they thought they had known so well were their betrayers), the film might then be read as a saga of familial separation within the plantation family (as well as the white nation's increased alienation from its own body – a defining condition of whiteness to begin with).

This estrangement should be read against the backdrop of the white American romanticisation of the antebellum South, at once a Golden Age and an historical embarrassment, a 'fossil land, … dreaming of past glories', as postcolonial theorist Albert Memmi once described it.[17] We now know that this period was extremely short and that the lives of very few families approximated the mythologised lives of the southern planter class. What we have in the southern myth is an eroticised longing for an historical past, which makes even more sense when you consider Andy Warhol's profound observation that 'Sex is nostalgia for sex.'[18] Why is it that the iconography of this period recollected so fondly is the same iconography that defines the fantasies of the fetishist? Why the hoop skirts and waist cinches, the riding whips and the four-poster beds? The sloth and revelry attributed to this period appeal to the senses, and the subtropical climate evokes a sexualised lethargy that permeates all aspects of southern daily life. Sexual encounters in this historical dream are a cross between the sedentary fantasy of the love slave and the secrecy of adolescent sexual discovery. But this is the white version of the story, isn't it?

Griffith assumes this American collective nostalgia for the antebellum South and refers to it in some of the early sequences depicting the frolicking of the Camerons and Stonemans against a backdrop of black fieldhands picking cotton and slaves performing for the young people.

And in the silent film title: 'Quaintly a way of life that is to be no more', we hear an audible sigh.[19] In contrast, Micheaux, in his representation of the agrarian South in *Within Our Gates*, locates his encounter between the planter class (son of a slaveholder) and the sharecropper (son of a former slave) in a milieu of the plantation gone to seed. He sets his plantation sequence back in time and off from the rest of the film in what I call the 'Nightmare Flashback', a method of containing the horrors of lynching and protecting the contemporary uplift narrative. According to his introductory titles addressed to the Spanish audience he intended for the film in 1920, this is: 'The American South where ignorance and lynch law reign supreme.'[20] Like W. E. B. DuBois's description of his return to the Black Belt in *The Souls of Black Folk*, Micheaux's return to the scene depicts ruin and desolation. DuBois describes the Waters-Loring plantation 'stilled by the spell of dishonesty' standing 'like some gaunt rebuke to a scarred land'.[21] Micheaux gives us a single shot of the exterior of a white-columned mansion. Inside, Philip Gridlestone (hated and feared by all – 'A Modern Nero') is reduced to one servant, the duplicitous Efrem, shown helping himself to the liquor. Gridlestone quarrels with sharecropper Jasper Landry who comes to claim what he is owed. It is during the dispute with Landry that the stalking farmer to whom I referred earlier takes aim with his shotgun. This white farmer, according to the titles, insulted by Gridlestone (who had 'called him poor white trash – no better than a Negro'), watches through a window. When Gridlestone is killed, Efrem blames Landry and the sharecropper flees with his family.

While the town mob is hanging and burning Jasper Landry as well as his wife, his foster daughter Sylvia circles back to their house for supplies. And it is Sylvia's fate rather than that of her parents that I want to consider here. Alone in the house, Sylvia is interrupted by Armand Gridlestone, brother of the murdered Phillip, who, the titles suggest, is still searching for more blacks on whom he can vent his rage. After a brutal physical struggle, Armand reaches to rip Sylvia's dress from her bosom. But he abruptly stops his aggressive pursuit when he sees something on her body.

Seared Identity and Scarred Flesh

It is a fateful coincidence, a telling 'scar' on Sylvia's 'chest' that stops Armand, as the titles explain. But what does the scar signify? Although it is a sealed rather than a gaping wound, it is yet an ineradicable sign of 'sexed' and 'raced' identity. Located close to Sylvia's breast and covered by her dress, it is secret and suspect. This scar, modestly

concealed, tells much more than that her flesh has been seared just above her breast. Such a wound on a young woman is always about a past that will not stay buried, an identity that cannot remain concealed, a traumatic event that will not stay repressed. And it has a rhetorical function in the way that it insists that something or someone is responsible for the cruelty that has marred her otherwise perfect body. The scar points to a villain.

And at this point, Sylvia calls up associations with other similarly scarred light-skinned black women in film history. Like the neck wound Louise hides in *The Scar Of Shame* (Colored Players of Philadelphia, 1926) and the breast wound borne by Susannah in *Raintree County* (Edward Dmytryk, 1957), Sylvia's scar is a clue. Deep in the white imagination, exemplified by the *Raintree County* narrative, the unsolved mystery of the scar is the unanswerable question of the real racial identity of the heroine whose black heritage is intimated and somehow linked with her insanity, her infantilism, and the fire she survives. White culture thrashes around, trying to find the right metaphor to express these twin terrors – sexual and racial difference – finally conflating them into the same bodily sign: a wound.[22]

To some degree, as 'race' films, both *Scar Of Shame* (1926) and *Within Our Gates* answer this white mythology about the racial mark. In the variation on the myth worked out in the former, the exquisite mulatto Louise bears a wound that demonises not interracial sexuality but intraracial conflict, specifically, the class distinctions that threaten to divide the black community. Tragically, she is caught in gunfight crossfire and shot in the neck in this drama (enacted by the Colored Players of Philadelphia and directed by white producer David Starkman). But Micheaux's vision diverges significantly from the work of the Colored Players. In *Within Our Gates*, the scar is the point of intersection between race and gender and, far from being a race martyr like Louise, Sylvia is saved as well as violated. Interracial rape is both averted and enacted in a particularly Micheauxesque dramatic solution.

In order to appreciate the economy of Micheaux's solution to the political question of interracial rape, we need to turn back once again to D. W. Griffith, to see how Micheaux's staging is a counterpoint to Griffith's three scenes of interracial sexual assault. Three scenes? While critics since the release of *The Birth of a Nation* have generally counted one and sometimes two dramatic interracial sexual assault scenes, I count three. In addition to the encounter between Gus and Little Sister, as well as that between Lucy Stoneman and Sylas Lynch, which I have already mentioned, I would also cite the black mob attack on the cabin at the end of the film, particularly since it is the Cameron women who are the target in the last desperate moments of frenzied cross-cutting.

These sexual attacks are best understood in the classic sense as crimes against white male territory and I want to look at them again as cases of interracial rape, cases in which what is threatened is a radical invasion of that psychic stronghold, the family, an invasion from *within*, not from without. It is the secret invasion, over the body of the white woman (that other dark continent), and it always takes place out of sight of white men, an unseen but largely hallucinated crime.[23] Griffith gives us three different versions of the horrors of the crimes that never happened. Micheaux condenses the crimes that *did* into one short scene.

Griffith's most infamous sex scene, the encounter between Little Sister and Gus, has often been referred to as the *The Birth of a Nation* 'rape' scene, although viewers will at the same time observe that the girl throws herself off the cliff 'rather than to submit' to the overtures of the importunate Gus. Why is this a 'rape' we ask (after all these years), if she jumps off to avoid being violated? The scene, one might suppose, is a literalisation of the popular wisdom, 'better off dead'. But what audiences and critics alike appear to understand is that Little Sister's horrible fall is one long extended metaphor for the physical agonies and psychic terror of interracial rape. She dies both instead of and because of the rape. Blood drips from her virginal mouth, wiped away by the Little Colonel who holds the limp and battered body, no longer of any use to anyone.

Micheaux's representation of interracial rape does Griffith one better. Like the scene between Little Sister and Gus, the scene between Sylvia and Armand Gridlestone is analogised with the most grisly of human punishments – hanging and burning. I have argued elsewhere that the cross-cutting between Sylvia's sexual ravishment and her foster parents' lynching suggests the historical correlations between these two white acts of reprisal against black men and women.[24] Simultaneously, Micheaux is also able to represent Sylvia's sexual torture as an ordeal by fire, for the agonies she suffers are likened to the experience of being burned alive. But why so horrific?

Let me pick up Sylvia's narrative where I left off. In the scene, very like an inverted version of Silas Lynch's attack on Lucy Stoneman, the two circle the room. Sylvia flees from him as he chases her around the table, her desperation echoing the trapped animal panic of Lillian Gish, but with a significant difference. Sylvia's black, matted curls fly out around her, giving her an exquisite wildness that complements her formidable frame and considerable strength. She heaves a chair at her attacker and then, cornered, she climbs on top of the table and hurls a large book. In contrast with Sylvia's tough fight, the golden-haloed Lucy gives us a quivering, frantic set piece. While Lillian will be saved from a forced marriage (interracial intercourse) by the horde of white fathers in the

robes of the Ku Klux Klan, Sylvia will not be rescued by the patriarch. For the man who has accosted her is none other than her own white father. Her scar, her badge of race and gender, identifies her to him, an identification reminiscent of the discovery of the old birthmark that proves the lineage of the lost heir.

Like Griffith, Micheaux has it both ways, as I have said – interracial rape is enacted as well as averted – and the double strategy allows Micheaux to castigate the white patriarch at the same time that he proclaims Sylvia's total innocence. And we should not overlook the significance of the symbolic outcry against Sylvia's violation, for not only does she stand in for all of the clandestine sexual acts against black women in US history, but she stands for the fact that they were raped. In one of the few feminist analyses of interracial rape, Valerie Smith has argued that the notion of 'raping' a black woman has historically appeared to be a 'contradiction in terms' because of the presumption that she was a willing and ready sexual partner.[25] Given this historical background, Micheaux's representation would seem to be even more radical than it first appears, for he is saying that black women have been raped by their masters. But he goes further: *black women have been raped by their white fathers*. And further still. Micheaux reverses the old white supremacy logic underpinning *The Birth of a Nation*, that is, if the child of a white parent is black and blood-related, he or she is *not* family. This logic is stood on its head by Micheaux: if the child of a white parent is black and blood-related, he or she *is* family.

Within Our Gates gives us a number of alternative conceptions of family, perhaps even enough to some day challenge the notion of family in melodrama theory: a functioning foster family, an extended black family with members in the North and the South, a broken family, an incestuous family, and an interracial family. Micheaux has given us what would appear to be an anomaly according to popular wisdom – an interracial marriage and an estranged white father who pays for his black daughter's education. It is here that Micheaux's concept of family goes beyond Griffith's. 'Family' is not synonymous with race, neither is it confined to it, but this enlarged sense of family would serve as the model for the nation where white privilege would need to subsidise black uplift.

Just as Armand reaches for Sylvia's dress, the film cuts to the present, interrupted by titles explaining that the scar on her breast proved to him that she was his child (by a woman of her race whom he had married). This interruption, returning us from the past to the present of the film, returning us from the bad old South to the better North, also returns us to the character Alma. We are reminded that it is Alma's telling that has motivated the flashback sequence that digs up Sylvia's painful past. Sylvia's cousin, the divorcee Alma, is telling Sylvia's history

to Dr Vivian, Sylvia's fiancee. But Alma, who has already proved her duplicitiousness by attempting to steal another one of Sylvia's suitors, could be seen here as flirting with her cousin's fiancée. In an earlier scene, Alma sets up a situation in which the former suitor observes Sylvia in a bedroom with the (then) mysterious white-haired patriarch, who Alma later tells us is her cousin's father. But if Alma is the unscrupulous character and the unreliable narrator that we suspect she is, what does this do to the entire southern lynching episode that includes Sylvia's white father?

Micheaux uses a device that he would later perfect in *Body And Soul* (1924). In this film, the main character, Martha Jane, awakens from a dream only to discover not only that her daughter has *not* been raped by the local minister but that he has not stolen her life savings. As Richard Dyer was the first to point out about this scene, the African-American mother's fears about black male sexuality have been rehearsed in this dream sequence that envelops the entire film.[26] And again, Micheaux has placed the worst of the black American's fears – the return of the white patriarch from the dead, the mob lynchings, the rape of the daughter – in a nightmare flashback. But the flashback is a tale told by a jealous divorcee. Micheaux is able to rehearse it without performing it, to 'say it' and 'take it all back'.

THE EPILOGUE

Two tales of the American South; two films conceived as minority attempts to come to terms with a nation to which their authors wanted to belong, Griffith as a Southerner, Micheaux as a Negro. But whereas *The Birth of a Nation* is one long expression of unmitigated white patriotism, *Within Our Gates* represents all of the ambivalence toward American nationalism that DuBois summarised in his famous statement that blackness and Americanness were 'two warring ideals in one dark body'.[27] All doubts about being an American patriot are cleverly camouflaged, however, so that Micheaux is able to have it both ways – to give us a concluding statement of pro-American support for American intervention in the Spanish American War and the First World War, but to give it to us as a curious epilogue. The socially aware Dr Vivian insists that his fiancée Sylvia forget her past (the un-American lynching of her foster family) and to recognise her legacy. 'After all, we were never immigrants', he says. The film ends as she admits that he is right, an assertion of national belonging that depends upon a fantasy of superiority over those Americans who arrived later in time – the Irish, the Italian, the Chinese.

NOTES

1. Oscar Micheaux, Letter to Virginia Motion Picture Censors, 13 March, 1925. (Motion Picture Censors Collection, State of Virginia Archives, Richmond, Virginia).

2. Eve Kosofsky Sedgwick describes 'America' as a 'bad pun between the name of a continent and the name of a nation'. See 'Nationalisms and Sexualities in the Age of Wilde' in *Nationalisms and Sexualities*, eds Andrew Parker, Mary Russo, Doris Sommer and Patricia Yaeger (London and New York: Routledge, 1992) p. 241.

3. Anthony Appiah, *In My Father's House: Africa and the Philosophy of Culture* (New York: Oxford University Press, 1992) p. 50.

4. B. Michaels, 'Race into Culture: A Critical Geneology of Cultural Identity', *Critical Inquiry* vol. 18, no. 2 (Summer 1992) p. 658.

5. The standard work on 'race' movies is Thomas Cripps, *Slow Fade to Black: The Negro in American Film, 1900–1942* (London: Oxford, 1977). Important new books on Oscar Micheaux and his important relationship to 'race' movies by Ron Green, Pearl Bowser, Louis Spence and Charlene Regester are in progress.

6. W. E. B. DuBois, 'The Conservation of Races' in *W.E.B. DuBois Speaks: Speeches and Addresses, 1890–1919*, ed. Philip S. Foner (1879; New York, 1970), as quoted in Appiah, *In My Father's House*, p. 28.

7. Appiah, *In My Father's House*, p. 45, says: 'Talk of "race" is particularly distressing for those of us who take culture seriously. For where race works – in places where "gross differences" of morphology are correlated with "subtle differences" of temperament, belief, and intention – it works as an attempt at metonym for culture, and it does so only at the price of biologizing what is culture, ideology.' An earlier version of this important chapter on DuBois's conception of race appeared earlier as 'The Uncompleted Argument', in Henry Louis Gates, Jr, ed., *'Race', Writing, and Difference* (Chicago and London: University of Chicago Press, 1985).

8. Thomas Dixon, *The Clansman: A Historical Romance of the Klu Klux Klan* (New York: Doubleday, 1905); *The Leopard's Spots* (New York: Doubleday, 1902).

9. Mary Ann Doane, 'Dark Continents: Epistemologies of Racial and Sexual Difference in Psychoanalysis and Cinema', in Mary Ann Doane, *Femmes Fatales: Feminism, Film Theory, Psychoanalysis* (New York and London: Routledge, 1991) p. 228, says that in this film 'whiteness is not a characteristic of the skin but is hyperbolized and ritualized as the white robes of the Ku Klux Klan ...'

10. Michael Rogin, '"The Sword Became a Flashing Vision": D.W. Griffith's *The Birth of a Nation*', in Robert Lang, ed., *The Birth of a Nation* (New Brunswick, N.J.: Rutgers University Press, 1994) p. 254.

11. Toni Morrison, *Playing in the Dark: Whiteness and the Literary Imagination* (Cambridge, MA. and London: Harvard University Press, 1992) p. 48; I have written about the way melodrama finds its material in contradiction in 'The Melos in Marxist Theory', in Rick Berg and David James, eds, *The Hidden*

Foundation: Film and the Question of Class (Minneapolis: University of Minnesota Press, forthcoming).

12. Micheaux's judgement on Efrem and others like him is straightforwardly stated in one of his novels: 'My race's greatest enemies are not white people who even dislike and hate us; but Negroes who want to be white and who hate and despise us.' (The Wind From Nowhere (New York: Book Supply Co., 1944), p. 123.)

13. The proprietor of the Micheaux Book and Film Company was deeply invested in the idea of American enterprise. W. E. B. DuBois's reference to 'the speech and thought of triumphant commercialism' of Booker T. Washington might as easily have described Micheaux who dedicated one of his novels to Washington. (W. E. B. DuBois, The Souls of Black Folk, 1902; [New York: Signet Books, 1982] p. 81.) See Appiah, In My Father's House, (p. 62) for a discussion of the way in which Pan-Africanism was indebted to an essentially European notion of the Negro.

14. See, for instance, Manthia Diawara, 'Black Spectatorship: Some Problems of Identification and Resistance', in Manthia Diawara, ed., Black American Cinema (New York and London: Routledge, 1993) pp. 211–20; C. Taylor, 'The Re-birth of the Aesthetic in Cinema', Wide Angle, 13, nos. 3 & 4 (July–October 1991) pp. 12–30; Mimi White, 'The Birth of a Nation: History as Pretext', in Lang, ed., The Birth of a Nation, pp. 214–24; Rogin, 'The Sword', pp. 250–93; Russell Merritt, 'D.W. Griffith's The Birth of a Nation: Going After Little Sister' in Peter Lehman, ed., Close Viewings (Tallahassee: Florida State University Press, 1990).

15. Lillian Smith, Killers of the Dream (1941; New York: W.W. Norton, 1978) p. 87.

16. Joel Williamson, A Rage for Order (New York: Oxford, 1986).

17. Albert Memmi, Dominated Man: Notes Towards a Portrait (New York: Orion Press, 1968) p. 17.

18. Andy Warhol, The Philosophy of Andy Warhol (New York and London: Harcourt Brace, 1975) p. 53.

19. If we ever doubted that Griffith had an interest in the plantation milieu, we only need to consider the antebellum effulgence of The White Rose (1924).

20. Within Our Gates was considered lost for years. Thomas Cripps identified it in an archive in Madrid in the mid-1970s. Retitled La Negra, the film had Spanish language inter-titles when it was returned to the Library of Congress in the US in the late 1980s. In 1994, an English language version with music track was released on videotape and distributed by Smithsonian Videotapes.

21. DuBois, The Souls of Black Folk, p. 150.

22. See my 'The Scar Of Shame: Skin Color and Caste in Black Silent Melodrama', Cinema Journal vol. XXVI, no. 4 (Summer 1987), reprinted in Marcia Landy, ed., Imitations of Life: A Reader on Film and Television Melodrama (Detroit: Wayne State University Press, 1991). One of the few considerations of Raintree County is G. Bisplinghoff, 'Mothers, Madness, and Melodrama', Jump Cut, no. 37 (July, 1992) pp. 120–6.

23. See Doane, 'Dark Continents'.

24. See my 'Fire and Desire: Race, Melodrama, and Oscar Micheaux', in Manthia Diawara, ed., *Black American Cinema* (New York: Routledge/American Film Institute, 1993).

25. Valerie Smith, 'Split Affinities: The Case of Interracial Rape', in Marianne Hirsch and Evelyn Fox Keller, eds, *Conflicts in Feminism* (New York: Routledge, 1990).

26. Richard Dyer, *Heavenly Bodies: Film Stars and Society* (London: Macmillan, 1987) pp. 114–15.

27. DuBois, *The Souls of Black Folk*, p. 45.

12

Traditions and Transformations: Vernacular Art from the Afro-Atlantic South

Judith McWillie

The historian of religion, Albert Raboteau, has observed that African influences remained vital in the Western Hemisphere, 'not because they were preserved as a "pure" orthodoxy but because they were transformed'.[1] He understood, first-hand, the African-American penchant for creolisation – for compounding meaning by adapting selected features of Native and European cultures to African continuities and needs. The social skills involved in creolisation are shaped as much by the aspirations of particular individuals and communities as by their experiences of the past and, often, the first stirrings of these aspirations emerge in the arts. Artists employ a complex array of 'double-voiced, allegorical, and parodic' strategies of invention, testing the legacies of their own traditions as well as others. But while the stunning successes of African-American music are now firmly established within the global cultural continuum, less is known about a parallel phenomenon in the South's visual culture. Therefore, this essay introduces some of the primary channels of African cultural transmission in the South's vernacular art and examines the progressive transformation of these influences in contemporary life. In a deeper sense, it is also the story of how 'stifling official cultures' can be replaced by 'more vital unofficial ones'[2] even in (and perhaps especially in) repressive situations.

THE MIDDLE PASSAGE

In 1808, the United States Congress banned the slave trade; but in the South, where the economy was exclusively dependent on forced labour, new captives continued to be imported illegally, smuggled directly

193

from Africa without a customary 'seasoning' period in the West Indies. 'Seasoning' was a frequently brutal indoctrination aimed at preparing slaves for life on the mainland by shattering their indigenous languages, religions, social hierarchies and ancestral fidelities. The effects of 'seasoning', along with the slaveholders' ban on African ceremonial objects and practices, reinforced the impression that few if any visual traditions from the Old World survived the apocalyptic conditions of the Middle Passage. They were said to have been diffused, emerging only occasionally, and passively, through subliminal 'encoding' in crafts and material culture.[3] But testimonies recorded in Georgia's coastal communities during the 1930s verify that African-Americans in these communities continually created autonomous artworks in wood and clay as well as a wide array of charms that were used for religious purposes.[4] Cultural resistance did, in fact, occur, resulting in an independent New World tradition of exceptional resonance and depth.

While the African nations that populated the Western Hemisphere include, among others, the Yoruba, Kongo, Ejaham, Dahomean and Mande, Bakongo cultural paradigms are most visible in the South.[5] This is probably due to the number of Bakongo slaves who arrived during the period of 'direct importation' (1808–1858), when slave-traders concentrated almost exclusively on the Bantu-speaking nations of west central Africa.[6] The homelands of these nations were in Kongo, in the vicinity of today's Angola and Zaire. Arriving directly from Africa, having bypassed 'seasoning' in the West Indies, the subsequent dispersal of these Africans to locations as far west as Texas meant that more established slave communities were suddenly infused with men and women whose cultural legacy remained intact.[7] Often several generations removed from their origins in West Africa, these communities experienced a revived awareness of their heritage through the newcomers.[8] The Bakongo thus served as catalysts for black cultural identity in the crucial decades before the Emancipation Proclamation of 1863.

A BAKONGO LEGACY

'The Bakongo people bore the brunt of the Congo slave trade', says the historian John Ryan Seawright, 'but their society also proved the most resistant to the economic and social devastation brought on by these plagues. When the Belgian Congo gained independence in 1960, its first president, Joseph Kasavubu, was a Bakongo.'[9]

Opposite: Cyrus Bowens's Grave Monuments, Sunbury, Georgia, circa 1938 (photograph: Malcolm and Muriel Bell, Georgia Historical Society, Savannah, Georgia).

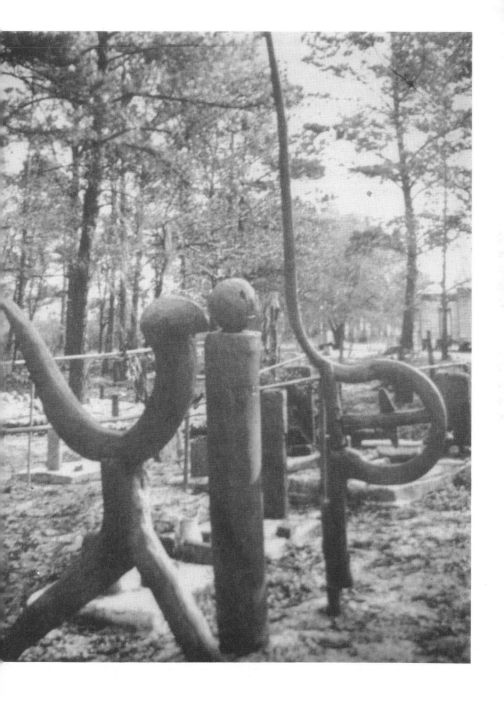

The same can be said of Bakongo cultural resistance in the American South. Nowhere is this more apparent than along the Rice Coast – the Atlantic Coast of the Carolinas, Georgia, and Florida. In the early 1930s, not far from Jekyll Island, Georgia, in the tiny tidewater community of Sunbury between Savannah and Brunswick, Cyrus Bowens, a renowned 'Spiritual Father' of the Sunbury Missionary Baptist Church, experienced a vision that instructed him to 'make images in wood in honor of the family dead'.[10] Afterwards, he created a series of grave monuments for the church's cemetery that would one day serve as a lexicon of Kongo traditional ideography. Bowens took trees that had been deformed in an ice storm, stripped their bark and 'freshened' them, and created three figures – a bird, a serpent, and a human – for the family grave enclosure in the cemetery of the Sunbury Missionary Baptist Church. He made a marker for his wife, Rachel, an imprint of her hand embedded in a concrete slab with a mirror in the palm. He placed a porcelain commode next to a cross of terracotta bricks on the grave of Alec Bowens, his father. Sometimes he would pick up objects that surfaced in the shallow marshes near his house, such as a fragment of iron pipe resembling a ladder (retrieved from a shipwreck), or a dolphin skull, or a load of shells. These too found their way to the cemetery, where Bowens added bottles to the 'rungs' of the iron pipe and scattered the shells beneath the headstones of family and friends. At one time, there was a full-sized bed mounted, ark-like, over a grave. Eva Mae Bowens recalled that her father had also made 'a little man' that once stood next to the more abstract wooden sculptures.[11] Later, Bowens's children would mark his own grave by placing the dolphin skull on top of a cross and painting it silver.

Although Cyrus Bowens was never officially ordained a minister, part of his job as a Spiritual Father of the Sunbury Missionary Baptist Church was to interpret dreams and visions experienced by the faithful during periods of 'seeking for the church'. 'Seeking' required night-long vigils in the woods or in cemeteries as a preparation for baptism.[12] Customs such as 'seeking' and the citation of visionary experience as the licence to make art are common motifs in the lives of black southern vernacular artists. They are also consistent with testimonies found in *God Struck Me Dead*, a volume of oral histories collected at Fisk University during the 1930s, in which a hundred former slaves from Tennessee detailed their Christian conversion experiences in imagery unprecedented in white communities.[13] The image of the 'little man' that Cyrus Bowens reportedly made for the Sunbury cemetery appears repeatedly in *God Struck Me Dead*. It was also a feature of the seeking vision of Eddie Bowens, the artist's cousin.[14]

In rural Sunbury of the 1930s, as in Africa today, resistance to placating spirits with conjure and 'root work' was forbidden after conversion to Christianity. Nevertheless, while Cyrus Bowens instructed seekers about 'the big-eyed God, the God that comes to show all what is hidden',[15] his works in the cemetery carried the cosmographic signatures of his ancestors, functioning as a necessary bridge between the repressions of slavery and segregation and an uncertain but hopeful future.

According to the Africanist art historian, Robert Farris Thompson,

> The influences of and improvisations on Kongo art and religion in the western hemisphere are most readily discernible in four major forms of expression: cosmograms marked on the ground for purposes of initiation and mediation of spiritual power between worlds; the sacred Kongo medicines, or *minkisi* (sing. *nkisi*); the use of graves of the recently deceased as charms of ancestral vigilance and spiritual return; and the related supernatural uses of trees, staffs, branches, and roots.[16]

These are 'outwardly humble signs that reveal their inwardly transforming secrets', says Thompson, who interviewed members of the Sunbury community in 1968, shortly after Cyrus Bowens's death.[17] Thompson's visits to Sunbury were part of a larger undertaking in which the Yale professor catalogued a wealth of parallels between sign systems in Kongo and the American South, culminating in the 1981 exhibition, *The Four Moments of the Sun: Kongo Art in Two Worlds* at the National Gallery of Art in Washington D.C. The catalogue of this exhibition, and Thompson's subsequent work, *Flash of the Spirit: African and African American Art and Philosophy* (1983), are necessary primers for anyone interested in Kongo/Southern fusion.

Thompson explains that, in the Kongo universe, death involves a journey through *kalunga*, a watery region sometimes inhabited by dogs where all is reversed and upside-down as in a reflection. Metal and terracotta pipes marking graves act as symbolic water-bearers and as 'bridges between worlds capable of transmitting messages from the beyond'. Decorating graves with the last used objects of the deceased seals covenants of communication between the living and the dead. Ceramic shards and inverted pots, as well as porcelain (kaolin) bowls and basins, represent 'the reversing power of death'. Mirrors, glass, mica, tinfoil, and chrome – all bearers of mystic flash – 'hold the spirit at an appropriate distance from the living while allowing those remaining to see into the next world'. Lamps light the way of the deceased along their spiritual journey. Trees planted directly over the body invoke 'immortality and perdurance'. Bottles on trees or pipes, as in the Bowens family enclosure, guard the land against intruders while capturing malevolent powers and containing them.[18]

These and other seemingly ordinary objects are familiar fixtures in African-American cemeteries in the rural South today as well as in contemporary Zaire.[19] But no other known site in the United States is more richly arrayed than the cemetery at Sunbury. Another grave marker, probably not by Bowens, shows a large diamond shape incised in a concrete slab with a horizontal line cut through the centre – a literal evocation of the Kongo sign of The Four Moments of the Sun. 'It emphasizes', says Thompson, 'that man, as such, moves in God's time not his own'.[20] In this context, the diamond can also be read as two mountains opposed at the base, one reflecting the other in the ocean, with the *kalunga* line mediating the boundary between the living and the dead. The Kongo cosmogram is also sometimes rendered as a cross superimposed on a circle. The extremities of the cross, like those of the diamond, signal the spirit's counter-clockwise journey through time: i.e. dawn – 'rising, beginning, birth, or re-growth'; noon – 'ascendancy, maturity, responsibility'; sunset – 'setting, handing on, death, transformation'; and midnight – 'existence in the other world, eventual rebirth'.[21]

The stream of crossed circles and emblematic diamonds in black southern communities winds its way from the Rice Coast to quiet middle-class neighbourhoods in Mobile, Alabama, to the neon-coloured facades of juke-joints in the Mississippi Delta, resonating with other ubiquitous Kongo-derived signs used in yard decoration such as wagon wheels, hubcaps, millstones, rotating fan blades, and whitewashed 'tire crowns'. All evoke the perpetual motion of cyclical time that translates the dialogic powers of the cemetery into the domestic settings of yards and homes. Recurrences of these signs in the South's art and material culture also testify to the powers of 'syndetic' growth where 'linear, evolutionary growth tends less to dominate than does ardent proliferation'.[22] Syndetic growth reminds us that improvisation is as crucial as inheritance in the ongoing development of culture.

During slavery and segregation, compounding the meaning of ordinary objects from everyday life served as a means of psychological integration and cultural resistance. As vessels of coded communication, these objects were easily recognised by the initiated; as the ordinary props of daily existence, uninformed oppressors simply overlooked them. But while the growth of this strategy often defied linear connections from one community to the next – from a community on the Georgia coast, for example, to a neighbourhood in Memphis, Los Angeles, or New Bedford, Rhode Island – its persistence in contemporary life and its constant recurrence in vernacular art suggest an even deeper divergence from the status quo, paralleling the social transitions of African-Americans as a people. 'I suggest', says Thompson, 'that the coming of

the artistic traditions of West Africa to the New World provided life insurance on a hemispheric scale and that the full range of possibility embodied in this history helps us to understand some of the central issues of our time'.[23]

DOUBLE SIGHT

Most African-American vernacular traditions 'are as much about how to do things in an open-ended way', says the anthropologist, Grey Gundaker, 'as they are about what gets done ... Connections to a past as distant as Africa are not eroded, but rather reinvented through them.'[24] In rural Brent, Alabama, almost five hundred miles west of Sunbury, the Reverend George Kornegay transformed his three-acre tract of land into an epic yard show. He began this work in the late 1970s after retiring from his duties as pastor of a Methodist congregation in Selma, Alabama. Citing his desire to 'keep on preaching some of the things that can't be said',[25] Kornegay created a 'moral universe' that teaches history, conditions the soul, and inspires cultural confidence.[26] Like most Afro-Atlantic yard shows, Kornegay's contains idiomatic references to cemeteries. This is important, says Gundaker, 'because it's a common belief in Central and West Africa that the spirits of the dead influence the daily lives of the living. When African captives were shipped to America, these traditions were disrupted. Burial-like areas in yard shows became one way to reestablish ancestral connections in an alien land.'[27] Kornegay's yard is also a sophisticated rendering of the African principle of 'double sight' (i.e. 'four eyes'), the belief that mature vision oscillates between what is apparent and what is implied, between the seen and the unseen.[28] Here, traditional interpretation and contemporary improvisation do not contradict each other, rather they add to the yard's array of relevancies. A wheel on a post thus becomes both an evocation of the Kongo cosmogram and 'Ezekiel's Wheel'; a stack of old television sets painted silver with bottles on top becomes both a 'TV motel' and an all-seeing eye enlivened with the protective flash of the spirit; a pile of whitewashed stones refers not only to ancestral legacies but to the scriptural exhortation, 'On this rock I will build my church'; an indecipherable script beside a telephone receiver electrifies 'the word of God';[29] a tepee (Kornegay is part-Indian) becomes a locus of empathy for all who have been culturally displaced.

In Africa the custom of 'dressing' yards predates modern times. Thompson quotes the eighteenth-century historian, L'Abée Proyart's reaction to the decorated houses and fields he encountered along the coast of northern Kongo. 'The most determined thief would not dare

cross their threshold when he sees it thus protected by these mysterious signs'.[30] While in Africa, as well as in the United States, the yard was the centre of family life, Eugene Genovese points out that in the West Indies, 'it was much more than a social center and a means of additional food. The slaves buried their dead there; the yard took on a religious significance ... One did not walk into another's yard without permission.'[31] In turn, some contemporary African-American graves are beginning to assume the volume and complexity of yard shows.

Afro-Atlantic graves and yard shows also resonate with the tradition of Kongo *minkisi*, i.e. sacred medicines made from ritualised configurations of objects and substances. In pre-colonial Africa, *minkisi* were usually attached to carved figures and kept in homes. They were said to be capable of both hurt and healing, enforcing strict taboos, while reminding the community that all power is double-sided. The trend toward modernisation in the twentieth century, as well as African Christianity's proscriptions against 'wizardry',[32] gradually sent *minkisi* into the more detached environments of Western art museums. They survive in Kongo today only as 'little plastic packets discretely worn, ballpoint pens medicated to help schoolboys pass examinations, and special sunglasses that taxi drivers hope will protect them from accidents'.[33] In black southern yard shows like the Reverend Kornegay's, the aspect of protection associated with *minkisi* remains intact with references to trespassing extended to the domain of Christian ethics and right-mindedness. Both traditions acknowledge orders of power that, at times, must transcend the legalistic proscriptions of municipal authority. While the Reverend Kornegay's yard continues to be a welcome sight in the small community of Brent, Alabama, in other instances yard shows have been destroyed by local police at the behest of incredulous neighbours and passers-by.

From the late 1960s until shortly before his death in 1990, Eddie Williamson (1922–1990) occupied a strip of land at the intersection of Highland Avenue and the Southern Railroad in the Normaltown district of Memphis, Tennessee. This busy urban crossroads divides the fashionable suburbs of the city's east side from the racially segregated neighbourhoods to the southwest. It is perhaps no accident that Williamson established himself in a liminal zone that would test the boundaries of both constituencies. Living as a 'squatter' on the southern side of the railroad tracks, sleeping in a tent-like construction made of discarded packing crates, Williamson created a sprawling yard show that shop owners and neighbourhood residents described as 'Parking Lot

Opposite: The Reverend George Kornegay, Yard, Brent, Alabama, 1994 (photograph: Judith McWillie).

Eddie's bottle garden'.[34] The axis of his design honoured the horizontal sweep of the railroad tracks and resonated with the patchwork grids of rural subsistence gardens. Within a two-block radius of the central installation, Williamson cultivated virtually every patch of exposed earth, pulling weeds from the crumbling parameters of parking lots where they intersected the bases of buildings, exposing enough raw ground to plant zucchini and watermelon. Later he harvested and distributed the yield, free of charge, to patrons of the shopping centre across the street. During the twenty years Williamson lived at the site, legal machinations continually threatened his work. The white merchants and restaurateurs of the neighbourhood championed him in court battles and media investigations, but transient motorists constantly complained about the 'junk yard' adjoining the railroad tracks. Six years before his death, Williamson permitted the city to bulldoze the site, since ill health prevented him from further maintaining it.

African-American yard shows like Williamson's and Kornegay's are the United States' least sanctioned form of public art. They are also local manifestations of a more pervasive cultural contrast in which the myth of the stubborn individualist, a myth at the core of twentieth-century American thought, gives way to a more community-oriented connective impulse in the Afro-Atlantic tradition. This contrast blinded Parking Lot Eddie's detractors to the purposes of his art. Nevertheless, his highly publicised wranglings with the law brought constituencies together (white merchants, media professionals, legal experts, private citizens, students and scholars) who might otherwise never have stopped to consider such things. In the end, Williamson became a legend, while the peach trees he planted along the tracks of the Southern Railroad continue to feed the homeless year after year.

A New Dispensation

In the decades following the Second World War, the use of art to signal the emergence of new dispensations of power in African-American life extended from vulnerable outdoor constructions to autonomous monuments meant to last indefinitely. But, as Eddie Williamson's experience demonstrates, the explosive shaping and elaborating of 'grassroots' idioms by those we call 'artists' involves a quantum leap through politics as well as tradition. James Hampton's luminous visionary altar, *The Throne of the Third Heaven of the Nation's Millennium General Assembly*, now permanently installed in the National Museum of American Art of the Smithsonian Institute, is a compelling example of

this process and of the ways in which perceptions of black southern vernacular artists changed during the 1970s and 1980s.

Hampton (1909–64) was born in Elloree, South Carolina but left when he was 19 to settle in Washington, D.C. There he remained, off and on, until his death in 1964. After serving in Guam during the Second World War, he resumed employment in Washington as a maintenance supervisor. He then experienced a series of visions that recurred throughout the rest of his life, prompting him to begin constructing the Throne. Events surrounding the monument's accidental discovery in a small rented garage after the artist's death, a description of the Biblical aspects of its iconography, and the few known details of Hampton's contemplative life, were investigated by curators when the Throne entered the National Collection around 1965.[35]

The Throne's 27-foot wide superstructure consists entirely of recycled materials, including light-bulbs and fragments of discarded furniture collected by Hampton on his daily rounds. These he wrapped with silver and gold aluminum foil before incorporating them into a symmetrical design. At the apex of the Throne is the centrally-located 'Mercy Seat', a velvet upholstered chair positioned under a gilded diadem that says 'Fear Not'. In his original installation in the garage, Hampton mounted crosses superimposed on diamonds across the front. He placed squares in the quadrants of the crosses, evoking the four eyes of 'double sight'. Wall plaques on either side contained texts 'composed of graceful characters resembling those of Semitic or oriental languages'.[36]

Though the details of Hampton's theology have yet to be fully investigated, the artist made no secret of his work, often inviting individuals to the garage to experience it. In 1986, Otelia Whitehead of Washington, D.C. described how she had visited the garage on several occasions and observed the artist writing in 'more than twenty' notebooks, using the same enigmatic script as in the wall plaques.[37] Only one of these notebooks is known to have survived. Its ninety-seven pages are numbered with the English heading 'St James' at the top and 'Revelation' at the bottom. The abstract characters of the script are limited to a specific number, suggesting a coherent alphabet or a transposition from another source, but attempts by cryptographers to decipher its meaning have failed.[38] Whitehead also recalled how Hampton used the garage as a chamber of soul healing, inviting individuals to pray with him and having them sit on the Mercy Seat. This ceremony recalls a similar one performed by the Spiritual Baptists (Shouters) of Trinidad, recorded by George Eaton Simpson in 1978, in which the sect's new members are seated on a bench, also called the Mercy Seat, that had been signed 'with mystical symbols' and ciphers.[39]

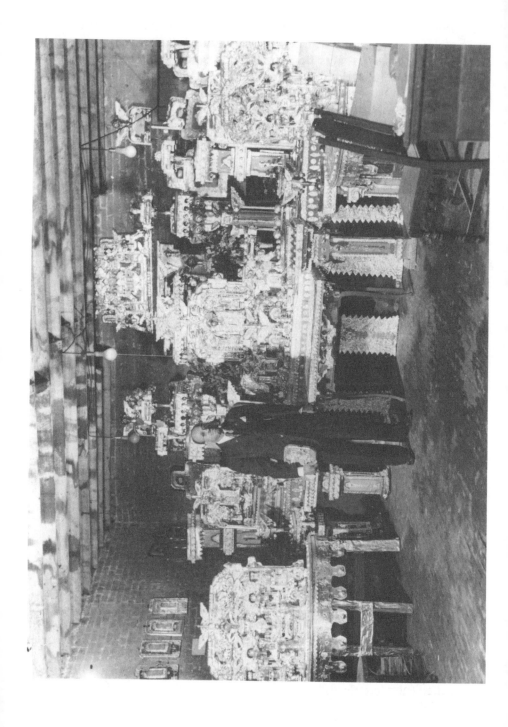

Before the Throne's discovery, works by African-American vernacular artists had been routinely displayed in museums of ethnography and history, rather than in America's more aesthetically-oriented art museums. Thus, the transfer of the Throne from its ceremonial setting in a rented garage to a major museum in Washington, D.C. marked a historic shift in the priorities of the American 'art world'. But its displacement also involved a degree of cultural drift. Recontextualised as art, the physical characteristics of objects and ensembles display affinities with other works that are often unrelated in provenance and intentionality. Relationships are constructed according to the interests of viewers, whether or not those interests coincide with the artist's original motives. The problem was compounded at the time of the Throne's discovery since few art historians were prepared to understand it within an Afro-Atlantic continuum. Yet the witness of Hampton's devotion and cultural literacy was vastly expanded. In the meantime, it is a testament to the power of *The Throne of the Third Heaven of the Nation's Millennium General Assembly* that it continues to defy facile classification. Art world terms such as 'folk', 'naive', 'primitive', 'idiosyncratic', and 'outsider' – labels still associated with vernacular artists – collapse under the weight of the monument's sophistication and complexity. While the Throne remained an anomaly in the Smithsonian collection for over twenty years, the same museum recently purchased a number of works by other black southern vernacular artists, preparing the way for a more universal understanding of America's African dimension. In the meantime, a janitor from South Carolina, working in an 'unheated, poorly lit'[40] garage in Washington, D.C., with no means of knowing where his vision would eventually travel, turned 'an imposed culture back on itself, transformed'.[41]

THE LANGUAGE OF THE HOLY SPIRIT

Unlike James Hampton, John B. ('J. B.') Murray (1918–88), of Glascock County, Georgia, a lifelong farmer, enjoyed international acclaim prior to his death at the age of 70. In the last decade of his life, Murray produced thousands of drawings in colour using an improvised script that he called 'the language of the Holy Spirit'. The script is cursive and rhythmic when compared with James Hampton's more tenacious, 'upright' notations.

Opposite: James Hampton with The Throne of the Third Heaven of the Nation's Millennium General Assembly (National Museum of American Art, Smithsonian Institute, photographer unknown).

The drawings show meandering lines spreading in all directions, sur-
rounding pictographic human figures which the artist decribed as 'the
evil people, the people who are dry tongued, those who deny God'.
Murray insisted on the efficacy of his abstract paintings, maintaining
that it wasn't necessary to draw 'like what's outside' because:

> God gives knowledge direct. The Lord changes the instrument on me and
> that is why you see different writing. Different writing represents different
> languages and folks. It's like he uses different verses and prayers and psalms
> – the same. Its the language of the Holy Spirit direct from God.[42]

Murray began making art after an initiatory vision that surprised him
one day while he was working in his yard. Here he describes what
happened:

> When I started I prayed and I prayed. And the Lord sunk a vision from the
> sun. Everything I see is from the sun. He showed me signs and seasons and
> he tells me. He turned around and gave me a question to ask him and I asked
> him to see my mother. He brought her before me and two brothers. And the
> three come up as a shadow – a spiritual shadow – not like us, not like our
> body.
> The Lord told me I had to be hung. You have to hang on to God for trouble
> to pass over. When he told me I had to be hung, tears came to my eyes. And
> my mother (she was dead) her spirit cried, 'Lord take care of my child!'
> See, Spirit will talk with Spirit. And when I left there the eagle crossed my
> eye – a spiritual eagle. The eagle can see farther than any bird in the world
> and that's why I can see things some more folks can't see. What I see between
> here and the sun is in a twinkle.

Murray accepted curiosity about his 'spiritual work' with character-
istic poise and patience. In answering visitors' questions he would
begin by holding a bottle of water in front of a drawing while reciting
the Lord's Prayer. The water was an instrument of discernment for
Murray – a means of focusing attention and testing the efficacy of his
answers. 'The water does different things when you ask it', he explained.
'Answer us, Lord! Give me a louder word up!' Visitors were then invited
to freely interpret his art in a call and response dialogue with him.
Murray bore the anxiety as well as the ecstasy of his charismatic
experiences. He was briefly incarcerated in a state hospital for the
mentally ill for 'acting religion', a pattern all too persistent in the
South's economically stressed communities. Temporarily at least, he
shared the fate of another gentle and soft-spoken religious visionary,

Opposite: J. B. Murray, colour drawing, circa 1986 (Phyllis Kind Gallery).

Simon Kimbangu of Kongo, founder of the Church of the Lord Jesus
Christ on Earth, Africa's largest indigenous Pentecostal denomina-
tion.[43] Among the tracts and leaflets distributed by Kimbanguist
evangelists in the 1940s were 'identity papers for the road to heaven',
showing drawings of whirling suns and spinning crosses surrounded
by a script resembling J. B. Murray's 'language of the Holy Spirit'.[44]

Murray's use of 'wordless' writing also recalls an interpretation of the
practice by the modern Kongo poet, Fu-Kiau Bunseki. 'Because the
message is rising from another world into our known', says Fu-Kiau, 'it
should be used someday, there should be someone here to discover and
de-code it'.[45] But there are even more striking parallels between 'the
language of the Holy Spirit' and Afro-Muslim practice. Rene A. Bravmann
describes a plenitude of Muslim-derived expressions, still flourishing in
West Africa today, in which God is 'evoked elliptically through cryptic
letters'.[46] African-influenced spiritualism in the South has a strong
Muslim component, which is probably the result of both ancestral and
contemporary influences. These include the popular use of *The Book of
Moses* (Kitab Moussa) as a manual for divination; the manufacture of
special solutions ('washes') designed to impose supernatural interven-
tion; and the employment of 'seals' in the focus of power. At this point,
one can only speculate about J. B. Murray's contact with spiritualism
and hoo-doo in Glascock County, Georgia, a region rich in oral histories
concerning its healers and 'root doctors', and about the significance of
the fact that nearby Washington County was the birthplace of Elijah
Muhammad (Elijah Poole), who, in 1933, became a founding father of
the Black Muslims in Detroit. Murray avoided discussing spiritualism
except to say that it 'works by hands' with no regard for the guilt or
innocence of its target, and that 'Jesus is stronger than hoo-doo'.

SHARED VISIONS

During the 1970s and 1980s, it became increasingly common for black
southern vernacular artists to accept commissions from collectors who
learned of their work either through word of mouth or from local folk
art exhibitions and antique fairs. For example, J. B. Murray's patron,
William Rawlings of Sandersville, Georgia, had relatives in the antiques
business and began discreetly showing the artist's paintings to potential
buyers and promoters. Rawlings later teamed up with Andy Nasisse, an
artist/professor at the University of Georgia, who introduced Murray's
work to dealers and collectors of 'folk' and 'outsider' art. The enormous
popularity of this art would not be fully realised until the 1990s, but

patronage by mostly white collectors in the South has not been confined to the twentieth century.

Three decades after the landing of *The Wanderer*, the last slaving vessel to arrive along the South's Atlantic coast, Harriet Powers, a former slave living in Athens, Georgia, sold a quilt to Jennie O. Smith, a painter and teacher who had seen it at a local cotton fair in 1886. Though reluctant at first to sell, Powers accepted five dollars for the quilt in 1891 (her original asking price was ten)[47] and gave Smith a description of its iconography. Little is known of Smith's and Powers's continuing relationship except that Powers is said to have visited her patron occasionally to see 'the darling offspring of my brain'. Eventually, the quilt was donated to the National Museum of American History of the Smithsonian.

The only known photograph of Harriet Powers shows her in a dress apron with appliquéd suns and moons, stylistically consistent with the Smithsonian quilt and with another she completed, around 1895, after she sold the first one to Jennie Smith. The second quilt is now in the collection of the Museum of Fine Arts in Boston. Both quilts offer non-chronological, conceptually aligned scenes from the Bible, as well as celestial events and legends of supernatural intervention. The fact that these quilts are pictorial is a significant departure from the geometric abstractions of European-Americans and African-Americans of the period, strengthening the impression that Powers originally used them as teaching tools, perhaps in connection with a local lodge or fraternal order.[48]

'It is interesting to note', says the African-American art historian and collector, Regenia Perry, 'that several of the descriptions Powers provided in 1914 [to a newspaper reporter from New York] are drastically different from her original descriptions to Smith in 1891'.[49] Powers was not being disingenuous. In Afro-Atlantic tradition, interpretations of art are actively linked with spiritual exhortations. Aesthetic merit is assessed in relationship to moral cogency. This cogency extends not only to the ability to create powerful physical objects but also to the artist's role in transmitting treasured wisdom to future generations. In contrast, from the perspective of some contemporary collectors of African-American vernacular art, the quilts of Harriet Powers stimulate syncretisms rooted not in the artist's cultural values but in her stylistic inventions. For, just as J. B. Murray's 'language of the Holy Spirit' resonates with twentieth-century painting styles such as Abstract Expressionism, Powers's appliqués land securely within sensibilities conditioned by twentieth-century modernism. Syncretisms with the works of modernists such as Henri Matisse (Matisse would have been thirty-one years old when Powers completed her second quilt) may have little to do with Powers's life in nineteenth-century rural Georgia, yet they are addressable within the

concerns of contemporary art history and criticism. Predictably, controversies on this point are intense, with cultural nationalists claiming parallels with colonialism on the one hand, and collectors and critics touting the advantages of 'collaboration' and 'de-isolation' on the other. While these controversies will probably never be completely resolved, they have nevertheless served to propel Powers's art into the global flow of contemporary culture, infusing it with a prophetic dimension.

In the same vein, the wood and resin sculptures of another artist from Athens, Georgia, Dilmus Hall (1900–87), as well as the stone carvings of the Nashville visionary, William Edmondson (1883–1951), have been compared with works of the modernist sculptor, Constantin Brancusi. Each of these artists engage what Roger Lipsey calls 'the virile mysticism'[50] of those who tap into the wisdom, poetry and integrity of primary forms. Ironically, from the standpoint of conscious memory, Dilmus Hall was more aware of his debt to Europe than to Africa, but not from museums, galleries, and the media, rather from the perspectives of lived experience. Hall cites his wartime exposure to sculpture in France, where he had served as a stretcher bearer during the First World War, as the inspiration for his art:

> I have seen a lot of the world and I have an idea of America. After the war I went traveling. When I went to Europe, there were many things that we saw over there that the people had made, just like America. And I told some of them, 'I'm going to carry something back from here', because these people are very glad, in their manufacturing, to show you around. So I came back and began to make these different things. The more I would make them, the more I would understand about it. See? I had to make it like that, because that proves the daily life of people.[51]

In the 1950s, Hall built a house of cinder blocks and painted two versions of the Kongo cosmogram on its ceilings: one in the bedroom, a red diamond with circles at the points; the second in the living room, four blue diamonds that, like the other, rotated around the ceiling light. Until his death in 1987, Hall continuously produced allegorical sculptures of wood and concrete for his yard and decorated the facades of his house with blue and yellow suns, moons, and diamonds (the KiKongo word for 'diamond' also means 'star').[52] From about 1985, he produced several hundred drawings that were quickly sold to collectors for little more than Jennie Smith paid for Harriet Powers's quilt in 1891. But it was Hall's last works, his wooden crucifixes, that would transcend the more domestic emphasis of 'folk art' as well as the tendency to view black southern vernacular art only through the lens of the past.

Consider, for example, a crucifix Hall made in 1985. Putty encrusted over the front of the body renders a flayed belly, a single defining wound. The head, a wooden sphere dripped with silver, red, and black paint, is pounded through with nails. A single toothpick traverses the mouth. The arms bend downward, as if to part the wound, rendering an inverted triangle, evoking the realm of the ancestors below the *kalunga* line. Here is Christ as *Nkisi Mabyaala*, the assertive one who 'comes on strong', who, in nineteenth-century Kongo, would have been aroused with spikes and nails, would have been decorated with the same colour signatures, would have had its powers deployed through the same open centre veneered with mirrors and packed with sacred medicines.[53] But here, Nkisi Nkondi and the Good Shepherd are reconciled, in a structural 'coincidence' that magnifies the mysteries of syncretism and cultural transmission rather than merely decoding them.

The emergence of black southern vernacular artists within the mainstream of American contemporary art during the 1990s introduces a 'doubling of histories within an overarching transformation of cultural priorities',[54] establishing the South as a definitive force in American art for the first time in its history. Yet most of the individuals discussed in this essay were unaware of the historical connections that would associate their art with a global context. None of them knew each other, nor any other artists except those who came to purchase their work. Still, while contemporary art critics actively resist discussing Afro-Atlantic perspectives, the prominence of the tradition within the larger dimensions of American culture is already firmly established.

In the meantime, younger artists, such as Lonnie Holley (b. 1950) of Birmingham, Alabama, maintain a consciously cultivated identification with Africa. 'The earth is made up of the dust of the ancestors', Holley says, 'We are living off their bodies.'[55] Some of the biographical motifs and creative strategies common to older artists recur in Holley's life: (1) the experience of an initiatory vision as the licence to make art; (2) the construction of environmental works made from cast-off objects; (3) the use of abstract improvisational 'writing' and painting to transmit moral exhortations ('In the future there's going to be a new language and a new code', Holley says); (4) the association of art with divination. To these add an accessibility to tourists and dealer/collectors as well as the steady conviction that God endows talent as a sacred trust to be used for the liberation and edification of African-Americans and other kindred souls.

Holley joins his friend, the visionary painter, Thornton Dial, in challenging fundamental critical assumptions about the social autonomy of artists. Both Holley and Dial maintain strong ties with their communities, refusing to move to New York or Atlanta where dealers organise the distribution of their works. Dial, in particular, in collabo-

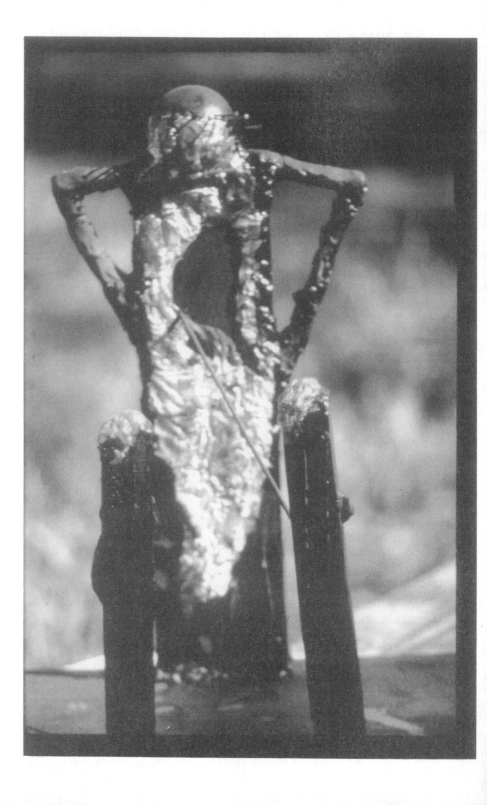

ration with his dealer, William Arnett, of Atlanta, has challenged the stereotypes imposed on black southern vernacular artists by exhibiting in galleries reserved for 'international contemporary art', such as the New Museum for Contemporary Art in lower Manhattan, as well as venues devoted exclusively to folk art such as The Museum of American Folk Art in New York. His larger paintings currently sell for as much as $120,000 each. Lonnie Holley's financial gains are more modest, but he is proud of his role in introducing Dial, a mentor twenty years his senior, to the dealers and writers who have made him famous.

Holley and Dial also represent the diversity of artists rooted in the South's vernacular traditions as well as the changes that occur when they enter a more cosmopolitan milieu. Dial's work, in particular, seems destined to become an art historical watershed. While his early works exhibit the aesthetically frugal reverence typically associated with rural sensibilities, his extravagant new triumphalist paintings seem to aggressively address the approaching millennium. While he remains in Bessemer, Alabama, where he was born, he has become actively interested in other successful painters and sculptors who exhibit in the fashionable galleries of Europe and New York. He maintains a courteous cooperation with his dealer whose promotional skills have been successful in attracting museums', critics', and historians' attention. But this cooperation also extends to the dealer's request that Dial be inaccessible to the public. Controlled access thus marks a significant change in the way vernacular artists have functioned in the past. Holley, on the other hand, maintains his liminality, a quality that may be related to his divinatory approach which, according to the anthropologist Philip Peek, 'never results in a simple restatement of tradition to be followed blindly. It is a dynamic reassessment of customs and values in the face of an ever-changing world.'[56] His life continues to be a percussive rondo of visionary episodes, eloquent dialogues with spur-of-the-moment visitors, manic spasms of painting and drawing, and fervent sculptural meditations on the fecundity of family and community.

Poised between the past and the future, making art 'out of intention, not habit',[57] Holley, Dial, and a litany of other Afro-Atlantic masters add their voices to the ever expanding resonance of the American South, as if to say, 'I will project, flank, and balance the world.' No contemporary voice is more eloquent in this context than Holley's, so the closing paragraphs of this chapter belong to him:

> To deal with me as an artist and see all of my art as art and not just junk is to see that I went to the depths of where no one else would even go to speak

Opposite: Dilmus Hall, Crucifix, 1985 (photograph: Judith McWillie).

for life. How have we allowed the values that we have proclaimed to be in the way of a continuation of life? They all come running and they ask on their own individual terms. God said, 'I made enough in your yard that I could show my people how to change.' And I have to work it all right back out of me so I can come back and handle another one. And that's what keeps me from going insane. And I think that's the way it is with every artist.[58]

NOTES

Parts of this essay have been previously published by the author in significantly different form in the following: *Public Art Review* (Summer/Fall 1992); Charles Reagan Wilson ed., *Cultural Perspectives on the American South*, vol. 5 (1991); *The Arts Journal* (Summer 1990); *Another Face of the Diamond: Pathways through the Black Atlantic South* (1989); and *The Clarion Magazine of the Museum of American Folk Art*, New York (Fall 1987).

1. Albert Raboteau, *Slave Religion: The 'Invisible Institution' in the Antebellum South* (New York: Oxford University Press, 1978) p. 4.
2. Robert Stam, *Subversive Pleasures* (Baltimore: Johns Hopkins University Press, 1989) pp. 89, 123.
3. John Michael Vlach, *The Afro American Tradition in the Decorative Arts* (Cleveland: The Cleveland Museum of Art, 1978) pp. 1–15.
4. The Georgia Writers' Project, *Drums and Shadows: Survival Studies among the Georgia Coastal Negroes* (Athens, Georgia: The University of Georgia Press, 1939) pp. 21, 26, 33, 53, 70, 224–6 and illustrations.
5. Robert Farris Thompson, *Flash of the Spirit: African and African American Art and Philosophy* (New York: Random House, 1983).
6. Joseph E. Holloway and Winifred K. Vass, *The African Heritage of American English* (Bloomington: Indiana University Press, 1993) p. xxv.
7. John Ryan Seawright, 'Wuta Cowany: Corps, Kings, and Georgia's African Legacy', *Flagpole* (Athens, Ga.), June 9, 1993, p. 12.
8. Ira Berlin, 'The Making of Americans', *American Visions* (Washington, D.C.) February 1987, pp. 26–30.
9. Seawright, 'Wuta Cowany', p. 12.
10. Robert Farris Thompson, 'Cyrus Bowens of Sunbury, Georgia: A Tidewater Artist in the Afro-American Visual Tradition', in *Chant of Saints* ed. Michael Harper and Robert B. Stepto (Chicago: University of Chicago Press, 1979) p. 139.
11. Eva Mae Bowens interviewed by the author, November, 1987 on videotape.
12. I was introduced to the tradition of 'seeking for the church' in an interview with Cornelia Walker Bailey of Sapelo Island, Georgia in April 1991, also by Albert Raboteau in December 1989.

Opposite: Lonnie Holley: Detail of yard, Birmingham, Alabama (photograph: Judith McWillie, 1992).

13. *God Struck Me Dead: Religious Conversion Experiences and Autobiographies of Negro Ex-Slaves* (Nashville, Tenn.: Social Science Institute of Fisk University, 1941).
14. Eva Mae Bowens interview.
15. Ibid.
16. Robert Farris Thompson, *Flash of the Spirit*, p. 108.
17. Robert Farris Thompson interviewed by Judith McWillie,' Total Relay: Conversations with Robert Farris Thompson', *The Arts Journal*, vol. 15, no.1 (Asheville, N.C.) July 1990, p. 7.
18. Robert Farris Thompson, *The Four Moments of the Sun: Kongo Art in Two Worlds* (Washington D.C.: The National Gallery of Art, 1981) pp. 44, 178–81, 186, 187, 193–4, 198, 200.
19. Thompson, *The Four Moments*, p. 202.
20. Ibid., p. 44.
21. Wyatt MacGaffey, *Religion and Society in Central Africa* (Chicago: University of Chicago Press, 1986) p. 45.
22. Robert Plant Armstrong, *The Powers of Presence* (Philadelphia: The University of Pennsylvania Press) p. 67.
23. Robert Farris Thompson, 'From Africa', *Yale Alumni Magazine* (November 1970) pp. 16–21.
24. Grey Gundaker, 'Reverend Kornegay's Yard Show', *Metropolis* (New York), October, 1994, p. 151. Photography by Judith McWillie.
25. Reverend George Kornegay interviewed by the author, February 1993.
26. See Grey Gundaker, 'African American History, Cosmology, and the Moral Universe of Edward Houston's Yard', *Journal of Garden History*, vol. 14, no. 3 (Autumn 1994) pp. 179–205.
27. Gundaker, 'Reverend Kornegay's Yard Show', p. 151.
28. Grey Gundaker, 'Double Sight', in *Even the Deep Things of God: A Quality of Mind in Afro-Atlantic Traditional Art* (Pittsburgh: Pittsburgh Center for the Arts, 1990) p. 8.
29. Gundaker, 'Reverend Kornegay's Yard Show', p. 107.
30. Thompson, *Four Moments of the Sun*, p. 179.
31. Eugene D. Genovese, *Roll Jordan Roll: The World the Slaves Made* (New York: Random House, 1972) p. 537.
32. Harvey Cox, *Fire From Heaven: The Rise of Pentecostal Spirituality and the Reshaping of Religion in the Twenty-first Century* (New York: Addison-Wesley Publishing Company, 1995) p. 245.
33. Wyatt MacGaffey and Michael Harris, *Astonishment and Power: The Eyes of Understanding Kongo Minkisi* (Washington D.C.: The Smithsonian Institution Press) p. 29.
34. Judith McWillie, 'Inter-cultural Inter-connections: Eddie Williamson, Tyree Guyton and the Cosmogonic Crossroads', *Public Art Review* (Summer/Fall 1992) p. 14.
35. Lynda Roscoe Hartigan, 'James Hampton's Throne', in *The Throne of the Third Heaven of the Nation's Millennium General Assembly* (Montgomery, Alabama: Museum of Fine Arts, 1977) pp. 6–8.
36. Ibid., p. 18.

37. Otelia Whitehead interviewed by the author, 27 February 1986 on audiotape.
38. Linda Roscoe Hartigan interviewed by the author, 27 February 1986.
39. George Eaton Simpson, *Black Religions in the New World* (New York: Columbia University Press, 1978) p. 118.
40. Lynda Roscoe Hartigan, 'James Hampton's Throne', p. 5.
41. Stam, *Subversive Pleasures*, p. 124.
42. Murray interviewed by the author, 19 April and 31 May 1986 on videotape. All Murray quotes are from these interviews.
43. Harvey Cox, *Fire From Heaven*, p. 246.
44. Robert Farris Thompson, *Face of the Gods: Art and Altars of Africa and the African Americas* (Munich: Prestel/The Museum for African Art) p. 52. Details of the Kimbanguist script are obscured in the reproduction for this source. Thompson refers the reader to Efraim Anderson's *Messianic Popular Movements of the Lower Congo* (1958) for further information.
45. Robert Farris Thompson, *The Four Moments of the Sun*, p. 69.
46. Rene Bravman, *African Islam* (Washington D.C.: The Smithsonian Press, 1983). p. 22.
47. Regenia A. Perry, *Harriet Powers's Bible Quilts* (New York: Rizzoli Art Series, 1994) p.1.
48. Maude Southwell Wahlman, *Signs and Symbols: African Images in African American Quilts* (New York: Museum of American Folk Art, 1993) p. 64.
49. Regenia Perry, *Harriet Powers's Bible Quilts*, p. 2.
50. Roger Lipsey, *An Art of Our Own: The Spiritual in Twentieth Century Art* (Boston: Shambhala, 1988).
51. Dilmus Hall interviewed by the author, July 1984 on videotape.
52. Wyatt MacGaffey, *Religion and Society in Central Africa*, p. 124.
53. Wyatt MacGaffey, *Astonishment and Power*, pp. 39, 44.
54. Grey Gundaker, 'Double Sight', p. 5.
55. Lonnie Holley interviewed by the author on videotape.
56. Philip M. Peek, 'African Divination Systems: Non-Normal Modes of Cognition', *African Divination Systems: Ways of Knowing* ed. Philip M. Peek (Bloomington: Indiana University Press, 1991) p. 195.
57. Miles Davis quoted. National Public Radio interview, 1987.
58. Lonnie Holley interviewed by the author (November 1991) on video tape.

Afterword

Negotiating Differences:
Southern Culture(s) Now
Richard Gray

> The memory is a living thing – it too is in transit. But during its moment, all that is remembered joins, and lives – the old and the young, the past and the present, the living and the dead.
>
> Eudora Welty, *One Writer's Beginnings* (1984)

> I come from people who believe the home place is as vital and necessary as the beating of your own heart ... It is your anchor in the world, that place, along with the memory of your kinsmen at the long supper table every night and the knowledge that it would always exist, if nowhere but in memory.
>
> Harry Crews, *A Childhood: The Biography of a Place* (1978)[1]

The words are those of two very different southern writers, taken from books that describe almost opposite ways of growing up in the South. Eudora Welty, born into a comfortable family home in Jackson, Mississippi where she still lives more than eighty years later, may have little enough in common with Harry Crews, the illegitimate offspring of an itinerant and impoverished farming family: little enough, that is, except a taste for Jack Daniel's whiskey and a habit of good writing. What Welty and Crews have in common besides this, however, is measured by these words. Two of the most famous sentences written by that most famous of southern writers, William Faulkner, are: 'The past is never dead. It's not even past.'[2] And, like Faulkner, both Welty and Crews testify to the indelible nature of memory, personal and cultural: the degree to which Southerners of all kinds have distinguished themselves from other Americans, and perhaps still do, by their passionate commitment to old times. Traces of that commitment can sometimes be found in the most unexpected of places. Some of the best southern writers of the present generation, for instance, come from the ranks of those who have sound reasons for being, at the very least, sceptical about that backward

looking impulse which marks out the cultural boundaries of the region. As women and/or African-Americans, a certain resistance might be anticipated from them, a measure of reluctance to embrace that traditionalism which carries as one of its consequences a tendency to banish them to the social and cultural margins. Yet, as Welty poignantly illustrates, the marginalising of women by traditional southern culture has evidently not prompted women writers to resist the nostalgic drift, the undertow of memory that characterises so many different regional cultural forms. Writing from what used to be called the margins is dauntingly similar to writing from what used to be called the centre: to the extent that it too can be characterised in the terms made famous by one deeply traditional southern writer, Allen Tate, who characterised southern literature as above all 'a literature conscious of the past in the present'.

A woman writer of the newer generation like Ellen Gilchrist, for instance, can talk in her first novel, *The Annunciation* (1983), of her central character possessing memories that she 'must carry with her always', because they have become 'her cargo', part of her that she carries *inside* her. Similarly, another woman writer from the South, Jayne Anne Phillips, begins one of the best recent books to emerge from that region, *Machine Dreams* (1984), with the announcement, 'It's strange what you don't forget' – before moving into a tortured account of how memory charges that elaborate circuitry of power and passion that we call the family. More telling still, perhaps, the main figure in *Meridian*, the novel published in 1976 by the African-American writer from Georgia, Alice Walker, seems like a not-too-distant relative of all those ghost-haunted figures in earlier southern fiction from Edgar Allan Poe to Faulkner. 'But what none of them seemed to understand', says Walker of her protagonist,

> was that she felt herself to be, not holding something from the past, but *held* by something in the past: by the memory of old black men in the South who, caught by surprise in the eye of the camera, never shifted their position but looked directly back: by the sight of young girls singing in a country choir, their hair shining with grease, their voices the voices of angels.[3]

The past is never dead, it seems. It is there, as a sudden, unexpected chord in books like *The Annunciation* and *Meridian*; or it is there as a rich, bass theme in a story such as *Machine Dreams*.

One of the more commonplace phrases deployed in many accounts of the South refers us to the 'irony' of southern history. And a particular irony of the recent history of that region is one implicit in the writings

of people like Gilchrist, Phillips and Walker – or, for that matter, Welty and Crews – and openly explored in several of the essays that constitute this volume: the irony, that is, of change within continuity. As some of the essays in this book testify, the social and cultural fabric of the South has experienced radical alteration. So too has our perception of that fabric. Not so long ago, it might have been possible to produce a book on the southern states of America that was in effect a form of surrender to white, male hegemony: a tacit acceptance of the premise that the best that was ever thought and said in those states was represented by a tradition running from, say, William Byrd of Westover and then Thomas Jefferson and John Taylor, through various figures like George Fitzhugh, John C. Calhoun and William Gilmore Simms, right up to the Fugitives and Agrarians and Faulkner – with, it might be, a concluding reference to Richard Weaver or Hodding Carter or even Wendell Berry. All these figures remain crucial to our understanding of what makes the South distinctive: but to them must be added a diverse, and potentially endless, series of other makers of southern culture.

As the essays assembled here demonstrate, these other makers include some white, male Southerners of a very different kind from the ones just mentioned. One name, Elvis Presley, measures just how different, and just how influential in the shaping of our present understanding of the South these other white, male makers are. Far more to the point, however, are those makers of the South and things southern whose achievements previously tended to be ignored or minimised for reasons of caste and/or gender: ranging from popular novelists, through blues singers, to those numerous and frequently anonymous men and women who have resurrected and reshaped the traditions of African art in the region. And just as much to the point here is our vastly enriched sense of exactly what 'making' a culture involves: the recognition, to which this volume testifies, that a culture expresses and in fact creates itself by a variety of means – means that include the individual book or essay, of course, but go far beyond this to incorporate the artefacts of everyday life and the endless products of mass culture, the voice perhaps heard in passing on the radio or images flickering on a screen. What emerges with particular power from this series of contemporary perspectives on the southern US, in short, is the sense of a rich, pluralistic, sometimes warring and at other times embracing series of influences and energies: not so much southern culture, really, as southern *cultures*.

What adds to the richness here is something else to which these essays bear witness. As our sense of the multiple character of southern culture(s) grows, so too does our understanding of the accelerated pace of material change in the South. Over the past forty or fifty years, in particular, there has been a drastic process of economic and social transformation. The

Mississippi that Faulkner wrote about has more or less disappeared. Atlanta, Georgia, where Scarlett O'Hara in *Gone With the Wind* witnessed the fall of the Confederacy, has become an urban metropolis: a centre for information technology with an African-American mayor, and a rich breeding-ground for yuppies. 'One drives', the Georgia writer Marshall Frady has mournfully reflected, 'through a Santa Barbara gallery of pizza cottages and fish'n'chip parlours, with a "Tara Shopping Centre" abruptly glaring out of the fields of broom sedge and jack pine'.[4] Frady does not say this himself, but one could add that, when driving through the South now, one also drives through a social terrain that has – despite all the continuing drawbacks and perpetuated injustices – seen dramatic improvements, genuine progress.

The South is no longer as viciously and openly segregated as it was even thirty years ago: even if the African-Americans of the region, like African-Americans generally, still suffer disproportionately in terms of health, education, employment and the basic day-to-day matter of survival. For that matter, the population of the region as a whole, including *all* ethnic groups, is no longer as underprivileged and uneducated as it once was. The region is no longer regarded as it was, say, in the 1930s: as 'the Nation's No. 1 economic problem'. Just over twenty years ago, two sociologists measured the change in detail, by examining all the crucial social and economic indicators and concluding that 'the South has been changing *more rapidly* than the rest of the nation', so as to become 'more like the rest of American society in terms of its primary dimensions of living'. 'The South, which has seemed like another country for so long', they announced, 'is now sharing in a national (and, in many respects, international) culture.'[5] Since these conclusions were drawn, the strictly material indicators have served only to confirm them; in terms of its economic and social structures, it seems, the South – or at least significant elements in it – is no longer the South but part of the Sunbelt.

Here, however, we enter into a further irony of recent southern history: one hinted at in those echoes of old, forgotten, far-off things that sound in even the most contemporary of southern texts and are more openly exposed and unravelled in essays in this volume. If there is change within continuity, then there is also continuity within change. In terms of its material landscapes, day-to-day social life, the South may now be part of a new, urban, industrial or even post-industrial America. It may, in the telling phrase of one historian, have become 'urbanised, standardised, neonised' – or, in the even more sardonic words of another, it may have been 'happily homogenized'. Nevertheless, the transformation of the Southerner into the American has not really occurred or, at the very least, not been completed yet. What might be termed

'the modernising of the southern mind' has been announced many times: not least, with the election of those two evidently new, reconstructed Southerners, first Jimmy Carter and now Bill Clinton, to the office of the President. The announcement, however, has invariably proved to be partial and premature. For every Bill Clinton, it seems, there is a Newt Gingrich. Everywhere one looks, even now – or, perhaps, especially now after the November 1994 elections – there is evidence of what one commentator on the South once termed 'deep-rooted continuity behind the symptoms of basic change', or what another has called 'subcultural persistence in mass society'.[6] Quite apart from the fracturing of our idea of southern culture into a perception of southern *cultures*, there is this sense of a constant backward drift, sometimes acknowledged and at other times not: the feeling that, for good *and* ill, the regional past *is* 'never dead'.

There are many ways of registering this backward drift. Several are deployed in this volume. Two in particular seem interesting because the terms in which they come to us are so different. On the one hand, there is the rich and often conflicting information supplied by historical and social research. On the other, there are those many recent fictional texts from the South that start off with the depthless landscapes and jazzy discords of the modern US – and then quite suddenly slip the reader some faint, stirring recollection of familiar themes, some echo of the old, ineradicably southern rhythms. As far as fictional texts are concerned, many examples are possible: but one book that shows this slippage between new and old with unusual power – and, in doing so, reveals the edgy, richly plural and various nature of southern culture now – is *In Country* by Bobbie Ann Mason, published in 1985.

In Country begins on the road; and with two lines from the Bruce Springsteen song, 'Born in the U.S.A.', 'I'm ten years burning down the road/Nowhere to run ain't got nowhere to go'. Both song and story introduce us to a world notable, above all, for its motion and surfaces: for its exclusion of everything but the present, and for its scrupulous avoidance of meaning and depth. Quickly, we meet three travellers on the road: Samantha Hughes, who likes to be called Sam, an eighteen-year-old girl whose father died in the Vietnam War; Emmett Smith, Sam's uncle, a Vietnam veteran still bearing some of the physical and mental scars of war; and Mamaw Hughes, Sam's paternal grandmother. They are on their way to visit the Vietnam Veterans Memorial in Washington; and the landscapes they encounter as they travel there are typical of what is called (at one point in the story) 'contemporary, state-of-the-art U.S.A.'. 'Everything in America is going on here, on the road', Sam says to herself. And the places that slip by her are defined by products, media-generated icons; while the prose that describes them for us

crackles with the urgency, the immediacy, and the depthlessness, of an on-the-spot news report. 'At the next exit', begins a passage on the very first page of *In Country*:

> Exxon, Chevron, and Sunoco loom up, big faces on stilts. There's a Country Kitchen, a McDonald's, and a Stuckey's. Sam has heard that Stuckey's is terrible and the Country Kitchen is good. She notices a hillside with some white box shapes – either beehives or a small family cemetery – under some trees. She shoots onto the exit ramp a little too fast, and the tires squeal.[7]

The jumpy nervous rhythms here. The allusive and minimalist spareness of the prose. The pruning away of all but the present. Even the emphasis on the alienating detachments of the eye: images glimpsed for a moment through a car window. All this alerts us to the fact that we are watching America at the vanishing point: experiencing what Jean Baudrillard (in his book on America) has called the 'hyperreality' of American culture. That is, we are being asked to bear witness to a culture of 'surface intensity and pure meaninglessness' – a culture, as Baudrillard puts it, of 'insignificance', which exists 'in a perpetual present of signs'.

This is how *In Country* begins: in a land of surfaces, ephemeral intensity. And Mason's understanding, both of this land and her characters' immersion in it, never wavers. What happens in the course of the rest of the novel is too surprising, too rich and strange, to be charted here. But it is worth drawing attention to just one thing. By the end of the book – after it has circled backwards and forwards in time – our three travellers do arrive at the Vietnam Veterans Memorial; and, for each of them that arrival makes a difference that measures a change, too, in the way their story is told. Sam, for example, touches the name of her father on one of the stone walls of the Memorial where, along with the names of all the other dead veterans, it is carefully inscribed. 'A scratching, on a rock', as she observes it, and feels it. 'Writing. Something for future archaeologists to puzzle over, clues to a language.' To her surprise, she also notices her own name (which is, of course, the name of a namesake) nearby on the same wall: 'Sam A Hughes'. 'It is down low enough to touch', the narrative tells us. 'She touches her own name. How odd it feels, as though all the names in America have been used to decorate this wall.'[8] Through this strange, startling experience, this touching of her own name, Sam 'is just beginning to understand', we are told. That is, she is just on the threshold of knowing, understanding the past. She is starting, quietly, to accept her part in it, and its part in her. Sam's discovery here releases her from the depthless present into an engagement with history: a process of recording, and accounting,

that both assumes the presentness of the past and accepts the long reach of time. Everything becomes history: that is what Sam has learned. Sam has come into reality, out of hyperreality, by meeting her own name inscribed in history. What she has learned, in effect, is what William Faulkner insisted on: that there is no such thing as past. It is not even past. In the process, *In Country*, the novel that charts this process of learning, has moved slowly, and beautifully, from a culture of the present to a culture of presence: out of the traditions of the South – and then, eventually, back into them again.

Another and no less intriguing demonstration of slippage between new and old – the way the South now seems to drift in and out of its own past – is offered by the equivocal position of women and African-Americans, as outlined by a whole host of recent studies and surveys. The voices of African-Americans, for example, may now be heard. There may now be some long overdue recognition of their determining impact on southern culture. More to the point, the old rhetoric of social prejudice in the South may have largely disappeared. But, in some circles, that rhetoric has only been replaced by a new vocabulary of class opportunity: a vocabulary that conveniently ignores the differences of opportunity available in a white, middle-class suburb and in a black ghetto. In this fashion, the old ways survive in however shadowy a disguise; the old racial prejudices are sustained in indirect, coded form. Or, to take another instance, there is the irony of the position of many women in the South now. The social and economic position of southern women – and, in particular, southern *white* women – has certainly improved over the past thirty or forty years. Not the least significant evidence of this is that they now occupy more than a third of all executive and managerial jobs in the region. But the *image* of the white southern woman has not altered much. She is still seen in terms of what has been called the 'most cherished of white southern stereotypes' – as (to quote one commentator on the South) 'a fragile flower' or (in the words of another) 'the soft submissive perfect woman'.[9] In short, she is still conceived of as the southern *lady*, placed on a pedestal: where her purity, frailty, and untouchability can be seen and celebrated – a bodiless embodiment of all that is best about old southern society.

A distinctive, even ritualistic attitude towards the otherness of women and African-Americans; and, not unrelated to this, an obsession with roots, place and particularly the past, and the living signature of roots, place and past supplied by clan and kinsfolk: these resonant southern themes still survive, among many of the people and much of the writing of the region. Southerners – in particular, *white* Southerners – still 'think southern' much of the time; and several surveys have revealed just how far this continued capacity to 'think southern' goes. If you are southern,

these surveys show, you are more likely than other Americans to choose kin and local people as those you most admire. You are more likely to be Christian and, being Christian, to be fundamentalist. You are more likely to rely on yourself and your own notions of honour, right and wrong: to fight, for example, rather than call in the police or a lawyer. You are more likely, too, to oppose gun laws. For that matter, you are more likely to own a gun yourself: 'the biggest single predictor of pistol ownership', one survey on the possession and use of firearms concludes, 'is southernness'.[10] Owning a gun, as a Southerner you are also more likely to use it, so helping to generate what has been called 'a regional culture of violence'.[11] If you are a Southerner, it seems, you not only think differently, you also think yourself to be different. Southerners, the surveys show, still think of themselves as conservative, tradition-loving, courteous, and loyal to family ties. In turn, they think of Northerners as industrious, materialistic and progressive; and they think of Americans in general, too, in precisely the same terms. In other words, they still think of themselves as a distinctive minority within the nation: not nearly as 'American', nowhere nearly as part of the cultural mainstream, as people from other parts of the United States. 'What makes the South different is that it *thinks* it is', one historian wrote in the 1940s. Evidently, the South still tends to think that some of the time, despite all the change. In spite of the material transformation of South into Sunbelt, many Southerners seem reluctant to allow the old habits to die.

Many Southerners, and many others too: despite the steady erosion of social, political, and economic differences, there is also a tendency on the part of the rest of the United States to think of people from the former Confederacy as different. As geographers have established, many non-Southerners have distinctive 'mental maps',[12] a consistent pattern of regional evaluation that has as its centre a remarkable, and for the most part sharply negative, image of the South. This emerged with particular force from a survey of northern attitudes to Jimmy Carter when he was first elected, which set out to discover if – as many observers claimed – Carter's election did signal a change in outsiders' perception of the region. The survey revealed that, whatever impressions northern people had of Carter – and, at this time, they were mostly favourable – they did not perceive him as southern at all. Added to that, their notions of the South and Southernness fitted comfortably into the familiar stereo-types. Southerners were, it was felt, inherently provincial and traditional and usually at odds with the rest of the nation. Not much has changed with the Presidency of Bill Clinton. Clinton may have his origins in the old Confederacy: but he has found support in the South at best partial and, interestingly enough, he has tried to establish himself with the American electorate at large by emphasising his specifically *non*-southern

credentials – which is to say, his place in the American Dream ('I still believe in a place called Hope'). Southerners may now occupy the two supreme executive posts of President and Vice-President. For their part, Southerners in general may now participate in the national culture. They may watch television, eat at McDonald's, listen to popular music, and play video games. But the old tendencies and legends persist. Scarlett O'Hara and Rhett Butler still cast their shadows over the mental maps of the region. So too do the Waltons, the Beverley Hillbillies, Colonel Sanders of the Kentucky Fried Chicken chain, and just about every image of the small southern town or the plantation that has appeared recently in the movies from *Driving Miss Daisy* through *Doc Hollywood* and *My Cousin Vinnie* to *Mississippi Burning*. There seems, at the very least, to be some kind of cultural lag, some sort of fissure or divide between material change and mental alteration. The South, and many Southerners, still manage to inhabit two separate moral territories: the one not quite dead, the other not yet fully born. For that matter, both the South and Southerners are now more than ever before a site of struggle between conflicting interests and voices, each one of them demanding recognition and power. Of course, no collection of essays can ever hope entirely to capture the fractured, changing character of southern culture(s) now, or the full extent to which change persists within continuity and continuity within change. But the sheer multiplicity of perspectives offered here, and the adventurous, speculative vision that all the contributors to this volume share, represent a definite step in the right direction. Not least, what all these essays show is that – whatever else may have happened – the ironies of southern history continue to run deep.

NOTES

1. Eudora Welty, *One Writer's Beginnings* (Cambridge, Mass., and London: Harvard University Press, 1984) p. 104; Harry Crews, *A Childhood: The Biography of a Place* (1978), reprinted in *Classic Crews: A Harry Crews Reader* (London: Gorse, 1993) p. 31.
2. William Faulkner, *Requiem for a Nun* (New York: Random House, 1951) p. 85. See also Allen Tate, *Essays of Four Decades* (New York: Swallow Press, 1968) p. 545.
3. Alice Walker, *Meridian* (London: Women's Press, 1983) p. 14. See also Ellen Gilchrist, *The Annunciation* (London: Faber, 1984) p. 15; Jayne Ann Phillips, *Machine Dreams* (London: Faber, 1984) p. 3.
4. Marshall Frady, 'Gone with the Wind', *Newsweek*, 28 July 1975, p. 11.
5. John C. McKinney and Linda B. Bourque, 'The Changing South: National Incorporation of a Region', *American Sociological Review*, XXXVI (June, 1971), pp. 399, 407.

6. Numan V. Bartley and Hugh D. Graham, *Southern Politics and the Second Reconstruction* (Baltimore, Md.: Johns Hopkins University Press, 1975) p. 200; John Shelton Reed, *The Enduring South: Subcultural Persistence in Mass Society* (Lexington, Mass.: D.C. Heath & Co, 1972). See also Jack Temple Kirby, *Media-Made Dixie: The South in the American Imagination* (Baton Rouge, La.: Louisiana State University Press, 1978) p. 159; C. Vann Woodward, 'From the First Reconstruction to the Second' in Willie Morris, ed., *The South Today: 100 Years After Appomatox* (New York: Harper and Row 1965) p. 14.

7. Bobbie Ann Mason, *In Country* (London: Fontana, 1987) p. 3. See also Jean Baudrillard, *America* translated by Chris Turner (London, Verso 1988) pp. 28, 63, 76.

8. Mason, *In Country*, pp. 244–5.

9. Anne Firor Scott, *The Southern Lady: From Pedestal to Politics, 1830–1930* (Chicago: University of Chicago Press, 1970) p. 21; Diane Roberts, *Faulkner and Southern Womanhood* (Athens, Ga. and London: University of Georgia Press, 1994) p. 3; Anne Goodwyn Jones, *Tomorrow is Another Day: The Woman Writer in the South, 1859–1936* (Baton Rouge: Louisiana State University Press, 1981) p. 9. For changes in the material conditions of southern women see, e.g., *Atlanta Constitution*, 11 April 1984, p. A1. For the survival of the traditional imagery, and some possible reasons for this survival, see, e.g., Jones, *Tomorrow is Another Day*, p. 4; Colette Dowling, *The Cinderella Complex: Women's Hidden Fear of Independence* (New York: HarperCollins, 1982) p. 87.

10. J. Sherwood Williams et al., 'Southern Subculture and Urban Pistol Owners', in Merle Black and John Shelton Reed, eds, *Perspectives on the American South*, vol. 2 (New York: Gordon and Breach, 1984) p. 269.

11. Raymond D. Gastil, 'Homicide and a Regional Culture of Violence', *American Sociological Review*, XXXVI (June 1971), p. 416. See also J. F. O'Connor and A. Lizotte, 'The "Southern Subculture of Violence": Thesis and Patterns of Gun Ownership', *Social Problems*, XXV (1978), pp. 420–9. For the other surveys mentioned, see Reed, *Enduring South*, especially chapters IV–VI.

12. Peter Gould and Rodney White, *Mental Maps* (Baltimore, Md.: Johns Hopkins University Press, 1974) pp. 93–118. See also Robert M. Pierce, 'Jimmy Carter and the New South: The View from New York', in Black and Reed, *Perspectives on the South*, pp. 181–94.

Index

Acadia, French (Old), 67–8, 72
Acadian Bicentennial Celebration
 (1955), 71–2
Acadian Cultural Centers, 75
Acadians
 cultural legacy of, 68–70, 72, 75
 see also Cajun; Cajun culture
advertising
 radio, 131
 in Southern Living, 94–5
 in Veranda, 93–4
Africa
 influence on jazz, 27
 language and blues, 59–60
 slave homelands in, 194
 as source of folk culture, 13–15,
 16, 193
 see also Bakongo; music
African-American art
 African images in, 10, 196–8
 cemetery art, 195, 196–8, 201
 development of, 209–15
 Kongo imagery, 197–201, 210–11
 popularity of, 208–9
 yard shows, 199, 200, 201–2
African-American literature,
 women's, 61–2
Agrarian poets, 40, 41, 220
 see also Fugitives
Alabama Citizens' Council, 142
Allen, Richard, 24
Allman Brothers Band, 116, 121,
 125, 128n, 129n
 'From the Madness of the West',
 121

'Kinda Bird', 121
'Whippin' Post', 121
Allman, Duane, 121, 128n, 129n
Allman, Greg, 121
Anderson, Sam, 133
Angel Heart film, 153
Angelou, Maya, 11, 64n
Appiah, Anthony, 179
Arceneaux, Thomas J., 71, 72
architecture
 Cajun, 69–70, 75
 in Southern Living, 85, 95
Ardoin, Amédée, 77
Armstrong, Lillian Hardin, 20
Armstrong, Louis, 20, 21, 25–6
 on New Orleans music, 22–3
Arnett, William, 213
Arsenault, Bona, 75
Atlanta, burning of, 117, 118
Atlanta Cotton States Exhibition
 (1895), 91
authenticity, in blues, 62–3

Bailey, Deford, 21–2
Baker, Houston, Blues, Ideology and
 Afro-American Literature, 51, 59
Bakongo people
 cultural legacy of, 194–9
 Kongo imagery, 197–201, 210–11
Baldwin, James, 5
Balfa, Dewey, 77
banjo, 17
Barker, Danny, 18, 23, 156
Bass, Ralph, 142–3
Beatles, the, 104, 109

Belasco, David, 171
Belgian Congo (Zaire), 194
Benjamin, Walter, 4–5
Bernal, Martin, 174
Berry, Chuck, 106, 121
Berry, Jason, *Up from the Cradle of Jazz*, 157–8
Berry, Wendell, 220
BEST (Best Efforts For Soul in Television), 138, 139
Better Homes and Gardens, 91
Betts, Dickey, 121–2, 126, 127n, 129n
'Atlanta's Burning Down', 118
Bingham, Mark, 157
Birmingham, Alabama
radio stations, 132, 140, 141
violence ignored by *Southern Living*, 86, 88–9
Birth of a Nation, The
(D.W. Griffith film), 6, 11, 165–7
familial estrangement in, 183–4
lighting techniques, 171–4
place in cinema history, 170–1, 172
racial characterisation in, 167–70, 183, 186–7
sexual assault scenes, 186–7
use of melodrama, 182
Bishop, Elvin, 126n, 127n
black culture, promoted by radio, 134, 145–6
black people
African folk culture of, 13–15
as broadcasters, 133–4, 139–40, 143–4
characterisation in *The Birth of a Nation*, 167–8
importance of radio to, 130–2, 145, 146n
nature of memory, 4
as owners of radio stations, 132, 139, 143–4
portrayed in *Southern Living*, 87, 95–6, 98n
see also black women
black women
in Alice Walker, 54–5

as blues singers, 54–6, 57–8, 60–1, 63
and sexism in *The Color Purple*, 52
Blackfoot band, 119, 124, 127n, 128n
Blackwell, Ed, 156
Blayton, Jesse, 144
bluegrass music, 20
blues
aesthetic of, 58–60
African linguistic heritage of, 59–60
black women's, 54–6, 57–8, 60–1, 63
Delta blues style, 20
as individual, 65n
origins of, 17–19, 51–2
Body and Soul, 181, 189
Bolden, Charles 'Buddy', 23
Book of Moses (Kitab Moussa), 208
Borders, William Holmes, 134–5
Bowens, Cyrus, grave monuments, *195*, 196–8
Boyd, Professor William, 135
brass bands, in New Orleans, 22
Brigier, Ernie 'The Whip', 134
Brinkmeyer, Robert H., *Three Catholic Writers...*, 42–3
Brookshire, Bruce, 117–18, 127n
Brown, James, 121
Brown, Steve, jazz player, 24, 25
Brown, Tom, bandleader, 24
Brown v. Topeka Board of Education (1954), 27, 135, 137, 138, 140, 142
Brunies, George, 25
Butler, Eugene, 87–8, 89
Byrd, William, 220

Cable, George Washington, 152
Cachière, Tony, 78
Cajun
definitions of, 67–8, 79, 80
ethnic consciousness revival, 73, 74–6, 79–80
Cajun culture, 14
architecture, 69–70

food, 70, 76, 78, 79
 music, 69, 74–5, 77
Calhoun, John C., 220
Canada
 French language revivalism, 73, 74
 see also Acadia
Capricorn record company, 121, 128n
Carey, Papa Mutt, 23
Carter, Asa, 142
Carter, Dan, 13
Carter, Hodding, 220
Carter, President Jimmy, 222, 225
Carter, Maybelle, 20
Carter family, country music of, 20,
 22
Cash, Johnny, 21
Cash, W.J., The Mind of the South, 2
Center for Louisiana Studies,
 Lafayette, 74
Center for Southern Folklore,
 Memphis, 7
Center for Study of Southern
 Culture, Mississippi, 7–8
Chambers, Iain, Urban Rhythms: Pop
 Music and Popular Culture, 101–2
Chapital, Arthur, 139
Chaplin, Charlie, 109
Chapple, Steve, 103
Charles, Ray, 21
Charlotte Post, 136
Chenier, Clifton, 77
Chicago, jazz in, 24, 25, 152
Christian, Charlie, 26
Christianity, and Darwinism, 34–5
cinema
 lighting techniques, 171–4
 place of The Birth of a Nation in
 history of, 170–1
 'race movies', 178–9
 use of melodrama, 181–2, 188–9
 see also The Birth of a Nation;
 Within Our Gates
Citizens Communications Center, 139
Civil Rights movement (1954–68), 3,
 4, 77
 ignored by Southern Living, 85, 91
 and radio broadcasts, 135–8, 139

and religious broadcasts, 134–5
 see also segregation
Civil War, 3–4
 contemporary ethos of, 117–19
 determinist view of, 35
 as treated in The Birth of a Nation,
 166
 see also Confederacy;
 Reconstruction
class
 in definition of South, 2
 in Southern Accents magazine, 92–4
 in Southern Living, 85, 92, 94, 95
 in Veranda magazine, 92–4
Cleftones group, 142
Clinton, President Bill, 222, 225–6
CODOFIL (Council for the
 Development of French in
 Louisiana), 73, 74, 76, 78–9
Cohen, Sara, 150
Coleman, Ornette, 156
Collins, Allen, 125
Collins, Patricia Hill, Black Feminist
 Thought, 60, 61
Color Purple, The (Alice Walker), 6,
 52, 54, 55–6, 57, 59–60, 61–3
Color Purple, The (Spielberg film), 6
Coltrane, John, 156
Comeau, Francois G.T., 71
Confederacy
 mythology of, 88, 89–90, 225
 symbolism of flag, 3, 115, 117,
 126–7n
 see also Civil War
Connor, 'Bull', Birmingham Police
 Commissioner, 86, 88
consumer market
 growth of black, 131, 133, 145
 see also tourism
'Contemporary Perspectives on US
 Southern Culture' conference
 (1994), 8–11
Cooper, Margaret, 172
Coster, Graham, 110–12
country music, 2, 27, 103
 black, 21–2
 white cultural origins of, 19–20

Cox, Herbie, 142
Creole Magazine, 77
creoles
 and Cajuns, 77–8
 French-speaking, 76–7
creolisation, 14, 193
Crews, Harry, 218
Crudup, Arthur 'Big Boy', 21
Crutchfield, Charles, 135, 136
cultural studies, 7–9
 and Elvis Presley, 107, 108–10
culture (southern)
 African traditions in, 193
 diversity of southern, 4–7, 220–1,
 226
 European enthusiasm for, 8–9, 156
 folk origins of, 13–14
 influence of, 11
 mixed traditions in, 27–8
 as portrayed in *Southern Living*,
 85–6, 87, 90–2
 see also Bakongo; South, the
Cunningham, Emory, 87
Curtis, Jim, 121, 122

Dabbs, James McBride, 14
Daily World newspaper, 135
Dale, Bishop, 136
Daltry, Roger, 127n
Daniels, Charlie, 'The South's Gonna
 Do It Again', 116, 126n
Daniels, Josephus, Secretary of the
 Navy, 24
Daniels, R.L., 69
Danley, J.C., 133
Danny Joe Brown band, 128
Dante Alighieri, *The Inferno*, 43
Darrow, Clarence, 33
Darwinist determinism, 33–4, 45
 in Ellen Glasgow's books, 35, 36,
 45
Davidson, Donald, 13
Davis, Jimmie, 20–1
Dayton, Tennessee, 'Monkey Trial'
 (1925), 33, 40, 41
deejays (broadcasters), black, 133–4,
 139–40, 143–4

DeLillo, Don, *White Noise*, 100
Dial, Thornton, painter, 211–13
disk jockeys *see* deejays
Dixieland jazz, 25
Dixon, Thomas, Jr
 Ku Klux Klan trilogy, 89, 179
 The Clansman, 6, 175
 see also The Birth of a Nation
Doane, Mary Ann, 168
Doc Holliday band, 117–18, 120,
 128n
 Son of the Morning Star album, 128n
 'Song for the Outlaw', 124
Domengeaux, James (Jimmie), 73, 74
Domingue, Dr Gerald J., 79
Domino, Fats, 153, 154
Doucet, Michael, Beausoleil group,
 74–5
Douglass, Frederick, *Narrative*, 51–2
DuBois, W.E.B., 178–9, 189
 The Souls of Black Folk, 185
Dukes of Hazzard, The, 7
Dunbar-Nelson, Alice, 152
Durr, Virginia Foster, 88–9
Dylan, Bob, 99, 104

Easy Rider film, 153
Edmondson, William, stone carver,
 210
Egerton, John, 3
Elijah Muhammad (Elijah Poole),
 208
Ellison, Ralph, 5, 18
Encyclopedia of Southern Culture, 8
England, as source of folk culture, 13
Europe
 enthusiasm for southern culture,
 8–9, 156
 as source of folk culture, 13, 15, 19
Evangeline legend, Acadian, 71
Evans, Leonard, 144

Falcon, Cleoma, 'Blues Nègres', 14
family
 estrangement in film, 183–5,
 187–8
 in melodrama, 181–2, 188–9

music networks in New Orleans, 157–8
and nation, 179
Farnham, Christie Anne, 119
Fata Morgana, in Welty's *Golden Apples*, 47–8
Faulkner, William, 1, 3, 10, 11, 152, 218, 220
 Absalom, Absalom!, 13, 15
 Intruder in the Dust, 45–6
 The Sound and the Fury, 46–7, 48
 The Unvanquished, 94
 use of myth, 45, 47, 49
feminism, in *The Color Purple*, 52
Ferguson, Bert, 133–4, 140, 141
Ferris, William, 7–8
fiddle, 17
Finnegan, Ruth, 162
Fischer, David Hackett, 13
Fitzhugh, George, 220
folktales, oral, 77–8
food
 Cajun, 70, 76, 78, 79
 central to *Southern Living*, 86, 87, 93, 95
Forrest Gump, 7, 11
Fortier, Alcée, 69
Fosdick, Harry, 134, 135
Four Movements of the Sun exhibition, 197
Frady, Marshall, 221
Frazier, E. Franklin, 13
'Freebird' (Lynyrd Skynyrd), 115, 122, 124–5, 129n
French heritage, Louisiana's links with, 76–8
French language
 among Cajuns, 69, 70, 78
 among Creoles, 76–7, 78
 Cajun revival of, 73, 76, 78–9
 Canadian revival of, 74
Frith, Simon, *Sound Effects*, 102
Fu-Kiau Bunseki, Kongo poet, 208
Fugitives, the (poets), 39, 40–2, 220
fundamentalism *see* religion

Gambit, New Orleans newspaper, 158

Garber, Marjorie, 104
Garofalo, Reebee, 103
Gazette de Louisiane, La, 76
genealogy, Acadian, 75
Georgia
 African cultural legacy in, 194, *195*, 196–8
 creole culture, 14
 Glascock county, 208
 Washington county, 208
Gianna, Beverley, 158–9
Gilchrist, Ellen, *The Annunciation*, 219–20
Gillespie, John Birks 'Dizzy', 24, 26–7, 28
Gillett, Charlie, 104
Gilman, Caroline, *Recollections of a Southern Matron*, 90–1
Gilroy, Paul, *The Black Atlantic*, 62, 63
Gingrich, Newt, 222
Gish, Lillian, 172, 174
Glasgow, Ellen, 45
 Barren Ground, 37–8
 meeting with Thomas Hardy, 35
 The Battleground, 35
 The Sheltered Life, 36
 Vein of Iron, 37, 42
 Virginia, 36
God Struck Me Dead oral slave histories, 196
Goldman, Albert, 102–3, 109, 110
Gone With the Wind (Selznick film), 6, 11
Goodgame, Rev. John W., 134
gospel music
 in New Orleans, 157, 158–62
 in southern rock, 125
Great Britain
 and Acadian exile, 76
 see also England; Scotland
Gregory, Neil and Janice, *When Elvis Died*, 101, 107
Griffith, D.W., 165, 177
 use of melodrama, 182
 see also The Birth of a Nation
Grinderswitch band, 116, 126n

Groh, William Carl (III), 93
guitars, in folk music, 19–20
Guralnick, Peter, 106, 107

Haley, Alex, *Roots*, 6, 11
Hall, Dilmus, sculptor, 210–11, *212*
Hamilton, Charles, 139
Hamm, Charles, 102–3
 Yesterdays: Popular Song in America, 102
Hammontree, Patsy G., *Elvis Presley: A Bio-Biography*, 101
Hampton, James, *The Throne of The Third Heaven...*, 202–3
Hansen, Miriam, 171
Hardy, Thomas, 'The Blinded Bird', 34–5
Harris, Wynonie, 153
Hatfield, Richard, New Brunswick premier, 74
Heilbut, Tony, *The Gospel Sound*, 103
Hendrix, Jimi, 99, 104
Herskovits, Melville J., 13
Hill, Bertha 'Chippie', 18
Hines, Earl 'Fatha', 20, 21
Hinton, Milt, 26
Hobsbawm, Eric, on jazz, 24, 109
Holiday, Billie, 51, 52, 54, 56, 60, 63, 106
Holley, Lonnie, artist, 211, 213, *214*, 215
Hopkins, Jerry, 106
horns, in jazz, 19
Howard University, Washington DC, 144
Howard, Wilson, 158
Howe, Irving, 5
Hulbert, Maurice 'Hot Rod', 133
humour, 7
Hunter, Alberta, 18–19
Hurston, Zora Neale, 54, 56–7, 61
 'Jumping at the Sun', 59
 Their Eyes Were Watching God, 55
Hutchinson, James, 145

industrialisation, in Louisiana, 70
Inner City Broadcasting, 143

Inter Urban Broadcasting, 143, 145

Jackson, Mahalia, 158
jazz
 bebop, 27
 first recordings of, 24–5
 origins of, 19, 22–4
 progress of, 25–7, 153
 and tourism in New Orleans, 153–4
Jefferson, Thomas, 220
Johanson, J. Johnny 'Jaimoe', 122
John, Dr, 157
Johnny Van Zant band, 128n
 see also Van Zant, Johnny
Johns, Vernon, preacher, 135
Johnson, Robert, blues player, 11, 17–18
Johnson, Robert, 'Nova Britannia' (1605), 90
Johnson, Smokey, 157
Jones, Gayl, 59
Jones, George, 22
Jones, LeRoi, 55, 58, 59–60
 Blues People, 51
Joplin, Scott, 22

Kaplan, Cora, 'Keeping the Colour in *The Color Purple*', 52
Kaslow, Andrew Jonathan, 158
KCOH-Houston radio station, 144
Kelley, Anna, 137
Keppard, Freddie, 23
KFFA-Helena (Arkansas), 'King Biscuit Time', 132–3
Kimbangu, Simon, 208
King, 'Daddy', preacher, 135
King, Florence, 7
King, Martin Luther, 1, 85, 134
 and influence of radio, 130, 138, 142
King, Pete, National Language Act (1995), 79
Kirkby, Joan, 107
Kmen, Henry, 152
KOKY-Little Rock radio station, 137, 141

Kongo (Zaire/Angola) area, 194
 imagery, 197–201, 210–11
 poetry, 208
 see also Bakongo
Kornegay, Rev. George, yard show,
 199, *200*, 201
Krantz, Dale, 124
Ku Klux Klan
 in *The Birth of a Nation*, 89, 166–7,
 172–3, 174–5, 188
 destruction of WEDR's antenna,
 141

La Rocca, Nick, 24
LaBelle, Patti, 161
Lafayette, Louisiana, and Acadian
 revival, 74, 75, 78
Laine, Blanche, 22
Laine, Papa Jack, 23–4
Lalonde, Raymond 'LaLa', 67–8, 79
Lawson, Belford W., 137
LeBlanc, Dudley J., 71
Leigh, Frances Butler, *Ten Years on a
 Georgia Plantation...*, 89
Lennon, John, 99
Levellers band, 129n
Lewis, Howard, 142
Lewis, Jerry Lee, 21, 109, 121
Lewis, Smiley, 153
'Little Richard', 121, 153, 154
Little Rock
 radio station, 137, 141
 school crisis, 140
Lombar, Dru, 126n
Longfellow, H.W., 'Evangeline', 68,
 70–1
Louisiana
 Acadian flag, 72
 Cajun minority bill (1988), 67
 civil rights record, 77
 industrialisation, 70
 use of French in, 69, 78–9
 see also Cajun
Lull, James, 127n
Luper, Clare, 137
Lynyrd Skynyrd band, 116, 119,
 124–5, 126n, 129n

Anytime, Anyplace, Anywhere
 album, 124
'Can't Take That Away', 118
'Freebird', 115, 122, 124–5, 129n
'Kiss your Freedom Good-bye', 118
'Pure and Simple', 123
'Sweet Home Alabama', 122–3
The Last Rebel album, 118–19

Magnolia, The, periodical, 91
Maillet, Antonine, 74
Malinowski, Bronislaw, 13–14
Malm, Krister, 155
Malone, Bill C., *Country Music USA*,
 103
Marcus, Greil, 99, 107, 108
 Dead Elvis, 110, 111
Mardi Gras, in New Orleans, 153,
 157
Mares, Paul, 25
Maritain, Jacques, 42–3
Marling, Karal Ann, 100
Marsalis, Wynton, 155
Marsh, Dave, 107
Marsh, Mae, 172
Marshall Tucker Band, 126n
Martin, Dean, 109
Mason, Bobbie Ann, 7
 In Country, 222–3
Matassa, Cosimo, 154
Matisse, Henri, 209
Mays, Benjamin, 135
McGee, Dennis, 77
McIntosh, Neil, 173
McWhiney, Grady, 13
Means, Ruth Shaver, 'Exodus', 72
Medlocke, Rickey, 127n
Memmi, Albert, 184
memory, as unifying, 3–4, 225
Memphis, Tennessee, 7
 parking lot garden, 201–2
 radio stations, 132, 133–4, 135,
 139, 140–1, 142
Memphis World newspaper, 140
Mencken, H.L., 1, 33
Meredith, James, 137
Michaels, Walter Benn, 168, 173, 178

Micheaux, Oscar, 177, 179, 180
 The House Behind the Cedars (film),
 177
 treatment of race, 180–2
 see also Within Our Gates
Middleton, Richard, 106, 111
Miller, Bruce 'Sugar Throat', 134
Miller, Keith, 134
Minton's Playhouse, Harlem, 26, 27
Mississippi, 32
 and Delta Blues, 20
 University, 3–4, 7–8, 137
Mitchell, Margaret, *Gone With the
 Wind*, 6, 221
Molly Hatchet band, 124, 126n,
 128n, 129n
Moncton, New Brunswick, 74, 75
Monk, Thelonious, 26–7
Monroe, Bill, 20, 21, 22
Montgomery Bus Boycott, 137, 140
Moore, Max, 133
Morrison, Jim, 99
Morrison, Toni, 181
 Jazz, 59
Morton, Jelly Roll, 23, 24, 25
Murray, J.B., drawings, 205, *206*,
 207–8, 209
music
 among slaves, 17
 black and white interaction in,
 19–20, 27–8, 77, 142, 156–7
 Cajun, 69, 74–5, 77
 centrality of, 6–7
 and place, 151–2, 154–6
 and segregation laws, 23–4, 25,
 156–7
 studies of popular, 100–1
 see also blues; country music;
 gospel; jazz; New Orleans;
 Presley, Elvis; rhythm'n'blues;
 rock'n'roll; soul; southern rock;
 spirituals
music recording
 Capricorn company, 121, 128n
 companies, 131–2
 early jazz, 24
 payola scandal, 143

musicians
 in New Orleans, 156–8
 and tourism, 155–6, 161–2
Muslim influence, in African spiritu-
 alism, 208
myth
 in Acadian revival, 68
 literary use of, 44–5, 47, 49–50

NAACP (National Association for the
 Advancement of Colored
 People), 137, 138, 139, 141
Nashville, Fugitive poets of, 40–1
Nasisse, Andy, 208
National Association of Broadcasters,
 Minority Division of, 145
National Black Media Coalition,
 139
National Conference on Black
 Power, 144
National Language Act (1995), 79
nationalism
 black ambivalence towards, 189
 growth of, 73
NATRA (National Association of
 Television and Radio
 Announcers), 130, 139, 143
nature *see* time, historical and
 seasonal
Negro Network News, 144
Negro Voters League, 138
Nelson, Willie, 28
New Brunswick, Acadian revival in,
 74, 75
New Orleans
 gospel music, 157, 158–9, 160–2
 Greater St Stephen's Catholic
 Church, 159
 jazz in, 22–3, 24–5
 literary images of, 151–2
 musical images of, 152–3
 tourism in, 153–4, 162
New Orleans Convention and
 Tourism Commission, 158
New Orleans Jazz and Heritage
 Festival, 159
New Orleans Rhythm Kings, 25

New Orleans Tourism Marketing
 Corporation, 154
New Times in the Old South, 7
New York, Harlem Renaissance, 26
Newman, Mark, 133
Newsome, Rev. L.H., 132
Niebuhr, Reinhold, 44–5
Nordan, Clay, 91, 95
North Carolina, University of, 7, 8
North, the
 as portrayed in films, 166–7, 172,
 174–5, 179–80, 183
 as seen by *Southern Living*, 88–9
nostalgia *see* myth

Oakley, Berry, 129n
Oliver, 'King' Joe, 23, 25
Olivier, Louise, 72
Orbison, Roy, 21
Original Dixieland Jass Band, 24–5
Ory, Kid, 25
Our World black magazine, 136, 142
Outlaws band, 128n

Page, Thomas Nelson, *Meh Lady*, 89
Parker, Charlie 'Bird', 26, 27
Parker, Colonel, Presley's manager,
 99, 105, 106–7
Patton, Charley, 17
Payne, Rufus 'Tee-Tot', 20
Peek, Philip, 213
Penniman, Richard *see* Little Richard
Pepper, John, 133, 140
Percy, Walker, 152
Perkins, Carl, 21
Perrin, Warren, 75–6
Peterson, Ernest L., Catholic
 Archbishop, 134
Petty, Joe Dan, 126n
Phelan, Eddie, 141
Phillips, Dewey, 142
Phillips, Jayne Anne, *Machine
 Dreams*, 219
Phillips, Sam, 106
Phillips, Ulrich B., 12
piano, for ragtime, 22
Pleasants, Henry, 100, 104, 105–6

Poe, Edgar Allan, 91
Popular Music journal, 101
Popular Music and Society journal, 101
Powers, Harriet, quilts by, 209–10
Pratt, Linda Ray, 107
Pratt, Ray, 58, 64n
Presley, Elvis, 7, 11, 28, 112n, 121,
 123, 220
 in academic studies, 99–102,
 110–11
 in cultural studies, 107, 108–10
 ignored by *Southern Living*, 86
 musicology of, 102–6
 and origins of rock'n'roll, 21
 the sociological, 106–8
Price, Lloyd, 154
Pride, Charley, 21–2
Professor Bop, deejay, 134
Progressive Farmer magazine, 86
Proyart, L'Abée, 199–201

Quebec, French revival in, 73
Quezergue, Wardell, 157
Quinones, Marc, 122

Raboteau, Albert, 193
race
 and characterisation in *The Birth of
 a Nation*, 167–70, 183–4
 in definition of South, 2
 disguised in *Southern Living*, 95–6
 mulattos and miscegenation in
 films, 168–70, 183–4, 185–7
 and origins of southern culture,
 5–6
 and racial identity, 178, 185–8
 and southern rock, 121–4
 see also black people; Civil Rights
 movement; segregation; white
racism
 in 1960s, 88
 as central theme of southern
 history, 12
 radio broadcasts against, 137
radio
 all-black programming, 132–4,
 140–1, 142–3, 145

Radio, *cont.*
 and black community affairs,
 139–40
 importance to black community,
 130–2, 146n
 ownership of stations, 132,
 139–40, 143–4
 payola scandal, 143
 preoccupation with soul music,
 138–9, 145
 religious broadcasts, 133–5
 and rhythm'n'blues, 142, 149n
 role in civil rights movement,
 135–8
Raeburn, Bruce, 153
ragtime, 22
Raines, Howell, 88
Rainey, Ma, 18, 56, 59
Raintree County film, 186
Randolph, J. Thornton, *The Cabin
 and the Parlor* (1852), 90
Ransom, John Crowe, 40–1
 'Antique Harvesters', 38–9
Rappolo, Leon, 25
Rawlings, William, 208
Reconstruction
 in *The Birth of a Nation*, 166–7,
 169, 183, 184
 as portrayed by Ellen Glasgow, 35
 in Ransom's 'Antique Harvesters',
 38–9
Redding, Otis, 121
Reed, Ishmael, 7
Reed, John Shelton, 7
Reed, Revon, 80
regional consciousness, 3
religion
 and African-American art, *195*,
 196–8, 201, 203, *204*, 205, *206*,
 207–8
 Catholicism and gospel music,
 158–9
 Christianity and Darwinism, 34–5
 church choirs, 159–60
 fundamentalism, 2
 and gospel music, 157, 158–9
 Protestant evangelicalism, 2

 radio broadcasts, 132, 134–5
 role of spirituals in, 15–16
 in southern rock, 125
Reveil Acadien, Le, periodical, 75
Reynolds, J. Edward, 140
rhythm'n'blues, 21
 on radio, 142
Rice, Anne, *Interview with the
 Vampire*, 6
Richard, Zachary, 74
Richbourg, John, 142
Riddles, Leslie, 20
Riley, Sam, 95
Rilke, Rainer Maria, *Sonnets to
 Orpheus*, 49
Robichaud, Louis, New Brunswick
 premier, 74
Robins, Kevin, 155
rockabilly music, 21
rock'n'roll, 104, 141–2
 New Orleans and, 153
 origins of, 21, 121
 white segregationist view of, 142
 see also southern rock
Rodgers, Jimmy, 20, 21, 22
Rodman, Gil, 100, 101
Roemer, Buddy, Governor of
 Louisiana, 67
Rossington Collins Band, 124, 129n
Rossington, Gary, 124
Rundles, Jim, 143
Russell, Michele, 57–8
Ryan, John, 99

St. Cyr, Johnny, 23
Sandow, Gregory, 105
Sargent, John Singer, 93
Savoy, Joel, 77
Scar of Shame film, 186
Schwartz, Marlyn, *A Southern Belle
 Primer*, 94
SCLC (Southern Christian Leadership
 Conference), 138, 139
Scopes, J.T., trial (1925), 33
Scotland, Klux Klan connection,
 174–5
Scott, W.A., 135

Sears, Zenas, 142
Seawright, John Ryan, 194
Second World War
 and jazz, 27
 in southern poetry, 43–4
segregation
 in Birmingham, Alabama, 88
 influence of rock'n'roll on, 142
 and music in New Orleans, 23–4,
 156–7
 racial progress within, 135–6
 radio campaign against, 137
 whites' Massive Resistance
 campaign, 141
 see also Civil Rights movement
sex, interracial, 184, 186–7
sexism, 52
 in antebellum South, 119–21
Shakespeare, William, Macbeth, 46
Shepherd, John, Music as Social Text,
 101
Sheridan Broadcasting, 143
Shultz, Arnold, 20
silver, as status symbol, 94–5
Simmon, Scott, 166
Simms, William Gilmore, 220
Simpson, George Eaton, 203
Sinatra, Frank, 104
Skynyrd, Lynyrd see Lynyrd Skynyrd
slave trade, abolition, 193–4
slavery
 emancipation (1863), 194
 and myth of southern destiny, 45
slaves
 and creolisation, 14–15
 use of music, 15–17
Smith, Bessie, 18–19, 56, 59, 60
Smith, Jennie O., 209
Smith, Lillian, 1
 Killers of the Dream, 184
Smith, Mamie, 56
Smith, Michael P., 157
Smith, Timothy D'Arch, 99
Smith, Trixie, 56
Smithsonian Museum, African-
 American art in, 202–3, 205,
 209

Sockman, Ralph, 134
soul music, on radio, 138–9
South Carolina, creole culture, 14
South, the
 assimilation into modern America,
 221–3, 225–6
 and Darwinist determinism, 33–4
 definitions of, 1–3, 224–6
 geographical definition of, 1
 Lost Cause literature of, 89–90
 racial definitions of, 2, 166–7, 175
 regional musical styles, 151
 search for central theme, 12–13
 seasonal and historical time in
 literature of, 31–50
 and slavery, 45
 Southern Living's portrayal of, 89,
 90–2
 and themes of southern rock,
 116–17, 123–4
 see also culture (southern)
Southern, Eileen, 65n
Southern Accents magazine, 92–4
Southern Belle
 romanticisation of, 120
 see also women
Southern Exposure magazine, 96
Southern Literary Messenger, 91
Southern Living
 denial of violence, 86, 88–9
 influence of, 96
 origins of, 86–7
 policy of, 87–8, 91
 portrayal of South as Arcadia, 89,
 90–2
 readership, 85–6, 87
Southern magazine, 96
Southern Progress Corporation, 86
Southern Review, The, 91
southern rock, 115–16, 125–6, 128n
 continuing Civil War ethos in,
 116–19
 issue of race in, 122–4, 128nn
 sexist agenda of, 119–21
Southern Rose, The, periodical, 91
Spence, Bill, 134
Spillers, Hortense, 55–6

Spin Doctors band, 129n
Spingarn, Arthur, 137, 141
spiritualism
 language of Holy Spirit, 205–8
 Muslim influence in, 208
spirituals, African origins of, 15–16
Stampley, Jerome, 135
Starkman, David, 186
Steel Magnolias, 7
Stillwater band, 128n
Stone, Chuck, 144
Stowe, Harriet Beecher, *Uncle Tom's Cabin*, 6, 90, 169–70
Streetcar Named Desire film, 153
Sunbury, Georgia, grave monuments, *195*, 196–8
Sundquist, Eric, 90

Tate, Allen, 40, 45, 219
 'Causerie', 41
 'Idyll', 43, 48
 'Ode to the Confederate Dead', 41–2
 'Retroduction to American History', 41
 'Seasons of the Soul', 43–4
 The Fathers, 43
Taylor, John, 220
Taylor, Paul, 101
Tee-Tot (Rufus Payne), 20
Tennessee
 'Monkey Trial' (1925), 33, 40
 see also Dayton; Memphis; Nashville
Tharpe, Jac L., *Elvis Images and Fancies*, 101
Thomas, Rufus, 133
Thompson, E.P., 28
Thompson, Robert Farris, 197, 198–9
 Flash of the Spirit, 197
.38 Special, 'Wild-eyed Southern boys', 119, 124
time, historical and seasonal, 32, 33, 36–7, 39, 42, 44
 and myth, 44–5, 47, 49–50
Tindall, George, 1
Toole, John Kennedy, 7

tourism, 7
 and Cajun's French heritage, 76–7
 gospel choirs and, 158–9, 160–2
 in New Orleans, 153–4
Tross, Dr J.S. Nathaniel, 135–6
Trucks, Butch, 122
trumpet, 26–7
Tucker, Stephen, 107
Twain, Mark, *Adventures of Huckleberry Finn*, 6

United Church of Christ, 139
United Daughters of the Confederacy, 91
Urban League, civil rights broadcasts, 137, 138

Van Zant, Johnny, 118, 125, 128–9nn
Van Zant, Ronnie, 124, 125
Veranda magazine, 92–4
Vicksburg, siege of, 127n
violin, 17
Vogue magazine, 91
Voorhies, Felix, *Acadian Reminiscences*, 71

Wade, Theo, 133
WAGA radio station, 135
Walden, Phil, Capricorn records, 121, 122, 128n
Walk on the Wild Side film, 153
Walker, Alice
 'Everyday Use', 55, 58, 62
 Meridian, 53–4, 60, 63, 219
 'Nineteen Fifty-five', 54–5
 Possessing the Secret of Joy, 58
 The Color Purple, 6, 52, 54, 55–6, 57, 59–60, 61–3
 The Temple of My Familiar, 60
 The Third Life of Grange Copeland, 57–8
Walkup, Robert, 137–8
Wallace, George, Governor of Alabama, 123
Wallis, Roger, 155
Waltons, The, 6

Warhol, Andy, 184
Warwick, University of (England),
 conference, 8–11
Washington, Nolan, 157
Waters, Ethel, 56, 60–1, 141
 His Eye Is On the Sparrow, 57
Wavelength music magazine, 150,
 155
WBCO-Birmingham/Bessemer radio
 station, 132
WBT-Charlotte radio station,
 'Community Crusaders'
 programme, 135–6
WCAO-Baltimore radio station, 141
WCSC-Columbia (South Carolina)
 radio station, 137
WDIA-Memphis radio station, 135,
 139
 all-black format, 132, 133–4, 140–1
Weaver, Richard, 220
WEDR-Birmingham radio station,
 132, 140, 141
Welty, Eudora, 10, 218–19
 The Golden Apples, 47–9
 The Robber Bridegroom, 31–3, 45, 47
 use of myth, 45, 47–9
WENN radio station, 138
WERD-Atlanta radio station, 132,
 135, 137, 144
 support for civil rights campaign,
 138, 139
West Indies, slaves 'seasoning' in,
 194
WGST-Atlanta radio station, 135
WHBQ-Memphis radio station, 142
White, 'Bukka', 17, 51
white people
 as blues singers, 64n, 121–2
 characterisation in *The Birth of a
 Nation*, 167
 European folk culture of, 13
 as jazz musicians, 23, 24–5
 nature of memory, 4, 224–5
 as owners of radio stations, 132,
 139–40
 as readers of *Southern Living*, 85–6,
 87–8

and southern rock, 122–4
 see also white women
White, 'Tall' Paul, 138
White Trash, 88, 96
white women
 images of, 119–21, 224
 response to Alice Walker, 52–3, 63
 and use of lighting in *The Birth of
 a Nation*, 171–4
Whitehead, Otelia, 203
whiteness, and cinematic lighting
 techniques, 171–4
*Why Scarlett's in Therapy and Tara's
 Going Condo*, 7
Wicke, Peter, *Rock Music: Culture,
 Aesthetics and Sociology*, 101
WILA-Danville radio station, 144
Williams, Hank, 20, 22, 106
Williams, Nat D., 133, 140
 and civil rights, 135
Williams, Tennessee, 152
Williamson, Eddie, parking lot art,
 201–2
Williamson, Joel, 88
Williamson, Sonny Boy, 132–3
Willis, Paul, 108
Wilson, Charles Reagan, 7
Winslow, Vernon, 134, 139–40
Wise, Sue, 110
Within Our Gates (Oscar Micheaux
 film), 177, 183, 185–7
 concept of family in, 188–9
 race and culture in, 178, 179–80,
 181–2
 sexual assault scene, 187–8
WJXN-Jackson radio station, 136–7
WLAC-Nashville radio station, 142
WMBM-Miami radio station, 134
WMC-Memphis radio station, 141
WMJR-New Orleans radio station,
 134
WNOE-New Orleans radio station,
 132
WOAK-Atlanta radio station, 142
WOKJ-Jackson radio station, 132,
 143
Wolf, Howlin', 17

women
 cinema representation of, 171–3
 in Ellen Glasgow's books, 35–6
 as gospel singers, 162
 and miscegenation and interracial
 rape in films, 168–70, 183–4,
 185–7
 modern, 224
 romanticised in southern rock,
 119–21
 see also black women; white women
Woodward, C. Vann, 13
 on African culture, 14–15
 The Burden of Southern History, 3
WQBC-Jackson radio station, 135
WQUE-New Orleans radio station,
 145
Wright, Richard, 5, 17
Wright, William, 138–9

WSOK-Nashville radio station, 132
Wyatt-Brown, Bertram, 91
WYLD-New Orleans radio station,
 139, 145

Yeats, W.B., 49
Young, Andrew, US ambassador to
 UN, 160
Young, Lester, 28
Young, Neil, 'Southern Man', 122
Young Black Programmers Coalition,
 145
YWCA, radio broadcasts by, 137

Zaire, 194, 198
 see also Bakongo
Zion Harmonizers gospel group, 158

Index by Auriol Griffith-Jones